espadaña press
S A N T A B A R B A R A

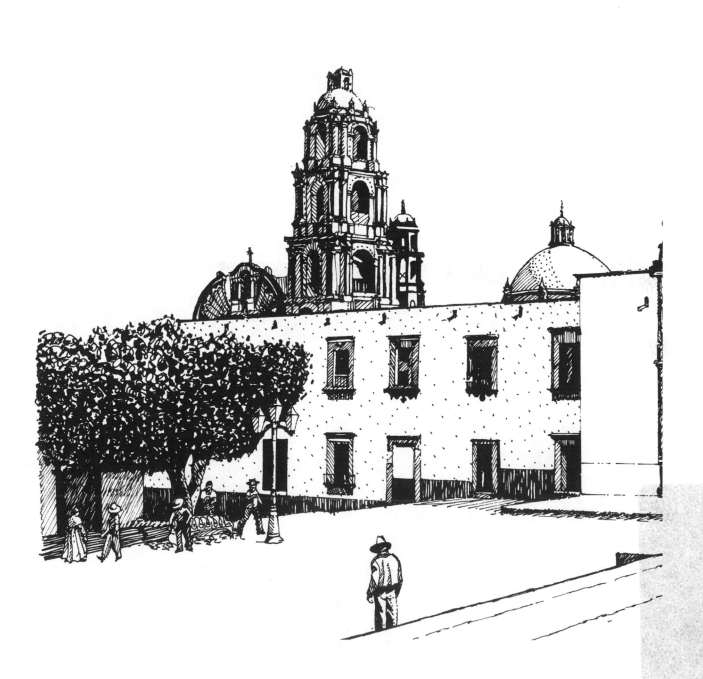

BLUE LAKES & SILVER CITIES

THE COLONIAL ARTS AND ARCHITECTURE
OF WEST MEXICO

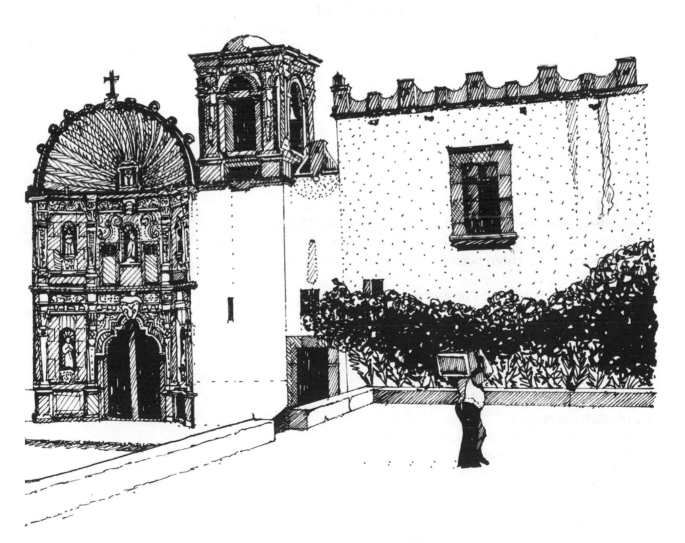

by Richard D. Perry

with illustrations by the author

Also by the author:
Maya Missions (with Rosalind Perry)
Mexico's Fortress Monasteries
More Maya Missions

To Tony and Gwen Burton
con amistad

Printed in the United States of America. First Edition

ISBN 0-9620811-3-2
Library of Congress Catalog Card Number 97-60544

CIP Data:
Perry, Richard D.
Mexico—Description and Travel
Mexico—Art and Architecture
Architecture—Spanish Colonial—Mexico

Published by Espadaña Press
PO Box 31067
Santa Barbara, California 93130

Frontispiece illustration: The Oratorio complex, San Miguel de Allende. Guanajuato

C O N T E N T S

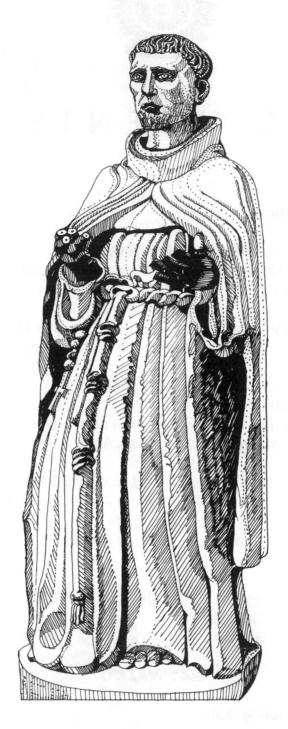

Querétaro, statue of St. Francis of Assisi

P R E F A C E

West Mexico has it all. Although the lakes of this picturesque region may not be as deep and blue as formerly, and its storied cities not paved with silver as earlier writers reported, there is still much here to charm and awe the receptive traveler.

We can still recapture something of the magic that pervaded both city and countryside in colonial times—a magic that is, above all, preserved in the surviving arts and monuments of that vanished era.

Indeed, the artistic heritage of Spanish colonial west Mexico is one of extraordinary variety and richness, spanning the entire viceregal era. The rural mission-hospitals of Michoacán, the Plateresque monasteries of Guanajuato, the imposing urban churches of Guadalajara and Morelia, and the spectacular gilded baroque altarpieces of Querétaro—all reveal special characteristics unique in Mexico and the Americas.

Readers of my earlier guides are aware of my fascination with the 16th century in Mexico. This tumultuous era that followed the Spanish conquest saw an epic clash of cultures, with wrenching social changes that gave birth to a new race in the Americas.

In the arts and architecture, as in other spheres of colonial life, this confrontation produced exciting new forms that have shaped Mexican artistic sensibilities ever since.

While the 16th century artistic legacy is full and fascinating in western Mexico, it is the achievements of the 17th and 18th centuries—in architecture, painting and sculpture—that reached their apogee in this region.

In describing this later patrimony I have tried to explore the baroque era in Mexico, with whose social and artistic manifestations I was not initially familiar or entirely in sympathy. Through further study of the 17th and 18th centuries and its monuments, however, I have come to a greater appreciation of the complexity, inventiveness and importance of this formative period in Mexico.

Even the dead hand of academic neoclassicism, whose imposition late in the viceregal period prompted the tragic destruction of earlier colonial art in the region, was leavened by the irrepressibly creative Mexican imagination and love of ornament.

Acknowledgments

In preparing this guidebook I am indebted to many people. First, I thank Paul Berg, and especially Tony Burton and his family for their generous hospitality, invaluable local knowledge, considerable patience and above all, their enthusiasm for the project.

I should also like to express my appreciation to Karl Anton Bleyleben, Tony Burton, Sam Edgerton, Janet Esser, Damian Leader, Enrique Luft, Norman Neuerberg and Jeanette Peterson for kindly critiquing sections of the manuscript. As always, I wish to thank my wife Rosalind, who in addition to her invaluable counsel as adviser, editor and one-woman support group, bravely accompanied me on numerous forays into the scenic highways and byways of western Mexico.

Richard Perry Santa Barbara 1997

WEST MEXICO

Jalisco

GUADALAJARA

Lake Cajititlan

Lake Chapala

Lake Sayula

Michoacán

Lake Pátzcuaro

Uruapan ○

Pátzcuaro ○

Lake Zirahuen

○ MORELIA

Lake Cuitzeo

Lake Yuriria

Guanajuato

GUANAJUATO ○

Irapuato ○

San Miguel Allende ○

Salamanca ○

Querétaro

○ QUERETARO

Jalpan ○

Mexico State

INTRODUCTION

The subject of this guidebook is the Spanish colonial artistic heritage of West Central Mexico, a scenic and historic land that stretches west from the Valley of Mexico to the Pacific Ocean.

Geographically, this highland region broadly corresponds with the great Tarascan empire of pre-hispanic times, which rivaled that of its neighbors and arch-enemies, the Aztecs. After the Spanish conquest, the region was transformed into the vast colonial province of Michoacán—an area that now includes the modern state of Michoacán as well as parts of the adjacent states of Jalisco, Guanajuato and Querétaro.

Artistically, western Mexico is remarkable not only for the breadth and variety of its colonial architecture and arts, but also for the unique regional pathways that they followed during the three centuries of Spanish rule.

The 16th Century

When the Spaniards arrived in Mexico in the early 1500s, the vast expanse of the Tarascan empire was ruled by its hereditary kings, the Cazonci, from their royal capital of Tzintzuntzan on the banks of Lake Pátzcuaro.

Although strong enough to repulse the repeated military advances of the powerful Aztec empire, the Tarascans ignored their enemy's call for an alliance to resist the Spanish conquest. Following the defeat of the Aztecs in 1521 and the destruction of their capital at Tenochtitlan, Caltzontzin, the last Tarascan king, approached the Spaniards in peace, sending gifts of gold to the Spanish conqueror Cortés.

The next year, Cortés sent an expedition west under Cristóbal de Olid, who returned with more treasure but believed the region to be unsuitable for Spanish colonization. However, gold mining in the tropical lowlands of Michoacán attracted Spanish adventurers, followed by settlers, causing great hardship and creating unrest among the Indians. Several native rebellions erupted, all of which were put down by Spanish troops amid accusations of atrocities on both sides.

But worse was to come. In 1528, Nuño de Guzmán, the brutal president of the infamous ruling council of the conquistadors, the First Audiencia, led an expedition into Michoacán in search of gold and treasure, holding Caltzontzin for ransom. Disappointed with the size of the booty, Nuño tortured the Tarascan lord and then tried him on charges of idolatry and treason. The hapless king was strangled and burned at the stake.

Chaos followed. Native uprisings and raids by Chichimec tribesmen from the north continued, disrupting settlement until they were decisively suppressed by Spanish troops during the Mixton War of 1541.

Under the moderate influence of the Second Audiencia, made up of royal officials including Vasco de Quiroga, peace and stability slowly returned to Michoacán.

Vasco de Quiroga

The name of Bishop Vasco de Quiroga dominates the early history of colonial west Mexico and Michoacán. This irascible and stubborn cleric was called "Tata Vasco" by the Indians, to whom he was paternalistically devoted; indeed, his place in local folklore has outlasted his more tangible works.

A professor of canon law from Valladolid, Spain, he was appointed to the Second Audiencia in 1531, becoming one of its most influential members. As part of his investigation into the oppressive and corrupt practices of the First Audiencia, in 1533 he visited western Mexico, developing great sympathy for the Indians and their plight.

Acting as their advocate, Quiroga pressed their case with the king. When named as bishop, he proceeded to found a series of model Christian villages, each with a mission hospital as its communal focus, using his own private funds.

Known as "pueblo-hospitals," these exclusively Indian communities were based on the utopian writings of St. Thomas More, and infused with equal parts of humanism and paternalism. However, only two of Quiroga's idealistic communities came to full fruition. The first pueblo-hospital, just outside Mexico City, attracted large numbers of Indians, alarming the civic authorities, and was subsequently dissolved.

The second community was established at Santa Fé de la Laguna, on the north shore of Lake Pátzcuaro. It continued to function into the 1700s, and on its site is a little museum dedicated to the memory of the indefatigable bishop.

The concept proved popular with the king, who ordered similar hospitals built in every mission town and Indian village. Thus, Quiroga's ideas lived on, adopted by the religious orders, whose missions across colonial Michoacán all included an Indian hospital and chapel.

In an attempt to repair the ravaged Tarascan economy, Vasco de Quiroga also established special crafts in each village to make them self supporting and interdependent—a regional tradition of local artesanry that continues to the present day.

Although Don Vasco's interests later focused on grander projects in Michoacán, he continued fiercely to defend his pueblo-hospitals until his death at the age of 95.

The "Spiritual Conquest"

Although Vasco de Quiroga looms large over the spiritual as well as the secular life of early Michoacán, much of the gritty missionary work was accomplished by two mendicant orders of friars—the Franciscans and the Augustinians.

Evangelization of western Mexico, which began in 1525 with the conversion and baptism of Caltzontzin, the last Tarascan king, spread rapidly to every corner of the region. Missionary work was pioneered by the Franciscans, joined later by the Augustinians.

The Franciscans

As the first of the missionary orders to arrive in New Spain, the Franciscans firmly established themselves in the geopolitical center of the new colony, rapidly evangelizing the Valley of Mexico and adjacent areas.

Shortly after his conversion, the Tarascan king requested Martín de Valencia, the leader of the Apostolic Twelve—the first contingent of friars to arrive in Mexico—to send missionaries to the Tarascan capital.

Three Franciscans led by Fray Martín de la Coruña—also one of the Twelve—arrived at Lake Pátzcuaro soon after. The trio established themselves at Tzintzuntzan as guests of Caltzontzin, who encouraged his subjects to convert to Christianity. Fray Martín de Jesús, another dedicated friar, arrived the next year and started work building a modest mission nearby.

Initially the process of conversion proved difficult, largely because the Tarascan nobles were reluctant to give up their ancient customs and religious rituals. But as numbers of friars grew, the Franciscans' work began to bear fruit, especially with the arrival of the charismatic Fray Juan de San Miguel in 1528. As elsewhere in newly conquered Mexico, the friars often came to be viewed by the Indians as their best protectors against the depredations of the Spanish colonists.

The western expansion of the order centered on the Lake Pátzcuaro region, where numerous mission-hospitals were founded in cooperation, and occasionally in conflict with, the Augustinians.

As early as 1533 the Franciscan missions of Michoacán and Jalisco were incorporated into the Custody of San Pedro and San Pablo under the jurisdiction of the main Franciscan Province of the Holy Gospel. In 1565, San Pedro and San Pablo was raised to the rank of an independent province.

The Augustinians

The first contingent of Augustinian friars reached Mexico in 1533, led by Fray Francisco de la Cruz, "el Padre Venerable." Initially part of the Augustinian Province of Castile, the Mexican apostolic mission grew rapidly, so that by 1545, the independent Province of the Holy Name of Jesus was established in New Spain.

The Augustinian order traced its origins to the early hermitages established in the fourth century

by St. Augustine in the deserts of north Africa. For centuries, the order consisted of a tenuous network of monastic communities dedicated to the contemplative life, but in the 13th century was transformed by Pope Innocent IV into an active mendicant order, dedicated to teaching and preaching to new converts on the fringes of Christendom.

As the order grew in Mexico, its network of missions and monasteries expanded from Mexico City, reaching from Malinalco into western Mexico by the mid-1500s. There the Augustinians began to blaze their own missionary path between areas already evangelized by the Franciscans, eventually taking over some of their rivals' missions.

The challenges of this frontier region continued to attract energetic missionaries of high quality from Spain, at a time when established monasteries near the colonial capital were increasingly staffed by less adventurous *criollo* (Mexican-born) friars.

The growing independence of the western friars, preoccupied with their ambitious program of founding missions and building large monasteries, provoked conflict with the metropolitan Province of the Holy Name of Jesus. In 1602, the independent Augustinian Province of San Nicolás Tolentino de Michoacán was created, named for the popular 13th century Augustinian preacher and saint.

Art and Architecture

In the wake of the Spiritual Conquest, western Mexico proved fertile ground for the establishment of monasteries and mission towns by the mendicant orders.

Monastic Art & Architecture
By the late1500s, the Franciscans and Augustinians had established monasteries and priories in the larger settlements of western Mexico. Although some developed from smaller missions, others were intended from the start as regional centers, designed to house and instruct incoming missionary friars and to administer the growing mendicant provinces.

Several of these more or less grand monasteries from the 16th and early 17th centuries have survived, some in the cities and towns of the region but others in more rural areas. Major urban mendicant houses stand in Pátzcuaro, Morelia, Guadalajara, Salamanca and Querétaro. Outside the cities, large monasteries were established at Tzintzuntzan, Cuitzeo (Michoacán), and Yuriria (Guanajuato).

These religious monuments were built on a grand scale. Situated within large atriums, they feature spacious vaulted churches and ample conventos built around sunlit stone cloisters. The monastic churches have especially striking facades, ornamentally carved in the Spanish Plateresque style—a distinctive 16th century architecture in which late Gothic features are combined with Renaissance elements.

The Frescoes
In all the monasteries, large scale frescoes covered the walls of church and convento alike.

As an essential tool of the Spiritual Conquest, these didactic murals illustrated the Christian story and glorified the history of the mendicant orders. Painted by native artists under the direction of the friars, these murals were based on a few graphic sources—engravings, woodcuts and book plates—opening up a new and rich creative vein that fused European and native artistic traditions.

But by the late 1500s, with the end of the era of evangelization and under the influence of the Counter Reformation, these enormous murals, which had adorned almost every surface within the great monasteries as well as more modest missions, were covered with whitewash. In the churches, the newly bared walls were covered by fashionable carved and gilded altarpieces.

Ironically, while many of these retablos have, in their turn, disappeared, some of the old frescoes have emerged from behind their centuries-old coats of paint.

Although in western Mexico most of the surviving murals are now only fragmentary—confined to friezes and small scale lunettes—some are complete enough to remind us of how spectacular these painted walls must have looked in their heyday.

Outstanding examples include the extraordinary cycle of 16th century murals adorning the monastery of Charo, and the celebrated frescoes at Malinalco to the southeast.

The Pueblo-Hospitals
In the predominantly rural provinces of early colonial west Mexico, especially populous Michoacán and New Galicia (modern Jalisco), in place of grand priories, the most popular form of mission was a simpler version of the pueblo-hospital pioneered by Vasco de Quiroga.

As modified by the Franciscans, the mission-hospital, as it became known, was designed to attract the Indians, thus aiding the task of conversion and settlement.

Throughout the region, the hospital rapidly became an institution in its own right, forming an essential element of the early mission complex. Distinct from the friars' church and convento, the hospital, with its own small chapel, ministered solely to the Indians.

Funded and maintained by a dedicated native religious brotherhood, or *cofradía*, the chapel, commonly known by its indigenous name of *yurishio*, was usually dedicated to the Virgin Mary, and lavishly ornamented with retablos and painted *artesonado* ceilings.

Often built at the same time as, or soon after, the mission churches, these hospitals and their chapels were permanent stone structures, many of which have survived virtually intact to the present day, while the mission churches have frequently undergone changes that mar their original character.

Following Tarascan tradition, a communal meeting house or hospice was also integral to the mission-hospital complex. Several of these mission-hospitals survive, notably those at Ocumicho, Zacán and San Lorenzo in Michoacán, and Acámbaro, Guanajuato.

"Pidgin Plateresque"

Most early churches and rural chapels of the region share a provincial architecture quite distinct from the great monasteries.

Labeled "Pidgin Plateresque" by the Mexican art historian Manuel Toussaint, this eclectic style is peculiar to western Mexico, especially Michoacán. Plateresque forms and decoration were infused with another Spanish building legacy, inherited from the centuries long Islamic occupation of the Iberian peninsula.

Popularly known as *mudéjar*—named for the Moorish artisans who worked under Christian rule during the Reconquest of Spain—this deeply rooted artistic tradition employed a broad range of characteristic structural and decorative devices: scalloped, lobed or serrated archways, usually enclosed by an ornamental rectangular frame or *alfiz*; octagonal columns, towers and domes; the *ajimez*, or divided Moorish window; and especially the use of complex decorative carpentry and stuccowork in roofs and ceilings.

In 16th century Michoacán, this popular regional style developed its own distinctive features,

in particular the almost universal use of the scallop shell, which is prominently carved in high relief on facades throughout the area.

Although the attachment to this marine device in an inland province is puzzling, the shell is the primary symbol and instrument of Christian baptism—the essential sacrament in the conversion of unbelievers—as well as an ancient symbol of rebirth and new beginnings.

It is also the emblem of St. James, or Santiago, the patron saint of Spain, who figured prominently during the conquest of Mexico. In addition, it was a popular decorative motif in Plateresque decoration in the mother country, as for example in the 15th century palace of La Casa de Las Conchas in Salamanca.

Generally, shells and other architectural ornament in the facade were limited to carving around the doors and windows. In the Plateresque tradition this usually took the form of foliated arches, swagged baluster columns and ornamental jambs carved with intricate foliage, urns, pearls, angels' heads and "grotesque" masks.

Throughout Michoacán, we can see superb early examples of Pidgin Plateresque at Angahuan, Uruapan and Zacapú.

Carved Crosses

Perhaps the most popular and original type of 16th century sculpture was the carved stone cross.

Whether marking hilltop shrines, surmounting the churches and chapels or simply standing in the mission atrium, the cross was the most conspicuous Christian symbol. But as the earliest and most prominent sculptural genre to emerge in New Spain, it often embodied pre-hispanic as well as Christian formal and mythical elements.

The almost universal use of the stone cross carved with Passion iconography is unique to the New World. Familiar to native peoples because of its resemblance, physically and conceptually, to the ancient Tree of the World or Tree of Life, the carved cross was employed by the friars as an prime evangelizing tool in the Spiritual Conquest.

Typically, the cross illustrated the Instruments of the Passion and often bore the Face of Christ and His Wounds, so that the cross itself became an object of worship to neophyte Indians. Almost all the crosses bore the letters INRI, the Latin initials of the legend, "Jesus the Nazarene, King of the Jews."

In addition, crosses were frequently embellished with carved foliage, vines and flowers of sacred significance, further emphasizing in the

native mind its connection with trees and nature.

Indigenous influences were felt in other ways. Stoneworking was carried out by native craftsmen who followed prehispanic traditions in the use of flat, undercut relief. This technique, especially when combined with the often crude European woodcuts that were the source for much of the imagery, produced a unique sculptural style that has been called *tequitqui*, from an Aztec term meaning a subject or tributary—the New World counterpart of the Spanish term *mudéjar*.

Numerous 16th century crosses can be admired in western Mexico. They range from the austere examples of Jalisco to the stunning ornamental crosses of Michoacán, especially those in the eastern part of the state, at Ucareo and Ciudad Hidalgo (Tajimaroa), where magnificent sculpted crosses are inset with obsidian disks—an indigenous device symbolizing the heart or soul of the icon.

Cristos de Caña

In addition to stone crosses, another type of cross common to western Mexico was the *cristo de caña*. This lightweight processional crucifix was formed from a malleable but durable compound of cornpith and orchid glue—a sculptural technique from pre-hispanic times.

The lifesize figures of Christ on the cross are naturalistically rendered in often harrowing detail, with bloody wounds and torn flesh. Such repellent but also morbidly attractive images, with their emphasis on suffering and sacrifice, are characteristic of Spanish colonial religious art, especially in Mexico.

Bishop Quiroga set up a famous workshop in Pátzcuaro, manned by native artisans and devoted to the production of these crosses, which were then dispersed to all areas of Michoacán and widely imitated, even centuries later, creating a sculptural genre that thrived all across colonial Mexico.

Outstanding examples of crucifixes, many dating back to the 1500s, grace public collections in Morelia and Pátzcuaro, and can be found in countless churches throughout western Mexico.

Artesonado Ceilings

Mudéjar and Tarascan architectural traditions happily combine in numerous religious and public buildings of colonial Michoacán, with their steeply pitched wooden roofs, overhanging eaves and interior beamed ceilings—a tradition that continues even today.

One of their outstanding features is the finely crafted *artesonado* ceiling—perhaps the most distinctive and widespread of the *mudéjar* survivals. Also known as *alfarjes*, they are usually complex structures of intricate joinery and inlaid carpentry, trimmed with painted or sculpted moldings and supported on carved, painted brackets known as *zapatas*.

In addition, separate paneled, suspended ceilings, called *artesones*, adorned numerous rural churches and chapels in colonial and post-colonial times, especially in Michoacán. Although they occasionally covered the entire structure in smaller chapels, in larger churches they were usually confined to areas above the choir or the sanctuary.

These *artesones* were frequently painted with narrative or emblematic designs—an art form particularly favored in western Michoacán, where a few rare colonial examples survive. Although they vary in scale, quality and condition, the ceilings are invariably embellished in a vivacious popular style, with an emphasis on firm contours and bright colors.

The best known colonial examples are at Naranja de Tapia, and the magnificent polychrome ceiling at Tupátaro, near Pátzcuaro, which has been called the "Sistine Chapel of Mexico."

The Baroque Age

With expanding Spanish colonization, the 17th century saw the growth of larger towns and cities across western Mexico. Morelia (colonial Valladolid) and Pátzcuaro were established in Michoacán. Guadalajara, further to the west, grew in importance, and the cities of Guanajuato and Querétaro flourished along the silver routes to the north.

As the Spiritual Conquest came to an end, the influence of the mendicant orders waned as the power of the Jesuits and secular clergy waxed. The friars' humanistic vision of an Indian republic had faded in the face of devastating native mortality, while *criollos* and *mestizos*—the rapidly growing classes of Mexican-born citizens of white and mixed race respectively—began to dominate colonial society.

While rural monasteries were being secularized or even abandoned, new religious buildings arose in the towns and cities across New Spain.

The spirit of the 17th century is best captured in the monumental classical architecture of the great cathedrals that dominated the city centers of the region, notably in Morelia and also in Guadalajara, the earliest Mexican cathedral after that of Mérida, in Yucatán.

Built on a basilican plan—with a nave and side aisles separated by arcades—these urban cathedrals featured sober classical facades flanked by massive, multi-tiered towers—a style influenced by the severe Mannerism of Juan de Herrera, the Spanish architect of El Escorial, King Philip of Spain's brooding 16th century palace and monastery in the hills above Madrid.

The other leading force in 17th century urban life and architecture was the Society of Jesus, the militant champion of the Counter Reformation and traditional proponent of higher education, whose teachings fed the emerging Mexican patriotism of the *criollo* class.

Expressing both the grandiose goals and uncompromising austerity of the Jesuit order, the design of their Mexican churches and colleges reflected the sober monumentality of the Roman Baroque, as exemplified by their mother church of the Gesú in Rome, influenced by the refined Mannerism of the Mexican cathedrals. Their elegant cruciform churches, with classical facades, twin towers and high domes, often overlooked the spacious arcaded courtyards of the adjoining colleges.

Distinguished by its geometric clarity, soaring towers and gabled facades, this restrained baroque style defined the urban religious architecture of the 1600s and characterized the centers of Guadalajara, Querétaro and especially Morelia.

As in the previous century, architectural decoration was initially limited to patterned relief around the doors and windows. But as the century progressed, there was a greater emphasis on ornament. The austere Mannerist church fronts gave way to more elaborate retablo facades, so-called because of their derivation from the Renaissance altarpieces of the late 1500s and early 1600s.

One innovative feature was the "Solomonic" column, whose twisted shaft—often embellished with carved grapevines—was named after the legendary columns that supported the Temple of Solomon in Jerusalem. Ornate examples include the facades of Santa Mónica and San Francisco in Guadalajara.

Following the edicts of the Counter Reformation, emphasis was placed on the power and majesty of the Catholic Church, its imagery, liturgy and rituals. Didactic iconography, glorifying the saints, church and biblical history and, above all, the story and symbols of Christ's life and Passion, spread across facades and altarpieces alike, using figure sculpture, carved reliefs and painted panels.

Although some statuary had appeared on 16th century churches, it was only with the spread of the retablo facade with its numerous niches, that figure sculpture came into its own on the church front. Initially awkward and primitive, stone statues of saints and angels became increasingly expressive and style conscious, even though many were still carved in a popular idiom.

Altarpiece statuary, by contrast, entered a new stage of refinement. Guilds of specialists skilled in the production of figure sculpture mushroomed during the 1600s, introducing the new baroque canons of realism and drama into church retablo art. Lifelike figures with animated gestures and facial expressions, enhanced with glass eyes and real hair, and clothed in sumptuously painted and gilded *estofado* costumes replaced the stiff, iconic statues of earlier altarpieces.

The 18th century

In the late 17th and early 18th centuries, the fertile crescent between Guanajuato and Querétaro, known as the Bajío, became an economic powerhouse. Hundreds of *haciendas* were devoted to raising wheat and livestock—primarily sheep, whose wool fostered a burgeoning local textile industry. In addition, the fabulous wealth generated by silver mines fed a vigorous commerce in cities across the region.

With the approach of the 18th century, materialism and ostentation became the mark of the prosperous *criollos*. Public displays of piety encouraged by the *criollo* priesthood replaced the austerity and humanistic religious values preached by the friars.

Rapid urban growth ushered in a prolonged building boom, in conspicuously ornate churches, urban mansions, schools and especially nunneries, creating the impressive architectural heritage of these "silver cities" that we can still admire today.

While many early 18th century religious and civil buildings clung to the sober baroque look of the previous century, their interiors began to display a growing opulence, characterized by an exuberant style of architecture and decoration popularly called the Churrigueresque, which eventually spread to the church facades.

The Churrigueresque

Taking its name from the Churrigueras, a prominent family of baroque architects and designers,

this highly ornate Spanish style of altarpiece and facade design reached its apogee in 18th century Mexico.

As refined and transported to Mexico by such Andalusian designers as Lorenzo Rodríguez and Gerónimo Balbás, the Churrigueresque blossomed into a truly Mexican art form. By adding *mudéjar* and even indigenous motifs, it developed into an intricate style that perfectly expressed the complex temper of 18th century Mexico.

Sponsored by the wealthy Mexican aristocracy, which included the rich mining barons, this sumptuous style reflected the growing national pride of the elite creole class and their patriotic vision of greatness, *la grandeza mexicana.*

The signature motif of this artistic movement was the *estípite*, a complex column or pilaster of inverted obelisks, scrolls and applied moldings piled one atop the other, that combined elements from Flemish Mannerism and French Rococo design, and replaced the spiral Solomonic column of the 17th century. The Churrigueresque achieved its high point in the grand facades and sumptuous altarpieces of a group of late 18th century churches and mansions located in the capital and the prosperous silver cities of the Bajío.

Outstanding architectural examples can be seen in and around the city of Guanajuato, most notably at the churches of La Compañía and San Diego, as well as at the outlying hilltop temple of La Valenciana. The complex facade of the nearby parish church at Dolores Hidalgo is mirrored in its ornate interior retablos.

In later manifestations of the Churrigueresque, the *interestípite*—an ornamental niche-pilaster that housed elaborate statuary and relief sculpture—eclipsed the *estípite* itself in church facades and altarpieces, turning the classical tradition on its head.

Figure sculpture also became increasingly stylized and theatrical. Realism gave way to the lighter decorative influence of the Rococo, which encouraged effete stances, exaggerated gestures and overblown, billowing draperies.

The Churrigueresque altarpiece reached its zenith in western Mexico after 1750, in what has been called the Queretaran style. Large scale late works, designed by masters of the genre and opulently carved, painted and gilded by the hands of expert craftsmen, adorn San Agustín in Salamanca, and the nuns' churches of Santa Clara and Santa Rosa in the city of Querétaro.

Ornament also triumphed in popular art of the late 1700s, outside the major cities. Folk sculpture in stone and stucco ran riot on the carved church fronts of smaller towns and rural areas. Angels, statuary and every variety of foliated relief adorn clusters of colonial buildings all across the region. Outstanding examples of folk baroque can be seen among the lakeside churches south of Guadalajara, and on the painted stucco facades of the Franciscan missions of the Sierra Gorda, in the state of Querétaro.

The Churrigueresque reached its logical—or illogical—conclusion in a mode mockingly called *anástilo* or "styleless," in which virtually all formal structure was banished in favor of a complex, all-enveloping tapestry of exquisitely carved, gilded and painted ornament.

"Neostyle"

By the late 1700s, a reaction had set in against such decorative excess and the progressive dissolution of architectonic form. Dubbed "neostyle," this movement was led by the Mexico City architect Francisco Guerrero y Torres. He advocated a return to logical structure by reasserting the primacy of the column and the pilaster, and by restricting the use of unnecessary ornament.

In an attempt to re-establish a coherent national style, this eclectic school also drew on traditional *mudéjar* and Mannerist motifs from earlier colonial architecture. The cathedral of San Felipe Neri in Querétaro is one of the few examples in the area of this terminal phase of the Mexican baroque.

Neoclassicism

As the 18th century came to a close in Mexico, change was in the air. Political and artistic ferment, inflamed by the liberating ideas of the French Enlightenment, spelled the end of the viceregal era.

Under the influence of the newly established Academy of San Carlos in Mexico City, designers and architects reacted against the artistic excesses of the Baroque. The fervid spirit of the Churrigueresque was swept away by the cool rationalism of Neoclassicism, which favored a return to the strict canons of Greek and Roman architecture and ornament.

Magnificent baroque retablos were dismantled and even consigned to the flames as *leña dorada*, "gilded firewood," to be replaced by stark stone altars more suited to a Roman mausoleum. Color and flamboyance were banished in favor of severe whites and marbled grays. The sparing use of a few gold accents took the place of the shimmering gilded expanses of yesteryear.

But in Mexico, the decorative instincts of centuries died hard. The purism of the academy was undermined, even by its own most fervent proponents. Eduardo Tresguerras, the best known Mexican advocate of neoclassicism and its leading practitioner, was a native of Celaya where some of his signature works are to be found—buildings in which echoes of the baroque subtly subvert their correctly classical lines.

The End of Empire

The chaotic upheavals of the early 1800s, that accompanied Independence, also undermined the cause of ideological and artistic purity. The hybrid neoclassical style as practiced by Tresguerras and his colleagues outlasted Spanish dominion, continuing well into the 19th century under the rubric "Republican Baroque."

The love of surface ornament embellishing an underlying symmetry that we see in colonial architecture and decorative arts—a trend that became evident during the early 1500s and reached its zenith in the baroque era—must count among the most authentic expressions of the Mexican spirit.

As Octavio Paz, the great Mexican writer and thinker, has pointed out, the age-old Mexican preoccupation with elaborate outward forms as a device to mask and yet express profound inner feelings and an innate sense of order predates the Spanish conquest, and remains an enduring characteristic of Mexican life and society.

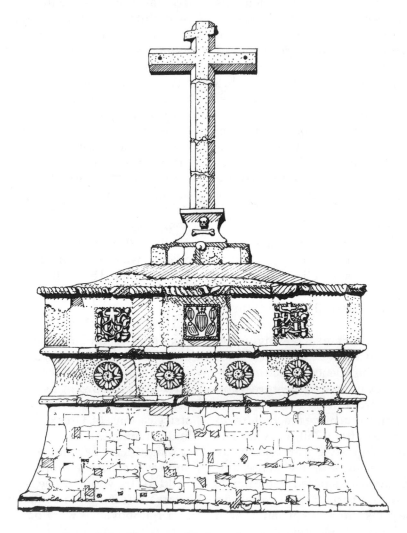

San Juan Tuxpan (Jalisco), atrium cross

P A R T O N E *MICHOACAN*

Because of the extraordinary variety, long time span and sheer number of its Spanish colonial buildings, Michoacán is the main focus of this guide.

Although Part One describes places within the boundaries of the present state of Michoacán, the colonial province was much larger, extending into the present day states of Jalisco and Guanajuato.

In former days Michoacán was even more beautiful than now—a predominantly rural area with large freshwater lakes and pine-forested sierras. It was also home to a large indigenous population, the Tarascan or *purépecha* people, who established one of the most extensive and advanced civilizations in the Americas.

The Tarascan Empire

Beginning in the 14th century, Tariácuri, the legendary warrior king of Pátzcuaro, united the various Tarascan chiefdoms in the region of Lake Pátzcuaro, and embarked on a 200 year campaign of conquest and consolidation.

This sustained expansion was so successful that when the Spaniards arrived in the early 1500s, Michoacán was a powerful empire rivaling that of the Aztecs in its strength. From their lakeside capital of Tzintzuntzan, the Tarascan kings ruled over a broad swath of western Mexico, stretching from the Toluca Valley in the east to the Pacific in the west, and taking in the entire highland region between the Balsas River to the south and the Lerma River in the north.

Their only foes were the Aztecs, their eastern neighbors, whose aggressive advances the Tarascans repeatedly repulsed from a chain of fortified frontier towns that included Acámbaro, Zinapécuaro, Ucareo and Tajimaroa, now Ciudad Hidalgo.

The Spanish Conquest

After learning of the defeat of the Aztecs and the destruction of their capital, Tenochtitlan, the Tarascan king sent gifts to Cortés, hoping to deter Spanish incursions into his kingdom. But the presence of gold attracted Spanish adventurers and settlers, causing disruption and hardship for the Indians.

Nuño de Guzmán's rapacious campaign of terror in west Mexico, ending with the trial and execution of Caltzontzin, the last Tarascan king, fomented even greater unrest. Rebellion erupted, abetted by fierce Chichimec tribes from the north. Spanish settlers were driven out and, for a while, chaos reigned.

Finally, with the successful prosecution of the Mixton War under the new Viceroy, Antonio de Mendoza, the Chichimecs were driven back and the insurrections petered out, so that by the 1550s, peace and stability had slowly been restored to the war torn province.

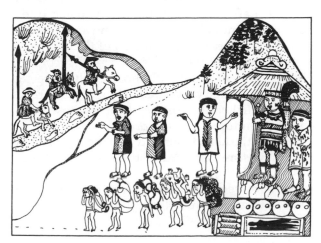

The Spaniards arrive in Michoacán, from the Relación de Michoacán

The Spiritual Conquest of Michoacán

Although the Franciscans had attempted to convert the Tarascans as early as the mid-1520s, it was not until the arrival of Fray Juan de San Miguel and Vasco de Quiroga in the 1530s that a program of evangelization and mission settlement was firmly established in Michoacán.

Fray Juan de San Miguel, the "Apostle of Michoacán," as he became known, traveled throughout the Tarascan highlands and beyond, preaching, resettling the Indians and founding numerous early missions, including those at **Uruapan** and **Charapan.**

Vasco de Quiroga was the first Bishop of Michoacán, remembered to this day for his great sympathy for the Indians and their plight. He is best known for his utopian settlements, one of which—at Santa Fé de la Laguna—provided the model for the numerous "pueblo-hospitals" that were founded all across early colonial Michoacán. In addition, Quiroga established various crafts in these communities to promote self-sustaining trade between villages.

Most of the missionary work, including the founding of mission towns and pueblo-hospitals was done by the friars, first the Franciscans and later the Augustinians. The rapid expansion of both mendicant orders in the region led to the creation of separate western Franciscan and Augustinian provinces in the early colonial years.

The pueblo-hospital was an institution unique to west Mexico. Inspired by Bishop Quiroga's utopianism, Franciscan communalism and Tarascan tradition, these settlements incorporated a community center, a hospice or travelers' rest and the hospital chapel, or *yurishio*, dedicated to the Virgin Mary and maintained by a native *cofradía*. Reflecting as it did pre-hispanic traditions of communal organization and architecture, notably the Tarascan institution of the *guatapera*, a compound for the seclusion or instruction of young women, the pueblo-hospital became the universal model of village life and culture in colonial Michoacán—an institution whose influence has endured into the present.

During the later 1500s and into the 1600s, while the Franciscans and Augustinians concentrated on consolidating their missionary empires, Spanish settlers were establishing themselves in towns like **Pátzcuaro** and fledgling cities such as Valladolid (**Morelia**).

Art & Architecture

Sixteenth century Michoacán proved fertile ground for the establishment of monasteries, rural missions and pueblo-hospitals. **Cuitzeo** is a star among Augustinian priories in Mexico, surrounded by its impressive satellite monasteries of **Copándaro**, **Charo** and **Ucareo**.

Substantial churches arose in many mission towns, many of them designed in the so-called Pidgin Plateresque style—a hybrid architecture based on the Plateresque facades of provincial Spain, but heavily influenced by *mudéjar* traditions of Islamic design and decoration. Typical examples include the church fronts at **Tzintzuntzan**, **Erongarícuaro** and **Zacapú**—all of which prominently feature the inverted scallop shell, a motif especially popular in rural Michoacán.

But perhaps the most distinctive colonial architecture of rural Michoacán is found in its pueblo-hospitals, many of which have survived to the present day. In these early mission settlements, the Pidgin Plateresque style merges with traditional Tarascan architecture and design. The pueblo-hospitals at **Ocumicho**, **Angahuan** and **San Lorenzo** present three interesting variations on this theme.

Other unique aspects of church design and decoration in Michoacán include the beautifully crafted *artesonado* ceilings, many of them covered with cycles of religious painting—among the most notable artistic achievements in the Americas. The best known of these works is the magnificent ceiling at **Tupátaro**, near Pátzcuaro.

Gilded baroque altarpieces often grace rural and provincial churches, frequently in the company of Michoacán's *cristos de caña*—naturalistic crucifixes fabricated of cornpith—many of which originated in Vasco de Quiroga's famous Pátzcuaro workshop.

Impressive cathedrals were planned in the cities of **Pátzcuaro** and **Morelia**, rising alongside urban churches, monasteries and nunneries founded by religious orders such as the Jesuits and Carmelites, as well as the Franciscans, Augustinians and Dominicans. By the 18th century, religious buildings proliferated, frequently on a grand scale and lavishly ornamented—a monumental legacy of urban architecture and planning that has established the character of these historic city centers.

Our Itinerary

Our journey through Michoacán falls into three main stages, proceeding from west to east. First we explore the highland region of western Michoacán, the Tarascan heartland known as *la meseta tarasca*, which stretches from the volcanic hills along the western borders of the state eastwards to include Lake Pátzcuaro and its environs.

Next we look at the baroque city of Morelia in the center of the state, formerly the Spanish provincial capital of Valladolid, and the only major city in Michoacán. The last part of our journey covers the eastern half of the state, a scenic region of mountains and lakes renowned for its 16th century monasteries and rare stone crosses.

As we traverse Michoacán, we focus on the most significant Spanish colonial buildings and works of art. But in such a historic region there are numerous other less visited places with notable viceregal monuments. From these, we have selected a few of special interest, designated as "off the beaten track," although almost all are readily accessible by paved road.

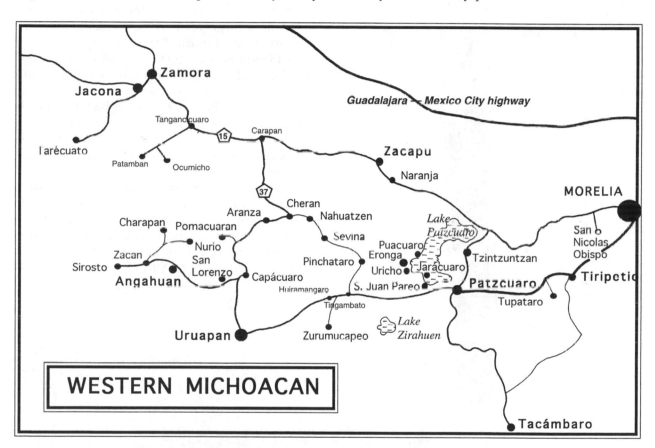

WESTERN MICHOACAN

THE TARASCAN HEARTLAND

At the height of their imperial power, the Tarascans held sway over all of present-day Michoacán and beyond.

But today, the Tarascan heartland, known as *la meseta tarasca*, is confined to the highland valleys of western Michoacán. Here they still speak *purépecha*, the ancestral tongue of the "common people," as the Tarascans traditionally call themselves. This picturesque but little explored region has been densely settled since ancient times and is dotted with indigenous villages, most of which contain early colonial missions built by either the Franciscans or Augustinians.

Our trail through western Michoacán starts from the flatlands on the eastern fringes of ancient Lake Chapala. We then wend southeast through the fertile sugarcane region, continuing through volcanic hill country to explore the villages of *la sierra tarasca*, on our way to the historic town of Uruapan.

Jacona, the hospital chapel

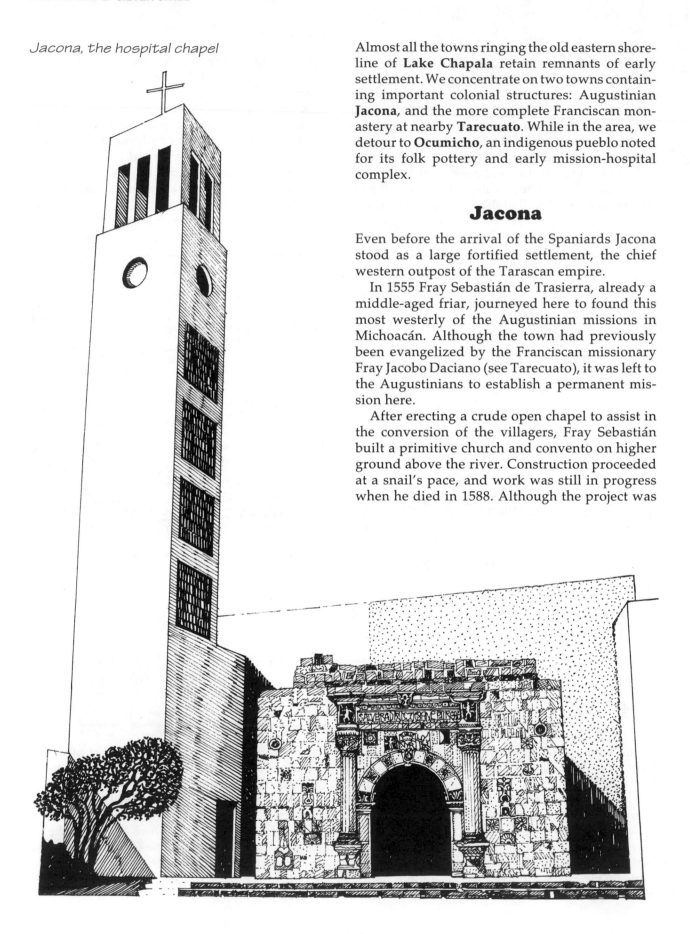

Almost all the towns ringing the old eastern shore-line of **Lake Chapala** retain remnants of early settlement. We concentrate on two towns containing important colonial structures: Augustinian **Jacona**, and the more complete Franciscan monastery at nearby **Tarecuato**. While in the area, we detour to **Ocumicho**, an indigenous pueblo noted for its folk pottery and early mission-hospital complex.

Jacona

Even before the arrival of the Spaniards Jacona stood as a large fortified settlement, the chief western outpost of the Tarascan empire.

In 1555 Fray Sebastián de Trasierra, already a middle-aged friar, journeyed here to found this most westerly of the Augustinian missions in Michoacán. Although the town had previously been evangelized by the Franciscan missionary Fray Jacobo Daciano (see Tarecuato), it was left to the Augustinians to establish a permanent mission here.

After erecting a crude open chapel to assist in the conversion of the villagers, Fray Sebastián built a primitive church and convento on higher ground above the river. Construction proceeded at a snail's pace, and work was still in progress when he died in 1588. Although the project was

carried forward by his successor, Fray Gerónimo de La Magdalena—the legendary builder of Cuitzeo and Copándaro in eastern Michoacán—the church remained unvaulted as late as 1626.

Since that time the priory has been altered almost beyond recognition. The broad west front still faces its former atrium at the heart of the old town. From the street, a rebuilt western gateway frames the whitewashed church facade, whose austere geometry exploits the sharp play of light and shadow in this sunny market town. The plain Corinthian doorway and mullioned choir window, enclosed by an unusual rounded *alfiz* and flanked by spearlike pilasters, are the only visible survivals from the colonial structure. The handsome, steepled tower is post-colonial.

A block to the north of the old priory, set back from the street at the end of a long paved forecourt, stands the venerable stone front of an 18th century chapel, dramatically juxtaposed against the stark facade of a modernistic church with a sky-scraping belltower. Most likely, this chapel belonged to the mission hospital at Jacona, once the shrine of the syncretistic cult of Our Lady of the Mandrake Root.

The sculpted portal of the chapel is emblazoned with the Augustinian pierced heart, and capped by an inscribed frieze in praise of the Virgin Mary. Sundry reliefs of angels, shells and monograms embedded around the doorway add interest and texture to this quaint facade.

Tarecuato

The farthest flung of the Franciscan missions in Michoacán, Santa María Tarecuato is now a shrine to its illustrious founder, Fray Jacobo Daciano.

This aristocratic Dane was the scion of two royal lineages. Born to Maria Cristina, queen of Saxony, and King Hans of Denmark, he served as the Provincial or the governing Franciscan prelate in Denmark. He was also a cousin of Emperor Charles V, who encouraged him to come to the New World after he was banished by Danish Lutherans.

Recently restored throughout, this dignified Franciscan monastery was built in the 1540s entirely from local brown basalt, called *janamú* in the Tarascan language. Just off the village plaza, a densely carved arched gateway admits the visitor to the atrium. Encrusted with vines, fleurs-de-lis and rosettes, the gateway is also banded with rows of *pomas*—Isabelline pearl beading—the signature motif of the monastery.

Once inside the atrium, we come to a remarkable old stone cross. Mounted on a stepped pedestal fringed with a knotted cord at the base, the cross is sculpted on every surface with instruments of Christ's Passion; even the steps are profusely carved with rosettes and intricate floral reliefs. Across the atrium, a broad flight of steps—sections of which are also carved with *pomas* and rosettes—climbs steeply to the broad platform upon which the monastery is built.

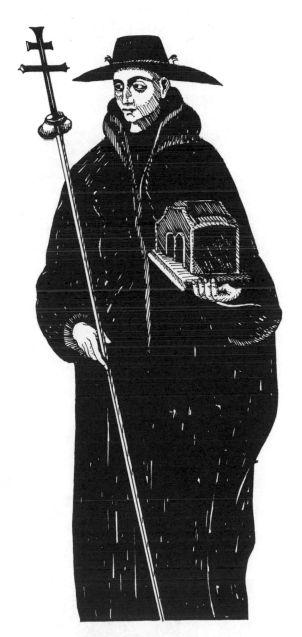

Fray Jácobo Daciano, from a colonial portrait

21

The monastery front stretches across the entire terrace. The church is flanked by a squat tower on its north side—a characteristic of many rural missions in Michoacán. The reconstructed facade is very plain, its only distinguishing feature being a broad-jambed doorway framed by an *alfiz* in the form of a looping, knotted Franciscan cord.

A long, low colonnade fronts the convento, its octagonal stone columns simply ornamented with rosettes and more *pomas*. Behind the tiled portico, the rounded outline of the former *portería* chapel can be traced against the rear wall.

The intimate cloister at the heart of the convento has a serene, timeless quality. Its cobbled patio is enclosed by bevelled arcades set on eight-sided *mudéjar* columns with Isabelline beading top and bottom. Wooden colonnades on the upper level carry a tiled roof with grooved *zapata* beam-ends painted blue and red.

Here in this humble convento, far from the courts of Europe, the royal founder of Tarecuato was finally laid to rest in 1566. The former chapter room is now a shrine to his memory, with portraits and other mementoes. Over a burbling fountain in the outer courtyard stands a rustic statue of Fray Jacobo, dressed as the humble pilgrim that—despite his high birth—he always considered himself to be.

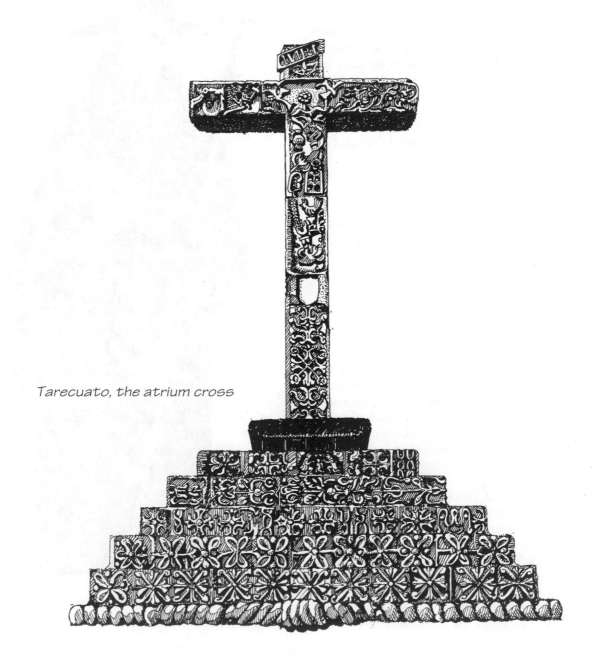

Tarecuato, the atrium cross

Ocumicho, the mission church

Ocumicho

Well known for its colorful folk ceramics—especially the striking "devil" figurines much sought after by international collectors—the picturesque Tarascan village of Ocumicho also merits a visit for its classic blend of Plateresque and traditional Tarascan architecture.

The village is located some 20 kms east of Tarecuato and is currently best approached along an improved road to Patamban from Tangancícuaro, located on Highway 15 south of Zamora.

Founded in the early 1500s as a *visita* of the Franciscan monastery at Tarecuato, the settlement has preserved the layout and structures of an early pueblo-hospital, and is one of the most complete examples in Michoacán.

A sequence of intimate walled compounds linked by covered gateways steps down a ter-

raced hillside from the upper village. Within the two main compounds an evocative 16th century mission building coexists in harmony with traditional Tarascan *trojes*—indigenous wood and tile structures with verandas and overhanging eaves.

From the veranda of the community center, the visitor passes through a covered brick gateway to the atrium of the main church, which is centered on a stone cross of Lorraine. Note the raised, colonnaded house front flanking the church on the right.

The whitewashed church front shows off to advantage a variety of popular 16th century stonecarvings. A colonnaded *alfiz* frames the Plateresque doorway, whose archway is fringed by a chain-like cord motif. Intricate patterns of acanthus leaves and thistles are chiseled in sharp relief around the jambs and arch—a design enlivened

by imp-like figures, perhaps cherubs, perhaps demons, clinging to the tendrils. Identical mullioned windows, adorned with shells and rosettes, and capped by triangular merlons, pierce the facade and belltower.

In the lower patio, a second churchyard cross faces the old hospital chapel, whose tiled overhang shelters an imposing Italianate doorway with sunken medallions of rosettes and shells. The rustic interior houses a colonnaded altarpiece bedecked with pieces of colonial statuary.

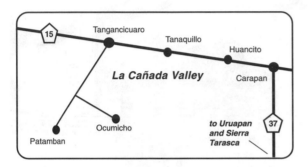

Off the beaten track...

Just west of Ocumicho, on a new road from Tangancícuaro, lies **Patamban**, another Tarascan village renowned for its excellent, if more utilitarian pottery.

Legend has it that Fray Juan de San Miguel visited this village in the 1550s and built a thatched chapel here. Although this primitive structure is long gone, vestiges of its sturdier successor mission remain, notably the imposing side doorway of the church, now surrounded by embedded fragments of decorative sculpture. The hospital chapel of the Immaculate Conception also still stands in an enclosed precinct, its simple stone portal framed by the whitewashed front.

In the nearby valley of La Cañada, rare painted ceilings have survived in the chapels of **San Miguel Tanaquillo** and neighboring **Huancito**, both colonial villages off the highway between Tangancícuaro and Carapan.

The Tanaquillo ceiling is emblazoned with a series of rococo medallions depicting the Apostles and the Archangels—unfortunately retouched with a heavy hand. The Huancito ceiling, also heraldic in appearance, seems to be authentically 18th century, although now deteriorated almost beyond recognition.

MISSIONS OF LA SIERRA TARASCA

South of Ocumicho, the land rises into a rugged region of pine forest and volcanic mountains. This is the *sierra tarasca*, or Tarascan highlands, where early colonial monuments abound in the rural communities. Almost every church contains one or more feature of interest—a sculpted doorway, an ornamental wooden ceiling, a gilded altarpiece or a carved crucifix.

At the heart of the highlands stands **Angahuan**, a gritty but picturesque Tarascan village, whose sculpted church of Santiago is the artistic gem of the region. Approaching from the Carapan-Uruapan highway (Rte 37), the side road to Angahuan winds westwards through oak and pineclad hills until, just before reaching the village, the red and green countryside becomes dramatically scarred by lava flows and sterile cinder cones.

Nestled in the volcanic hills around Angahuan are several other indigenous villages with rustic mission churches and chapels dating back to the 16th century. To the west we visit the mission and hospital of **Zacán** and the rambling former Augustinian priory at nearby **Zirosto**.

North of Angahuan, we climb to the 16th century hilltop chapel of **San Antonio Charapan**, and at nearby **Nurío**, we can admire the vividly painted folk ceilings that embellish the Augustinian church and hospital chapel there. The traditional village of **San Lorenzo**, between Angahuan and the Uruapan highway, is not to be missed for its sculpted 16th century church and colonial hospital with painted ceiling.

Back on Highway 37, we detour north to the Tarascan town of **Cherán**, stopping en route to look at the Pidgin Plateresque churches of **Capacuaro** and **Aranza**.

Fray Martín de Jesús preaching to the Indians (from the Chronicles of Michoacán)

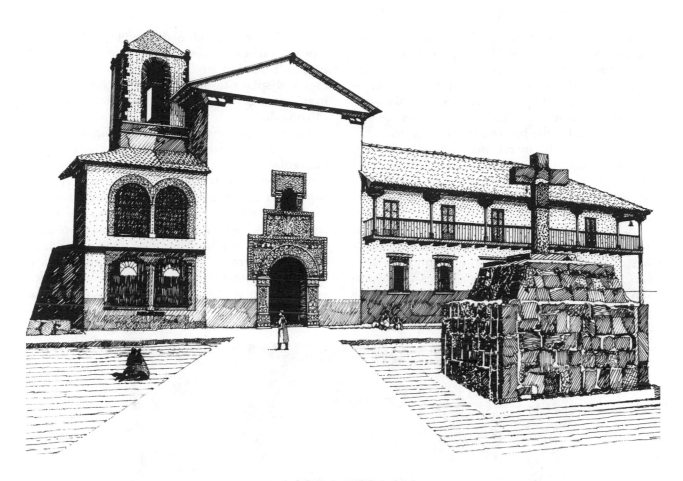

ANGAHUAN

In February 1943 the new volcano Paricutín burst forth from the earth, engulfing the town of San Juan Parangaricutiro—also known by its quaint colonial name of St. John of the Bedspreads—in a black tide of lava. The townspeople hastily abandoned the settlement, pausing only to retrieve the crucifix that stood before the main altar of the parish church.

Fleeing to nearby Angahuan, the weary refugees celebrated Mass before the church door to give thanks for their deliverance and that of their beloved *Cristo de los Milagros.* Today, the *santo* is installed in the church of a new settlement, Nuevo San Juan Parangaricutiro, located west of Angahuan.

Angahuan lies at the heart of the Tarascan hill country and, like the surrounding lava fields, is predominantly charcoal-colored, looking more like a Welsh mining town than a village in Mexico. The streets are cobbled with basalt blocks and the distinctive local houses, known as *trojes,* are built of stout pine logs with steeply-pitched shingle roofs and covered verandas. In contrast to these gray surroundings the women of the village wear brightly colored satins, usually with woollen *rebozos* or shawls to keep out the highland chill.

The mission town was founded in the 1540s by Fray Jacobo Daciano and construction of the mission, with its adjacent hospital and chapel, followed soon afterwards. The church faces a large atrium in which stands an old stone cross carved with the Instruments of Christ's Passion. The 16th century hospital and chapel still stand beside the church, across a street that now bisects the atrium.

The Church of Santiago

Flanked by an open chapel and convento, the church of Santiago is distinguished by its extraordinary *mudéjar* facade—one of the most archaic in Mexico. Hewn from black basalt and dramatically set against the whitewashed west front, the geometrical facade rises in three stages, each framed by a projecting *alfiz.*

The facade is densely sculpted with reliefs similar to those of the Guatapera chapel in Uruapan. And although it may lack the sculptural finesse of Uruapan, the Angahuan facade is vigorously

25

detailed in sharply undercut *tequitqui* relief. Foliated grotesques, gripped by several angels, swirl about the tasseled Franciscan cord carved on the doorjambs. The medallions on the bases and capitals are also framed by twisted cords with penitential knouts. Medallions with cherubs and floral motifs fill the beaded *alfiz* overhead.

An archaic Latin inscription above the densely carved archway proclaims St. James the Apostle (Santiago Apostol) as the patron of the church, probably in honor of his namesake, Fray Jacobo (James) Daciano. Perhaps because of this connection, the primitive attic relief depicts the saint as a humble, barefoot pilgrim instead of the sword-wielding horseman of his more common alter ego, Santiago Matamoros (St. James the Moor-slayer). The relief is flanked by stylized plants with the heads of winged angels. Paradoxically,

especially for a church dedicated to St. James the Apostle whose principal attribute was the pilgrim's scallop or cockleshell, the Angahuan facade displays none of the shell reliefs so common among other 16th century churches in Michoacán.

The interior of the church looks as archaic as the exterior. Although a modern wooden barrel vault has replaced the old hipped roof, most of the 16th century wooden frieze is still in place. A long inscription in condensed, Arabic-style characters, marked with the date 1557, runs along the entire frieze, invoking Christ and St. James as protectors of the village. A gilded baroque retablo stands in the apse, framed by *estípite* columns and a scrolled pediment, upon which rest several modern *santos*, notably an equestrian figure of Santiago Matamoros. The wooden ceiling above the retablo

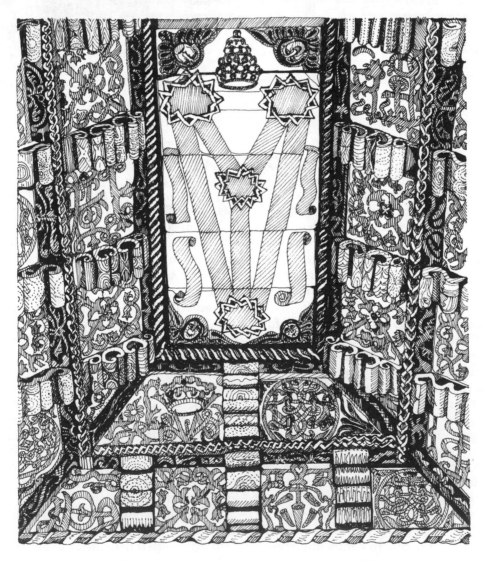

Santiago Angahuan, the apsidal ceiling

is another intriguing *mudéjar* survival. Shaped like a truncated pyramid, its four sloping sides are divided by carved ribbon cornices, cords and ornamental scrolled *zapatas*. Each panel contains Franciscan insignia or religious monograms composed of intricate strapwork painted red, brown and gold. Framed by winged cherubs in each corner, the complex center panel, or *almizate*, features a bishop's miter linked by banderoles to four crowns of thorns outlined in spiky strapwork—again evoking the theme of Christ's Passion.

A striking group of wooden *cristos* in the naturalistic Pátzcuaro style creates a powerful impression on the visitor. The most expressive of these scarred figures hangs above a great carved stone font in the baptistry, which functioned as the open chapel in former times.

The Open Chapel
An integral part of the original mission, the raised open chapel was attached to the north side of the church. The upper colonnade, originally the preaching gallery, remains divided by a bulbous candelabra column, and the lower opening is now spanned by a long wooden beam supported on stone corbels and beaded half-columns.

The squat belltower and triangular pediment are later additions. The two-story *convento* on the south side of the church features an exterior balcony with Tarascan style wooden balustrades and overhanging eaves. Similar rustic galleries face three sides of the interior patio.

The Hospital
The former mission hospital, now, appropriately, a vocational school for young Tarascan women, lies across the road on the north side of the atrium.

Anchoring the southwest corner of the gated courtyard is the restored chapel, an austere rubblestone building with a gabled roof and a cylindrical stone cross in front. Two primitive cornpith crucifixes with silver tiaras hang inside the chapel. The *alfiz* above the doorway frames a relief inscription, which dates its construction to the year 1570 and names as its benefactor Juan de Velasco, at that time the prior of nearby Zirosto.

The new wooden door of the chapel was carved by Simón Lázaro Jiménez, a local Tarascan carpenter, storyteller and village elder who also sculpted an intriguing carved house doorway across the plaza graphically illustrating the eruption of Paricutín. He has also written an anecdotal account of that momentous eruption.

Zacán

Another early mission-hospital complex lies astride the road at Zacán, some 10 kilometers west of Angahuan in the shadow of the Paricutín volcano. Although village life here was also disrupted by the eruption, the colonial buildings fortunately escaped major damage.

The main church of San Pedro, built by Augustinians from Zirosto, stands in the center of the village behind a large walled atrium with a carved stone cross.

Distinguished by its classical portal and coffered choir window, carved with medallions, rosettes and angels' heads in high relief, the facade is strongly reminiscent of the urbane front of the Augustinian priory in Morelia. A long Latin inscription above the doorway is dated 1560, considerably predating the Morelia priory, and the legend below the choir window also proclaims "Mine is the House of God." The stubby tower with its rosette-studded belfry arches is thought to be contemporary with the church—a rare 16th century survival.

Inside, as our eyes become accustomed to the darkened nave, the carved brackets and spiral cord moldings of the rugged wooden ceiling come into view. A handsome, screen-like main retablo, designed in provincial Churrigueresque style, spans the east end, its worn gilding and faded paintwork still radiating a warm glow throughout the church. Elegant baroque saints, serene in their black and gilt *estofado* finery, occupy both tiers of the ornate frame while an almost childlike figure of St. Peter, the patron of Zacán, is seated in the center niche, wearing the papal tiara and giving his benediction.

Of the eight original side altarpieces, only the retablo of the Immaculate Conception remains, still in good condition. Better proportioned and more richly ornamented than the main altarpiece—replete with decorative *estípites* and sinuous foliage—it is an outstanding example of

18th century carving and decoration with a popular accent.

The Hospital

As at Angahuan, the pueblo-hospital and its adjacent chapel are found across the road, installed in a walled compound with an imposing covered gateway. The chapel was re-christened the Rosary Chapel in the last century, but is still popularly known as La Guatapera, from its Tarascan name signifying House of the Virgins.

Its exterior is smaller and even plainer than the hospital chapel at Angahuan, but inside is a colorful painted *artesonado* ceiling in vivid popular style—one of several such decorated ceilings to be found in the rural churches and chapels of western Michoacán. Dozens of painted panels cover the surfaces of the hipped chapel roof, their reds, blues and whites still surprisingly vibrant despite age, neglect and water damage. Although they appear to date from different periods and the iconography is confusing, several panels depict various attributes of the Virgin—images possibly taken from an illustrated colonial litany of the Rosary. This is not the only precious survival at Zacán. Along the colonnaded corridors of the L-shaped hospital building are placed a number of ornate *mudéjar* windows. Strikingly similar in outline and detail to those at La Guatapera in Uruapan, they employ bold, stylized floral motifs interwoven with the braided Franciscan cord—clearly based on the same designs and probably executed by the same skilled stonecarvers.

Zacán comes to life every October, when singers, dancers and musicians from nearby villages compete in the regional Purépecha Festival.

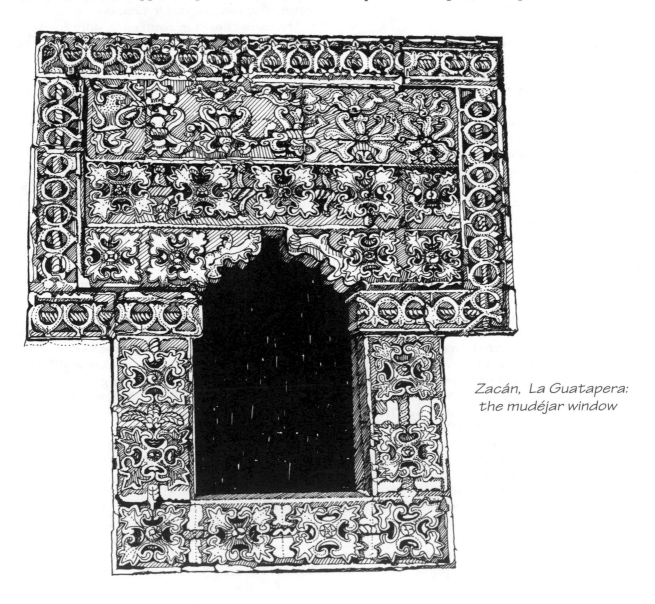

Zacán, La Guatapera:
the mudéjar window

Santa Ana Zirosto, carved relief on the atrial cross

Zirosto

Eight kilometers west of Zacán, the earthquake-ravaged priory of **Santa Ana Zirosto** stands on a windswept hillside outside the village.

The monastery was erected during the 1570s under the supervision of Fray Sebastián de Trasierra, the builder of Jacona. By the end of the 16th century it had become the principal Augustinian house in the *sierra tarasca*, with Angahuan and Zacán as dependent *visitas*.

A solitary stone cross carved with the skull-and-crossbones stands in the dusty atrium. On its base, winged angels hold up an eroded crown of thorns. The barn-like church stands on an elevated terrace, its gabled front flanked by a low north tower and the remains of the convento. The cut stone Plateresque facade is idiosyncratic but surprisingly refined, again reminiscent of San Agustín in Morelia. A broad triumphal arch frames the west doorway, its oddly partitioned half columns interposed with blade-like wall pilasters and shell reliefs.

Like Zacán and other older churches in the area, such as Charapan and **San Francisco Corupo** (also noted for its chiseled 16th century atrium cross), the church has been re-roofed with a heavy beamed ceiling in traditional Michoacán style. A wooden lunette above the newly carved church doors gives the sculptor's impression of the monastery as it might have looked in its heyday.

The convento at Zirosto is a ruin. Except for a few pillars and part of the east range, the arcaded cloister has succumbed to successive temblors over the years. But from the rubble-strewn cloister patio the visitor is still impressed by the massive nave of the church, as well as the surrounding labyrinth of roofless rooms and corridors that testify to the vast extent of this once formidable priory.

Santa Ana Zirosto

San Antonio Charapan

On the hill above this small village, set between its two churches, stands a modern statue of the pioneering Franciscan missionary Fray Juan de San Miguel, the founder of Charapan and many other area missions including Uruapan.

The larger church of San Antonio has undergone virtual reconstruction, outfitted with a magnificent new beamed roof. But the rustic chapel behind San Antonio is much earlier, and of particular interest for its carved 16th century facade.

Formerly the hospital chapel of the pueblo, it is dedicated to the Virgin of Bethlehem, whose stocky statue rests in a shell niche over the porch. She is identified by an inscription on the arch, while at her feet a basalt or obsidian disk is inset into the pedestal—a pre-hispanic device symbolizing the soul or spirit of the sculpted image. The facade is liberally studded with shell reliefs, rosettes and winged angels as well as tiny medallions of the sun and moon—traditional attributes of the Virgin.

In Tarascan style, the roof beams originally rested on tall timber columns along the nave, a few of which can still be seen embedded in the partially exposed adobe walls.

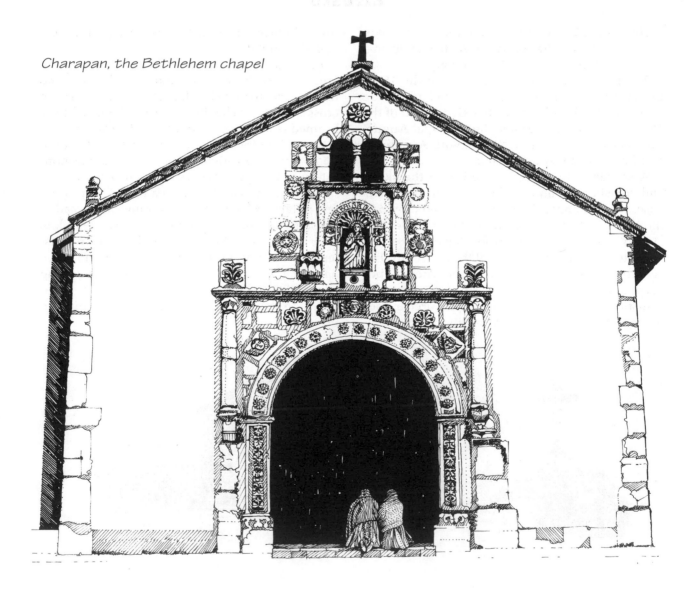

Charapan, the Bethlehem chapel

Nurío, musical angel (mural)

Nurío

Like Charapan, Nurío possesses two linked colonial structures: a large Augustinian church with a flamboyant curvilinear gable, and the more humble hospital compound behind.

The main church features a large Renaissance porch with ominously bowed Corinthian columns. A primitive relief of St. Augustine cradling a church is emblazoned on the keystone of the archway. In the Augustinian tradition, a Latin frieze inscribed with the date 1539 stretches above the porch, proclaiming the church as the House of God.

Inside the church, the painted underchoir attracts our attention with its brightly colored angels disporting and playing instruments inside late colonial cartouches of ornamental strapwork. Naively drawn portraits of the Four Evangelists decorate the wooden enclosure of the adjacent baptistry, while painted beams and ceiling fragments embellish the dim nave.

A covered gateway at the rear of the church admits us to the enclosed hospital compound. On the left side of the sunken precinct, elevated on a terrace across from the former hospital building, stands an old adobe chapel, still maintained as a traditional shrine to La Purísima—the Virgin of the Apocalypse. The cut stone doorway is fringed by embedded fragments of colonial reliefs, including the sun and moon, and is protected from the elements by a projecting wooden portico.

The chapel also boasts a painted ceiling, undoubtedly earlier than the one in the church. Biblical scenes and episodes from the life of the Virgin are accompanied by rococo archangels.

A small but quite sumptuous 18th century baroque altarpiece, carved and painted in red and gold, also graces this humble sanctuary of the Virgin.

Nurío, relief of St. Augustine

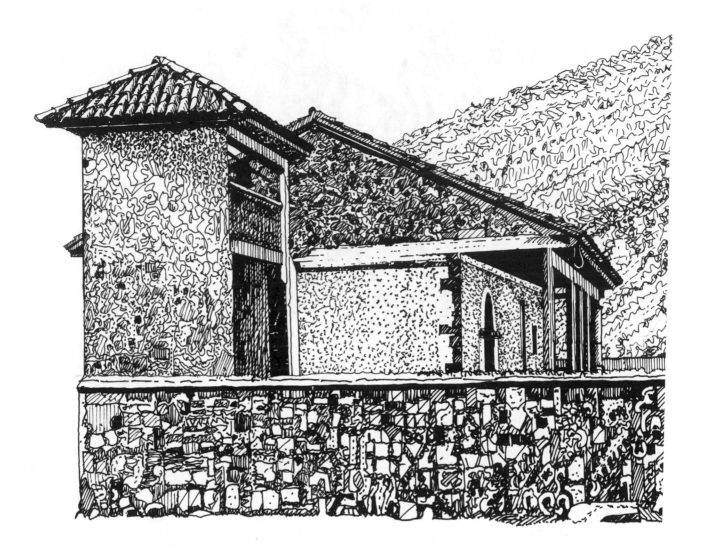

San Lorenzo

Visitors to the Tarascan highlands should make time to visit San Lorenzo, a picturesque indigenous village just off the road between Angahuan and the Uruapan highway (Mex 37).

Like Zacán, San Lorenzo boasts a remarkably complete early pueblo-hospital layout that includes not only a handsomely carved 16th century church but a walled hospital compound with a colonial *yurishio* chapel and hospice building.

The Church
Although somewhat altered over the centuries and most recently renovated in 1945, the village church retains its original sculpted entry, a porch closely related to that of neighboring Angahuan

and possibly the work of the same stonecarvers. Framed by a complex triple *alfiz*, the arched doorway is trimmed on its inner frame by the traditional Franciscan cord. But the finest carving is reserved for the broad jambs and archway, on which is woven a beautiful stone tapestry of stylized vines, flowers, tassels and *fleurs-de-lis*, skilfully modeled in the round.

A round wooden vault covers the cavernous nave, which is lit by a sequence of moorish windows derived from those at Zacán, but of recent manufacture. At the east end a gilded 18th century retablo houses several saints including the village patron, St. Lawrence, who clutches a grill—the instrument of his martyrdom.

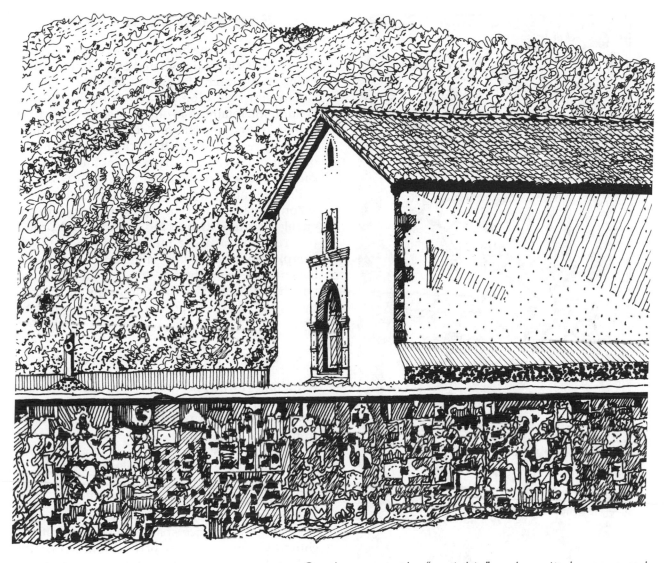

San Lorenzo, the "yurishio", or hospital compound

The Hospital

But the most singular feature at San Lorenzo is its separate hospital complex, whose various structures are dramatically outlined against the wooded hillside. A newly tiled belfry/gatehouse admits the visitor to the enclosed precinct, where the broad hospital building beside the entry faces the chapel at the far end across a wide courtyard. A rugged stone cross stands on a pedestal midway between the two buildings.

The original hospital doorway is still in place, framed in cut stone and trimmed with relief rosettes. An elongated doorframe of later colonial vintage, incised with foliage, adorns the simple, whitewashed chapel front at whose apex an irregular niche houses a tiny figure of the Virgin.

A brightly colored *artesonado* ceiling, vividly painted in folkloric style, spans the interior. Its numerous panels—probably dating from the 1800s, although subsequently retouched with a heavy hand—naively illustrate biblical scenes and portray a range of popular religious personages along with a panoply of decorative devices and a wealth of anecdotal detail. Note the lively seascapes with galleons.

A good time to visit San Lorenzo is at New Year's, when the post-Christmas festivities include traditional Tarascan folk dances, especially the Dance of the Blackmen—a colorful masquerade dating from colonial times that was once performed in villages throughout the *sierra tarasca*.

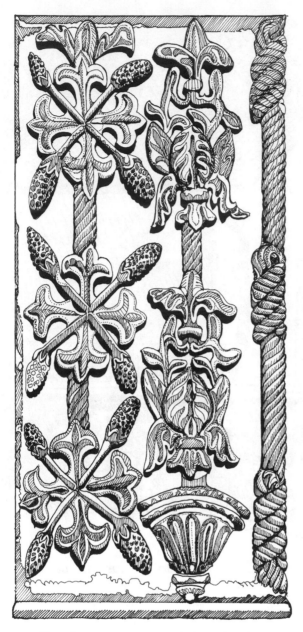

San Lorenzo, carved door jamb

San Juan Capacuaro

Our first stop on the highway is at Capacuaro, an ancient settlement dominated by its 16th century Franciscan church of San Juan Bautista.

Crossing the elongated plaza—the former atrium, still retaining an old stone cross—we come to the battered church front. Although rather haphazardly reconstructed, the facade has kept many of its original features, in particular the timeworn carved doorway and balustraded choir window.

Rosette and shell reliefs crowd the facade, some set on pinnacles and others crowning the busts of angels, who bear distinct Indian features. A primitive relief of El Padre Eterno (God the Father), complete with orb, cross and tiara, gestures in benediction from the keystone of the archway, which is framed by a crown of thorns and ringed by angels' heads—opposing symbols of grief and joy.

San Jerónimo Aranza

A few miles further north we come to San Jerónimo Aranza, another venerable mission in the same mold as Capacuaro, with a carved atrium cross in front of the church door.

A shell-encrusted entry admits us to the interior, whose beamed ceiling rests on carved and painted corbels. An archaic 16th century stone font rests inside the doorway. In startling contrast to the rustic nave, a stylish white and gold "barococo" altarpiece spans the east end of the church. Created at the end of the colonial era, with a date of 1819, its rigid neoclassical outline is softened with passages of gilded baroque ornament.

A few kilometers east of San Lorenzo we come to Highway 37, the main north-south artery through the *sierra tarasca*. Before exploring the town of **Uruapan** and its *barrios* to the south, we first look north towards the key Tarascan town of **Cherán**, from where the visitor may take a side trip through a string of traditional Tarascan villages with significant colonial monuments.

En route to Cherán we stop to look at the two early Franciscan mission churches at **Capacuaro** and **Aranza.**

The tiny chapel at **Pomacuarán**, just off the road between Capacuaro and Aranza, is also worth a detour for its carved facade, heavily encrusted with outsize shell reliefs. A rosette-studded *alfiz* frames the coffered doorway which is decorated with numerous reliefs of angels.

Pomacuarán is also of interest for its large painted ceiling—a colorful piece of pure folk art, probably dating from the 19th century.

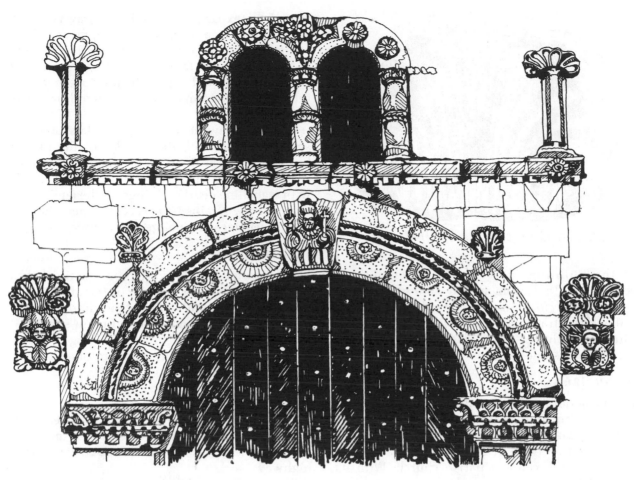

San Juan Capacuaro, church doorway (detail)

off the beaten track ...

FROM CHERAN TO HUIRAMANGARO

At **Cherán**, a newly paved side road winds southeast through rolling countryside to **Huiramangaro**, offering us the opportunity to visit a string of formerly remote Tarascan villages, each of which contains surviving colonial buildings and artifacts of interest.

Note: This route may be followed in reverse, starting from Huiramangaro, located on the Uruapan-Patzcuaro highway.

Cherán

The Tarascan cultural hub of Cherán is a busy market town whose main plaza is dominated by the late colonial parish church.

With the complete remodeling and reorientation of the church in recent years, its original west front has been closed off, almost hidden behind what is now the sanctuary. But the visitor can still spot archaic statues of St. Francis and a pair of archangels peering over the surrounding rooftops from their overgrown niches on the former facade.

Across the street stands an even older colonial building, the former Franciscan hospital chapel. A plain rectangular stone building with a tiled roof and overhanging eaves, it has recently been rehabilitated as the municipal library.

As with the main church, the original facade is no longer in use but has been preserved at the rear

Cherán, hospital chapel: shell relief

of the building, now facing a neighboring schoolyard. Its simple arched doorway, framed by a molded *alfiz* and a pair of bold shell reliefs, follows the traditional pattern of 16th century Michoacán chapels. Mullioned windows pierce the massive stone walls of the facade and nave.

Nahuatzén

From Cherán we come next to Nahuatzén, a sizable *mestizo* town endowed with a spacious terraced plaza.

Elevated on the east side of the square is the imposing 19th century parish church. With its broad, gabled front and sturdy three-stage tower, it replaced the 16th century mission church on the site. Its main attraction for us is an enormous baroque canvas, located in the south transept, of Las Animas—a popular late colonial devotional theme. The painting portrays the Assumption and Coronation of the Virgin, who is shown in the upper part and to whom the pitiful ranks of Souls in Purgatory below appeal for mercy.

The small gabled structure beside the church may be the former hospital chapel, or perhaps a *posa* or cemetery chapel. Despite a later makeover, the simple arched doorway flanked by carved pilasters and surmounted by a *mudéjar* choir window seems to have preserved the form of its 16th century antecedent.

Sevina

Down the road a few kilometers we come to the Tarascan village of Sevina, the site of another early Franciscan mission-hospital. The broad front of the main church facing the central plaza has been substantially rebuilt over the centuries, al-

though its expansive arched doorway is intact, surmounted by a beaded *alfiz*. Fragments of old stone carvings are embedded higgledy-piggledy in the fabric of the facade, including the familiar shells, rosettes and angels' heads, together with religious monograms and several heraldic reliefs of rampant lions.

At the northwest corner of the plaza stands a small raised chapel, the *yurishio* of the former hospital here. The doorway is edged by a tasseled cord, knotted in the Franciscan style, and carved with Isabelline pearl moldings on the jambs. The trim interior retains its carved wooden choir as well as vestiges of a painted *artesonado* ceiling.

Pichátaro

Now dwarfed by the vast modernistic church beside it—erected on the site of the old mission church—the hospital chapel of Pichátaro presents an austere, self-effacing front of plain stone and stucco. Within, we find an unassuming 18th century altarpiece—the only other colonial relic of interest to survive here.

Huiramangaro

Two churches from the early viceregal years can be found in the narrow streets of this small village, located beside the Uruapan-Pátzcuaro highway.

The much remodeled parish church boasts a broad interior whose high, paneled ceiling rests on a coffered *arrocabe* support painted with biblical scenes. The nave also contains a number of colonial carved stone capitals and holy water fonts. Framing the sanctuary is an ornamental arcade, behind which stands an early colonial altarpiece—thought to be the sole surviving Plateresque retablo in Michoacán. Candelabra columns support its two tiers, framing figures of the Virgin, various Franciscan saints and a selection of dim *tenebrista* paintings.

A tumbledown second church, a block away, may be the former hospital chapel. Built of wood and adobe, it probably retains more of its original fabric than the parish church, but is now close to ruin.

Back on highway 37, the road descends south from Cherán through forested hills with vistas of ash cones and lava fields—the visible legacy of Paricutín—before entering the sub-tropical avocado and macadamia plantations that herald Uruapan.

Uruapan, the barrio chapel of San Francisco

URUAPAN

Ringed by scenic volcanic hills and pine woods, this once sleepy town is now a busy commercial city and the center of a thriving avocado agriculture. Despite its congested traffic, the old town center retains much of its colonial charm, especially around the Jardín Morelos, the terraced main plaza. Here we find the parish church of San Francisco and the adjoining hospital of La Guatapera.

Colonial Uruapan was founded in the late 1520s on the banks of the tumbling river Cupatitzio by Fray Juan de San Miguel, the itinerant Franciscan missionary and founder of hospitals, known affectionately as the "Apostle of Michoacán."

Fray Juan gathered Indians from the surrounding areas into nine *barrios*, each with its own humble *ermita*, or chapel. Some of these colonial chapels have survived—still the focus of local devotion and colorful festivals.

My favorite is the little walled chapel of **San Francisco**, noted for its monolithic brownstone cross planted in front. Behind its shell-encrusted facade is an intimate interior of great charm with wooden piers, carved roofbeams, painted ceilings and images of Franciscan saints crowding the altar.

Across the river, the reconstructed hilltop *ermita* of **San Pedro** boasts an exuberantly sculpted floral porch. And the tiny chapel of **Santiago** possesses a spirited folk statue of Santiago Matamoros mounted triumphantly on his rearing horse.

La Guatapera

Although the main church of San Francisco was rebuilt in the 19th century after a destructive fire, the adjacent 16th century hospital and chapel survived the blaze and are preserved to this day.

Founded in 1534 by Fray Juan de San Miguel on the initiative of Bishop Vasco de Quiroga, the hospital was erected on the reputed site of a Tarascan nunnery or women's house (Guatapera means House of the Virgins in the *purépecha* tongue). The building was completed in 1555— the year of Fray Juan's death—and, according to local lore, "*tata*" Vasco himself passed away in one of the upper rooms.

The diminutive chapel in front is one of the earliest architectural monuments in Michoacán. Its splendid *mudéjar* porch, skilfully sculpted from dark volcanic stone by Tarascan stonecarvers, is considered to be among the finest examples of *tequitqui* work in Mexico. Winged cherubs en- twined with delicately modeled relief foliage climb the jambs, beneath an intricate arabesque arch- way. Rosettes linked by the Franciscan knotted cord line the inner jambs and continue around the soffit of the arch, while bands of stylized vines and acanthus leaves border the surmounting *alfiz*.

Crowning the porch is a sculpture niche framed by a knotted cord that contains a striking frontal statue of a Franciscan friar, with large outstretched hands—popularly thought to be Fray Juan, but in actuality portraying St. Francis receiving the Stig- mata. To the left is emblazoned the Franciscan emblem of the Five Wounds—a sharply undercut, almost abstract bas-relief ringed by a crown of thorns.

The chapel interior is roofed by a three-sided wooden ceiling, resting on heavy beams with carved *zapatas*. A thorn-and-ribbon molding frames the sanctuary arch at the far end, which is spangled with stars, rosettes and sacred mono- grams. Vestiges of a painted wall retablo, whose

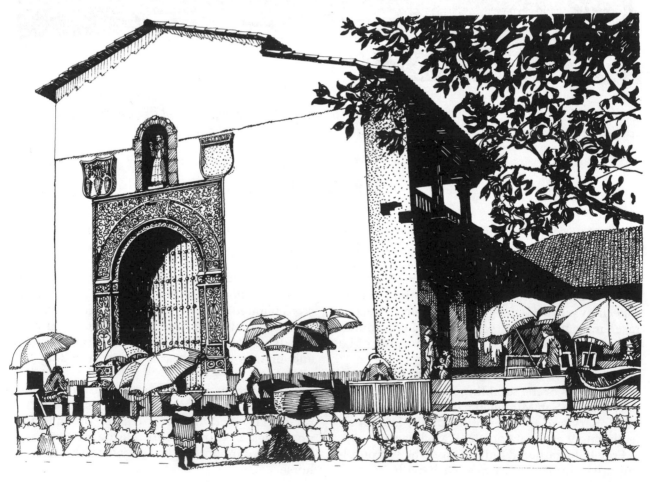

Uruapan, La Guatapera on market day

roseate niches display saints and archangels in blue and ocher, add color to the shadowy apse.

High on the south side of the chapel a colonnaded exterior gallery with a heavy beamed ceiling overlooks the hospital patio, which still boasts its rugged basalt cross and functioning colonial fountain. This gallery may have been a preaching balcony or elevated open chapel similar to the one at Angahuan.

The L-shaped patio, which houses seasonal exhibits of regional arts and crafts, is similar in layout and ornament to La Guatapera at Zacán. Its colonnaded veranda, which formerly extended along the side of the chapel, protects several original *mudéjar* windows, whose large frames are elaborately carved with vines, flowers and foliage, also strikingly similar to those at Zacán.

San Angel Zurumucapeo

The scenic highway from Uruapan east to Pátzcuaro passes through wooded hills of oaks and pines. Just past the ancient Tarascan ruins at **Tingambato**—formerly the site of an Augustinian mission—a tree-shaded side road winds steeply down to the village of Zurumucapeo.

Spread across the floor of an enclosed valley, Zurumucapeo boasts, in addition to its peaceful, rustic location, an imposing 16th century church with an unusual bounty of colonial art to attract the visitor.

Also founded by Fray Juan de San Miguel, the Franciscan mission of San Angel later became a dependency of the Augustinian monastery at Tingambato, now demolished.

Late in the 1500s, through the influence of a Tarascan noble family from the village, San Angel acquired a substantial stone church. Although since remodeled, much of its original fabric and several stone sculptures have been preserved for later generations.

San Angel is best known for its distinctive atrial cross, to which is affixed a lifesize but headless figure of Christ, whose gaunt body is powerfully carved in stylized detail. As with many other atrial crosses, the sides of the crucifix are profusely carved with Passion symbols.

The modern re-surfacing of the church front fortunately spared its colonial stone reliefs. Pairs of hovering angels hold up crowns on either side of the choir window while a dramatic relief of the Archangel Michael—the village patron and namesake of Fray Juan de San Miguel—skewers the Devil above the doorway.

More treasures line the nave, including a 16th century alabaster sculpture of Christ—just recently restored—and a faded 17th century painting of the Baptism of Christ, revealing excellent draftsmanship, that currently awaits much needed conservation.

At the end of September each year, the villagers celebrate the fiesta of San Miguel with performances of the colorful Tarascan dances of *negritos* and *moros*.

Zurumucapeo, the Archangel Michael

LAKE PATZCUARO

Lake Pátzcuaro was the hub of the ancient Tarascan empire and the sacred center of the Tarascan cosmos. This populous heartland was naturally the focus of early missionary efforts by the Franciscans in Michoacán, and was a favored location for early Spanish settlement.

The legendary bishop of Michoacán, Vasco de Quiroga, founded his pioneering community of Santa Fe de la Laguna beside its shores and established his bishopric in Pátzcuaro—which he named the "City of Michoacán."

Other missions were founded around the lake, almost all of them on the sites of pre-hispanic settlements. Although time has taken its toll, several of these early colonial buildings are still here to be admired, along with their many art treasures.

In exploring the lake region, we first tour the colonial city of Pátzcuaro. Then we make a circuit of the lakeside towns and villages, finally visiting selected outlying towns that retain significant colonial monuments and artifacts.

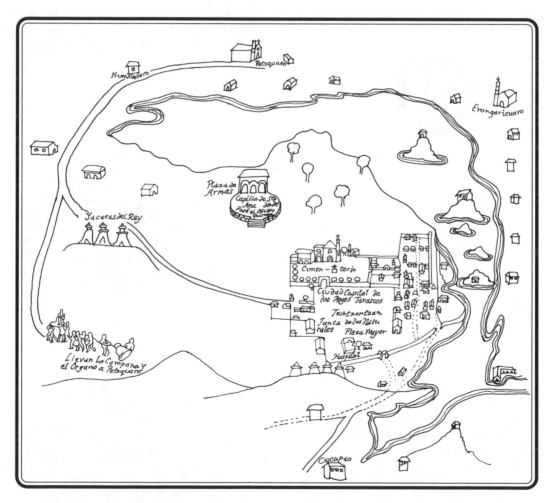

This early colonial map depicts Tzintzuntzan (right) and other lakeside communities at a moment of transition. A group of Indians is shown (left) hauling the church bell away from Tzintzuntzan, signifying the removal of the bishopric to Pátzcuaro (top).

THE CITY OF PATZCUARO

This ancestral city of the Tarascan kings, a royal retreat and pilgrimage center which they revered as the Gate of Heaven, retains traces of its prehispanic sacred character as well as a palpable Spanish colonial ambience.

Although very little is now visible of the Tarascan settlement, some of Pátzcuaro's most prominent religious buildings stand on the hillside above the colonial center, an area that was the ceremonial heart of the ancient city and the site of important Tarascan temples.

These include the **Basilica of La Salud**, Pátzcuaro's most sacred shrine, as well as the former Jesuit church of **La Compañía** and the rambling colonial convent of **Las Monjas Caterinas**.

The Spanish townscape below, which was laid out by Toribio de Alcaráz, the Spanish-born architect of Quiroga's ill-fated cathedral, follows the usual grid pattern. The most important civil and religious structures, including the mendicant churches of **San Francisco** and **San Agustín**, face the two main squares: the larger Plaza Vasco de Quiroga and the smaller Plaza Bocanegra, or Plaza Chica as it is commonly known.

Despite its picturesque colonial atmosphere and its key role in the early history of Michoacán, it must be said that the city of Pátzcuaro retains few colonial buildings of architectural distinction, and even those have been altered substantially over the centuries.

Soon after his appointment as Bishop of Michoacán, Vasco de Quiroga moved the episcopal seat from Tzintzuntzan to Pátzcuaro and, with the support of the Indian nobles, encouraged the Indians to relocate here, rapidly creating a sizeable town of 30,000 inhabitants. He promptly proclaimed Pátzcuaro to be the provincial capital, the new City of Michoacán.

But after the episcopal seat and provincial capital moved to Valladolid (Morelia) in the 1570s, Pátzcuaro, with the other lakeside communities, declined into a colonial backwater—a fate that, although it failed to produce colonial buildings of the first rank, helped to preserve the remaining monuments from destruction during later centuries.

Pátzcuaro and Bishop Quiroga
Don Vasco's charismatic presence pervades colonial Pátzcuaro, in whose every project the crusty old bishop seems to have taken a hand. His benevolent looking statue—a work by the well known contemporary Mexican sculptor Francisco Zuñiga—stands beside the fountain in the tree-shaded main plaza that still bears his name.

The Plaza Vasco de Quiroga occupies the heart of old Pátzcuaro. The vast square is ringed by colonial mansions, many of them now hotels and stores as well as public buildings like the 16th century *cabildo*, which still performs its official function as the Palacio Municipal, and the former royal Customs House on nearby Calle Ponce de León.

Also on the square stands the two-story 16th century house of the Tarascan lord and native governor Antonio Huitziméngari, a building attributed to Toribio de Alcaráz, who also designed many of Pátzcuaro's bridges, fountains and aqueducts, in addition to the bishop's unfinished cathedral.

It was here too that Don Vasco established his celebrated workshop for *cristos de caña*—the realistic crucifixes of lightweight corn pith that were distributed to churches and missions all across his vast see.

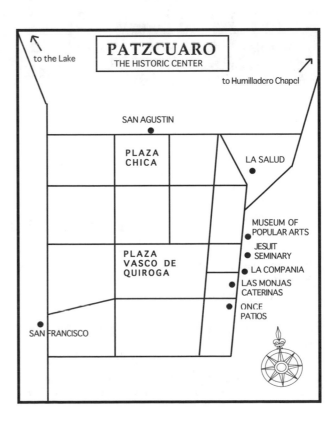

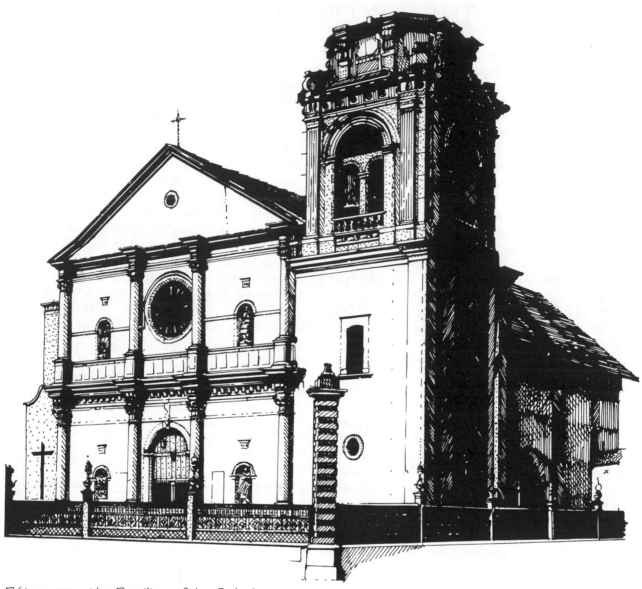

Pátzcuaro, the Basilica of La Salud

The Basilica of La Salud

High on a ridge overlooking the town stands this palatial shrine to Our Lady of Health (Nuestra Señora de La Salud), the revered patron saint of Pátzcuaro, whose demure figure fashioned from carved wood and *pasta de caña* graces the high altar.

But behind the unexceptional facade of the present building—rebuilt following an earthquake in 1845 and known locally as La Colegiata—lies an intriguing and even calamitous history that stretches back to the founding of the colonial settlement.

Don Vasco's Cathedral
As Pátzcuaro's most celebrated—or perhaps notorious—early colonial monument, Vasco de Quiroga's great Cathedral of San Salvador was an ambitious and controversial project that was never

realized. Although only traces of the 16th century cathedral now remain in the fabric of the Basilica—the revolutionary concepts that lay behind the original structure have resonated down the centuries.

After the move from Tzintzuntzan, Bishop Quiroga decided early in the 1540s to build a new cathedral large enough to hold the entire population of his new City of Michoacán during mass. To this end he conceived an innovative church with five naves radiating from a central main altar and sanctuary—a radical plan that has been preserved in the city coat-of-arms granted by the Spanish monarch to Pátzcuaro in 1553. (See the Humilladero chapel.)

By 1550 the cathedral was under construction on a hilltop site personally selected by the bishop and formerly occupied by the *yácata*, or platform, of the principal Tarascan temple here.

The plans were drawn up and construction supervised by the experienced Spanish architect, Toribio de Alcaráz, but a succession of events conspired to halt the aging bishop's grand scheme. Spanish settlers objected to sharing the cathedral with the Indians, and many of them abandoned Pátzcuaro for the fledgling Spanish town of Valladolid (Morelia), which was then rising on a mesa to the east. The friars chimed in with complaints about the abuse of native labor and the excessive cost of the project.

Finally, reports criticizing the scale of the cathedral, its faulty construction and inconvenient location away from the town center came to the attention of the Viceroy, Luís de Velasco, who in 1560 dispatched his own architect, Claudio de Arciniega, on an inspection tour. Arciniega's negative report on the project brought work to a halt despite vigorous protestations from Toribio de Alcaráz.

With Don Vasco's death in 1565, his dream cathedral also died. In 1571, the episcopal seat of the see of Michoacán was officially transferred to Valladolid, by then the new provincial capital, where plans were promptly launched to build a new cathedral.

The Basilica

Only the central one of the five projected naves of Quiroga's vast cathedral was ever built. Sections, including the foundations and part of the sanctuary, together with a few columns and an isolated shell arch, were incorporated into the later basilica. This single nave was eventually roofed, and served as Pátzcuaro's parish church throughout the 17th and 18th centuries. But repeated earthquakes during the early 1800s severely damaged the colonial structure, which was finally reduced to a burned-out ruin in mid-century by occupying French troops.

The present church of La Salud was rebuilt in the 1870s, and major additions—notably the simple neoclassic facade—were made in the present century after the Pope raised the church to the rank of Basilica. Even now, the south tower remains unfinished.

The figure of Nuestra Señora de La Salud is probably the oldest object in the building. Originally commissioned by Bishop Quiroga for the hospital chapel of Santa Marta, it dates from before 1550 and to this day remains one of the most venerated icons of the Virgin in Mexico. Her image, the focus of widespread popular devotion and pilgrimage by the sick and infirm, is clothed in opulent blue and white robes and adorned with jewel encrusted gold and silver ornaments.

A handful of other colonial artifacts have survived the vicissitudes that plagued the church, notably the massive silver candelabra that still decorates the main altar.

But perhaps the work of greatest historic interest is the 1755 portrait of Bishop Quiroga, painted by the Pátzcuaro painter Juan de la Zerda.

Viceroy Luís de Velasco
(from the Codex Osuna)

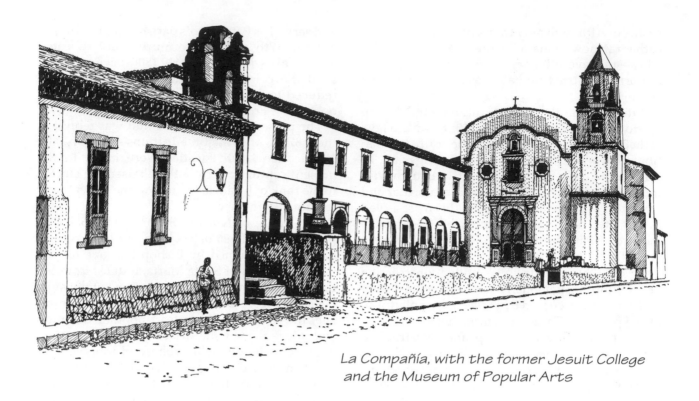

*La Compañía, with the former Jesuit College
and the Museum of Popular Arts*

La Compañia

Vasco de Quiroga is also closely associated with the nearby hillside church of La Compañía, where his pastoral staff is kept and, by tradition, his mortal remains are interred.

Founded upon another Tarascan temple, the precursor of the present church served as Bishop Quiroga's temporary seat while his utopian cathedral was under construction. After the episcopal seat was moved to Valladolid, the site was ceded to the Jesuits and the church substantially rebuilt. The 16th century church no longer exists, although, as with La Salud, archeological research has revealed remnants of its fabric surviving in La Compañía.

La Compañía is a classic 18th century Jesuit church, designed in the imposing but sober baroque style associated with the Society of Jesus, also known as The Company in the Americas.

The elongated Mannerist doorway is fitted with wooden doors studded with bronze clasps embossed with feline reliefs. Above octagonal windows in the upper facade, a discreet shell niche houses a statue of St. Ignatius Loyola, the founder of the order.

The curved pediment was superimposed on the original lobed cornice when the roof was later raised. The single tower is especially fine. From a broad, stepped base it rises in two tiers to an attractive conical spire atop the octagonal belfry.

Very little has been preserved of the 18th century interior. The baroque retablos have gone, long since replaced by gray stone altars. A pair of wooden *estofado* figures of Jesuit saints has survived, however—St. Ignatius on the main altar and St. Francis Xavier in the south transept—both sculptures of high quality that stand out amid the mediocre collection of post-colonial statuary found elsewhere in the church.

Also worth mentioning is a cycle of paintings depicting the Archangels—a favorite Jesuit theme. Attributed to the late 18th century artist Juan de Miranda, they repay inspection for their fine draftsmanship and subtle coloration.

Despite all the changes here since Vasco de Quiroga's time, his episcopal insignia have been preserved in the painted frieze around the upper nave in a gesture of homage to the old bishop.

The Seminary

The college of St. Ignatius, set back behind a long forecourt in front of the church, also has a checkered history. It was only the second Jesuit college

to be founded in Mexico and, despite the changes of fortune it has suffered over the centuries, its proud educational tradition has been revived in recent years. With its handsome, austere facade and elegant arcaded courtyards now extensively restored, the former seminary currently functions as a school of the arts.

The Museum of Popular Arts

This quaint arcaded structure facing La Compañía at the far end of the seminary forecourt was founded by Vasco de Quiroga around 1540 as the College of San Nicolás—generally acknowledged to be the first university established in the Americas. Like Don Vasco's cathedral however, the Pátzcuaro institution was eclipsed after removal of the college to Valladolid.

Distinguished by its beveled facade, baroque *espadaña* and curious octagonal entry vestibule, San Nicolás is now home to Michoacán's Museum of Popular Arts. Its charming patio is surrounded by rooms displaying fine regional arts and artifacts. Highlights of the collection include the carved stone pulpit from the church of San Agustín, now in the vestibule, and a roomful of striking regional crucifixes—some of wood and others of *pasta de caña*, including the famous figure of El Cristo del Pareo. Fragments of recently discovered 16th century murals are also on view, and a collection of antique dance masks is hung in an upper room.

Out back, we can admire the stepped base of a very early *yácata* that once occupied this site, as well as the remains of the colonial jail—both relics restored by Enrique Luft Pavlata, the distinguished sculptor and conservator who is a former director of the Museum.

The Franciscan emblem of the Stigmata

San Francisco, the convento doorway

San Francisco

The remnants of the rambling colonial monastery of San Francisco, at one time a city within the city, lie to the west of the Plaza de Quiroga.

Even before the advent of Bishop Quiroga, Fray Martín de La Coruña—among the first contingent of Franciscan missionaries to arrive in Mexico— founded the monastery of San Francisco here in the 1530s, making it one of the earliest to be established in Michoacán.

After Quiroga's episcopal seat was established in Pátzcuaro, construction of a flagship Franciscan monastery to oversee the entire lake region began. By the mid-1570s both church and convento were essentially complete. Although since that time the monastery has suffered numerous mishaps and ill-advised changes, parts of its 16th century fabric can still be seen in the 18th century building.

The Church

The large monastic church, flanked by its convento, faces west across its much reduced atrium towards two adjoining chapels, both later structures built for the Third Order of St. Francis.

A rugged stone cross, set on an octagonal base in front of the church and carved with the Instruments of the Passion, is the earliest colonial monument here, probably dating from the mid-1500s. The austere north doorway has also

survived essentially unaltered from the 16th century, its massive jambs and robust archway framed by a pink marble *alfiz*.

The sober baroque facade, distinguished by subtle passages of relief decoration, dates from the early 18th century, but has been partially obscured by a colonnaded post-colonial porch.

The interior was entirely remodeled following a devastating fire in the late 1800s, so that virtually nothing remains of the original furnishings. The sole surviving work of interest is an eye-catching crucifix, known as the Christ of the Third Order, which rests on the main altar. No doubt taken from one of the adjacent chapels, this fine *cristo de caña* may well date back to the era of Vasco de Quiroga. The contorted, bloodied figure of Christ, with its distended veins, hollow cheeks and protruding ribs, is rendered in super-realistic detail.

The Convento

Like the church, the convento has undergone changes. The original *portería* beside the church front has been walled up, although part of the arcade—most noticiably a Plateresque candelabra column—is still in evidence. Today, the entrance to the monastery stands behind the church, set back from the road behind a small garden.

The convento doorway, a handsome Renaissance portal inscribed with the date 1577, is worth the short walk. Leafy Corinthian pilasters support the arch, which is carved with sculpted medallions linked by a spiral ribbon molding. The sturdy two story cloister within, framed by low arcades of octagonal columns and broad-jambed doorways, retains its simple Franciscan character.

The Hospital Chapel

An interesting remnant of the monastery, now obscured by a high wall a block to the north, is the old hospital chapel, which in colonial times was maintained by and for the Indians of this former native quarter.

Although the hospital building has been leveled, leaving only a few stone fragments, the chapel still stands, bearing traces of its 16th century structure, primarily the simple doorway frugally ornamented with shells.

The rustic interior is of greater interest, primarily for its sacristy doorway—a handsome Plateresque entry framed by an *alfiz*, candelabra jambs and a string of shells around the arch,

linked, like the convento doorway, by a spiralling ribbon. Also of note is a group of canvases by the 18th century artist Juan de la Zerda.

San Francisco, hospital chapel: Plateresque sacristy doorway

San Agustín

Located on the north side of the Plaza Bocanegra in what was a native *barrio*, this imposing monastic church formed part of the grand Augustinian priory of Santa Catalina.

Founded in 1576, the church has been almost completely rebuilt since that time. One surviving 16th century remnant, however, may be the east doorway whose simple outline can still be traced on the exterior nave wall.

The late 18th century remodeling of the church was undertaken in keeping with the fastidious taste of the period. An elongated, scrolled porch of understated baroque elegance dominates the broad facade, which like La Compañía, terminates in a gable with mixtilinear cornices. A highly ornamented Moorish-style tower and matching belfry rise above the generally sober facade. The statue of St. Augustine in the overhead niche, surmounted by the pierced heart of the order, reminds us that this was the Augustinian mother house for the Lake Pátzcuaro region.

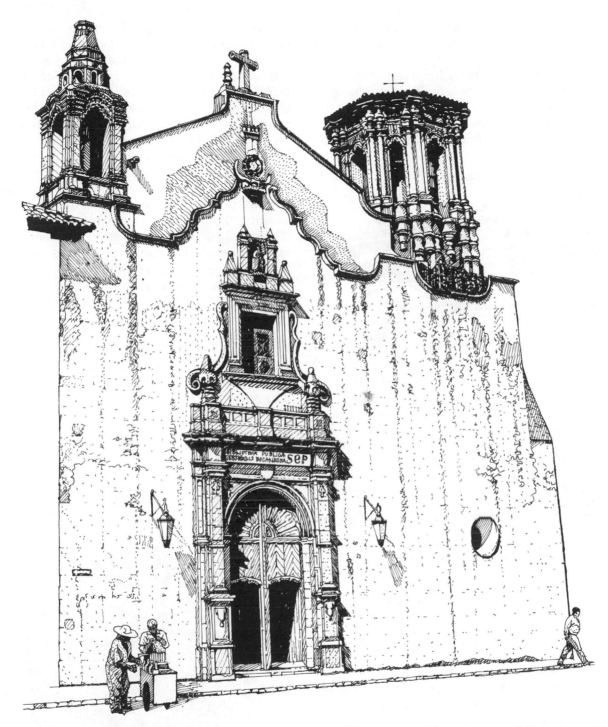

Pátzcuaro, the church of San Agustín

Beneath its barrel-like plank ceiling, large nave windows illuminate the remodeled interior, currently the Bocanegra Library. Juan O'Gorman's panoramic 1942 mural spans the far wall, illustrating the eventful history of Michoacán from Tarascan times through Independence and the Revolution.

But for us, the choir area holds equal interest. The intricate tracery of the underchoir is still in place, boldly outlined against the whitewashed archway. A spiked wheel—the symbol of St. Catherine of Alexandria, the patron saint of the priory—is encircled by Augustinian insignia. In the upper choir, a handsome pedimented door-

way, also prominently carved with Augustinian emblems, at one time led into the adjacent convento.

Fate has dealt harshly with the rest of this once spacious monastery. The convento was demolished to build a theater, while the remains of the old hospital chapel now languish in ruins, abandoned in a back lot behind the church.

Pátzcuaro, Las Caterinas: doorway

Las Monjas Caterinas

Situated across from La Compañía, the rambling hillside convent of Las Monjas Catarinas stands on the site of Bishop Quiroga's 16th century hospital of Santa Marta.

As early as the 1540s, Don Vasco founded a hospital and chapel on this spot to serve the indigenous population of Pátzcuaro. He donated a simple figure of the Virgin to the chapel for the devotion of the Indians—the venerated image of Our Lady of Health, now kept in the basilica of La Salud, up the hill.

The extensive Dominican convent is in two sections, separated by El Sagrario—a renovated church that occupies the site of the old hospital chapel, and which for 300 years housed the image of La Salud. The oldest part of the convent stands on the former hospital site adjacent to El Sagrario. Built in 1750, this structure incorporates two patios. The larger of the two was the main cloister—an ample, rectangular space with simple arcades of flattened arches and Isabelline doorways. A second patio of slightly later date stands at the rear, nestled against the Sagrario walls.

A unique relic of the convent is its former elevated portal, now used as a window, facing the quaint Calle Portugal. This baroque doorway is distinguished by its geometric frame of cushioned pilasters and upturned volutes. Between the volutes is emblazoned the armorial escutcheon of the colonial city, bearing the outlines of Lake Pátzcuaro and Don Vasco's five-naved cathedral.

La Casa de Once Patios

This popular emporium of handicraft workshops and galleries formed the rambling southern extension of Las Caterinas in late colonial times. Built somewhat later than the main convent, its numerous rustic courtyards show a greater concern with ornament and rich detailing than the two main cloisters. A delicately molded double archway sets the tone for the interior courtyards, framing the entry on Calle Madrigal—a later street that was cut through the colonial convent beside the church.

Pátzcuaro, La Casa de Once Patios: El Baño de las Monjas

48

High, rounded arcades enclose the principal patio, which is silhouetted by stone gargoyles along the roofline. An intimate suite of chambers, known as El Baño de las Monjas (the nuns bathroom), is sheltered beneath a grand stairway and sensuously ornamented with carved archways and ornamental reliefs. A broad archway opens at the top of the stairs, its keystone intriguingly carved in the form of a winged woman emerging from a cornucopia. Several fine rooms surround the upper cloister, especially the former nun's chapel which boasts a handsome stone doorway with sculpted jambs and a keystone relief of the Archangel Michael.

A second patio and three more partial courtyards complete the complex, which is famous for its burbling stone fountains. Although most of these patios are modern reconstructions, the visitor can often spot religious insignia and carvings taken from the colonial nunnery.

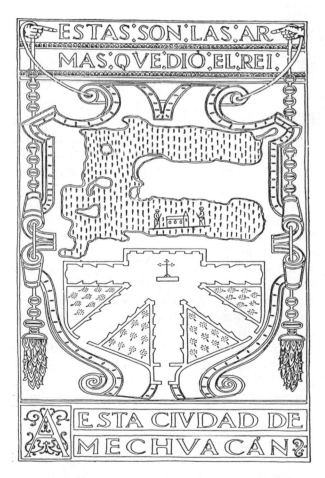

Pátzcuaro, the arms of the City of Michoacán (from the Humilladero Cross)

In addition to the buildings we have described, at every turn throughout Pátzcuaro, especially in the vicinity of the Plaza Vasco de Quiroga, the visitor can glimpse ornate doorways, carved stone fountains and intimate arcaded courtyards—mute but eloquent reminders of the city's pervasive colonial past.

The Humilladero Chapel

Before leaving town, we make a final stop at this little chapel where Vasco de Quiroga's memory is invoked one last time in Pátzcuaro.

Located on the northeastern outskirts of the city where the colonial *camino real* to Valladolid (Morelia) began, this isolated chapel holds one of Pátzcuaro's most unusual and historic monuments.

In 1553 Vasco de Quiroga erected a stone crucifix on this elevated spot, reputed to be the place where the last Tarascan king swore allegiance to the Spanish crown. Traditionally known as the Humilladero Cross, it bears an inscription commemorating the granting of royal arms to the City of Michoacán. A detailed relief of the coat of arms is incised on the pedestal, together with a plan of the Bishop's ill-fated cathedral and an outline of Lake Pátzcuaro.

The little baroque chapel was erected as a shrine to house the cross and dates from 1628, according to an inscription on the atrial cross in the tiny forecourt. A simple *espadaña* caps the facade and a monogrammed cross set above the pediment is accompanied by the sun, moon and Instruments of the Passion—alluding to the crucifix lodged within.

Despite its limited space, the chapel interior is a gallery of colonial art objects. Mounted on a late colonial retablo, the 16th century Humilladero crucifix is the principal treasure. In addition to the tasseled escutcheon and inscription, it bears a well-proportioned and expressive stone figure of Christ—a rarity in early colonial sculpture and most likely the work of one of Don Vasco's Spanish stonecarvers.

The retablo displays several wooden *santos* including a pair of archangels arrayed in finely worked *estofado* cloaks. The chapel also boasts numerous paintings, including some in popular style no doubt belonging to an 18th century *apostolado*, or depiction of the Twelve Apostles.

AROUND THE LAKE

Today, the visitor can drive around Lake Pátzcuaro on good paved roads that allow easy access to formerly remote colonial towns and Tarascan villages.

On the east side of the lake, the principal attraction is **Tzintzuntzan**, the royal Tarascan capital, celebrated for its ancient temples and historic 16th century monastery.

Along the more densely settled western shore we can explore a string of indigenous villages, each with its colonial mission, the most notable of which is the market town of **Erongarícuaro**, whose well preserved Franciscan monastery overlooks the lake.

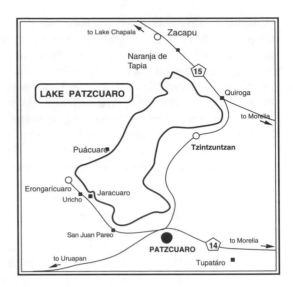

Tarascan hummingbird glyph

TZINTZUNTZAN

This ancient city of the Tarascan kings located on the eastern shoreline of Lake Pátzcuaro was the site of many temples, whose key-shaped platforms, or *yácatas*, still fringe the bluffs overlooking the lake. Among these structures was a great temple dedicated to the Tarascan hummingbird deity, whose sonorous wingbeats gave Tzintzuntzan its magical name.

When the Spaniards arrived, the Tarascan capital was chosen to be the first Christian mission town in Michoacán. In 1526, after throwing the pagan idols and religious paraphenalia into the lake, the zealous Franciscan Fray Martín de Jesús founded the mission of Santa Ana—a primitive affair of adobe and thatch—where he celebrated the first mass to the strains of traditional Tarascan music.

The mission was expanded on its present site by Fray Juan de San Miguel in the 1530s, when the new colonial settlement was grandly designated the first "City of Michoacán" by Bishop Vasco de Quiroga. Tzintzuntzan was briefly the seat of his bishopric before its controversial removal to Pátzcuaro in 1538.

Although the mission languished during the years following the move, its fortunes recovered again in the 1570s, when the provincial capital was moved yet again, to Valladolid (Morelia). At that time, construction of a stone church and convento began under the supervision of the energetic friar/builder Fray Pedro de Pila. This ambitious project was mostly completed by the end of the decade, probably with the help of master masons and artisans freed up by the abandonment of Bishop Quiroga's unfinished cathedral in Pátzcuaro.

Ancient olive trees of biblical proportions—reputedly planted by Quiroga himself—dot the park-like atrium along with stone crosses and an imposing statue of Don Vasco, creating an idyllic setting for Pedro de Pila's 16th century monastery.

The monastery front of red and black volcanic stone—much of it stripped from the nearby temples—stretches across the entire western side of the atrium, presenting a pleasing geometry of textured blocks and rounded arches framed by bands of white stucco. A second group of build-

ings, comprising the Third Order church and the former mission hospital, stands on the north side of the atrium.

The Church of San Francisco

Although the domed church has been enlarged more than once (the nave was rebuilt most recently in the 1940s, after a fire), the restored facade retains its classic 16th century forms.

The sculpted stone porch is effectively sandwiched between plain white walls. Swagged columns and paneled jambs flank the doorway, whose high archway is ringed by alternating shells and rosettes. A squat baluster column divides the choir window into two arched openings studded with tightly scrolled shells and overlapping sprays of acanthus leaves. The triangular surmounting pediment is triumphantly crowned with an enormous scalloped canopy carved in bold relief.

The remodeled interior is undistinguished, save for its early colonial cornpith crucifix, El Señor del Rescate (Our Lord of Redemption). This revered *santo* is kept in a side chapel except during his feast day in early February, when he leaves the church to preside over the colorful celebrations famous for their traditional Tarascan dances of Los Ancianos (Old Men).

The Chapel of San Camilo

The imposing archway of this former open chapel, positioned at the end of an avenue of gnarled olive trunks, is every bit as striking as the church itself. As the earliest surviving part of the monastery, the bold chapel front has great authority and may conceivably be the work of Toribio de Alcaráz, the architect of Pátzcuaro.

The simplicity of the chapel's ornament enhances its monumentality. Powerful flared and fluted piers support the broad coffered archway, which is studded with shells and winged angel's heads chiseled in sharp relief. The *alfiz* framing the archway also encloses a pair of classic shell reliefs, and a shallow ribbed vault covers the hexagonal interior.

The Convento

A plain archway between the church and chapel leads us to the sunlit cloister, whose handsome arcades are faced with classical paneled piers and broad molded arches.

The artistic jewel of the lower cloister is the Pietá, or polychrome relief of the Entombment of Christ, mounted in the southeast corner. Based on a 16th century Andalusian model, this colonial sculpture looks like alabaster but is actually modeled from lightweight *pasta de caña*. Despite some awkwardness in the posing of the figures, this popular image affects the visitor with its expression of tenderness.

By some miracle, sections of 16th century painted wooden *alfarje* ceilings are still suspended above the corner bays of the lower cloister. Al-

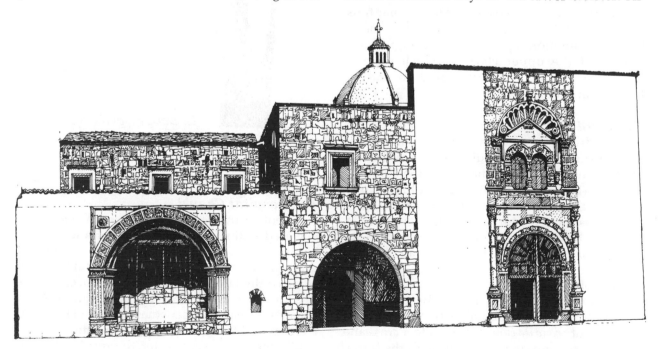

Tzintzuntzan, the monastery front

El Señor del Rescate

though now in varying stages of decay, they are notable for their intricate zigzag strapwork. Timely restoration could save these rare examples of the *mudéjar* craftsman's art from the disintegration that now threatens them.

Colonial era murals also grace the cloister. Below a lively multi-colored grotesque frieze around the lower walks, a sequence of frescoes unfolds illustrating the Seven Sacraments. Undoubtedly 16th century in origin, these frescoes were overpainted in brighter hues during the 1700s.

Two unusual 18th century paintings hang in the former sacristy, now the parochial office. One is a dark and dramatic Flagellation of Christ, in the style of Titian, and the other a naive but colorful portrayal of St. Francis standing in a local landscape, showing the lakeside monastery and its olive trees against a backdrop of volcanic hills.

A fresco of the Virgin appears at the head of the stairway, summoning us to view the fragmentary murals of the upper cloister, which seem to chronicle the miracles attributed to various Franciscan saints.

The Third Order Church of La Soledad

The handsome baroque church on the north side of the atrium, originally built for the Third Order of St. Francis, is now dedicated to the Virgin of Solitude (La Soledad). Although its high, curvilinear facade and multi-tiered tower are designed in the distinctive Morelian style (see Morelia, p.67), the trilobed arch and high triangular pediment of the archaic side porch recall the 16th century Franciscan doorways of colonial Morelos and Puebla.

La Soledad is home to a primitive articulated figure known as El Santo Entierro. At Eastertime, this ancient *cristo de caña* is affixed to a cross and carried in solemn procession through the *barrios* of Tzintzuntzan.

The Hospital Chapel

Adjacent to the Third Order church, facing an enclosed patio with a basalt cross and sunken baptismal *pila*, is an arcaded open-air chapel—all that remains of the mission hospital that formerly stood on this site. The chapel of La Concepción, as it is known, is raised on a terraced platform and consists of an arched sanctuary, flanked by faded frescoes and fronted by a broad arcade.

Like the monastery cloister, the arcade is simply framed by molded arches set on paneled piers.

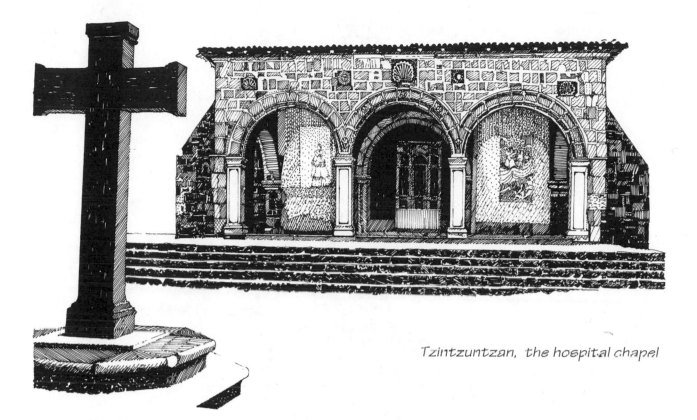

Tzintzuntzan, the hospital chapel

The center archway is accented by rosettes, and a row of shells is embedded above the arcade, along with reliefs of the sun and moon—traditional attributes of the Virgin of the Immaculate Conception. An inscription bears the date March 17, 1619.

Besides its tranquil ambience and monumental architecture, the monastery at Tzintzuntzan is distinguished by its stonecarving—a classic example of the Pidgin Plateresque style which set the pattern for numerous other church fronts around Lake Pátzcuaro and across western Michoacán.

Further reminders of Vasco de Quiroga's influence can be found along the north shore of Lake Pátzcuaro. In the crafts town of **Quiroga**, where the road north from Tzintzuntzan joins the main highway (Mex 15), his statue stands, head bowed, in front of a small museum that contains some of his personal effects. The facade of the 17th century Franciscan church of San Diego is carved with primitive floral and shell reliefs.

The old bishop's quarters in nearby **Santa Fé de la Laguna** have also been preserved, supposedly on the original hospital site, which is now also a tourist stop along the highway.

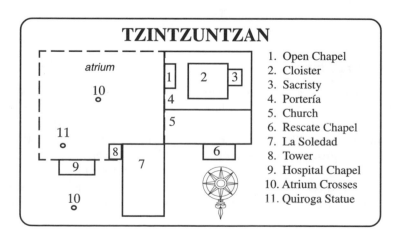

TZINTZUNTZAN

1. Open Chapel
2. Cloister
3. Sacristy
4. Portería
5. Church
6. Rescate Chapel
7. La Soledad
8. Tower
9. Hospital Chapel
10. Atrium Crosses
11. Quiroga Statue

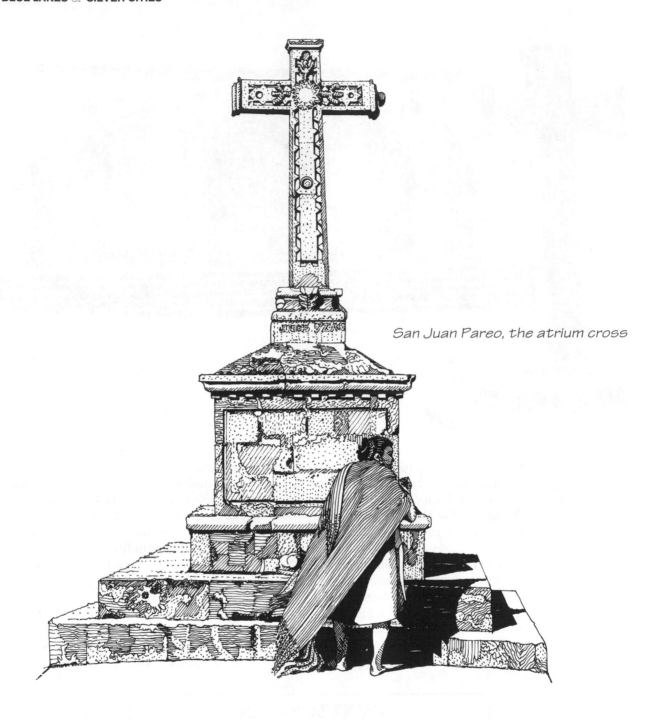

San Juan Pareo, the atrium cross

THE WESTERN SHORE

Although historically the most heavily populated stretch of lakefront, the western shore of Lake Pátzcuaro was, until recently, relatively isolated. Now, in only a few hours drive, the traveler can explore the Tarascan villages along this scenic shoreline.

Two places of special interest are the former island of **Jarácuaro**, whose hilltop mission is noted for its archaic carvings, and the delightful lakeside monastery of **Erongarícuaro**. Our first stop is at **San Pedro Pareo,** to admire the handsome atrium cross and the folk Plateresque church front with its shell encrusted doorway and rustic tower studded with a bewildering assortment of reliefs: animals, fish, keys, rosettes and especially its finely detailed carvings of the sun and moon.

Jarácuaro

Now a peninsula, reached by a curving causeway that crosses the low-lying marshland, Jarácuaro was once an island. In ancient times, it was sacred to the Tarascan moon goddess Xaratanga, whose hilltop temple was the object of ecstatic devotion and long distance pilgrimage.

Today, the early colonial church of San Pedro Jarácuaro occupies what must have been the dramatic site of this sacred shrine. From its atrium of windblown cedars, the church commands panoramic views of the surrounding lake.

The gabled facade of honey-colored stone is a close relative of the church front at Erongarícuaro and is of special interest for its wealth of primitive sculpture, in particular the iconic bas-reliefs of St. Peter and St. Paul carved on the jambs of the arched entry.

The animated figure of St. Peter overflows its confining niche in an exuberant display of graphic energy that typifies the 16th century Mexican interpretation of medieval European religious imagery. There is a searching eye for detail, with an almost abstract rendering of the sharp folds of the saints' robes.

No similar reliefs are to be found elsewhere in Michoacán. Their nearest relatives are the figures of Peter and Paul beside the north door at Huaquechula—a Franciscan monastery in the mountains of Puebla State.

A second relief of St. Peter, the patron saint of Jarácuaro, is mounted above the choir window—an ornamental two light opening divided by a swagged candelabra column and encrusted with cockleshells and acanthus foliage. Sun and moon reliefs are also embedded in the facade alongside the Mexican eagle and a 19th century cross.

Inside the church, which is roofed by a faded painted wooden ceiling, stands an ancient stone font carved with rosettes and the Franciscan cord. But the principal treasure here is the black Christ, a stunning wooden crucifix in the classic Pátzcuaro style with a corrugated rib cage, bulging veins and an agonized expression etched upon its scarred visage.

The nearby hospital chapel presents a simpler front. Its sculpted door jambs imitate those of the main church, this time displaying archaic reliefs of St. Francis and St. Clare. The adjacent *casa cural*, built on the site of the old hospital building, features homely wooden colonnades of carved beams and balustrades in the Tarascan manner.

Jarácuaro, relief of St. Peter

Uricho

Just off the road between Erongarícuaro and Jarácuaro stands the little Plateresque chapel of San Antonio Uricho.

Its broad arched doorway is surmounted with unusual, cabbage-like rosettes and, once again, primitive reliefs of the sun and moon—ubiquitous local motifs, again probably referring to the Virgin Mary.

Glowing beneath the remnants of a star-studded *mudéjar* ceiling that spans the sanctuary is an elegant gilded altarpiece, whose broad, rectangular framework is delicately ornamented with narrow *estípite* columns and baroque arabesques. The retablo frames a gallery of painted saints around an unusual black-robed statue of St. Anthony of Padua in the center niche.

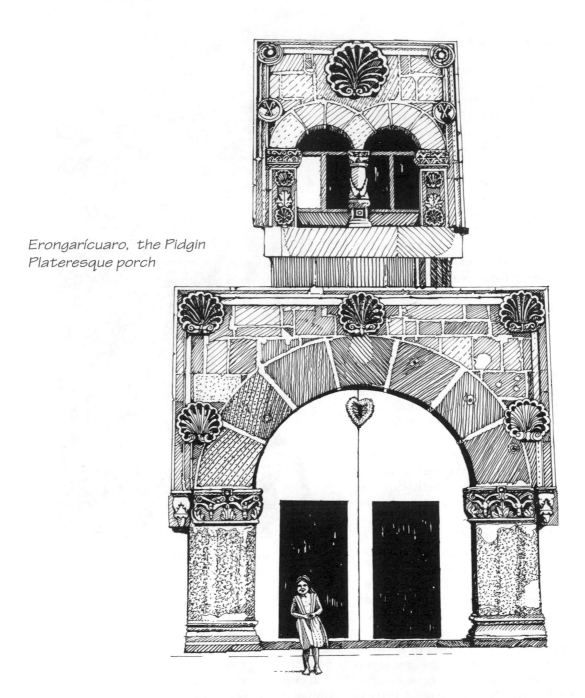

Erongarícuaro, the Pidgin Plateresque porch

ERONGARICUARO

The town of Erongarícuaro, simply called "Eronga" by the local people, is the largest settlement along the dry western shore of Lake Pátzcuaro. Erongarícuaro means "mirador" in the *purépecha* language and the picturesque Franciscan monastery here enjoys an exceptional vista of the lake. After 400 years the monastery still serves as a seminary and, to a great extent, preserves its 16th century appearance.

Although there was a primitive mission here in the early 1500s—a *visita* of Tzintzuntzan just a short canoe trip across the water—Bishop Quiroga refused the Franciscans permission to build a monastery here. So it was not until after Don Vasco's death in 1565 that construction began, continuing into the next decade and possibly involving some of the same artisans who were working on the monastery at Tzintzuntzan.

The Church

Just a few steps from the charming arcaded plaza, an arched gateway opens to the monastery atrium where an avenue of tall cedars leads us to the square church front.

The Plateresque west doorway and ornamental choir window, both cut from smooth, cafe-au-lait limestone, stand out sharply against the facade of dark, rough-hewn *tezontle*.

The broad Romanesque-style arch of the doorway rests on equally wide jambs, headed by capitals of rustic volutes and acanthus leaves. But the doorway's most striking features are its five giant inverted scallop shells—the classic marker of church ornament in Michoacán—here undoubtedly derived from the mother monastery at Tzintzuntzan.

An even larger shell relief projects above the double choir window—a broad-jambed opening divided by an ornate baluster column, like the one at Tzintzuntzan. Shells are also embossed on the jambs while relief rosettes and medallions of crossed keys cling to the surrounding *alfiz*. These similarities to Tzintzuntzan suggest the influence of Fray Pedro de Pila and his skilled stonecarvers.

A beamed ceiling covers the boxy nave, supported on a remarkable triple *arrocabe*, or wooden frieze, banded with painted, carved brackets and trimmed by a twisted cord molding.

The massive sanctuary arch, outlined in dark basalt blocks, draws the eye to the apse where an eye-poppingly naturalistic crucifix, known as El Señor de la Misericordia, hangs above the altar.

The Convento

An elegant triple arcade fronts the monastery beside the church. The high arches of the *portería* rest on fluted columns capped with intricately carved "ram's head" capitals adorned with angels, cornucopias and the Franciscan knotted cord—all cut from soft, ivory-colored limestone.

Recessed behind the center arch of the portico is the elaborate Plateresque archway of the 16th century *portería* chapel, a cousin of the open chapel at Tzintzuntzan, although more Renaissance in design. Flared, fluted piers brace its broad, paneled opening, surmounted by a dentilled frieze with medallions of the Sacred Heart alternating with the crossed keys of St. Peter. The flanking Gothic colonnettes strike a medieval note echoed by the rib-vaulted chapel interior, bare except for a plain stone font rimmed with the Franciscan cord. A choir loft spans the south end of the *portería,* and, at its north end, an arched doorway surmounted by an extravagant double *alfiz* of baluster columns gives access to the convento.

Blocks of reddish black lava stone like those in the sanctuary arch outline the stocky cloister arcades. Archaic doorways with low Isabelline arches open from the cloister into the surrounding rooms.

On a recent visit, the convento was crowded with boisterous young seminarians who proudly conducted us to the mirador at the rear, pointing out the panoramic view across the monastery gardens to the islands and shimmering waters of Lake Pátzcuaro beyond.

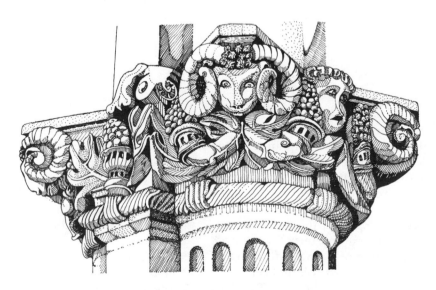

Erongarícuaro, "ram's head" capital

Puácuaro

After navigating the narrow, basalt-lined streets of this Tarascan village, we eventually emerge beside the picturesque 16th century mission, which also affords a breathtaking vista across the lake.

Architecturally, Puácuaro is a close relative to the other area missions. The rustic church is flanked on one side by a colonnaded *casa cural* with prominent overhanging eaves, and on the other side by a freestanding tower—another common regional feature—here capped by a pyramidal cupola.

The church porch is an authentic example of the *mudéjar*-inspired Plateresque style of the region. The doorway is framed by an *alfiz* carved with two styles of scallop shell superimposed on oak or acanthus leaves. The ornamental candelabra column dividing the shell-encrusted choir window frame is also typical.

Beyond Puácuaro, near the northern tip of the lake, remnants of other Franciscan missions survive at **San Jerónimo Purenchécuaro** and **San Andrés Zeróndaro**.

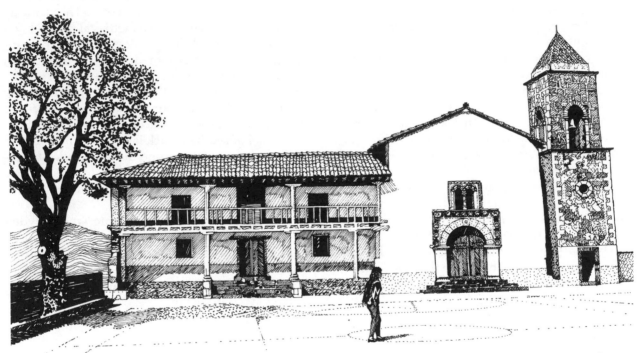

Puácuaro, the mission front

THE HINTERLAND

In every direction around Lake Pátzcuaro the visitor can explore historic towns and indigenous villages, almost all possessing some colonial monument or work of art. In this section we visit those of special interest.

North of the lake, we pick up Route 15 and proceed northwest to **Zacapú**, the site of an important early Franciscan monastery. En route we stop at the nearby church of **Naranja de Tapia**, of special interest for its painted colonial ceiling.

East of Pátzcuaro, the village church of **Tupátaro** is a must, internationally celebrated for its spec-

tacular painted ceiling—perhaps the finest colonial *artesonado* to survive in Mexico.

Then, going east along the Pátzcuaro-Morelia highway (Mex 14), we view the remains of the noble Augustinian priory of **Tiripetío**, and detour to explore the humble 16th century mission of **San Nicolás de Obispo** and its many colonial treasures.

South of Pátzcuaro, we recommend a scenic side trip to the quaint hill town of **Tacámbaro** to inspect the former Augustinian church and its mission hospital.

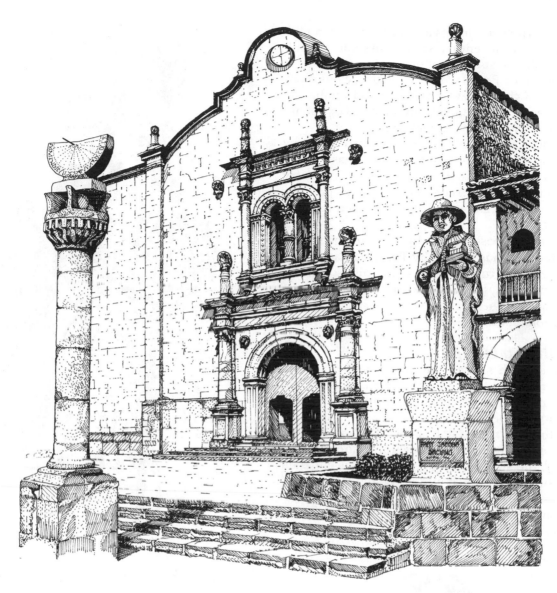

Zacapú, the church front

ZACAPU

In ancient times Zacapú was the site of a major shrine dedicated to the sun god Curicaueri, which overlooked a lake sacred to this greatest of the Tarascan deities. Although the lake subsequently degenerated into unhealthy marshland, the settlement remained populous into the 1500s.

Fray Jacobo Daciano, the Danish friar whose name is associated with Tarécuato, founded the monastery here in 1540, raising the first primitive thatched mission with his own hands. A statue has been erected in his memory in the atrium, wearing his broad-brimmed pilgrim's hat.

By the end of the 16th century, Santa Ana Zacapú was counted among the leading Franciscan houses in Michoacán. The present church was erected during the 1570s, reportedly under the supervision of Fray Pedro de Pila, the distinguished builder of Tzintzuntzan.

Studded with bold shell reliefs, the imposing Plateresque facade recalls Tzintzuntzan and Erongarícuaro, although the Corinthian columns, paneled jambs and pedestals give it a more classical appearance. Note the unusual angled shells flanking the doorway.

The atrium resembles a sculpture garden with its carved 17th century stone cross and a handsome colonial sundial set on a column alongside the figure of Fray Jacobo. The curvacious clock gable and church tower are recent additions and the interior has been entirely made over, retaining no obvious colonial features.

Although much of the *portería* arcade has now been closed in, the adjacent convento has a raised gallery in Tarascan style. The tunnel-like entry vestibule bears a fragmentary fresco, possibly portraying the 26 Franciscans martyred in Japan in 1596.

A narrow passage conducts us to the sturdy cloister, which is framed by Tuscan arcades with massive stone columns and slab capitals. Beneath low stone arches set on thick scrolled brackets, the cavernous corner niches still preserve vestiges of devotional murals.

The Hospital Chapel

On the north side of the vast paved plaza out front, partly obscured by a modernistic structure and high walls, we can still glimpse the former hospital chapel of Zacapú.

Although its facade has been haphazardly refinished to incorporate several colonial stone reliefs, the subdued beamed interior is enriched by a small but refined gilded retablo gleaming at the far end. The chapel and its peaceful precincts once more house Franciscans, this time the Poor Clares, nuns of the Second Order of St. Francis.

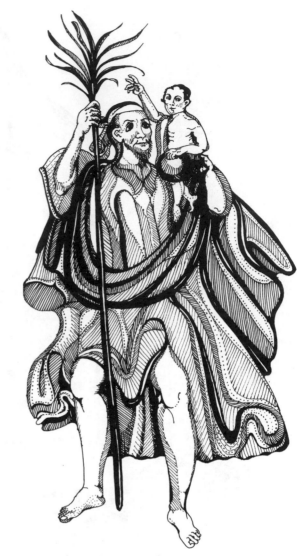

Naranja, St. Christopher

Curicaueri, the Tarascan sun god

Naranja de Tapia

The Tarascan town of Naranja lies a few kilometers south of Zacapú. Its spacious, gabled church of the Assumption contains one of the largest, earliest and best preserved *artesonado* ceilings in Michoacán.

The high paneled ceiling, pitched in the form of an inverted trough and tied by carved crossbeams, covers the sanctuary and part of the nave.

Painted in a colorful popular style, it is dated 1733 and signed by an otherwise unknown indigenous artist, one Pedro Ximénez. The ceiling is crowded with myriad religious figures representing the history of the Church.

Along the sloping side panels is arrayed a celestial assembly of saints, martyrs, prophets and biblical characters—more than seventy in all. The figures are naively sketched in fluid strokes, and vividly accented in reds and blues. One of the most imposing images is a majestic St. Christopher clad in voluminous billowing robes. Winged cherubs flutter and nod across the center section, peeping out from curling clusters of foliage.

TUPÁTARO

Acclaimed by Judith Hancock, the well known photographer and writer on Spanish colonial arts, as "one of the most magnificent creations of the colonial period in all Latin America," the church of Tupátaro has also been called the Sistine Chapel of the Americas. For the wooden ceiling of this humble village church is entirely covered with a cycle of 47 painted panels illustrating the Life and Passion of Christ.

Nestled within its walled churchyard, beside a simple village square framed by gaily painted red and white wooden *portales*, the adobe church of Santiago was originally a *visita* of the nearby Augustinian monastery at Tiripetío. Approached along a narrow pathway lined by ash trees and guarded by a stark stone cross, the unassuming whitewashed facade and primitive belltower are entirely plain, save for a few preserved mural fragments and rustic carvings of the sun and moon, giving little hint of the treasures within.

Entering the barn-like nave, the visitor's attention is immediately drawn to the imposing beam and plank ceiling, framed like a truncated pyra-mid. This impressive interior was enlarged in the mid-1700s to accommodate hosts of pilgrims paying homage to the statue of El Señor del Pinito—a miracle working crucifix discovered in a pine tree by a local Indian. This popular shrine was then embellished with a painted ceiling and a sumptuous gilded retablo—one of the handful to survive in rural Michoacán.

The Artesonado Ceiling

This extraordinary assemblage of images constitutes the finest painted ceiling in Michoacán—a region especially noted for these distinctive works of popular religious art. Painted in a vivid folk-baroque style with a luminous palette of reds, blues, greens and earth tones, the ceiling shines again thanks to painstaking restoration by the German-born artist Enrique Luft.

Several dates, ranging from 1725 to 1793, appear on the carved and painted crossbeams, indicating intermittent work and perhaps alterations. The raised center section, dating from 1772, runs the full length of the nave. It depicts familiar

The Tupátaro ceiling: Archangels with the Instruments of the Passion

scenes from the Christian story: the Nativity, the Adoration of the Magi, the Last Supper, the Resurrection and the Ascension, each with elaborate scrolled and foliated frames. Accompanying the Passion scenes are episodes from the life of the Virgin, illustrated with her biblical attributes from the Book of Revelation.

The long, sloping side panels constitute a gallery of magnificently costumed archangels in plumed headdresses, bearing Instruments of the Passion marked with lettered banderoles. These portraits are framed by whimsical decorative borders busy with cherubs, sun, moon and miniature portraits, all caught in a tumbling tapestry of clouds, strapwork and lush foliage. My favorite cameo is the tiny figure of St. Cecilia, the patron saint of musicians, shown seated at her organ above the choir. The entire ceiling is now gently illuminated by side lights operated on request by the resident INAH guardian.

Such a dazzling display of art in a humble rural church, designed to instruct and impress a congregation of mostly illiterate villagers and pilgrims, testifies not only to the depth of faith and religious devotion in this small corner of 18th century Michoacán but also to the creative popular imagination through which it found such eloquent expression.

The Retablo

The other principal gem in the church is the elegant baroque altarpiece fitted into the apse. Dated 1761 and also expertly restored by Enrique Luft, it is similar in style to the retablo at Uricho, although more ornate.

Gilded Solomonic columns with encircling grapevines replace the *estípites* we saw on the Uricho retablo. The base level is carved with polychrome reliefs of the Four Evangelists and the Doctors of the Church, separated by pelicans— common symbols of Christ's sacrifice. Above, two tiers of filigreed rectangular panels frame a sequence of paintings portraying the Passion of Christ in dramatic *tenebrista* style.

An intimate canvas of the Three Kings is placed in the center, and in the ornate pediment a panel of earlier date depicts Santiago Apostol, the peaceable patron saint of Tupátaro. A dusty vitrine contains the tiny effigy of El Señor del Pinito, a wooden folk santo almost smothered in richly embroidered draperies.

Among the other colonial treasures in the church, we should mention the carved 18th century altar, recently discovered to be veneered entirely with precious silver leaf, and a vigorous equestrian statue of Santiago Matamoros—the militant alter ego of Santiago Apostol—standing guard beside it.

An 18th century icon of the Virgin of Guadalupe, signed with the elaborate rubric of an undocumented artist, is affixed to the north wall close to the altar. Finally, the image of El Cristo de Cuanajo, a life-size *cristo de caña* in the expressionistic Pátzcuaro style, is mounted near the entry.

Tupátaro, the atrium cross

Adapted from the early colonial Lienzo de Jucutacato, this drawing shows Tiripetío in the mid-16th century. A great Tree of Life occupies the town center beside a bell-shaped yácata. Augustinian friars in black robes elevate the host amid scenes of village activity, which include construction of the priory at left.

TIRIPETIO

"The loss of Paradise," was how Matías de Escobar, the Augustinian chronicler and former prior of Tiripetío, mourned the destruction by fire in 1640 of this magnificent priory. A cultural and architectural oasis, it was celebrated as the "Athens of the Republic," the "Republic" being the western Augustinian province of San Nicolás de Tolentino.

Located on the plain between Pátzcuaro and Morelia, this ancient foundation has suffered its share of reverses over the centuries. Founded in 1537 by Fray Juan de San Román, the primitive thatched mission was the first to be established by the Augustinians in Michoacán.

During the 1540s, this humble mission was transformed into the model priory of San Juan Bautista with the assistance of a local *encomendero*, Juan de Alvarado, in whose honor it was named.

On the initiative of Fray Diego de Chávez, the nephew of the *encomendero* and a budding architect, Spanish masons were brought here to oversee construction and instruct the natives in European building methods. Fray Diego also worked at

Malinalco and went to Yuriria, to plan and supervise construction of the great Augustinian monastery there, but returned to Tiripetío in 1562 to complete the church facade.

The priory boasted a large convento, which housed a seminary and a school for artisans that was famous throughout the west. Members of the Tarascan nobility, including the 16th century native governor of Michoacán, Antonio Huitziméngari, were instructed in these precincts.

An excellent hospital was also attached, with its celebrated garden of medicinal plants and herbs—a resource that became the basis for colonial herbals and medical treatises.

Today, however, the monastery at Tiripetío is a shadow of its former self. Its convento is much reduced and the church burdened by later additions. The massive stone church, once noted for its handsome *artesonado* roof and sonorous bells, cast from local copper, has been frequently rebuilt—most recently in the early part of this century.

Nevertheless, Diego de Chávez' handsome church front, constructed of smooth, honey colored limestone, has been essentially restored to its classical 16th century appearance. Giant fluted half-columns bracket the wide facade, which is crowned in the Palladian manner by a triangular pediment topped with statuary.

The coffered doorway is flanked by paneled pilasters, and shell niches which contain battered statues of St. Paul and St. Joseph. In typical Augustinian style, an eroded Latin inscription runs along the lengthy cornice frieze. The moorish arches and octagonal upper tiers of the whitewashed tower testify to the persistent *mudéjar* tradition in Mexican architecture.

Fragments of a painted retablo inside the remodeled church, whose walls were once covered with tempera murals, are a reminder of the beautiful interior so frequently praised in early colonial accounts of the church.

Although the exquisite early cloister has been barbarously mutilated and is now virtually unrecognizable, much of the colonial convento and seminary has been rehabilitated for use as a training college, affiliated to the University of Morelia. Plans are reportedly under way to establish a major Augustinian archive at Tiripetío, intended to document the history of the order in the New World.

The vast former atrium now serves as a public park—neatly terraced, paved with limestone and planted with gardens. Along with a fountain and an octagonal atrium cross, the park also includes a modern statue of Fray Alonso de la Vera Cruz, the distinguished 16th century missionary and humanist who directed the school here.

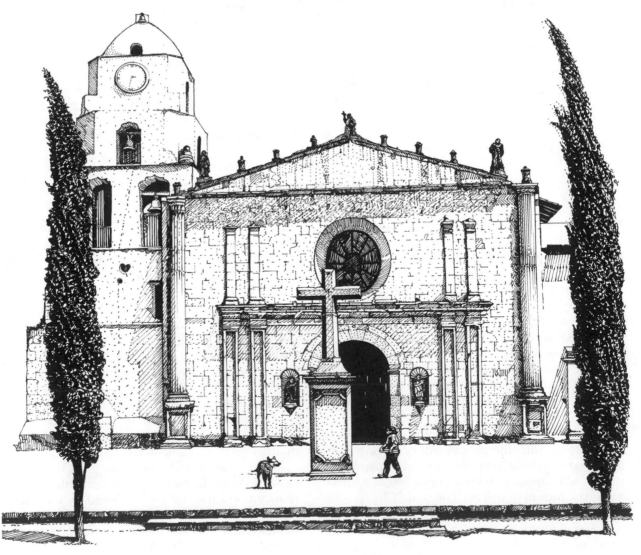

The Augustinian priory of Tiripetío

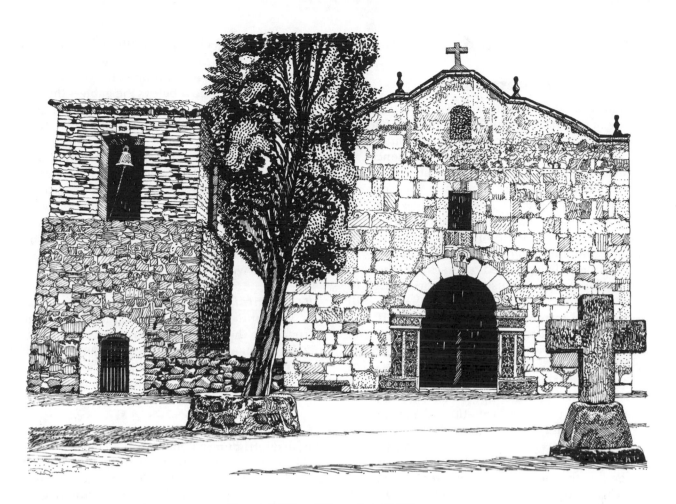

San Nicolás de Obispo

Less than ten kilometers from Morelia, hidden just beyond earshot of busy highway 15, lies **San Nicolás de Obispo**, a sleepy Tarascan village of neglected colonial treasures.

Little is known concerning the early history of the mission. The Franciscans were the first to establish a hospital and chapel here, although it later came under Augustinian jurisdiction. The rugged stone cross before the church doorway is engraved with Augustinian as well as Franciscan emblems, reflecting the moment of transition between these two missionary orders.

Although its profile has changed over the centuries—it is now topped by a baroque gable—the plain church front retains its homely, 16th century arched doorway, whose monolithic jambs are sculpted with stylized vines, foliage and pearl-like rosettes.

The old stone font inside the chapel dates back to the Franciscan era, its chalice-like basin carved with thistles, serpentine foliage, and rimmed by the knotted cord. The rustic interior is spanned by a wooden roof and beamed choir balcony, both hung with hand cut *mudéjar* wooden latticework secured with leather strips and dotted with red and blue stars.

A final treat at San Nicolás, quite unexpected in such a humble chapel, is the gilded altarpiece which glimmers opulently in the penumbra of the sanctuary.

Fashioned in florid Churrigueresque style, this 18th century retablo boasts a wealth of ornament. Amidst the flurry of swirls, pendants and angels, a few colonial *santos* remain in their place, including the popular Franciscan saint, St. Anthony of Padua, in company with the Augustinian bishop, St. Nicholas of Tolentino, to whom the church is dedicated.

In common with other early Michoacán missions, the church has a free-standing tower—a ruggedly rebuilt structure of rough basalt.

A section of stone colonnade to the right of the church probably formed the front of the original hospital building.

off the beaten track ...

Tacámbaro

A scenic road winds south from Tiripetío through forests of live oak to the picturesque foothill town of Tacámbaro, noted for its waterfalls, subtropical gardens and old world colonial ambience.

Tacámbaro was the southernmost stronghold of the Tarascan empire, and after the Spanish conquest, when settlers poured in to exploit the rich local veins of copper, gold and silver, it became an important colonial center and key Augustinian mission town.

Although it has suffered reverses over the centuries, the former Augustinian priory church of San Gerónimo, now called The Cathedral, still dominates Tacámbaro. Founded in 1537, it was the second Augustinian mission in Michoacán after Tiripetío. Fray Juan de San Román, the friar-architect who planned the Augustinian houses of Tiripetío and Malinalco, designed the monastery, and construction was supervised by Diego de Chávez, the builder of Tiripetío and Yuriria.

The large complex included a hospital as well as a native crafts school staffed by Spanish artisans. Although the priory initially flourished, by the end of the 16th century disaster overtook it. The church burned down in 1600, and again in 1700. The present building dates from the 1730s, but was radically modified in the 19th century.

The cathedral overlooks the arcaded main plaza, where some of the giant palms for which the ancient settlement was named still grow. Although the west front incorporates elements from the colonial structure—its mullioned tower openings and the ocular window below the gable—the colonnaded portico is post-colonial, as are the gray and gold neoclassical interior and the lofty tiled dome.

The broad arcade of the monastery front and the arch of the elevated open chapel belonged to the 16th century convento, but of the arcaded cloister only the meticulously restored northeast corner now survives, the rest having fallen victim to earthquakes and redevelopment. Jumbled fragments of the old facade inscription are embedded in the patio wall.

The Hospital Chapel

The substantial hospital chapel, just around the corner from the cathedral, also survives in recognizable form. A rustic, cross-beamed wooden roof with exposed tiles covers the nave, and a broad flattened archway like that of the monastery open chapel frames the apse.

El Molino

Another intriguing colonial survival in Tacámbaro is "El Molino," an 18th century water mill and aqueduct located on a steep hill above the town center. This historic building, now restored as an excellent hostelry, commands panoramic views of the town and the *tierra caliente* to the south, including, on clear days, glimpses of the distant volcanoes of Colima.

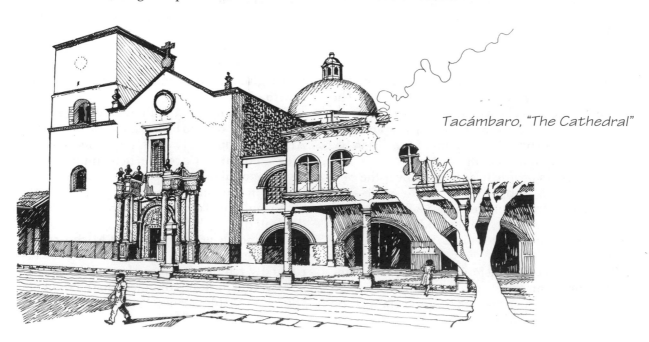

Tacámbaro, "The Cathedral"

THE CITY OF MORELIA

As we approach Morelia from the west, a break in the highland plain affords a sudden view of the city, nestled in the valley of Guayangareo. Still dominated by the great cathedral at its heart, the modern city spreads out like a carpet across the enveloping ridges and hillsides.

The history of Morelia began in bitterness and strife. In the late 1530s Bishop Vasco de Quiroga established his bishopric in the lakeside town of Pátzcuaro, at the heart of the old Tarascan empire, and planned the construction of a great cathedral there. However, Spanish colonists resisted settling in an Indian town and frequently clashed with the pro-Indian bishop. Heeding their complaints, Viceroy Antonio de Mendoza decided to establish a new regional capital, to be called Valladolid after the elegant university city of Castile in Spain, on a site near the ancient Tarascan settlement of Guayangareo.

Bitter arguments continued to rage about which town should enjoy the royal title of City of Michoacán, and construction started on two rival cathedrals—one in Indian Pátzcuaro and the other in Spanish Valladolid. But after Don Vasco's death the tide turned in favor of Valladolid, and in 1579 the episcopal seat was officially transferred there from Pátzcuaro. Thereafter, Valladolid—since renamed Morelia in honor of José María Morelos, a native son and the hero of Mexican independence—became the undisputed civil, religious and cultural capital of Michoacán.

Created as an urban Spanish enclave, the colonial city of Valladolid was set apart physically, culturally and visually from the predominantly Indian province of Michoacán. Its sober classical architecture is quite distinct from the Plateresque buildings of rural areas and small towns. Originally laid out on a grid by the viceroy's own surveyor, Juan Ponce, the sloping terrain and subsequent street changes subverted the planned symmetry. Unexpected vistas of the viceregal monuments—cathedral, churches, monasteries and public buildings, linked by plazas—open up at every turn.

Although the colonial buildings of Morelia range in date from the late 16th to the early 19th centuries, the great flowering of the Morelian Baroque took place during the first half of the 18th century. Despite this relatively late date, when the ornate Churrigueresque style was sweeping other urban centers, the facades of Morelia followed the austere Herreran tradition, named for Juan de Herrera, the Mannerist architect of the royal palace of El Escorial in Spain.

Special architectural features of the Morelian Baroque include multi-tiered towers with octagonal belfries, and high-gabled facades with outsized geometrical or foliated reliefs.

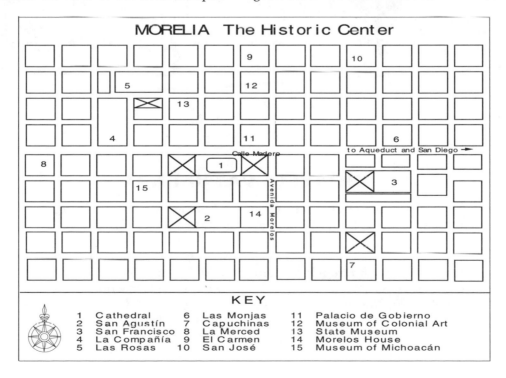

MORELIA The Historic Center

Calle Madero

to Aqueduct and San Diego →

Avenida Morelos

KEY

1	Cathedral	6	Las Monjas	11	Palacio de Gobierno
2	San Agustín	7	Capuchinas	12	Museum of Colonial Art
3	San Francisco	8	La Merced	13	State Museum
4	La Compañía	9	El Carmen	14	Morelos House
5	Las Rosas	10	San José	15	Museum of Michoacán

Morelia, the Cathedral of the Divine Savior

MORELIA CATHEDRAL

In its solemn grandeur, Morelia's Cathedral of the Divine Savior epitomizes the spirit of the vicere-gal city. Its several phases of construction stretch across the colonial centuries. Following removal of the episcopal seat to Valladolid from Pátzcuaro in 1579, work immediately started on a new cathedral. But by the mid-1600s the first structure of wood and adobe had already deteriorated and was replaced by a new cathedral—the present imposing edifice.

The new cathedral was conceived on a grand scale to a severe classical design. An Italian architect, Vicenzo Baroccio de la Escayola, known in Mexico as Vicente Barroso or "El Romano," was commissioned in 1660 to draw up the plans and supervise construction.

His excellent design, sound construction techniques and insistence on high quality stone-working are a legacy that has stood the cathedral in good stead over the subsequent centuries.

Work proceeded rapidly during the 1670s and after a hiatus following Barroso's death in 1695, construction resumed in the early 1700s under a succession of architects. Although the cathedral was dedicated in 1705, work continued for another two decades. The facade was completed in 1720, and the towers by 1744.

While each Mexican cathedral has its own special character, many observers consider Morelia's cathedral to be the finest of them all. Whatever one's opinion, there is no doubt that this magnificent building sets the tone for the historic city center.

Flanked by the two main squares—the *zócalo*, or Plaza de los Martires, on the west side and the smaller Plaza Ocampo to the east—the cathedral faces north, across from the Palacio del Gobierno, visually asserting the power of the colonial church, which rivaled civil authority in New Spain.

The Cathedral Front

Its front is configured in the customary style of Mexican cathedrals, with a center facade flanked by weighty bell towers. Elegant gateways, adorned with some of the most beautifully wrought ironwork in Mexico, give access to the narrow forecourt.

The broad, somewhat squat facade of pinkish violet stone encompasses the main entry and the flanking aisle doorways. The clearly articulated retablo facade radiates a sober dignity in the Herreran style. The use of flat pilasters and the lack of relief decoration results in a cool, planar effect that emphasizes the classical lines.

The later application of baroque elements to the upper facade—lambrequins, complex cornices, pediments, pendants and pinnacles—creates a lively silhouette above the severe front. But it is through the facade statuary and reliefs that a truly Mexican note is struck.

The three reliefs above the entries are cut from a finely textured white limestone, which stands out dramatically against the rosy masonry of the facade. These tightly composed reliefs, sculpted in an appealing folk-baroque style and enlivened with anecdotal details, focus on the life of Christ in its human and divine aspects.

Mounted above the center doorway, the key tableau of the Transfiguration of Christ is a conventionally symmetrical representation of this trancendental event. The stolid peasant faces—of Moses and the prophet Elijah, who flank the figure of Christ, of the dazed apostles sprawled below, and even of God the Father at the top—

recall Flemish engravings, which were probably the source for these reliefs.

On the left is the Adoration of the Shepherds, a dynamic composition distinguished by the animated poses of the various actors in this nativity scene. Over the right entry is a peculiarly elaborate tableau of the Three Kings paying homage to the Christ Child, watched over by a column of angels suspended from a bank of clouds.

Statuary is confined to the center facade. Graceful, Mannerist figures of Saints Peter and Paul occupy their usual positions on either side of the main doorway, while restless baroque statues of the Archangel Michael and John the Baptist flank the Transfiguration on the middle tier. In the upper facade, St. Barbara and St. Rose of Lima stand beside the Mexican coat of arms, which replaced the imperial eagle of the Hapsburgs after Independence.

The side porches follow the same format as the front entries. A conventional relief of the Virgin of Guadalupe is set above the east doorway, while St. Joseph stands amid a flutter of angels in the carving over the western entry.

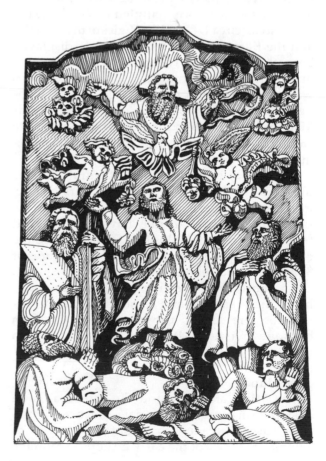

Morelia Cathedral, the Transfiguration

The twin towers are a prominent local landmark. Rising in two elegant tiers from plain, massive bases to a height of more than 200 feet, they give needed verticality to the cathedral. Like the facade, the lower sections are faced with flat pilasters and applied baroque decoration in low relief. Projecting balconies and medallions of the episcopal insignia embellish the octagonal upper stages which are capped by high lanterns with tiled cupolas.

The high ribbed dome of the cathedral, decorated with blue and yellow tiles and capped by a turreted lantern, recalls that of Puebla Cathedral, where Vicente Barroso also worked.

The Interior

Tooled leather doors open to the spacious nave, which is finished in neoclassical style with a coffered ceiling and arcades embossed with intricate filigree. Round *tecali* (Mexican alabaster) windows ringing the octagonal drum of the dome impart a warm glow to the side aisles.

Colonial art objects inside the cathedral include several pieces of solid silverwork. The enormous monstrance, sculpted in florid late baroque style (circa 1787) with effigies of the Apostles and the Evangelists, is conspicuously displayed beneath the crossing. There is also a silver baptismal font in which, by tradition, José María Morelos was baptized, and a pair of large gilt crucifixes designed by the noted neoclassical sculptor Manuel Tolsá. High in the choir stands an ornate 18th century organ case of consummate craftsmanship.

Statuary of interest in the cathedral includes the Christ of the Sacristy, a 16th century crucifix in the expressive Pátzcuaro style. Some of the saints on the side altars may have been salvaged from the baroque retablos that formerly lined the cathedral, in particular the fine *estofado* figures of St. Barbara and John the Baptist.

An impressive collection of colonial paintings hangs in the sacristy and adjacent rooms. Of special note are several canvases by the Mexican baroque masters Miguel Cabrera and Juan Rodríguez Juárez, in addition to an unusual folk picture of the Three Kings adoring the Virgin of Guadalupe.

The **Mitra** annex behind the cathedral is an austere 18th century episcopal residence with severe Tuscan arcades, that contains a series of colonial portraits of the early bishops of Morelia.

THE CHURCHES OF THE RELIGIOUS ORDERS

On the afternoon of May 3, 1738, the entire population of Valladolid—the colonial elite and curious townspeople alike—turned out to witness an unprecedented event.

On that day, the strictly cloistered and hitherto unseen Dominican sisters of Santa María de la Gracia walked publicly in ceremonial procession from their old nunnery to the new convent of Las Monjas Caterinas.

Fortunately for posterity, a large detailed canvas recording this unique occasion has been preserved in Morelia's Museum of Michoacán. This narrative painting affords us a fascinating glimpse of Spanish colonial society in Valladolid at its apogee.

In the 1930s, Manuel Toussaint, the dean of Mexican colonial art studies, followed in the footsteps of these 18th century nuns, in order to recreate for readers of his *Paseos Coloniales* the fading vision of this magnificent colonial city.

Inspired perhaps by Toussaint's pilgrimage, the distinguished architect and historian Manuel González Galván led a successful municipal campaign to revive the viceregal heritage of Morelia, restoring several historic colonial buildings, as well as the numerous parks and plazas for which the city is renowned.

The monasteries and convent churches of the religious orders that proliferated in New Spain still dominate the colonial centers of many Mexican cities and Morelia is no exception.

In addition to the imposing monastic houses of the Franciscans and Augustinians, who jointly evangelized Michoacán, the establishments of the Jesuits, Mercedarians, Carmelites and Capuchins have also survived, together with the two elegant Dominican nunneries of Las Monjas and Las Rosas.

The urban siting and sober architecture of the early monasteries of San Francisco and San Agustín, with their large plazas and open vistas, greatly influenced the development of the Morelian style.

Although both monasteries are fundamentally Renaissance buildings, they also incorporate Plateresque elements from the 16th century, and to some degree, the Mannerist influences that took hold in the early 1600s.

Morelia, San Agustín

San Agustín

Founded in 1540s and located one block south of the cathedral facing a handsome arcaded plaza, the priory of St. Augustine claims to be the oldest surviving colonial building in the city. Although the church has been restored, the once elegant convento continues to languish in a precarious state of neglect.

Construction of the monastery proceeded fitfully from 1550 until 1600 under the hand of its aristocratic first prior, Fray Jerónimo Marín, a former ambassador to China from the Holy Roman Empire.

In the early 1600s, using funds from profitable Augustinian sugar estates, the church was vaulted and the convento enlarged to its present size, supervised by Diego Basalenque, the celebrated linguist and historian of the Augustinian order in Michoacán.

The Church

The elegant facade is Morelia's earliest church front, dating from around 1600. Fashioned from fine-grained local ashlar stone in rich shades of cream and rose, it is composed in an eclectic Italianate style with Plateresque and baroque touches.

A simple triumphal arch with carved capitals frames the west porch, whose scalloped keystone incorporates the shell motif characteristic of traditional architectural decoration in Michoacán. The condensed Latin frieze quotes Genesis: "This is the House of God, the Gate of Heaven. Happy are those who inhabit it giving praise perpetually."

Baroque influences are revealed in the coffered frame and angel frieze of the choir window as well as the high-peaked gable. The statue of the Archangel Michael, with its agitated stone draperies, probably replaced the staid statue of St. Augustine that now stands above the north doorway.

Shell reliefs also adorn the belfry of the modest south tower, which dates from the early 1700s. The looming brownstone tower on the north side is an 18th century addition, out of scale with the carefully modulated facade.

Although Father Basalenque's baroque interior was long ago remodeled in neoclassical style, the sacristy retains its original rib vaulting, as well as a trio of canvases depicting scenes from Christ's Passion in a vivid popular style, by the indigenous 18th century painter Xavier Tapia.

The Convento

The monastery portico adjacent to the church remains intact, its robust Roman colonnades contrasting with the medieval Isabelline windows overhead.

The convento, however, is in a sorry state. Its spacious stairway is in poor repair and the conventual rooms have been disfigured, with only a few traces remaining of the murals that once covered their peeling walls.

Nevertheless, the sure eye and hand of the architect can still be admired in the pleasing proportions and fine detailing of the cut limestone cloister. Its broad lower arches, divided by faceted prow buttresses, give way to elegant double arcades on the upper level.

Fortunately, too, the splendid 16th century fountain still dominates the cloister patio, its primitive stone lions standing battered but alert on each corner.

San Francisco

In the 1970s, under the direction of Manuel González Galván, the noisome city market was removed from the Plaza Valladolid—originally the monastery atrium—to allow an unobstructed view of San Francisco's broad facade. Sad to report, in recent years market stalls have again encroached upon the plaza, partly obstructing the open vista.

This was the first monastery to be founded here—even before the settlement became a city. In the years after the Spanish conquest, Fray Juan de San Miguel evangelized the small Tarascan community, and sometime after 1531, a Portuguese Franciscan, Fray Antonio de Lisboa, erected a primitive adobe mission.

Although a permanent stone monastery was begun as early as 1546, despite a substantial royal grant it was not finished until the early 1600s.

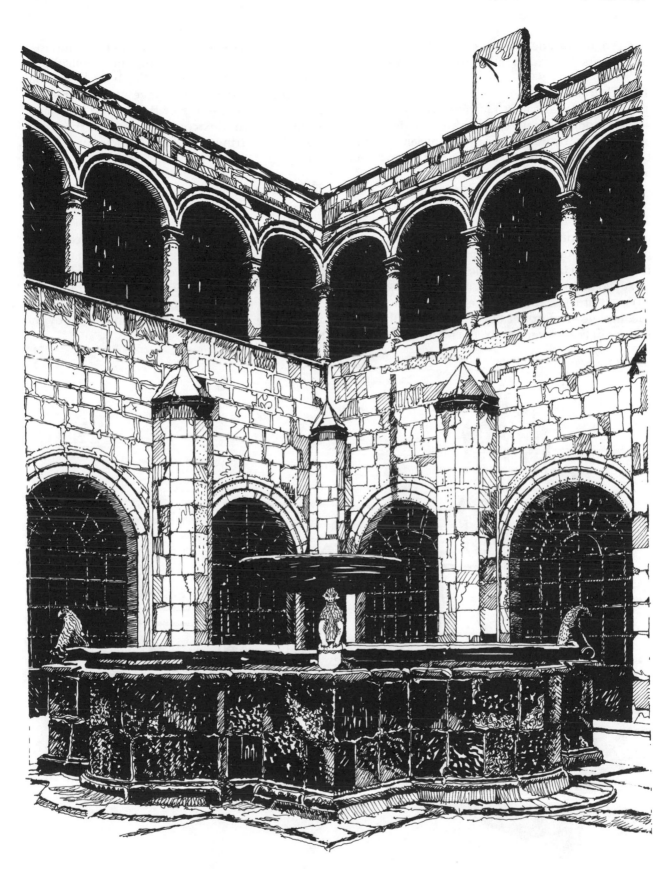

Morelia, San Agustín: cloister with lion fountain

Even so, the facade plaque, dated 1610, probably refers to its dedication rather than its completion.

The Church

The spare Renaissance facade, faced with pale stone in tones of mauve, ocher and pinkish-gray, although clearly influenced by that of San Agustín, bears Plateresque features that link it to Franciscan architecture elsewhere in Michoacán.

The doorway recalls Tzintzuntzan, with bands of angels heads, rosettes and cockleshell reliefs around the arch. Note the tiny sculpture of Virgin and Child mounted on the keystone. Although an ornate baroque pediment caps the choir window, the plain, rectangular profile of the facade lacks the eye-catching gable that crowns San Agustín.

For centuries, the massive belltower was left incomplete. The upper belfry, ringed with giant statues of Franciscan saints, is a modern addition.

The cathedral-like interior dates from the close of the 16th century. Following the classical prescriptions of Sebastiano Serlio, bold hexagonal coffering covers the long nave vault, and a fine segmented dome—one of the earliest and most harmonious in Mexico—stands above the crossing, its ribs fringed by the Franciscan knotted cord.

The Convento

The spacious convento is the oldest part of the monastery. Its monumental cloister has been thoroughly renovated as the Crafts Center of Michoacán—the antithesis of the dilapidated Augustinian convento. But despite its scrubbed and newly pointed stonework, the spare Franciscan cloister lacks the finesse of its crosstown rival; the arcades seem plain and artless, oppressed by the huge intervening buttresses.

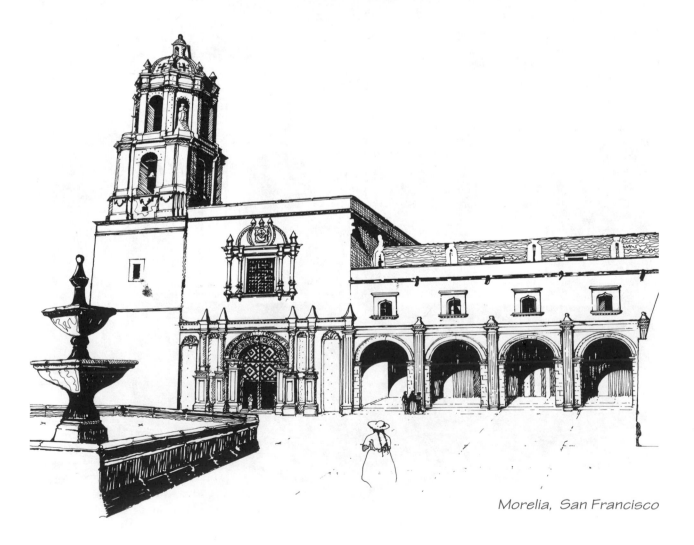

Morelia, San Francisco

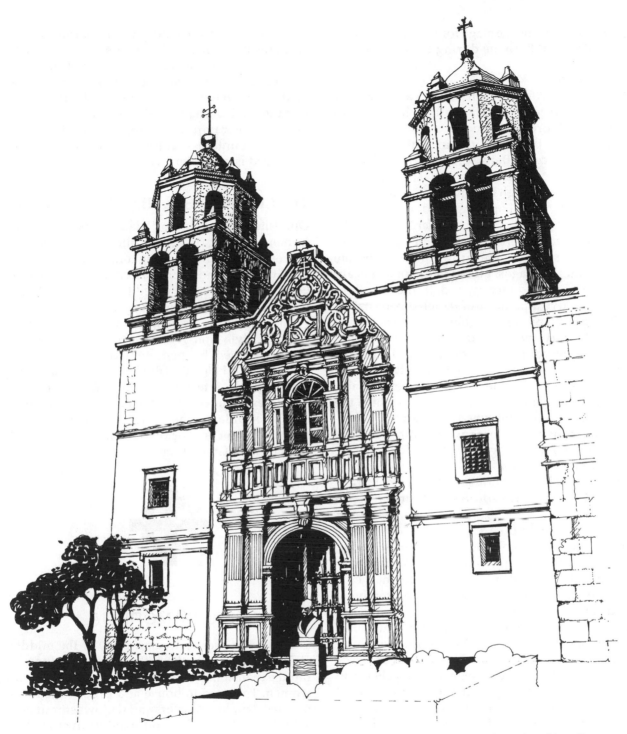

Morelia, the church of La Compañía

La Compañía

The Jesuit fathers arrived in Valladolid in 1582, a date commemorated by an inscribed frieze on the isolated tower above the south corner of the adjoining Jesuit college—all that remains of the first church on the site, built around 1600.

The church and college of St. Francis Xavier comprise one of the most impressive religious complexes in Morelia. This distinguished grouping embodies the best qualities of Jesuit architecture in Mexico—clarity, harmony and

grandeur—setting the stage for the full flowering of the Morelian Baroque during the later 1700s.

The Church

The church front, which faces east across a miniscule forecourt, displays all the hallmarks of the mature Morelian style.

Dating from the 1660s, it was reputedly built to a design of Vicente Barroso, the cathedral architect. Roughly rusticated towers support squat belfries that, although largely bereft of ornament, feature the twin bell openings and octagonal upper tiers that proclaim their *mudéjar* heritage. The facade is quite different, a study in planar Mannerism whose ornament grows more elaborate and sinuous by stages. Fluted Doric pilasters anchor the arched doorway and frame the choir window above a phalanx of paneled pedestals.

The striking pyramidal gable was the first of its kind in the city and exerted a profound influence on its contemporaries as well as later buildings. The confined geometric ornament of the lower tiers gives way on the gable to freeform arabesques deployed on a grand scale, in which the Jesuit insignia are entwined with sirens, scrollwork and foliage. The ornament is applied in flat relief, a distinguishing characteristic of facade decoration in Morelia.

The church now houses the state library (Biblioteca Publica) in addition to Jesuit archives.

The Clavigero Palace

This former Jesuit college of St. Francis Xavier, which dwarfs the adjacent church, was the leading educational institution of the colonial city. Renamed the Clavigero Palace after a prominent Mexican Jesuit educator and chronicler, the imposing structure was completed in the mid-1700s —a few short years before the precipitous expulsion of the Jesuits from the New World in 1767.

The magisterial stone exterior of ocher and mauve *cantera rosa* is punctuated by two tiers of square windows—severe and almost prison-like below, but framed on the upper level with paneled jambs and ornamental sills.

The entry porch, by contrast, is conspicuously elegant. Above its rectangular doorframe, paneled pilasters and a carved pediment encase the upper window. An undulating pediment projects above the roofline, now emblazoned with the Mexican eagle and a heraldic panoply of arms. Ranks of lantern-like finials crown the parapet running along the length of the building.

The vast interior courtyard is harmoniously bordered by open, paneled arcades below, and on the enclosed upper level, square-framed windows that match the exterior openings. A grandiose mixtilinear archway on the south side frames the monumental baroque stairway, which ascends via a double ramp to the upper level. The large Moorish fountain occupying the center of the courtyard is of modern vintage.

The College of San Nicolás de Hidalgo

Opposite the Clavigero Palace is the site of its former academic rival, the College of San Nicolás. One of the oldest functioning colleges in the Americas, it was founded in Pátzcuaro by Vasco de Quiroga in 1540 and moved here in the 1580s. It remains part of the University of Michoacán.

The original exterior was refinished in a neoclassical style that retains a Morelian severity, partly relieved by pedimented windows with wrought-iron balconies. But the graceful Italianate arcades of the interior courtyard date from colonial times. In the center of the patio stands a statue of Miguel Hidalgo, the Father of the Nation and a former student here, shown raising the banner of the Virgin of Guadalupe.

NUNNERIES IN MORELIA

The growing prosperity and piety of the middle classes in Mexico in the 17th century produced a rapid expansion in cloistered religious orders for women. The need to house and protect their unmarried daughters, sisters and widows stimulated a building boom for endowed convents that reached its peak in the mid-1700s.

The two most prominent nunneries in Valladolid were both built for Dominican orders: **Las Rosas** for the sisters of St. Rose of Lima, and **Las Caterinas**, simply known as Las Monjas, for the elite Order of Santa Caterina. A third convent, **Las Capuchinas**, was originally founded by the Franciscans to accommodate the daughters of the Indian nobility.

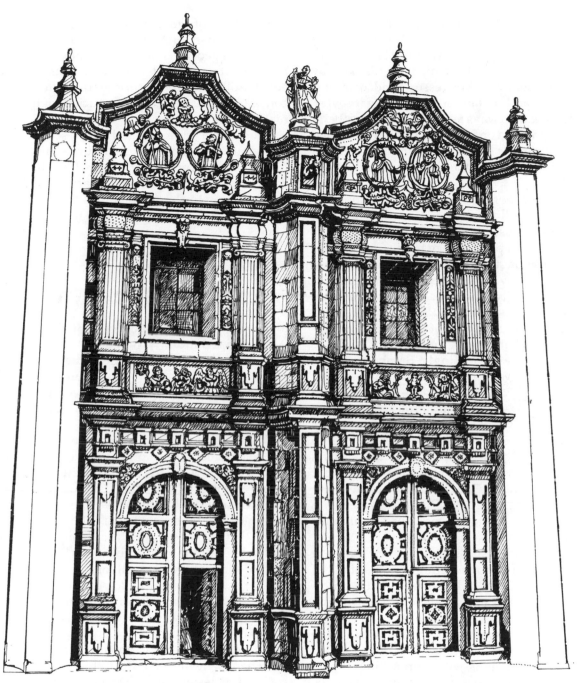

Morelia, Las Rosas: twin portals

Las Rosas

Early in the 18th century, when textiles were a principal source of Morelia's wealth, a pious local cloth magnate donated additional land on the site of the old Las Caterinas nunnery for the building of a new convent church and school for the Sisters of Santa Rosa de Lima, a Dominican teaching order of nuns familiarly called "Las Rosas."

The new church was designed by the regional architects Nicolás López Quijano and José Medina. Built between 1746 and 1756, it was dedicated in 1757 according to a facade plaque.

A typical nun's church, although small by 18th century standards, Las Rosas faces south across the Jardín de Las Rosas, a narrow, tree-shaded

park that contains a heroic statue of Bishop Vasco de Quiroga.

Plain nave walls provide a neutral backdrop for the ornate twin portals, which are flanked by deep, hexagonal pier-buttresses headed by jutting cornices and whimsical crocodile gargoyles. Although the doorways and windows are soberly framed by paneled or fluted pilasters with carved friezes, sobriety is banished in the profusion of sculpted reliefs above the doorways and on the high gables.

The portal reliefs are conceived in a popular style, undoubtedly influenced by the cathedral sculptures and possibly carved by the same hands. Mary and Joseph pay homage to the Christ Child in a conventional tableau of the Holy Family on the right, while over the left doorway an unusual Dominican "family" shows St. Rose of Lima holding the infant Jesus flanked by St. Thomas Aquinas and a bizarre, winged figure of St. Vincent Ferrer—all sculpted as half-length figures.

The gables are surprisingly flamboyant—the most ornate in Morelia. Large oval medallions, bedecked in playful rococo style with cherubs, garlands and inscribed banderoles, portray an ecumenical variety of saints and martyrs. On the left gable, God the Father watches over San Fermín and St. Francis Xavier, while St. Martin of Tours and Teresa of Avila are emblazoned on the right gable beneath the dove of the Holy Spirit.

A formidable statue of St. Dominic, armed with the gospel, a rosary and a broadsword, surmounts the center buttress like a sentinel.

Inside, we find the typical two-tiered choir of a nun's church. The lower choir retains its 18th century *reja*, or ironwork screen, fitted with diminutive side gates and an elaborately wrought, fan-like pediment.

Three enormous gilded altarpieces threaten to overwhelm the intimate nave. The huge Churrigueresque side retablos, whose projecting *estípites* face one another like frozen giants across the narrow nave, seem especially overbearing.

But the main retablo is more restrained. Elegant statues of Dominican luminaries are mounted against an intricate tapestry of carved arabesques and gilded strapwork. Although difficult to see in detail from the nave floor, charming figures of cherubs play musical instruments at the apex of the altarpiece while displaying a relief of the Holy Trinity.

The rest of the church interior was redecorated around 1900 in a tasteful art nouveau style with delicate "grotesque" designs.

Saint Rose of Lima was an accomplished harpist, and as part of their mission to educate the disadvantaged girls of the city, the Sisters of St. Rose maintained a noted music academy—reputedly the oldest on the American continent—giving concerts well attended by the society of the colonial city.

The former convent and itsconservatory—a long, austere building with an unusual arcaded external gallery, or *mirador*, overlooking the park—continues its role as a school for sacred music, and is now home to the famous Children's Choir of Morelia.

Las Monjas Caterinas

Nuns of the Dominican order of St. Catherine of Alexandria, popularly called Las Caterinas, arrived here from Guadalajara at the close of the 16th century. Their modest first convent—on the present site of Las Rosas—was eventually relocated and rebuilt on a more lavish scale between 1729 and 1737.

The dedication of this new convent occasioned the celebrated public procession of the sisters, described above, to their new quarters.

Las Monjas follows the standard plan for a nuns' church, with a single nave, twin entrances and spacious upper and lower choirs. The nave is wider than Las Rosas and the crossing is crowned with a high dome and cupola.

Sandwiched between walls of plain ashlar stonework, the handsome double portal faces directly on to busy Avenida Madero, the main artery of the city and formerly part of the *camino real* through colonial Valladolid.

Both entries display retablo facades in classic Morelian style. Fluted Corinthian columns on coffered pedestals enclose canopied shell niches, and discreet diamond friezes with bands of rosettes frame the openings. But much though one may admire this classical geometry, the interest of the relief carvings that enrich the portals at Las Rosas is lacking.

The few simply formed medallions and sculpture niches in the soaring gables are overshadowed by the bold hexagonal pediments that enclose them.

The only statues are those of St. Dominic and St. Catherine of Alexandria, the patron of Las Caterinas, flanked by Dominican escutcheons.

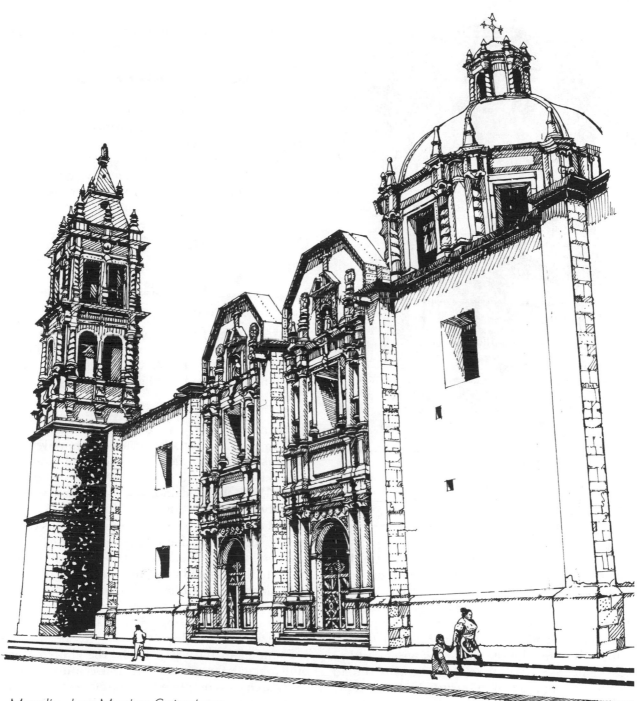

Morelia, Las Monjas Caterinas

At the west end of the church a tall, slender tower provides perhaps the greatest concession to decoration at Las Monjas. Its huge twin bell openings are framed by spiral columns on the corners, and flame finials sprout from the pyramidal spire. Another statue of St. Dominic, reputedly brought from the old convent, surveys the city from its perch atop the spire.

As at Las Rosas, the original wrought-iron choir screen remains in place, distinguished by its decorative metal fan spanning the upper choir. The chapel of El Santo Entierro contains a wooden or cornpith figure of Christ Entombed with a particularly fine sculpted head—a greatly venerated image that appears to date back to the 17th century.

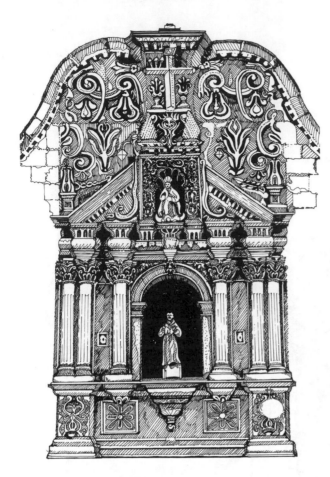

Morelia, Las Capuchinas: facade gable

Las Capuchinas

The third nuns' church in Morelia is that of Las Capuchinas, which faces a small plaza of the same name located a few blocks south of Las Monjas. Erected in the 1730s by the Franciscan order for the daughters of the indigenous nobility, this church is now all that remains of the convent.

Instead of the double entrances we saw at Las Rosas and Las Monjas, the church presents a broad facade surmounted by a curved baroque gable and soaring tower.

Above the classical doorway, elegantly flanked by double Corinthian columns, an elaborate triumphal arch rises to frame the choir window, against which is silhouetted an anorexic looking figure of St. Francis.

The broken pediment above the window encloses a niche containing a historic stone statue of La Purísima, originally brought from Pátzcuaro. Interwoven foliar reliefs scroll upwards around the niche to the apex of the undulating gable.

The tower rises to a giddy height—the tallest in the city. It is also the most ornate, decorated in the geometrical Morelian style.

Cushioned and spiral pilasters frame the paired bell openings on the lower stages, which are faced with blind arcading and balustrades. A high, domed cupola, set on zigzag cornices, crowns the octagonal upper tier.

Aside from the altarpieces of Las Rosas, the rather undistinguished 18th century retablos inside the church are the only other baroque examples to survive in Morelia.

OTHER MORELIA CHURCHES

San Diego

(SANTUARIO DE GUADALUPE)

The eye-catching fountain of the Tarascan Women, a heroic monument carved in blinding white limestone, invariably draws visitors to the Plaza Villalongin, located at the eastern end of the Avenida Madero.

The fountain is still fed by a colonial aqueduct that runs for almost a mile across the city. It was built in the 1780s by a Franciscan bishop, whose name is commemorated by a broad cobblestone walk, known as the Calzada Fray Antonio de San Miguel, which runs alongside the imposing Roman style arcades of the aqueduct.

Laid down even before the aqueduct was completed, the tree-shaded Calzada is lined by once fashionable old mansions, and opens up at the far end into the Alameda—a park-like plaza fringed with handsome public buildings. Fronting the Alameda on its south side is the church and former convento of San Diego, now known as the Santuario de Guadalupe.

Founded in the early 1700s, the church was built in stages through the mid-18th century. When the church was completed, the barefoot Franciscan order of San Diego, familiarly called *los dieguiños*, added the adjacent convento and hospice.

The north-facing church front projects a typical Morelian profile. The facade thrusts powerfully upwards, and is flanked by a single tall belltower. The doorway, choir window and sculpture niches are linked in an elongated design that also accentuates the verticality of the facade—a composition recalling the Plateresque facade at Cuitzeo. Its stepped, pyramidal gable is clearly derived from La Compañía.

Above the high arched doorway, a deep attic rises to the choir window, which is prominently flanked by ornamental escutcheons emblazoned with the Franciscan emblems of the Stigmata and the Crossed Arms. A primitive sculpture of the Virgin of Guadalupe rests in the upper niche, surrounded by a relief tapestry of vines and foliage into which the Franciscan insignia are sinuously woven. Projecting balustrades and a high, ribbed cupola distinguish the tower, which is very similar to that of Las Capuchinas.

Re-designed in 1915 by Joaquín Orta, the extravagant Rococo-Moorish interior is worth a visit in itself. Walls and ceilings glitter with foliated red and gilt tilework, providing an incongruous setting for the cycle of four large modern paintings depicting in an attractive narrative style the historic achievements of Franciscan missionaries.

The attached convento, conspicuous for its formidable neo-classical front, now belongs to the University of Michoacán. Its pedimented porch draws inspiration from other former conventual facades in Morelia, chiefly those of the Clavigero Palace and the present Palacio del Gobierno.

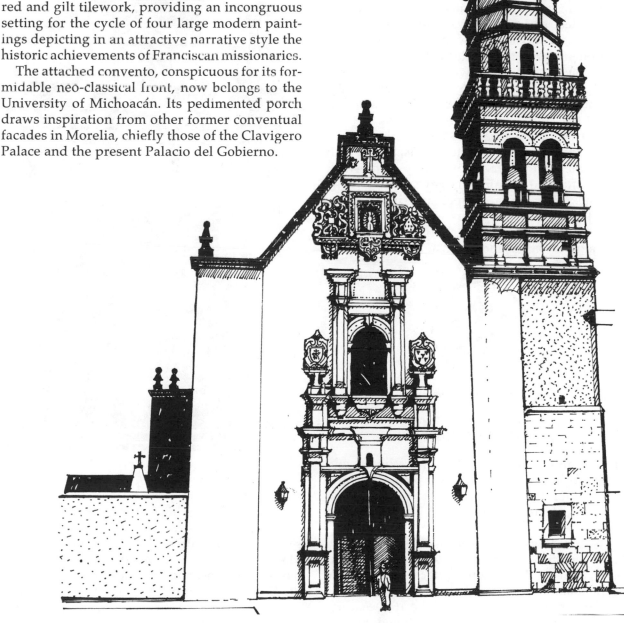

Morelia, San Diego (Santuario de Guadalupe)

The Mercedarian (Maltese) cross

La Merced

Numerous alterations over the centuries, often in conflicting styles, are reflected in this Mercedarian church, located a few blocks west of La Compañía.

Founded as early as 1604, it was not completed until 1736, and underwent even later changes. The earliest and most successful feature of the church is its classical north porch, which opens onto a small forecourt beside the Avenida Madero. This elegant *purista* doorway, outlined by cushioned pilasters, is surmounted by a broken baroque pediment that neatly frames an ornamental *escudo* of the Mercedarian (Maltese) cross.

The east facing facade is more elaborate, although less satisfying. A flattened Isabelline arch heads the main entry, apparently unfinished, which is flanked by pairs of large projecting *estípite* columns making a rare appearance in conservative Morelia. Wooden doors secure both entries, carved in an intricate Moorish style with reliefs of Mercedarian saints and the insignia of the order.

The Carmelite insignia

El Carmen

This rambling hillside Carmelite church and convento, north of the plaza, was planned by, and built under the supervision of the celebrated Carmelite friar-architect Fray Andrés de San Miguel.

The buildings have been recently restored to house the city's cultural center and Mask Museum, their scrubbed stone surfaces reflecting the brilliant sunlight of the Michoacán highlands.

Founded in the last years of the 16th century, construction of the monastery continued through the first half of the next century. Despite subsequent alterations, parts of this original complex survive. The vast cloister patio, incorporating a monumental vaulted stairway, remains impressive; and the frescoed refectory hall still retains the wall pulpit employed by the monks for mealtime readings. The belfry also dates from the 1600s and is capped, in typical Carmelite style, by a large *espadaña*.

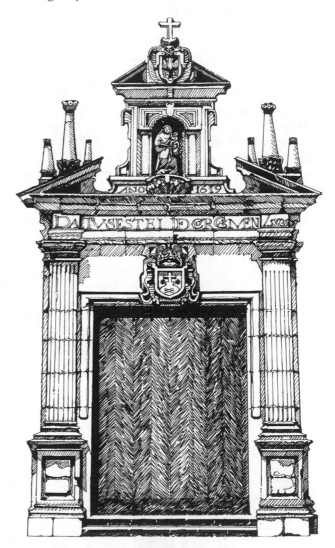

Morelia, El Carmen: the south doorway

But the most striking feature of the church is its stately south porch, dated 1619 and probably designed by Fray Andrés himself. Among the earliest Mannerist doorways in Mexico, it happily combines Renaissance and baroque elements and bears the Carmelite insignia. A diminutive but exquisite stone statue of the Virgin of Carmen rests in the pedimented niche overhead.

San José

One of the most imposing churches in Morelia, San José overlooks a landscaped garden plaza with a gushing fountain. The elevated facade which dates from the 1760s owes much to the cathedral and La Compañía, and represents the culmination of the geometric Morelian baroque.

Three broad tiers of fluted and paneled pilasters are massed across the facade, with decorative lozenges and lambrequin pendants applied to the pedestals. The rudimentary *estípites* on the upper levels acknowledge the Churrigueresque fashion then all the rage in other Mexican cities.

The handsome central relief, carved in popular style from white limestone, glorifies St. Joseph, the patron of the church. Multi-staged twin towers with high, bell-shaped domes add to the already impressive height of the church front.

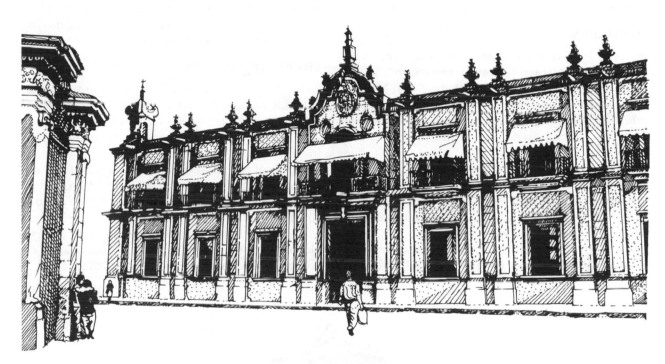

El Palacio del Gobierno, from the cathedral gates

COLONIAL CIVIL BUILDINGS

In addition to its numerous churches and convents, Morelia's colonial heritage encompasses numerous civil structures of note, including mansions, palaces and public buildings.

To its credit, the city has encouraged the imaginative conversion of colonial civil buildings, not to mention churches, schools and convents, to modern uses without compromising their historic and architectural values. These efforts have greatly enhanced the social and cultural amenities of the city while maintaining its unique character and appearance.

As well as various state and municipal agencies, other institutions such as schools, museums, hotels and even banks now occupy restored viceregal buildings to the benefit of the community.

El Palacio del Gobierno

The handsome state capitol building across from the cathedral, perhaps the most prominent civil structure in Morelia, was originally a seminary dating from the mid-1700s.

Like other collegiate and conventual buildings in the city, the Palacio boasts a severe but pleasing

facade in the geometric Morelian style, with rectangular balconied windows framed by flat, paneled pilasters.

The entrance stands out because of its elaborate balconied upper window and elevated mixtilinear gable. Pagoda-like finials along the roofline and the Byzantine-style corner belfries add an exotic, oriental touch to this sober baroque front.

Italianate arcades with delicately molded arches and scrolled pendants in the spandrels surround the main interior courtyard on both levels. Garish stairway murals by Alfredo Zalce portray the Independence leaders, Miguel Hidalgo and José María Morelos, who was a seminary student here.

Museums

Several 18th century mansions have been converted into attractive small museums. These include the Michoacán Museum (**El Museo Michoacano**), an ornate 1758 building found just south of the *zócalo*. Formerly a residence of the Emperor Maximilian, it is primarily a history museum.

The State Museum (**Museo del Estado**) is housed in an unassuming 18th century building located at the east end of the Jardín de Las Rosas. Ethnographic and crafts exhibits fill the modest rooms around the simple arcaded patio.

Installed in a small corner house behind the Palacio del Gobierno, the **Museum of Colonial Art** is a must, not only for its baroque paintings, which include several canvases by Miguel Cabrera, but also for its excellent collection of wood sculptures and *cristos de caña* gathered from all corners of Michoacán.

The modest but well-maintained **Casa Natal de Morelos**—the birthplace of José María Morelos— is located at the rear of San Agustín, its garden overlooked by the convento windows. The rooms around the tiny center patio contain historic exhibits, a library and even a gift shop and snack bar.

Two blocks away, on Morelos Sur, is located the **Casa de Morelos**, an 18th century mansion now serving as a house museum honoring Morelia's most famous native son.

Hotels and Banks

Several centrally located hotels occupy former colonial buildings. These include the **Virrey de Mendoza**, an elegant hostelry facing the *zócalo* with dark wood paneling and an intimate glassed-in lobby.

North of the cathedral are the small **Hotel del Catedral** and the attractive **Posada de La Soledad**, whose rooms are set around the arcaded stone courtyard of a former monks' hospice.

A row of banks is now quartered in several elegantly restored 18th century mansions on Avenida Madero, just east of the cathedral.

Morelia, San Francisco: Isabelline window

EASTERN MICHOACAN

Our exploration of eastern Michoacán falls into three sections. First we visit the 16th century monasteries bordering Lake Cuitzeo, north of Morelia, at Copándaro and Cuitzeo itself.

Next, we look at a string of hilltop mission towns along the route that leads northeast from Morelia towards Acámbaro in the neighboring state of Guanajuato, especially at Charo and its 16th century murals.

Finally we loop to the south to explore several lesser known churches and their colonial crosses in the scenic borderlands of eastern Michoacán.

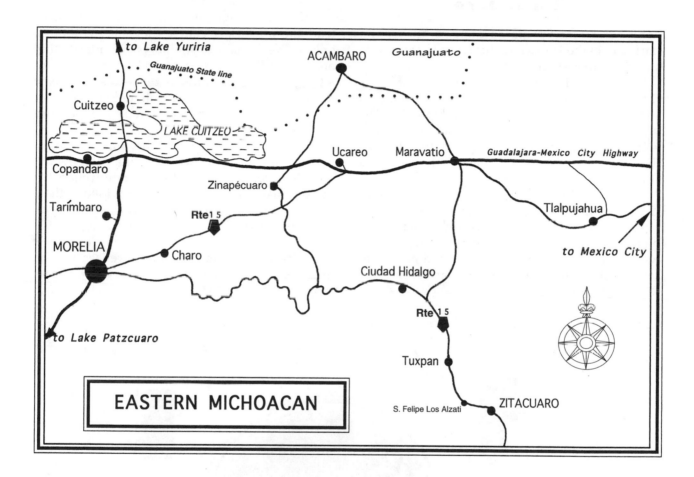

THE MONASTERIES OF LAKE CUITZEO

Augustinian missionaries were assigned to the populous area surrounding Lake Cuitzeo, a shallow, elongated body of water that lies near the Guanajuato state line.

Starting in the mid-1500s they built several missions around the lake, notably the gem-like monastery of **Copándaro** on the south shore, and their great priory of **Cuitzeo** on the north bank.

From Morelia, we follow the missionary route to Lake Cuitzeo, cutting across a gently rolling landscape of carefully tended fields before descending to the lake itself, where the new Guadalajara-Mexico City superhighway runs close to the south shore. On the way to the lake, we stop at the venerable Franciscan mission and pilgrimage church of **Tarímbaro**.

Tarímbaro (from a 1585 map)

Tarímbaro

Long before the Spaniards came to Michoacán, the ladies of the Tarascan court favored Tarímbaro as a place to rest and relax.

Situated amid fertile farmland, this 500 year old royal resort is now home to a large regional sports stadium, built beside the highway. The village is also the site of a 16th century Franciscan monastery—now a popular shrine to the Virgin of the Stairway whose cult image is housed in a sumptuous new chapel.

An enclosed atrium planted to large shade trees fronts the monastery buildings across from the busy village plaza. The plain church facade, completed in the years before 1600, is surprisingly wide and well proportioned; coffered panels inset with tiny, wheel-like rosettes flank its spartan Renaissance doorway.

The adjoining convento, dating from the 1570s, is even older than the church. Its *portería* arcade is missing, exposing the monumental open chapel, whose great coffered archway is anchored by massive angled jambs. The chapel interior is vaulted by a ribbed half dome and fitted with a continuous stone bench all around.

Although it appears similar to the Augustinian chapel at Cuitzeo, the form of the chapel is more likely derived from the Franciscan chapels at Tzintzuntzan and Erongarícuaro.

The cloister, originally in two stories, is now confined to a single level, whose Tuscan arches lend the arcades a simple elegance. Although only traces remain of the narrative murals that once lined the walks, sections of the black and white friezes still cling to the walls. Fantastic dolphin-like creatures with foliated tails gambol along the frieze, which is bordered by looped and knotted Franciscan cords.

Steps on the south side of the cloister lead up through the sacristy, whose walls are covered with devotional ex-votos, to the modern chapel of the Virgin of the Stairway, now provided with its own separate entrance and *alameda*.

The icon-like Virgin, installed on an impressive gilded altar, is the object of devout pilgrimage for her miracle-working powers as well as for the indulgences granted by the Catholic Church to all those who visit her shrine.

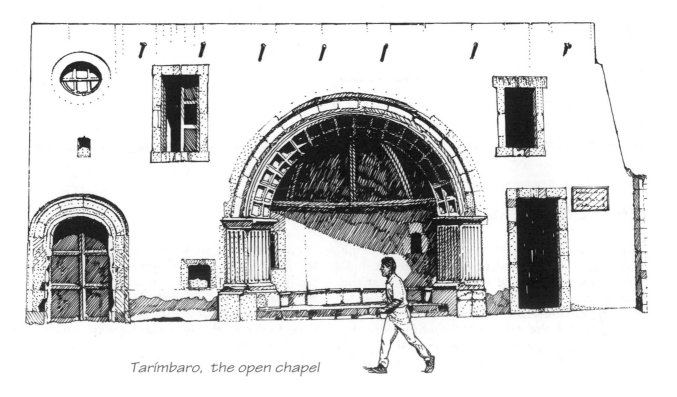

Tarímbaro, the open chapel

Cuitzeo, inscribed facade plaque

CUITZEO

From the causeway crossing Lake Cuitzeo, the grand fortress priory of Santa María Magdalena seems to rise like a mirage above the shimmering waters. This is the most sumptuous Augustinian monastery in Michoacán, rivaling its neighbor Yuriria (across the state line in Guanajuato) and ranking among the most splendid Augustinian foundations in Mexico.

On the arrival of the Spaniards, Cuitzeo was prospering from its salt and fishing industries and equaled the Lake Pátzcuaro area in population. But these numbers were much reduced after the savage incursion of Nuño de Guzmán, who burned the town to the ground and razed its ancient temples.

Like many other Michoacán settlements, the town was initially evangelized by Franciscans led by the peripatetic Fray Juan de San Miguel. But in 1550 it was assigned by Bishop Quiroga to the Augustinians. Two missionaries, Fray Francisco de Villafuerte and Fray Miguel de Alvarado, arrived in the same year, hastily erecting a wood and thatch convento. A few months later, the foundation stone for a permanent church was laid on the site of the demolished pyramid of Curicaueri, the Tarascan sun god, whose temple stones were used to build the new monastery.

Declared by the 18th century chronicler Fray Matías de Escobar to be "one of the most illustrious edifices in New Spain," the magnificent church rose steadily until its completion in the late 1570s, under the supervision of architect Fray Gerónimo

de la Magdalena. By 1600 the present convento had been completed and the church vaulted in stone. The tower and the *portería* were the last to be added.

The Church

From the busy main road, the visitor ascends through a shaded park to an open plaza terraced in white limestone. Behind a distinctive scalloped wall enclosing the monastery forecourt looms the church, whose towering facade seems to reach ever higher as one approaches.

This sculpted facade is the outstanding feature of the priory. Related to the church front at nearby Yuriria, which was derived from the influential Augustinian priory of Acolman, the Cuitzeo facade seems to surpass both of these in its soaring grandeur and sculptural dynamism.

Elevated above a flight of steps, the facade rises in tier after measured tier almost to the apex of the crowning gable, with each stage supported on swagged baluster columns and wide projecting cornices.

The rich Plateresque design and spirited carving of the facade is believed to be the work of a talented native sculptor. Across the facade, Christian symbols, Augustinian iconography and native floral imagery are artfully combined in an architectural vocabulary of Renaissance inspiration. Ornate candelabra columns bursting with fruits and foliage and hung with garlands frame the entry. On the lower shafts, cartouches of the Au-

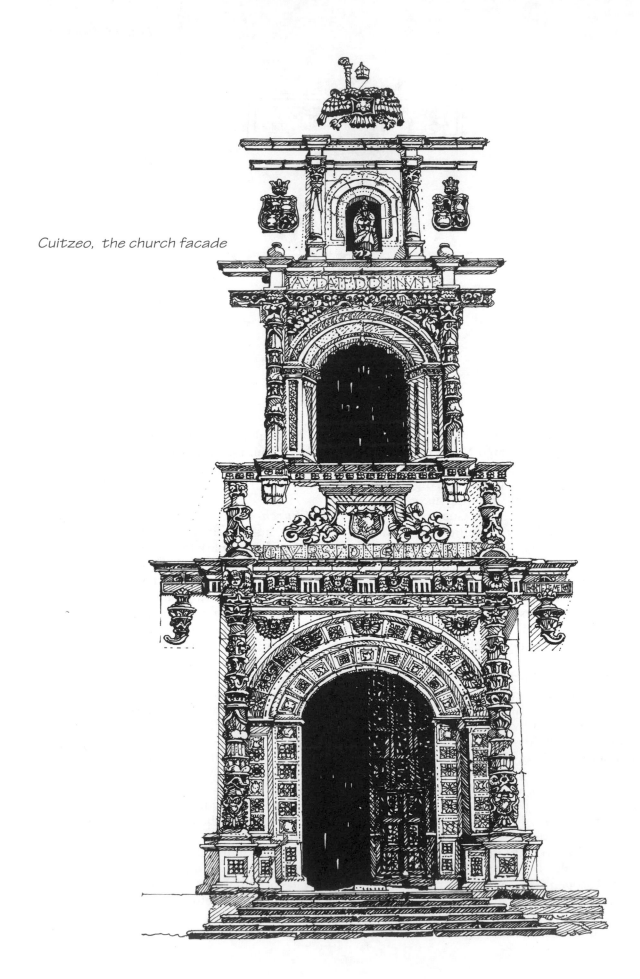

Cuitzeo, the church facade

gustinian pierced heart are emblazoned upon Hapsburg eagles, whose drooping, parrot-like twin heads and sharply undercut plumage suggest a powerful pre-hispanic influence.

Pierced hearts alternate with rosettes in high relief along the coffered panels of the inner archway, while winged cherubs replace the hearts around the outer frame as well as in the spandrels above. Boldly stylized angels also spread their wings along the porch frieze, alternating with classical triglyphs like miniature temples.

Inscribed plaques hang below the extended cornice on either side of the entry, supported by decorative brackets in the form of native calabash blossoms. The left hand plaque invokes the name of St. Mary Magdalene, the patron of the church, while the right hand plaque is carved with the legend, "Fr. Io. Metl me fecit." This is an abbreviated reference to the gifted Indian stonemason who carved this magnificent facade (*metl* is the Nahuatl word for the agave plant).

Since the Cuitzeo facade is the only signed example of stonework by a native artisan in Mexico, he must have been a person of high status as well as great talents. The "Fr." prefix to his name suggests that "Brother John Metl" was a member of the Augustinian order and, in the tradition of many pre-hispanic and early colonial artists, was a man of culture and possibly belonged to the Tarascan nobility.

A condensed Latin inscription above the cornice quotes from the *Confessions* of St. Augustine, and the Augustinian pierced heart appears again in the attic above the doorway, beneath an elaborate "slashed ribbon" *alfiz*, or frame, supported on cornucopia-like calabashes.

Festooned baluster columns also flank the choir window, whose flared archway is bordered by overgrown foliar reliefs and vine moldings. Augustine's injunction, "It is fitting to praise the Lord," taken from the Psalms, is spelled out in capital letters on the overhead frieze.

On the top tier a sculpture niche holds the statue of St. Mary Magdalene, conventionally portrayed with her long tresses and her box of ointment, with a lamb curled at her feet. Tasseled cords decorate the folk Corinthian columns flanking the niche.

The armorial escutcheons on either side represent the insignia of Cuitzeo, in which pelicans are quartered with large water jars. The jars signify its Tarascan place name (Place of the Jars), while the pelicans represent the lakeside location as well as being a traditional symbol of Christ's sacrifice. The arms are crowned with plumed diadems as worn by the Tarascan nobility.

The pierced heart device appears yet again, carved just below the gable, here surmounted by the bishop's miter and staff of St. Augustine, and framed by a splayed Hapsburg eagle carved in

CUITZEO

1. Church
2. Cloister
3. Portería
4. Open Chapel
5. Sacristy
6. Friars' chapel
7. Stairway
8. Baptistry

bold relief. The eagles' heads are bowed against their plumed breasts in an attitude of defeat or death—perhaps a comment on the defeat of the Tarascan culture by the religious and military power of the Spaniards.

Sandwiched between the *espadaña* of the massive north tower and the battlemented outlines of the convento, the lofty nave of the church extends eastwards, terminating in a rounded apse girded by sturdy buttresses and ringed by parapets.

The 17th century church interior was remodeled in the 1800s, when its renowned baroque retablos—the best and costliest in Michoacán, according to historian Diego Basalenque—were tragically replaced by the dull neoclassical altars we see today. The original choir stalls have survived, however, together with an ornate 18th century organ case now restored to its former splendor and installed in the upper choir.

Below the lofty stone vaults, austere classical portals on the south side of the church give access to the convento and sacristy.

The Convento

The spacious convento, situated on the south side of the church, is fronted by an arcaded *portería*, elevated like the church atop a stepped terrace. Believed to have been added when the convento was reworked in the early 1600s, the arcade is framed in a sumptuous Roman Renaissance style quite distinct from the Plateresque church facade. Fluted Corinthian half-columns set on high, paneled pedestals separate its six molded archways.

The open chapel at the rear of the *portería* is similar to the one at Tarímbaro, but even more imposing. Its great recessed archway rests on broad, flared and fluted piers. Only the ribbed half-dome of its vault, studded with relief rosettes, looks backward to the Gothic traditions of the previous century.

The surviving *portería* murals, too, seem archaic in appearance and theme. The most complete of the frescoes is a graphic Last Judgment covering the wall at the north end. Although the central figure of Christ is drawn in classical style, the conventions of scale and iconography in the composition—the massed ranks of the Blessed, the Torments of the Damned and the yawning mouth of Hell—hark back to medieval Christianity. The remaining murals are fragmentary, confined to isolated figures and ornamental grotesque friezes, most of them surrounding the simple entrance to the convento.

The monastery is well maintained by INAH, whose numerous publications—with the lamentable exception of any that deal with Cuitzeo itself—languish inside locked cases in the entry vestibule.

The cloister is a two story stone edifice of Renaissance purity. The four bays on each side are articulated by plain paneled archways and broad pilaster buttresses on the lower level. As at Copándaro, the arches double up on the second level, here divided by Tuscan columns and separated by sharp prow buttresses that terminate in projecting apron cornices. A series of fantastical gargoyles—lions, sirens and griffons—punctuate the cornices, which are topped by flame finials.

Barrel vaults cover the cloister walks, although Gothic ribs arch over the corner compartments. Simple arched doorways around the cloister admit the visitor to a sequence of large conventual rooms that include the refectory, kitchens and a second arcaded patio in the rear. Roomy friars' cells line the corridors around the upper cloister, leading to an elevated latrine, or "brothers' john," at the rear.

Formerly covered with large narrative murals—whose themes Escobar only hints at as he recounts how they were whitewashed—the cloister walls now only retain a few tantalizing fragments of fresco. These are mostly confined to sections of decorative friezes and a geometrical red dado along the lower walks. Vestiges of narrative murals still cling to the narrow lunettes above the corner vaults, illustrating what appears to be the Passion cycle on the lower level, and scenes from the birth and early life of Christ in the upper cloister.

The sole complete mural at Cuitzeo, enclosed by a severe Mannerist border, dominates the well of the monumental stone stairway in the southeast corner of the cloister. This forbidding painting was clearly intended to remind the friar of his solemn vows each time that he climbed the stairway. Entitled TYPUS VERI RELIGIOSI in Roman capitals, it depicts a black-robed friar nailed to a cross with a scourge in one hand and candle in the other. The suffering friar stands on a skull and orb, and is flanked by references to poverty, chastity and obedience.

The former hospital chapel of the monastery, located on the south side of the plaza inside its own walled churchyard, was considerably altered in the 17th century, but still serves as a temple to the Virgin.

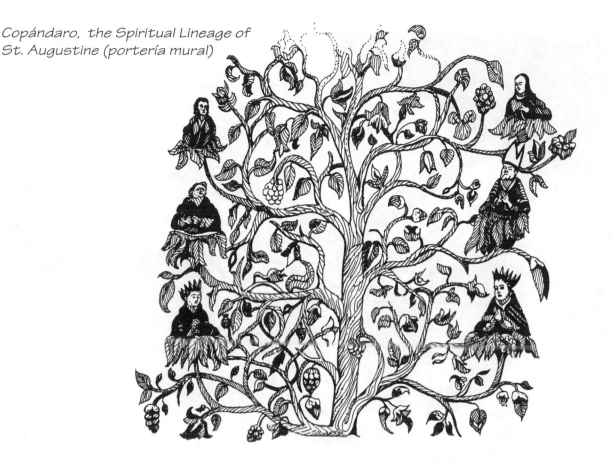

Copándaro, the Spiritual Lineage of St. Augustine (portería mural)

COPANDARO

Throughout colonial times, weary friars and other travelers from Valladolid eagerly anticipated their arrival at the lakeside monastery of Santiago Copándaro. After resting awhile at this idyllic mission, they would then paddle canoes across the placid lake to the great priory of Cuitzeo.

Soon after construction began on Cuitzeo, the Augustinians established the *visita* of Copándaro on the opposite shore of the lake, where it served as a house of retreat as well as a way station on the arduous journey north from the colonial capital.

Now rather down at heel, this gem of a Plateresque monastery was a showplace when it was first built—"like a beautifully worked silver goblet" as Diego Basalenque was moved to describe it. Laid out in the 1560s by Fray Gerónimo de la Magdalena, it was an early achievement by this distinguished friar-architect who later, as prior, built Cuitzeo.

Fortunately, little has been altered during the subsequent centuries. Church and cloister show a unity of style that reflects a sustained period of construction under a single designer. The refined forms and the high quality of stoneworking throughout suggest the hand of a master mason—quite possibly the talented native sculptor "Fr. Io. Metl," whose handiwork we admired at Cuitzeo.

The Church

Pleasantly shaded by a garden-like forecourt, the church presents a tall facade of mellow, honey-colored limestone, skillfully carved but sparely ornamented in a restrained Plateresque style.

Pillowed columns set on spool-faced pedestals frame the arched doorway, which is surmounted by a rosette-studded frieze. Above the elongated choir window, bold candelabra columns support a high entablature with an elegant shell pediment and projecting finials. A carved victory banner flutters from the center finial.

Tiny medallions of the Augustinian pierced heart, balanced on candelabra finials, flank the window, matching a second pair of *escudos* affixed just below the gable. A Latin inscription on the window frieze contains a dedication to Our Lady of the Lake, a locally venerated Virgin.

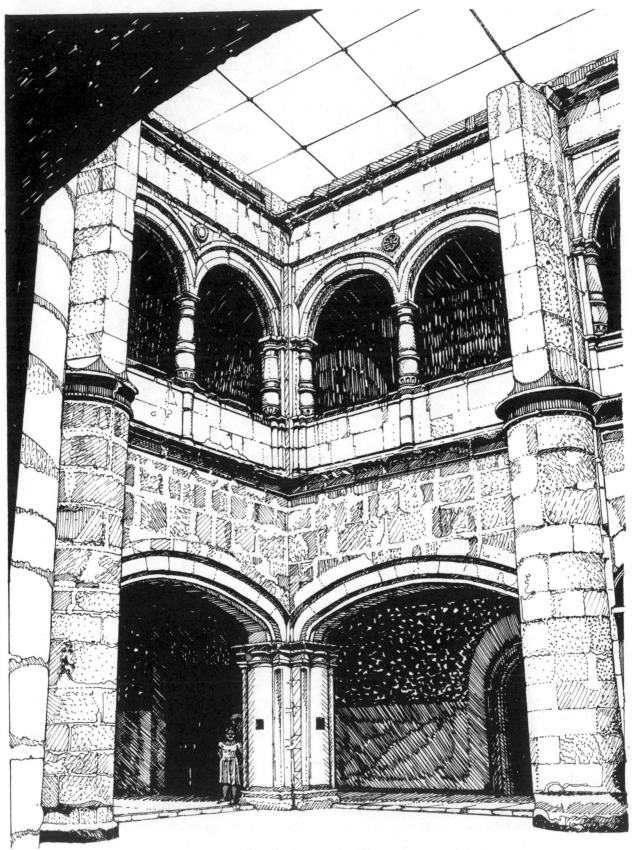

Copándaro, the Plateresque cloister

A long barrel vault covers the nave, abutting a ribbed half dome over the apse. Pilasters carved with floral reliefs outline the sanctuary arch. Grotesque friezes run below the vaults, bearing traces of delicate, late colonial polychrome decoration with biblical figures, angels and floral motifs.

The friezes continue around the baptistry, which houses a finely modeled *cristo de caña*. More mural fragments appear on the dome, accessible via a *caracol* stairway winding up through the stubby brick tower.

The Convento

The spare elegance of the facade carries over into the convento. Faced with dressed limestone blocks, the *portería* has a monumental simplicity; its triple arcade is unadorned except for coffered archivolts and the squared intervening buttresses.

An intriguing 16th century survival in the *portería* is a Spiritual Lineage of St. Augustine, painted on the north wall—sadly the only important mural to survive even relatively intact at Copándaro. Kings, nuns and martyrs of the order perch on the spreading branches of a family tree, which bears an astonishing variety of leaves, fruits, buds and blooms.

Following the conventional Christian image of the Tree of Jesse, the tree sprouts from the recumbent figure of the founder. Unfortunately, save for his disembodied miter, Augustine has been largely obliterated by the intrusion of a later doorway.

A handsome arched doorway at the south end of the *portería* leads into the convento and its delightful cloister, now protected from the elements by an unprepossessing translucent roof.

The tiny two story cloister is fashioned from the same mellow *cantera rosa* as the church front, but its harmony of design and subtlety of detail, with an emphasis on curving Plateresque forms, combine to produce a small architectural masterpiece that, despite its damaged stonework is, for me, more satisfying than the austere grandeur of the Cuitzeo cloister.

Broad basket-handle arches, separated by hefty rounded buttresses, span the two bays on each side of the lower level. The complex corner piers also have rounded mid-sections flanked by narrow coffered pilasters.

On the upper level, each bay becomes a double archway divided by a candelabra column. These bulbous columns, with ring moldings, slab capitals and scalloped, bowl-like bases, are repeated as half-columns superimposed on the paneled corner supports—an ingenious variation on the piers below. The upper level buttresses are hexagonal in section, springing from cushioned bases which visually undercut their weightiness.

Stone barrel vaults cover the cloister walks, changing to ribbed compartments in the corners in a restatement of the church roof pattern. At intervals, sections of antique murals and friezes—poorly preserved and crudely overpainted—cling to the dimly lit inner walls.

Despite some protection now afforded by the glass roof, much of the stonework of this exquisite cloister is crumbling and, like the murals, cries out for urgent attention.

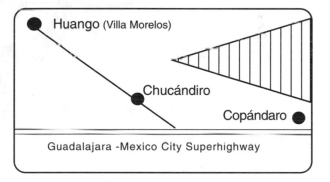

Off the beaten track...

Aficionados of old colonial missions can also visit two other remnant Augustinian houses near Copándaro.

San Nicolás Chucándiro, located on the extreme western edge of Lake Cuitzeo, boasts a 16th century cloister boldly emblazoned with scalloped reliefs.

West of the lake, the bustling town of Villa Morelos was formerly **Huango**, the site of another 16th century monastery, also dedicated to San Nicolás.

Although a grand church was planned here, the project was never carried to fruition and only the sacristy was built—a structure still spacious enough to house most of the present parish church. The convento was completed, however, and part of the fine old cloister is still intact with sturdy stone arcades and ribbed corner vaults containing shell reliefs and vestiges of early colonial murals.

THE ROAD TO ACAMBARO

Our exploration of eastern Michoacán next follows the main road from Morelia to Acámbaro. Now located across the state line in Guanajuato, Acámbaro was originally part of the colonial province of Michoacán and is noted for its early mission-hospital (see Part Three).

A good road links the two cities, allowing easy access to a unique group of hillside monasteries along the way. Our first stop is at the Augustinian monastery of **Charo**, which boasts some of the most spectacular 16th century frescoes in Mexico. Further along, we climb a volcanic hill to the obsidian-flecked Franciscan friary of **Zinapécuaro**. Then we loop northeast to the church and convento at **Ucareo**, notable for fine stonework, especially on its handsome carved atrium cross.

Charo, looped rosette

CHARO

With the accession of the boy king Characú to the Tarascan throne in late 1400s, the Aztecs saw a chance to take advantage of their ancient and hitherto unbeaten enemy to the west by annexing his rich lands to their burgeoning empire.

But the young monarch heard of the plan and enlisted the tough Matlatzinca warriors of the Toluca area—traditional foes of the Aztecs—as his allies. With their help, the Tarascans held off the Aztec forces, driving them back into the Valley of Mexico. As a reward for their services and to secure the buffer zone on the periphery of his kingdom, Characú granted the Matlatzincas land in a scenic, fertile valley east of Guayangareo (present day Morelia). The newcomers, known henceforth as *pirindas*, "those in the middle" in the *purépecha* language, prospered in their settlement, which was named Charo in honor of the youthful Tarascan ruler.

Following Cortés' defeat of the Aztecs in 1521, the Matlatzinca nobles joined the Tarascan king in declaring themselves vassals of the Spanish emperor and expressed their willingness to convert to Christianity.

In 1528 or 1529, Fray Juan de San Miguel visited Charo to baptize its leaders, who honored the distinguished Franciscan missionary by adopting the Archangel Michael as their patron saint.

The Franciscans, however, failed to establish a permanent mission, and in 1550 Bishop Vasco de Quiroga ceded Charo to the Augustinians, provided that they build a monastery there. Soon afterwards, Fray Pedro de San Gerónimo arrived to congregate the Indians of the area into a traditional mission town with several *barrios* and a centrally located priory.

Fray Pedro chose a commanding hilltop site, and planned the new building down to the last detail. He is even credited with directing its extensive mural program—the principal glory of Charo.

However, the ambitious priory was still unfinished at Fray Pedro's death in 1578, and it was left to his successors to vault the church and complete its facade, finally finished in 1606. Periodic earthquakes badly damaged the church thereafter, occasioning substantial reconstruction during the 1660s and into the 1700s.

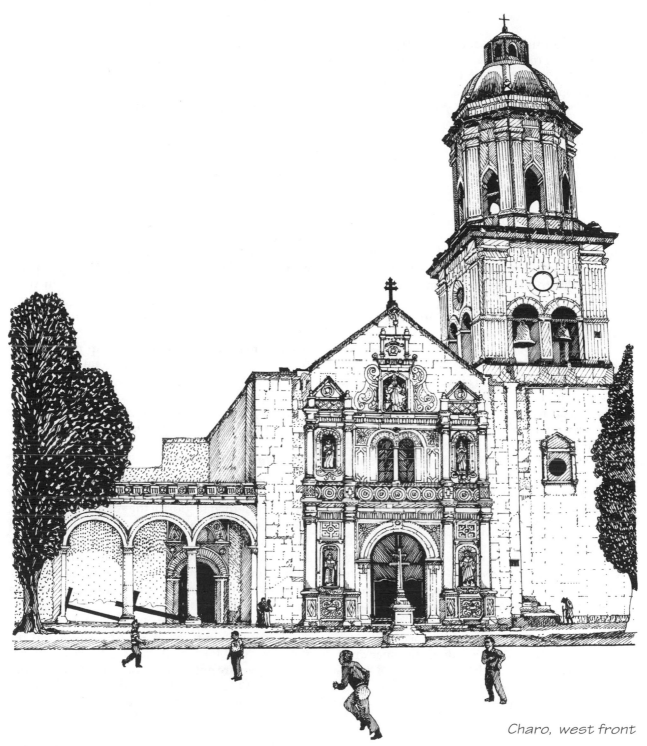

Charo, west front

The Church

A steep pathway winds up from the main street to the corner of the atrium, which offers the visitor a first view of the monastery's imposing west front. Charo's 17th century retablo facade is surprisingly elegant for a rural mission, with a polished, urbane look recalling the churches of nearby Morelia. Geometrical friezes and panels of ornamental scrollwork in low relief fill out its classic lines. The mullioned choir window is the only element that links Charo with the traditional architecture of Michoacán.

Tasseled reliefs adorn the jambs of the understated doorframe. Two tiers of paired columns serve to bracket the stylishly robed statues of Augustinian saints: Augustine and Nicholas of Tolentino on either side of the doorway and two

females, including Santa Mónica, on the tier above. A bold frieze of roundels separates the tiers, which are capped by triangular pediments enclosing the Augustinian pierced heart emblem.

A folk baroque relief of St. Augustine sheltering members of his Order—a popular Augustinian motif—fills the upper niche, surmounted by the sacred heart beneath a tasseled cardinal's hat. At the apex of the triangular gable we see yet another pierced heart superimposed upon a bishop's crozier.

The church interior is post-colonial. Stark colonnaded altars stand like miniature Greek temples beneath the heavy barrel vaults, although the painted walls and ceilings offer some decorative counterpoint to the prevailing neoclassical austerity. The huge tower was rebuilt around 1900, replacing the 17th century structure that was the victim of another temblor.

The Convento

A high Tuscan arcade, surmounted by a classical frieze with more medallions of the pierced heart, fronts the spacious *portería*. Placed at its north end beside the refectory entrance rests an unusual stone throne that, according to tradition, belonged to Diego Basalenque. This well loved 17th century prior of Charo wrote his famous history of the order here, as well as compiling early works on the Matlatzincan language and culture.

The monastery entrance, surmounted by an attic arch of carved rosettes, is the gateway to the remarkable painted convento.

Confined to a single story—no doubt because of the ever present earthquakes in this volcanic region—the cloister is also enclosed by airy Tuscan arcades, adorned with curious pinecone pendants below each keystone and emblazoned with complex rosettes and looped cords in the spandrels. Rounded doorways with broad paneled jambs and shell-studded arches open off cloister walks spanned by handsome wooden ceilings.

The Charo Murals

The frescoes at Charo are the most complete and thematically diverse in Michoacán, and rank among the finest 16th century murals to survive in Mexico.

Entirely executed in burnished *fresco secco*, the murals feature the flowing outlines and sharply drawn details characteristic of monastic wall painting in Mexico, clearly revealing their source in European religious prints and book illustrations—at that time the only graphic sources readily available to the friars and native artists. Painted by different hands at different times, the predominantly black and white murals are accented by flesh tones and earth colors of ocher and burnt sienna.

They fall into three main groups: the Passion cycle in the entry vestibule, the narrative cloister murals, and the extraordinary frescoes of the refectory.

The Passion Cycle

The scenes of Christ's Passion that line the walls of the vestibule are the most conventional of the murals in their themes and composition. The principals in the Passion drama, awkward in their heavily outlined robes, are posed in medieval landscapes of wooded hillsides and turreted buildings.

Four main panels—the Agony in the Garden, the Kiss of Judas, the Flagellation and the Mocking of Christ—line both sides of the narrow passageway. A rather static Crucifixion, dotted with sun, moon and indigenous cactus-like plants, flanks the doorway to the cloister.

The Cloister Frescoes

The cloister frescoes—some of them now only fragmentary—are the most dramatic at Charo, clearly designed to glorify the Augustinian order. All the narrative panels are framed by painted Plateresque pilasters with lively grotesque friezes that incorporate sacred monograms and Augustinian emblems, linked by cornucopias, dancing cherubs and fantastical monsters—part dragon and part acanthus foliage.

Adjacent murals along the north walk illustrate the Spiritual Lineages of St. Augustine and his mother, St. Monica. Although such pictorial genealogies are not uncommon in mendicant monasteries, it is unusual to find them paired in this way. Both murals use the medieval motif of the Tree of Jesse, in which a twisted tree rises from the chest of the reclining saint. Along spreading branches, birdlike Augustinian friars, nuns and prelates emerge from huge blossoms, each figure identified by an inscribed banderole, now generally illegible.

The Genealogy of St. Monica is less crowded than that of St. Augustine, permitting more anecdotal detail. The black-robed sisters share their branches with a large crow and numerous oversized buds and pomegranates.

A sequence of dynamic scenes unfolds along the south and west walls of the cloister, depicting the grisly fate of various Augustinian martyrs.

In graphic tableaux, deftly sketched in contrasting black and white tones, tonsured friars in black habits are variously speared, boiled alive and transfixed by arrows at the hands of brutal persecutors in white military togas. Youths stone one stoic brother, while pious female onlookers sink to their knees in grief or prayer. Other meek friars are dragged one by one to their beheading, by a trio of muscular executioners under the merciless eye of a pagan potentate.

Indistinct traces remain of a large mural along the east walk that undoubtedly represented the Eremitic Life—a reference to Augustinian beginnings in the desert hermitages and monastic communities of Thebaida, a remote province of Egypt.

This favorite Augustinian subject was frequently illustrated in the monasteries of the New World, where their missionary enterprise was viewed as a religious undertaking of equal significance to the early history and expansion of the order. This theme was embroidered by Fray Matías de Escobar in his baroque treatise *Americana Thebaida*, where he compares the seven Augustinian monasteries of Michoacán to the seven legendary pyramids of Egypt and praises the architectural and spiritual harmony of Charo, where he once served as a well-loved prior.

Unfortunately, the murals that occupied the corner niches have been erased, except for the single fragment of an Ecce Homo in the southeast corner, which may indicate that the Passion cycle continued from the vestibule into the cloister.

The Refectory Murals
The refectory is the third great repository of mural painting at Charo and the most recently uncovered. An extraordinary cycle of frescoes, some on rarely depicted subjects, extends around all four walls, generally showing a lighter touch and more liberal use of color than the other monastery paintings.

Appropriately for a refectory, the principal panel on the end (west) wall depicts the Last Supper, in which the white-robed apostles lounge around a long table. This is flanked by the related Feeding of the Five Thousand, as well as the Baptism of Christ. Beneath the Last Supper appears another portrayal of the Agony in the

CHARO

The Convento Murals:

1. Genealogy of St. Monica
2. Genealogy of St. Augustine
3. Augustinian nuns
4. Augustinian martyrs
5. Passion scenes
6. Crucifixion
7. Road to Damascus
8. Last Supper
9. Feeding of 5000
10. Archangel Michael
11. Adoration of the Virgin
12. Ecce Homo
13. Four Evangelists
14. Devil and Angel

Garden, although less intense than the vestibule version. The side walls of this large room are adorned with two tiers of painted panels, each framed by ornate pilasters, swagged borders and grotesque friezes.

A delicate fresco of the Adoration of the Virgin is painted beside the east wall, opposite the splendid Archangel Michael, a triumphal golden figure with outspread wings—the only image of the patron saint to appear at Charo.

The east wall is the most complex. An enormous but poorly preserved Calvary forms the centerpiece, flanked by portraits of the Four Evangelists, each seated pen in hand upon a throne with his identifying attribute. Located at bottom right is a dramatic fresco of Saul on the road to Damascus. In this scene—unique in 16th century Mexican mural art—we see the dazzled future apostle being thrown violently from his frightened horse, as a reproach issues from Heaven on an unfurling banner.

Finally, part of an interesting, cautionary mural appears above a side entrance to the refectory. A lone friar clutching a large crucifix—possibly the young St. Augustine—is tempted by an angel on one side and the Devil on the other, both pointing to a scripture and holding out a quill pen and inkhorn.

Of the seven Augustinian monasteries of colonial Michoacán lauded by Fray Matías, San Miguel Charo far surpasses even the grand priories of Cuitzeo and Yuriria in its mural decoration, a priceless gallery of early colonial art that is sure to enchant the visitor.

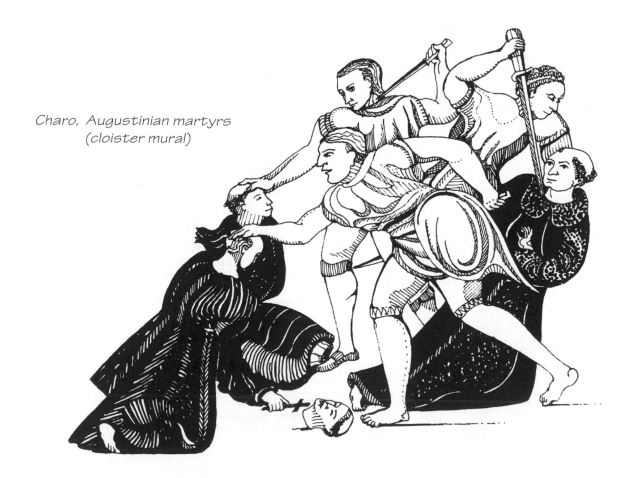

*Charo, Augustinian martyrs
(cloister mural)*

Viceroy Antonio de Mendoza (Codex Telleriano-Remensis)

ZINAPECUARO

In ancient times, a temple sacred to the Tarascan earth goddess Cueravaperi occupied the hilltop where the monastery of Zinapécuaro now stands. Fortified by the Tarascans as an outpost against marauding Chichimec warriors, this commanding site was strengthened in the 1540s by Viceroy Antonio de Mendoza during prosecution of the Mixton War, a successful campaign waged by the Spaniards against the insurgent Chichimecs and their allies.

The Franciscan mission of San Juan Bautista was built in the 16th century on the same foundations, using stone from the former temple as well as blocks of black basalt from a nearby quarry, according to an account of the roving Franciscan commissioner Fray Alonso Ponce, who visited Zinapécuaro during its construction in 1585. Although the church was rebuilt on a larger scale later in the colonial period, the humble convento and cloister date back to the late 1500s.

From the town center, a stone stairway winds up to the walled atrium of the monastery, which retains its arched gateways and antique stone cross. The monastery walls are formed of rough red and charcoal gray *tezontle* blocks, liberally chinked with shiny pieces of the locally plentiful obsidian. (*Zinapécuaro* means "Place of Obsidian" in the *purépecha* language.) This construction technique has created a distinctive mosaic effect, most noticeably around the base of the tower.

A grandiose colonnaded portico projects from the whitewashed church front, enclosing a pair of antique, goblet-shaped baptismal fonts—appropriately for a church dedicated to John the Baptist, whose statue is prominently mounted in a niche above the choir window. The portico obscures but also protects the church entrance, whose sinuously carved rococo doors are among the most attractive 18th century examples in Mexico.

The church interior is the soul of neoclassical restraint, although it retains some popular appeal in the form of a locally revered crucifix, known as El Señor de Araro. The image is the object of pilgrimage among drivers and chauffeurs, whose devotion is sorely tested by the steep climb to the atrium and painful progress on the knees to the church door, along pathways studded with unforgiving obsidian shards.

The Cloister

A simple arcaded cloister lies at the heart of the adjoining convento. Molded cylindrical arches spring from plain stone columns with spool bases and capitals. Sculptural ornament is restricted to decorative corbels, intricately carved with a knotted cord, that support the vaulting over the walks. Some of the inner archways along the arcades are painted with miniature medallions of angels holding the Instruments of the Passion—the only visible remnants of the extensive murals that formerly embellished the cloister.

Many eminent Franciscans once labored in these peaceful provincial precincts. They included the pioneering Tarascan linguists Fray Pedro Ximénez—mentioned by Father Ponce—and Fray Maturino Gilberti, a brilliant 16th century scholar and former Guardian of Zinapécuaro, who compiled the first Tarascan dictionary and grammar. Fray Maturino also gained notoriety for writing a controversial dialectic on Christian doctrine intended to enlighten his Indian neophytes, but which provoked the unwelcome attention of the Holy Office of the Inquisition.

Zinapécuaro, cloister corbel

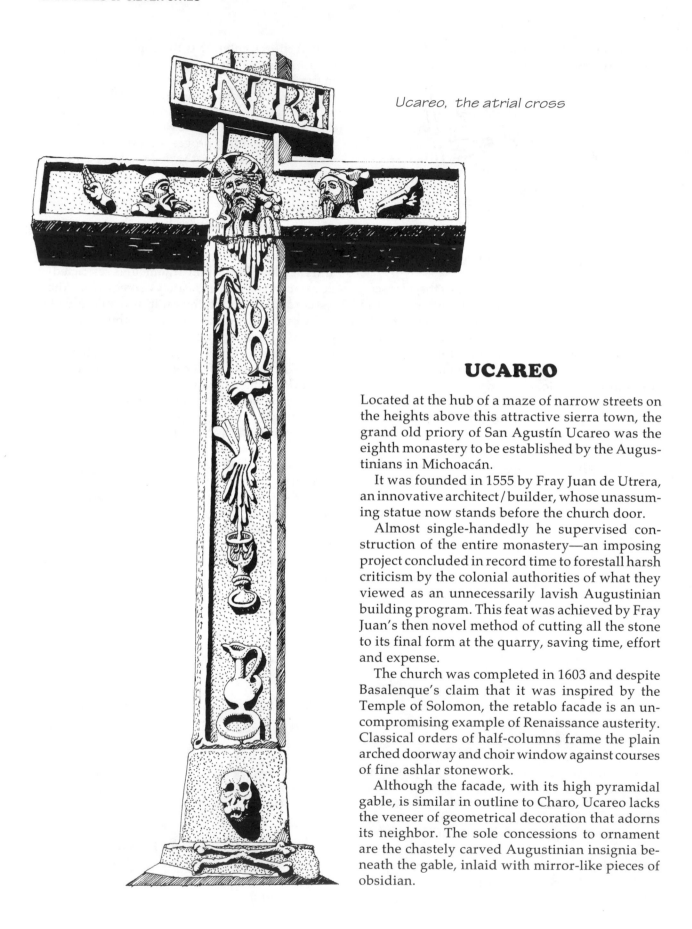

Ucareo, the atrial cross

UCAREO

Located at the hub of a maze of narrow streets on the heights above this attractive sierra town, the grand old priory of San Agustín Ucareo was the eighth monastery to be established by the Augustinians in Michoacán.

It was founded in 1555 by Fray Juan de Utrera, an innovative architect/builder, whose unassuming statue now stands before the church door.

Almost single-handedly he supervised construction of the entire monastery—an imposing project concluded in record time to forestall harsh criticism by the colonial authorities of what they viewed as an unnecessarily lavish Augustinian building program. This feat was achieved by Fray Juan's then novel method of cutting all the stone to its final form at the quarry, saving time, effort and expense.

The church was completed in 1603 and despite Basalenque's claim that it was inspired by the Temple of Solomon, the retablo facade is an uncompromising example of Renaissance austerity. Classical orders of half-columns frame the plain arched doorway and choir window against courses of fine ashlar stonework.

Although the facade, with its high pyramidal gable, is similar in outline to Charo, Ucareo lacks the veneer of geometrical decoration that adorns its neighbor. The sole concessions to ornament are the chastely carved Augustinian insignia beneath the gable, inlaid with mirror-like pieces of obsidian.

A wooden roof mounted on shaped corbels covers the roomy interior, which is brightened by a gilded Churrigueresque main retablo dotted with dowdy colonial saints. A large canvas of Las Animas hangs on the north side of the nave, dated 1733 but unsigned, in which an Augustinian saint—possibly San Nicolás de Tolentino—reaches down to a pitiful group of souls languishing in Purgatory.

A lofty Tuscan arcade frames the *portería* and the entrance to the rambling convento. Tantalizing traces of murals, some revealing the heads of assembled friars, appear on the *portería* walls. In view of the treasures found at Charo, more early colonial frescoes may yet await discovery beneath the accumulated layers of paint and whitewash.

The charming cloister is now limited to a single story, with plain, pillared arcades. Behind these, stone doorways with broad jambs lead into rooms sparsely adorned with scattered fragments of black and red friezes. Elaborately carved window frames with pointed Isabelline arches appear throughout the convento, notably in the cells of the adjacent novitiate wing. Even the garden well boasts a delicate Gothic arch.

The visitor cannot leave Ucareo without being impressed by the monolithic cross in the center of the atrium—a colonial monument of special interest even in this region of superb atrial crosses. Magnificently sculpted on all sides with birds and vines, it displays a broad inventory of objects associated with Christ's Passion, including pictorial references to Pontius Pilate, Caifas and two portrayals of the anguished face of Christ himself.

Travel Note: *Like Copándaro, formerly remote Ucareo is now readily accessible by paved road from the new Guadalajara-Mexico City superhighway.*

The "Pierced Heart" of St. Augustine

ACROSS THE SIERRA

The mountain region of eastern Michoacán is less well known than the central lakelands, but in addition to its natural beauty, the area is extraordinarily well endowed with historic colonial monuments, among them early monasteries rich in sculpture. A special attraction here is an exceptional group of carved 16th century stone churchyard crosses.

Crossing the sierras, we visit a handful of towns especially noted for their distinctive colonial churches. These include the former Franciscan monasteries at **San José Tajimaroa** (now Ciudad Hidalgo) and **Santiago Tuxpan**, as well as the rural mission of **San Felipe de Los Alzati**, with its unique atrial cross. Lastly, we explore the picturesque hill town of **Tlalpujahua** close to the Mexico State line, of particular interest for its highly original baroque church and 16th century chapels.

Ciudad Hidalgo

From Zinapécuaro a scenic road winds southeast through ridges of scented pine forests across the Sierra de San Andrés. Some 25 km further along on Mex 15 we arrive at the busy mountain town of Ciudad Hidalgo.

Originally called **Tajimaroa**, the pre-hispanic settlement was another vital bulwark on the Tarascan frontier against the expanding Aztec empire. In 1476, Tarascan forces decisively defeated a formidable Aztec army here—a critical battle that preserved the independence of the Tarascan empire.

Ironically, it was near Tajimaroa in 1521 that a Spanish expedition turned back, by negotiation and a show of force, the Tarascan imperial army gathered here to confront the foreign invaders.

A few years later, the Franciscans founded the mission town of **San José Tajimaroa** here, settling it with an ethnic mix of *pirindas*—Otomís and Matlatzincas—who had fought alongside the Tarascans against the Aztecs.

Construction of the fortress friary of San José began in the 1550s. A primitive stone cross stands in front of the church door, an impressive sixteenth century relic that bears Christ's Wounds finely chiseled in intaglio as well as high relief. A black obsidian disk is set in the cross—an ancient device that symbolized the heart, or soul, of the sculpted image. The disk is one of the very few to

remain in situ; most other examples have been lost, leaving only empty sockets.

The church was completed by 1600 and is distinguished by its severe Plateresque facade, recently stripped of later baroque additions and fitted with new battlements. The arched doorway is boldly framed with wheat sheaves and rosette-studded panels. Foliated arches also trim the tower openings.

A monolithic baptismal font—at one time a public fountain—stands inside the baptistry. Its capacious basin is carved with spouts in the form of primitive lions and winged cherubs, while let-ters of the alphabet are inscribed around the rim—probably a primitive teaching aid. The *"bonito retablo"* mentioned by the visiting Fran-ciscan Alonso Ponce in 1586, is sadly no longer in evidence.

Through the arcaded *portería* we proceed to the intimate two-story cloister, which is framed by simple basalt colonnades and a row of of handsome stone doorways with pointed Isabelline arches along the walks. In the north corner of the atrium, the decorative 18th century facade of the former hospital chapel provides a textural contrast to the austere church and convento.

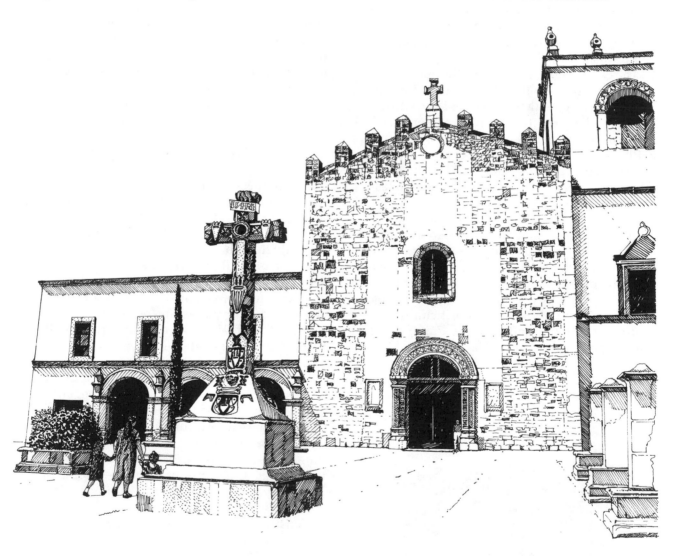

Ciudad Hidalgo, the friary of San Juan Tajimaroa, with its atrium cross

*Tuxpan, facade sculpture
of Santiago Matamoros*

SANTIAGO TUXPAN

Santiago Matamoros, the warrior saint of the conquistadors, sits triumphantly astride his rearing white charger high on the church facade at Tuxpan, a market town some twenty km southeast of Ciudad Hidalgo.

The church of Santiago was originally part of an early 17th century Franciscan monastery. It was rebuilt on a grand scale during the 1640s, under the patronage of the Counts of Miravalle, great colonial landowners in the region.

The impressive brownstone facade is even later, added in the 1720s under the supervision of the eminent Mexico City architect Pedro de Arrieta. This former master-of-works at the Mexico City Cathedral was also the designer of such distinguished metropolitan buildings as the House of the Inquisition and the Jesuit church of La Profesa.

The facade, although restrained, is subtly inventive. The austere classical porch, for example, is decorated with colonnettes, a scalloped arch and a frieze of shell-like rosettes. Fussy broken pediments surmount the central relief as well as the curious polygonal windows, and gaping gargoyles protrude from the flanking buttresses.

But the main attraction is the striking sculpture of Santiago Matamoros—probably salvaged from the earlier church front—mounted in an eared baroque frame. In this conventional but spirited composition, the militant patron saint of Spain and Tuxpan holds up a victory banner and raises his sword to smite the turbanned infidel, one of whom lies decapitated on the ground, his head and crescent-emblazoned shield crushed beneath the horse's hooves.

Two ornamental crosses traditionally associated with the Franciscan order surmount the facade. A two-armed episcopal Cross of Lorraine is mounted on the upper parapet, while the Cross of Jerusalem is set just below, bordered by a rococo frame.

The interior is unremarkable, save for an old stone font and a pair of ornamental portals. On the south side of the nave hangs a huge allegorical canvas of Las Animas by the prolific baroque master Cristóbal de Villalpando, dated 1708 and signed with his rubric.

The composition depicts a nun dressed in the Franciscan habit, accompanied by friars, prelates and the Archangel Michael, intervening on behalf of the souls in Purgatory clustered at the bottom of the painting.

The spacious redstone cloister beside the church has undergone considerable changes and retains little of its colonial character.

Off the beaten track ...

Travelers visiting the butterfly refuge at nearby Angangueo may wish to pause at the turnoff from Highway 15 to take a look at the unique 16th century atrium cross of **San Felipe de Los Alzati**.

Carved in time-honored Mexican style with the instruments of Christ's Passion, this venerable monument is fitted with a black obsidian disk like the cross at San José Tajimaroa.

A small niche or tabernacle at the foot of the cross is underlain by a rough basalt bowl, looking very much like a *cuauxicalli*—an Aztec vessel de-signed to hold the hearts of freshly sacrificed victims. The cross is mounted on a high pedestal and flanked by a quartet of smaller crosses capped with finials of interwoven fleurs-de-lis. These unusual, Celtic-looking motifs are repeated on the merlons at each corner of the walled church-yard—formerly a peaceful cemetary, but recently torn up for "improvements."

The two churches at San Felipe, although colonial in origin, have also been modernized and currently hold little of historical interest.

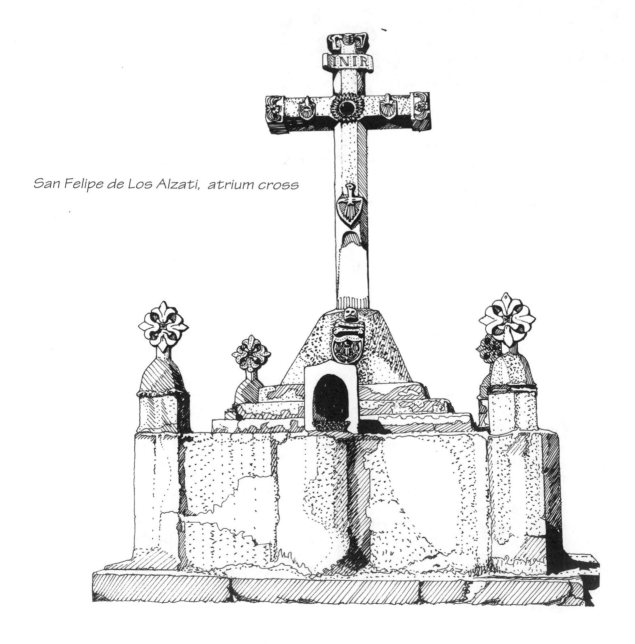

San Felipe de Los Alzati, atrium cross

TLALPUJAHUA

Tlalpujahua's silver boom began in 1558, when rich veins of the precious metal were discovered, attracting adventurers, miners and settlers. The prospect of great riches also caught the attention of the viceregal authorities, who hurriedly established an office of mines to regulate the new source of mineral wealth and protect royal revenues. At the same time, by order of Bishop Vasco de Quiroga, a new parish was founded under firm episcopal control—one of the few Michoacán settlements not originally missionized by the Franciscans or Augustinians.

*Tlalpujahua, St. Peter and St. Paul:
facade relief of a triton*

St. Peter and St. Paul

The parish church of the apostles Peter and Paul, also known as El Carmen, towers dramatically above this hill town bordering the State of Mexico.

Founded in the 16th century, the hastily built first church on this site lasted almost two hundred years, until the mid-1700s, when another silver strike financed its replacement by a splendid new church which, when completed, was one of the most celebrated and grandiose in Mexico.

This imposing late baroque temple was erected under the supervision of an energetic prelate, Felipe Neri Valleza, who is memorialized in a nave plaque.

The story goes that famed silver baron Don José de la Borda offered to underwrite the new structure, but when pressed by the cautious townspeople to put his offer in writing, took offense and left the area, moving to Taxco where he financed the even more ornate church of Santa Prisca.

Built of mellow sandstone, the church occupies a commanding site that overlooks the town and is visible from its every corner. The church is girded by numerous chapels and annexes, and faces a long, elevated atrium with high walls and several ornate gateways.

The West Front

Strikingly similar to the monastic church front of San Agustín in Querétaro, the eye-catching neostyle facade may be the work of the same architect, Juan Manuel de Villagómez.

Its inventive sculptural detail is contained within an idiosyncratic framework that harks back to the retablo facades of the 17th century. Although the figure sculpture is more conventional than that of San Agustín, the Tlalpujahua facade seems more dramatic, energized by its provincial vigor, bold surface textures and insistent neo-*mudéjar* geometry.

Jutting octagonal columns are slashed by opposing spirals, headed by swagged capitals, and crowned by minaret-like pinnacles. Above the polygonal doorway, complex *estípites*, richly ornamented with herms and animal masks, frame the Moorish choir window and extend upwards to flank the double sculpture niche in the upper facade. A cornucopia of geometrical and foliated reliefs fills the other intervening surfaces.

The facade iconography explicitly glorifies the power of the Catholic church and the supremacy of the 18th century ecclesiastical hierarchy. Statues of country priests and mitered bishops, carved in a naive, frontal style, occupy ornamental shell niches on the lower and middle tiers. The quality of the stonecarving improves markedly in the upper facade, focussing on the unusual double niche. Here, the twin figures of St. Peter and St. Paul—the apostolic founders of the church—appear in flowing robes, accompanied by reliefs of Saints Joachim and Anne carved on the flanking *estípites*.

In the bas-relief overhead, intricately wrought in a bold popular style, angels adore the Holy Sacrament and, in the lozenge-shaped medallions, they display the pontifical cross and keys of St. Peter. Atop the spectacular gable, curved in the shape of the papal tiara, is silhouetted a statue of the Archangel Raphael—the messenger of God and bringer of divine healing—outfitted in traditional buskins and cutaway skirt, and dangling his fish.

Note too the sirens and bearded tritons with fishtails and scales grimacing from the column pedestals at the base of the facade. Together with other mask reliefs on the facade, these images are thought to signify the sins and vices of the world, destined to be vanquished through the power of the established church and its members.

The Side Portals

The two lateral doorways of the church show contrasting versions of late baroque design with a marked *mudéjar* flavor. The geometric east entry is the more conventional, its neo-Mannerist frame enclosing a polygonal archway like the one on the facade. A helmeted figure of St. Michael occupies the scalloped niche, his dynamic pose and agitated draperies compensating for the statue's small scale.

Raised above a steep flight of curving steps, the sacristy porch is even more Moorish in flavor, with a complex mixtilinear archway and bull's eye window. Note, too, the row of expressive sculpted heads above the arch.

Inside the Church

Wholly remodeled in the early 1900s, the church interior is a florid fantasy in polychrome tile and stucco, created in the same eclectic style as the nave of San Diego in Morelia and by the same designer, Joaquín Orta. Every surface is studded with rosettes and fleur-de-lis reliefs, punctuated by lobed portals and Moorish arches dripping with extravagant neo-Gothic ornament. Don't miss the fantastic pulpit.

Few of the original church furnishings remain. One by one during the 19th century, reflecting changing fashions, all of the church's magnificent baroque altarpieces were dismantled. One or two paintings from these retablos have survived, however. On view in the sacristy is an unusual triptych of Christ's Passion, rendered in somber style by the famous baroque painter Nicolás Rodríguez Juárez. In a side chapel hangs a spirited canvas, portraying the Virgin of Light, by Juárez' even more prominent contemporary Miguel Cabrera.

Another early colonial survival is the monolithic baptismal font, possibly belonging to the primitive church on this site, splendidly carved with angel heads around its rim. The remodeled Chapel of the Passion, frescoed in a colorful, popular style, is an attraction of more recent vintage.

Pilgrims come from afar to venerate the image of Our Lady of Carmen which adorns the main altar. Miraculously surviving the destruction by a devastating mudslide of the *barrio* chapel in which it was formerly lodged, this charming late colonial icon portrays the Virgin as Protectress of the Carmelites. Bowing her head beneath a weighty gold and silver halo and crown, she shelters nuns and friars of the order beneath her ample red

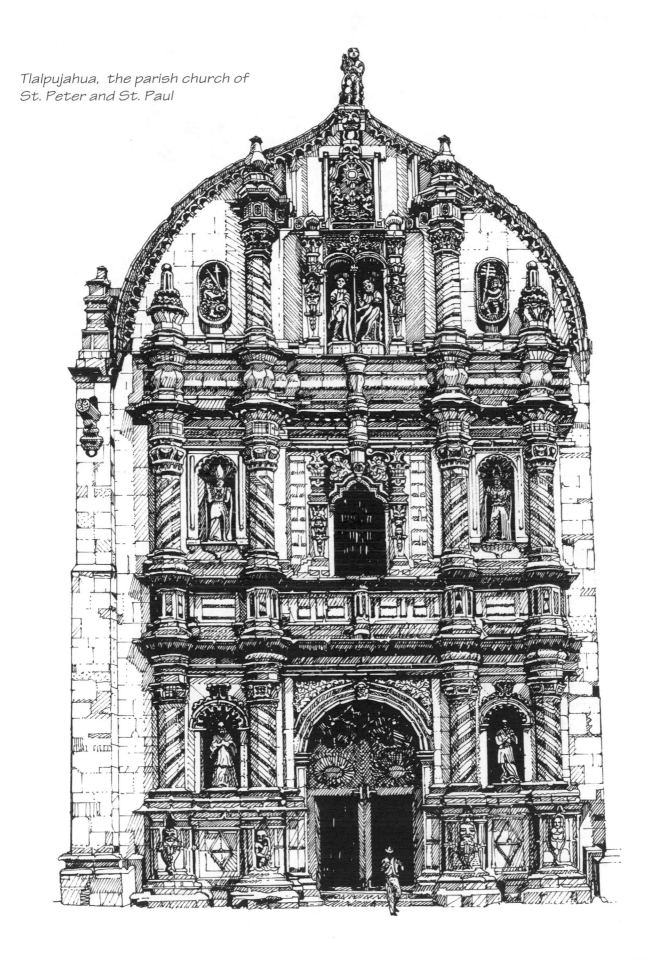

Tlalpujahua, the parish church of
St. Peter and St. Paul

107

mantle, which is lifted reverently at the corners by St. Joseph and the Spanish mystic Teresa of Avila.

The Cofradía Chapel

This simple late 16th century church—possibly a former hospital chapel, but now used as a theater—occupies the far end of the atrium. Its striking Plateresque facade of contrasting whitewash and black stonework provides a vivid counterpoint to the ornate ocher front of the 18th century parish church.

A slender *alfiz* of fluted colonettes, supported on tasseled corbels and headed with spiral cords, boldly outlines the porch. Rusticated jambs flank the entry, whose semicircular archway is ringed by a chain of star medallions.

The same motif repeats around the carved choir window above the *alfiz*. The massive brick belltower is a recent addition—a study in the stern Morelian style.

Tlalpujahua, the Cofradía Chapel

San Francisco

Unlike most other towns in Michoacán, Tlalpujahua was evangelized by the secular clergy. The Franciscans only settled here in the late 1600s, when they established a small Third Order chapel and hospital. But it was not until the mid-1700s, during the silver boom, that funds became available to build the present monastery.

The monastic complex of San Francisco occupies an attractive hillside location on the southern fringes of Tlalpujahua. The plain west front of the church displays the handsome, multi-staged porch to advantage. The elegant classical doorway, with its fluted pillow pilasters and paneled choir window, reveals the sober influence of the Morelian baroque. Overhead, the statue of the Virgin of Guadalupe still rests in its geometrical frame to remind us that she was the original patron of the monastery.

The church interior shows off another florid remodel in the style of Joaquin Orta, although lacking the refinement of the parish church. No colonial furnishings remain, with the exception of a handful of paintings preserved in the sacristy. These include a worn Guadalupe, reportedly signed by Miguel Cabrera, and a canvas of the Virgin being tenderly crowned by the Holy Trinity—pictured as three bearded young men in the traditional Mexican manner.

An imposing coffered doorway, surmounted by rearing baroque volutes embracing the Franciscan arms, admits us to the convento, and an even more elegant paneled doorway leads from the cloister to the sacristy.

Simplicity, however, is the keynote of the cloister, where unadorned stone piers support the plain, molded arcades. Even here, though, the subtle detailing of the bases and capitals and the curious half-pilasters applied at the springing of the arches strike a more sophisticated note.

Although fragments of 18th century murals have materialized here and there on the convento walls, the only well preserved colonial work is a large canvas of the Last Supper hanging in the old refectory.

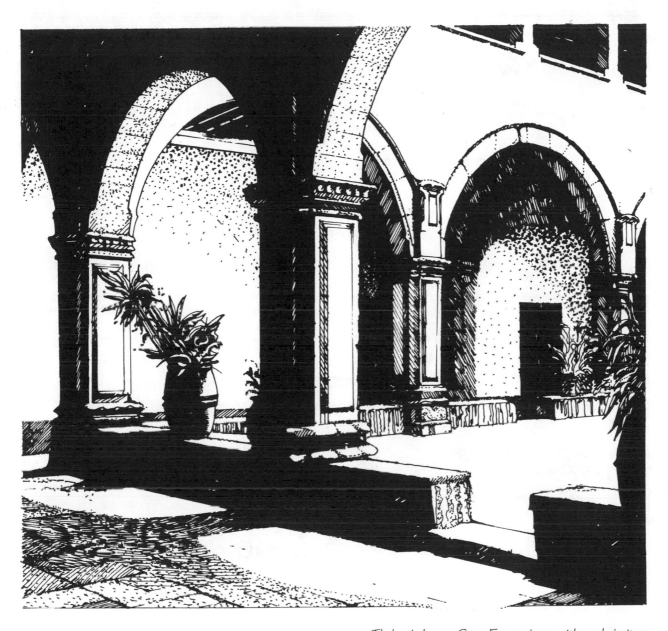

Tlalpujahua, San Francisco: the cloister

Santiago Puxtla

Located in the upper part of the town, this modest chapel is one of the earliest religious foundations of Tlalpujahua, and undoubtedly occupies the site of the hospital chapel originally located in the formerly indigenous *barrio* of Santiago.

Although the original adobe building was rebuilt early in the 18th century—its sober baroque facade dates from that era—the chief item of interest here is the classic facade relief of Santiago Matamoros. Carved in an archaic style, it is probably a survival from the primitive chapel.

While angels look on from either side, the warrior saint tramples the Moor beneath his horse's hooves.

A colorful folk canvas of Santiago also stands on the main altar of the renovated interior, whose rosette-studded sanctuary arch was modernized in imitation of the parish church.

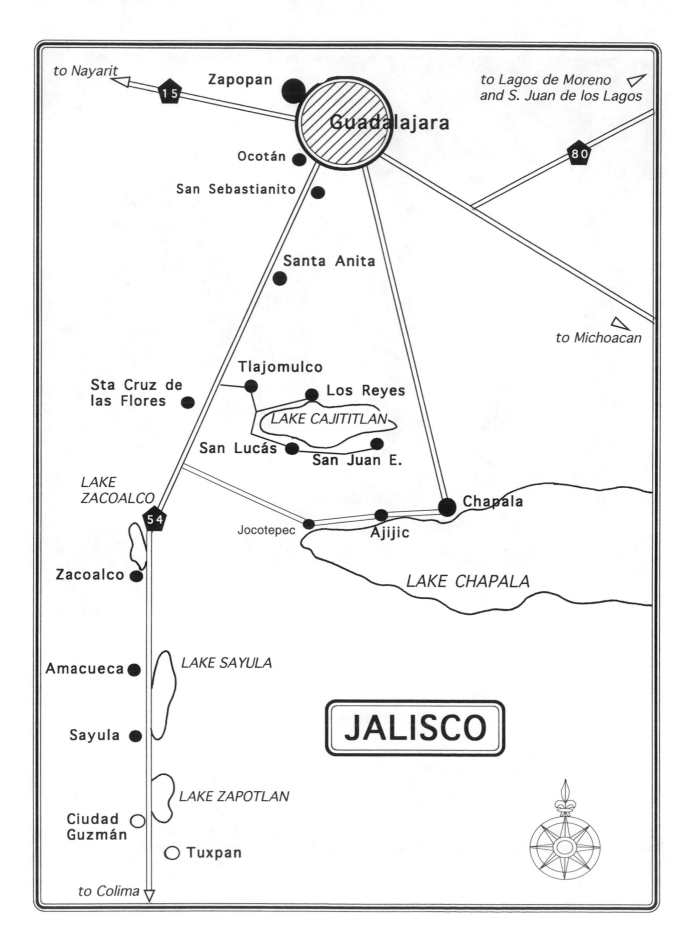

to Nayarit

15

Zapopan

to Lagos de Moreno
and S. Juan de los Lagos

80

Guadalajara

Ocotán

San Sebastianito

Santa Anita

to Michoacan

Tlajomulco

Sta Cruz de
las Flores

Los Reyes

LAKE CAJITITLAN

San Lucás

San Juan E.

LAKE
ZACOALCO

54

Chapala

Jocotepec

Ajijic

Zacoalco

LAKE CHAPALA

Amacueca

LAKE SAYULA

Sayula

JALISCO

LAKE ZAPOTLAN

Ciudad
Guzmán

Tuxpan

to Colima

110

P A R T T W O *JALISCO*

Throughout the 16th century Jalisco was a precarious frontier region. As in Michoacán, the native population bore the brunt of Nuño de Guzmán's brutal campaign of terror. As a result, early mission towns and colonial settlements suffered raids by rebellious local Indians, assisted by Chichimec tribesmen from the north.

These assaults reached a climax in 1541, with the death of Pedro de Alvarado, the conqueror of Oaxaca and Guatemala. Alvarado had led a disastrous expedition against the rebels, but mortally wounded, he was carried into Guadalajara. Warding off an Indian counterattack in the main plaza, the embattled Spaniards managed to repel the invaders by invoking the aid of Santiago, their patron saint, who appeared at the head of a band of angels urging the defenders on to victory—a frequent apparition at critical points during the Spanish conquest of Mexico.

The next year, Spanish troops and armed native allies, personally led by the viceroy Antonio de Mendoza, quashed the rebellion, and in the brutal Mixton War systematically eliminated Indian strongholds in the *peñoles*, or rugged hills around Guadalajara. They drove the Chichimecs from the region, including the rich silver mining area of Zacatecas to the north. Crown control was thus assured and the royal province of New Galicia established, with Guadalajara as its capital. Conditions remained unsettled, however, and few large towns developed immediately. Even in Guadalajara, major urban expansion was delayed until the late 17th and 18th centuries, while other colonial towns remained small throughout the viceregal period, often growing no larger than when they were founded in the 1500s.

The Franciscans in Jalisco

Even before the incursions of Nuño de Guzmán and Viceroy Mendoza, friars had arrived to convert the new subjects of the Crown to Catholicism. As elsewhere in New Spain, the Franciscans were first, enjoying a virtual monopoly in the province.

Fray Martín de Jesús and Fray Andrés de Córdoba, both members of the original Franciscan Twelve, who arrived in Mexico in 1524, preached across present day Jalisco. But systematic evangelization of the region did not begin until 1534, when Fray Antonio de Segovia founded a mission at Tetlán, just outside Guadalajara. Ten years later, following a Chichimec raid in which the mission was burned, the friars decided to move to safer quarters in the city.

In time, other missions were founded throughout New Galicia—so many that in 1606 a new Franciscan province of Santiago was created. The new province included Franciscan missions in nearby Colima and Nayarit as well as around Zacatecas to the north. From 26 in 1585, the number of area missions rose to 37 by 1650—the zenith of Franciscan influence in New Galicia. In addition to Guadalajara, important missions were founded in the frontier outpost of La Purísima Etzatlán, at San Antonio Tlajomulco near Lake Cajitítlan, and at San Andrés Ajijíc on Lake Chapala, each with several dependent *visitas*. The friars also evangelized the populous valleys to the south, founding lakeside missions at Zacoalco, Sayula, Zapotlán (now Ciudad Guzmán) and Tuxpan.

As in Michoacán, the Jaliscan missions included hospitals, invariably with chapels attached, to minister to the indigenous population. By custom, these were dedicated to the Virgin of the Immaculate Conception and maintained by Indian *cofradías*. In some cases, these chapels are all that have survived of the original missions.

Our exploration of colonial Jalisco begins with Guadalajara, a city that, despite its recent unbridled growth, retains a colonial heart of considerable architectural distinction. From Guadalajara and its environs, we travel in several directions—first southwards to the missions in and around Lake Cajitítlan and Lake Chapala, and then further south, in the direction of Colima, past Lake Sayula along a chain of waterside missions. Finally, we visit the spectacular pilgrimage churches of Lagos de Moreno and San Juan de Los Lagos, located in the Los Altos region of northeastern Jalisco.

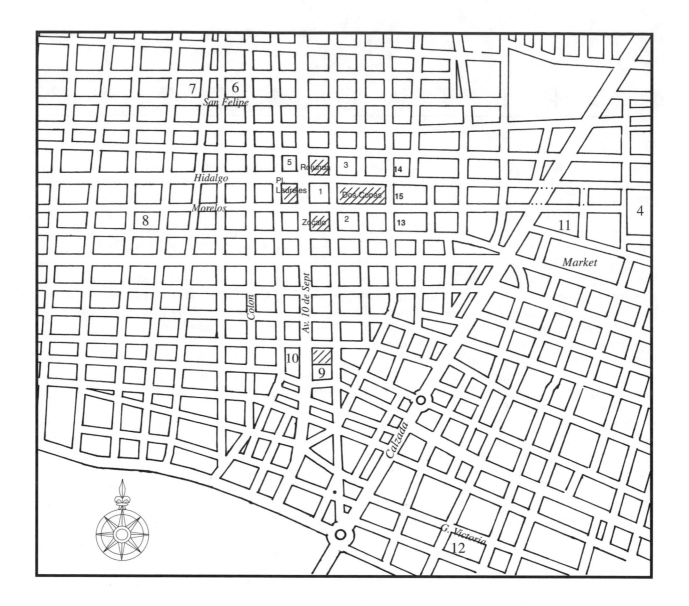

GUADALAJARA The Historic Center

1. Cathedral
2. Palacio del Gobierno
3. Regional Museum
4. Hospicio Cabañas
5. La Merced

6. Santa Monica
7. San Felipe Neri
8. Jesús María
9. San Francisco
10. Aranzazú Chapel

11. San Juan de Dios
12. Analco
13. San Agustín
14. Sta María de Gracia
15. Teatro Degollado

GUADALAJARA

Spread across the high, dry western plain and ringed by shallow lakes and mountain ranges, Guadalajara enjoys a benign, springlike climate, ruffled only by hot May winds heralding the spectacular summer rainstorms to come.

Now second only to Mexico City in size and importance, the colonial town of Guadalajara de Las Indias had an uncertain start. After Nuño de Guzmán's subjugation of the countryside in the 1520s, settlers arrived in the region to scout out a location for the capital of New Galicia. The granting of a royal coat of arms to Guadalajara by the Emperor Charles the Fifth in 1534 intensified the search for a permanent site for the city.

Harassed by mountain tribes under the warrior-king Tenamaxtli, who burned the first settlements, the colonists moved from place to place, finally settling on the present site in the Atemajac Valley, on the west bank of the swiftly flowing San Juan River.

Although named for the Spanish birthplace of Nuño de Guzmán, Guadalajara was founded in 1542 by Cristóbal de Oñate.

Lacking mineral wealth and a large, settled Indian population, Guadalajara remained poor in the early years, but with the development of wheat agriculture and the discovery of silver in Zacatecas—which made Oñate a rich man—the city became the hub of western trading and exploration.

By 1600, Guadalajara was emerging as a major provincial capital. A magnificent new cathedral was under construction across the main plaza from the imposing Palace of the Audiencia of New Galicia. As the population expanded, the colonists prospered and before long, churches and convents of the religious orders began to rise in the colonial city.

Colonial Art and Architecture

In recent years, conservation of its historic center has enjoyed a high priority in Guadalajara. Many of the city's important public and religious buildings, including its finest colonial monuments, are now linked by a sequence of handsome plazas, gardens and pedestrian walkways, landscaped with plantings, benches, fountains and sculptures.

This series of interconnecting open spaces stretches from east to west across the colonial center, from the Plaza de Laureles, past the cathedral and through the elongated plaza of Dos Copas, which is lined by colonial buildings and faced on the east by the Beaux-Arts style Degollado Theater. Terraced walkways continue eastwards, terminating in the grand plaza in front of the rambling Hospicio Cabañas.

Very little now remains of Guadalajara's 16th century structures. Almost all of the colonial buildings we see today date from the late 17th and 18th centuries. Despite their relatively late date, the majority of these structures followed conservative stylistic patterns established by one or two of the earlier colonial buildings, most notably the cathedral. Influenced by 17th century Mannerist and early baroque elements, the architecture is soberly classical, with decoration usually limited to surface relief in the form of geometric or foliated patterns on the columns and around the doors and windows.

Like that of Morelia, this homogeneous architecture shows little or no influence of the flamboyant Churrigueresque style that flourished in Guanajuato and other cities to the east. Archaic features such as Gothic rib vaulting—the hallmark of virtually every church in colonial Guadalajara—continued to be favored until the advent of neoclassicism towards the end of the 18th century.

Besides stylistic affinities, the colonial buildings are also unified by the universal use of the locally quarried stone—a textured, yellowish-gray oölitic limestone that often encases the entire edifice. In some older structures, this *cantera amarilla* is counterposed with coarse reddish basalt, or *tezontle*, to pleasing effect.

Tragically, save for some wrought-iron work and a handful of minor altarpieces, scarcely any art or furnishings from the baroque era have survived in Guadalajara—all swept away by the tide of neoclassical taste and the ravages of neglect and civil strife that followed Mexican Independence. The only exception is an opulent group of Churrigueresque retablos crowding the little Aranzazú chapel, south of the cathedral.

Guadalajara, Cathedral of the Assumption

114

The Cathedral

As its oldest building, located in the heart of the colonial city, the cathedral is still the pre-eminent symbol of Guadalajara. Its fanciful Gothic Byzantine spires, added in the 1850s, create a distinctive silhouette dear to the hearts of *tapatíos*, as the citizens of Guadalajara like to call themselves.

Flanked on all sides by plazas only fully opened up in the present century, the cathedral has never been seen to better advantage than today. Its construction spans the colonial centuries, from the 16th to the 19th, and the exterior reflects the succession of architectural fashions—an eclectic ensemble of styles that somehow work together well.

The corner stone of the grand basilican cathedral was laid in 1571, and architect Martín Casillas personally supervised construction over the next twenty years. Viewed from the Plaza de Laureles, the block-long west front is imposing and surprisingly colorful. The honey-colored facade, its triple entries separated by giant pilasters, is flanked by tower bases of red *tezontle*.

All three entries follow the severe Renaissance style of the early 1600s. The main doorway, elegantly framed by pairs of Corinthian columns, bears an inscription quoting the opening lines of Psalm 127: "Except the Lord build the house, they that construct it labor in vain." The triple sculpture arcade over the entry set a pattern for other city churches, in particular the nunneries. An unassuming statue of the Virgin Mary occupies the center niche, flanked by St. Peter and St. Paul.

A great curved pediment bristling with multitiered "flaming" pinnacles—another local architectural peculiarity—crowns the entire facade. An extravagant 19th century relief of the Virgin (La Purísima), the patron of the city and the church, is spread across the center of the pediment. Portrayed at the moment of her Assumption into Heaven, amid billowing clouds, she gestures expansively to the apostles kneeling below.

The towers support heavy classical belfries, capped by the bright yellow spires. Built following a severe earthquake and constructed of light, anti-seismic materials instead of stone, the spires do not seem out of place. Faced with sparkling yellow and blue tiles in the Pueblan style, their highly visible profile is emblazoned everywhere—even on the city's taxicabs. Local lore has it that

their design was inspired by the bishop's Staffordshire china service, embellished with a picture of St. Mary's Church in Oxford. The Palladian front of the Sagrario Chapel, on the cathedral's south side, however, looks strangely out of place.

The basilican interior, finished in glossy wedding cake tones of white and gold, is Martín Casillas' principal legacy—the only part of the cathedral erected as planned. Completed about 1600, its piers of clustered Doric columns support ornate ribbed vaults—a counterpoint of Gothic and Renaissance elements that established a pattern for Guadalajara's later colonial churches.

The cathedral boasts a fine collection of paintings that span the baroque era. Notable works by the Mexican artists Miguel Cabrera and Cristóbal de Villalpando are hung alongside a luminous Immaculate Conception, attributed to the Spanish master, Bartolomé Esteban Murillo. Other treasures include the ornate carved choir stalls and a fine wooden crucifix, now kept in the sacristy.

The Government Palace

(Palacio del Gobierno)

The Plaza de Armas, the main square of the colonial city, popularly called the *zócalo*, flanks the cathedral on its south side. The elegant cast-iron Art Nouveau bandstand, imported from Paris and ringed with seductive green caryatids, provides the best viewpoint of the state government building.

Occupying the site of the early colonial Palace of the Audiencia of New Galicia, the present sumptuous edifice was only completed in the final years of the viceregal period, and figured prominently in the subsequent struggles for Mexican independence. In 1810, Miguel Hidalgo proclaimed an end to slavery from its balcony—one of his last acts as an Independence leader—and Benito Juárez took refuge here during the French intervention of the 1860s. Later, during the Mexican Revolution, the building was also a gathering place for revolutionary armies.

The formidable west front was built between 1751 and 1775 to the plans of baroque architect Nicolás Enríquez de Castillo, who was succeeded by the more experimental Miguel José Conique. Projecting corner pavilions anchor the long facade, boldly punctuated by handsome Doric

Guadalajara, the Government Palace

window frames that extend from the lower sills to the upper cornice.

The "barococo" central porch, probably the work of Conique, has a different feel. Its restless vigor and unconventional ornament seem at odds with the measured harmony of the rest of the facade. Corinthian columns, overlaid with criss-cross patterning, frame the rusticated doorway, surmounted by giant scrolls. Extravagant *estípite* pilasters, faced with caryatids, flank the upper window. Gargoyles in the form of phallic-looking cannon and trophy sculptures of helmets and armor mounted at intervals along the roofline sound a martial note. The flamboyant clocktower-pediment is a 19th century addition.

The gray arcaded interior—especially the stair-case—provides a sober setting for José Clemente Orozco's lurid murals of the Carnival of Ideologies, in which Father Hidalgo looms large.

Paralleling the words of the cathedral frieze, a legend inscribed inside the palace doorway quotes a parallel line from Psalm 127: "Except that the Lord keep the city, the watchman waketh in vain."

The Regional Museum
(Museo Regional)

Behind its austere facade, facing the lush Parque de los Hombres Ilustres on the north side of the cathedral, this former Augustinian seminary is now home to a wonderful assortment of historic and artistic treasures.

From the tranquil arcades of the central patio, dotted with old worn coaches and presided over by a splendid, gesticulating figure of the Archangel Michael, lofty doorways with carved arches lead to other courtyards. Large reliefs of entwined religious insignia are mounted on the graystone walls, while a magnificent open stairway conveys the visitor to the upper level.

Attractively installed ethnographic and pre-Columbian exhibits fill the surrounding salons—handsome colonial rooms with high, beamed ceilings and polished, dark wood floors. Galleries with elegant French windows overlook the park and adjacent Liberation Plaza. They house a superb collection of colonial canvases by such noted baroque painters as Cristóbal de Villalpando, Báltasar de Echave Orío and Juan Rodríguez Juárez, as well as several works by *tapatío* artists Diego de Cuentas and José de Ibarra, who is nationally celebrated as the "Mexican Murillo."

LA PLAZA DE LA LIBERACION

Several distinctive colonial buildings face this elongated plaza, known familiarly as El Dos de Copas for its two gushing fountains. Anchored by the cathedral, its western end is dignified by the mellow colonial facades of the **Regional Museum** and the Palace of Justice, and the long flank of the **Government Palace** opposite. At the eastern end, the plaza is closed by the dramatic Greek temple front of the **Teatro Degollado**. This 19th century Beaux Arts structure from the Porfirian age, although undeniably handsome, seems rather showy beside the austere baroque fronts of its 18th century neighbors, the monastic churches of San Agustín and Santa María de Gracia.

The exceptionally long and narrow nuns' church of **Santa María de Gracia** is distinguished by a plain ashlar front and classical double portals, and is a favorite venue for fashionable weddings. The vast Dominican convent, once renowned for its lush gardens, is now occupied by the Hotel Mendoza.

Identified by its robust belltower and broad whitewashed front, the church of **San Agustín** is located behind a shady forecourt on the south side of the Teatro Degollado. Its former cloister now serves as a school of the arts.

El Hospicio Cabañas

Past the Teatro Degollado, a series of attractive stepped stone terraces, incorporating fountains and statuary, stretches away to the east, crossing the Calzada and opening up into a vast open space, the Plaza Tapatía, that fronts the monumental Hospicio Cabañas.

Founded as a hospital by a 17th century bishop, this ambitious structure was built across the San Juan River from the colonial city, in order to reduce the spread of infectious disease. The original plan, based upon the traditional Iberian layout for royal hospitals, incorporated 23 separate arcaded patios, linked by radiating walks.

In the late 1700s, Bishop Juan Ruíz de Cabañas y Crespo undertook conversion of the hospital into a city orphanage. The interior was reworked by the Spanish neoclassical architect Manuel Tolsá, who built the magnificently domed central chapel and added its colonnaded main entrance—the last major building project of the colonial era in

Guadalajara, El Hospicio de Cabañas

Guadalajara. Because of its monumental scale and grandly austere architecture, the Hospicio Cabañas has been called the "Escorial of the Americas." Although a civil structure, its endless courtyards and cavernous chapel recall the monastic severity of that royal Spanish mausoleum.

Now designated the Instituto Cultural Cabañas, offering classes in music, drama and fine arts, the building is probably best known for its brooding murals by the revolutionary painter José Clemente Orozco. Dark, violent and painted on an enormous scale, they cover the walls and vaults of the former refectory, but fail to overwhelm the classical interior—a tribute to the authority of the Tolsá's design.

The permanent exhibit of Orozco's drawings and cartoons for his other mural projects seems more satisfying than these gigantic murals. Less bombastic and executed on a more human scale, the smaller works better reveal the artist's superb draftsmanship.

GUADALAJARA'S CHURCHES

Guadalajara's principal colonial monuments are its churches. Most belonged to the monasteries and nunneries of the different religious orders: Franciscans, Augustinians, Dominicans, Jesuits, Mercedarians and Oratorians. Although many of them were founded in the 16th and 17th centuries,

the majority of the existing buildings date from the 1700s—the great era of church building in Guadalajara, as across Mexico.

While each church has its own special qualities, there are common features that constitute the *estilo tapatío*—a distinctive urban colonial architecture that continues to stand out amid modern development in the city center. In addition to their generally sober facades and rib-vaulted interiors, most of Guadalajara's churches also boast elaborate two-tier towers, usually with an octagonal upper stage. Togther with the frequent placement of prominent sculpture arcades above the doorways, these are examples of architectural features that originated with the cathedral.

The locally quarried *cantera amarilla*, an easily worked limestone capable of holding sculptural detail, was often used to great advantage in decorating church fronts. Sometimes this took the form of an intricate, popular style of stonecarving—of which Santa Monica is the prime example—that gave rise to the distinctive Jaliscan baroque style that adorns church facades throughout the region.

Most of Guadalajara's churches, monastic and secular, are located on the streets radiating from the cathedral. We start in the center with the church of La Merced, on the northwest corner of the Plaza de los Laureles across from the cathedral.

The Mercedarian cross

La Merced

*Guadalajara, La Merced:
sculpture of the Virgin of Mercy*

Behind its narrow, stone-flagged forecourt, attractively enclosed by intricate wrought-iron railings, the white stucco front of La Merced provides a perfect backdrop for its sculpted porch.

Elegant though it is, the understated classical composition of the entry is surprisingly restrained for the Mercedarians—an order much given to extravagant decoration of its buildings, for example their exuberant baroque conventos in Puebla and Mexico City, and their florid church at Atlixco in Puebla State.

Nevertheless, between the severe Doric pilasters, a more decorative note is sounded by the densely carved panels of floral relief, slotted scrolls and ornamental pinnacles.

The Virgin of Mercy (La Merced), or Our Lady of the Ransom of Captives as she is traditionally known, was the patron of this Spanish mendicant order, whose members offered themselves up in place of Christians held for ransom by the Moors. She has been a revered saint in Guadalajara ever since 1629, when a Mercedarian bishop, Francisco de Rivera, introduced her image here.

The present church was completed by the early 1700s. The naive, frontal figure of La Merced, in the sculpture arcade above the doorway, is flanked by two statuesque Mercedarian nuns displaying the emblem of the order—a Maltese cross with the three nails of the Crucifixion. The wide-eyed Virgin cradles the Christ Child, who holds up the orb of the world.

Only the squat lower stage of the tower remains, its ornate upper section having fallen victim to an earthquake earlier in this century. The interior reflects the popular veneration of its various saints, whose altars are always bedecked with a clutter of votive offerings and folksy tributes to their miracle-working powers.

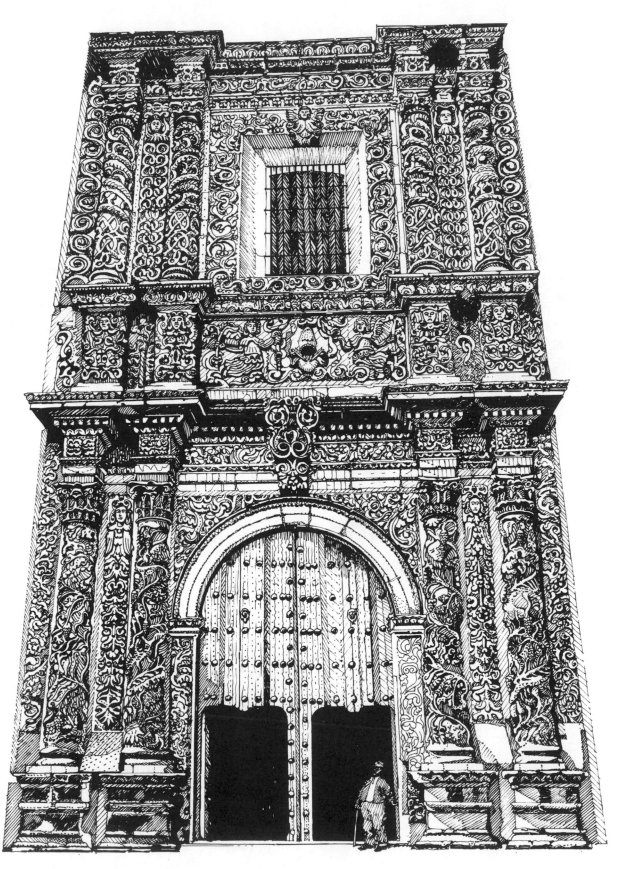

Guadalajara, Santa Mónica: south facade

Santa Mónica

The church is a special favorite of *tapatíos*, as much for its exquisitely carved baroque portals, as for its revered statue of St. Christopher.

Standing just north of La Merced on narrow Santa Mónica street, the early 18th century church of Santa Mónica was built by the Augustinians to house nuns of their order.

Regrettably, its unique sculpted porches, unprotected by any forecourt, face directly on a busy traffic route. A gray, sooty film masks the mellow golden hue of the stonework, while the risks of corrosion as well as accidental damage on this crowded thoroughfare are precariously high.

The exceptionally long church—five bays along the nave, in addition to the two enclosed bays of the choir—is a classic Mexican nuns' church, oriented north-south, with two portals on the east side. Although, like many other Guadalajaran churches, the interior was given an opulent neo-classical makeover, it retains its intricate Gothic star vaults. As it was in colonial times, the deep choir remains separated from the nave by a *reja*, or iron choir screen with the original side gateways.

Santa Mónica's finest architectural features are its celebrated sculpted portals, which exerted great influence on 18th century church decoration throughout the region. Although they follow the retablo-facade of San Francisco in form (see p.124), both facades are energized by a tapestry of decorative stonecarving. Virtually every surface is imaginatively carved with intricate relief decoration in pronounced popular taste—among the earliest examples of what has dubbed "Jaliscan folk baroque."

Double Solomonic columns frame both arched doorways, each spiral entwined with vines realistically carved in the round with bunches of grapes and little birds. Pedestals in grotesque style, with Indian-like masks, flank the friezes above both doorways.

Over the southern doorway, a pair of hovering angels, of archaic 16th century appearance, hold up an ornamental cartouche of the Augustinian pierced heart, crowned by an episcopal tiara. The northern portal features angels in flight who clutch long-legged birds and support the double-headed Hapsburg eagle, whose feathers are rendered in bold *tequitqui* style.

The windows and columns on the upper levels are also highly textured, although apparently carved by a different hand, with an emphasis on

Santa Mónica, corner sculpture of St. Christopher

intricate strapwork and stylized bands of foliage in folk baroque vein. Elaborately framed upper windows are placed at intervals between the portals, some with carved eagle gargoyles. Another two-headed eagle is emblazoned above the center window, flanked by sinuously posed heraldic lions holding up the Augustinian emblems.

An elongated, archaic statue of St. Christopher is set into an angled niche on the northeast corner of the building—possibly a survivor from an earlier building on the site. The empty round socket

in the breast of the Christ Child, perched on the saint's shoulder, probably once contained a jade or obsidian disk—a pre-Columbian practice that was carried over into Christian sculptures of the 16th century. (See for instance, the atrial cross at San José Tajimaroa, Michoacán.)

"El Cristobalón," as the gigantic statue is familiarly known, is a traditional target of appeals by *tapatías* for help, not only in finding desirable new husbands, but also in ridding themselves of the undesirable ones that they may already have.

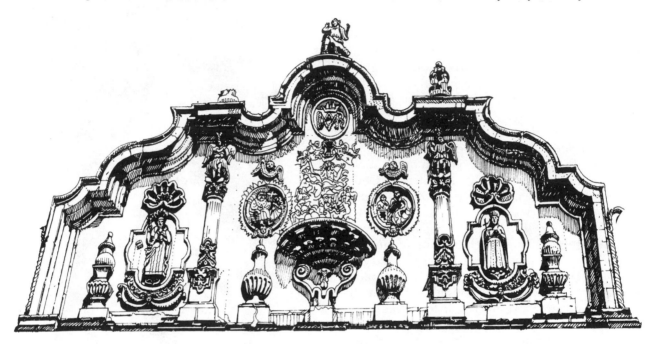

Guadalajara, San Felipe Neri: the upper facade

San Felipe Neri

The opulent churchfront of San Felipe Neri lights up a nondescript and narrow intersection on calle San Felipe, a dowdy commercial back street west of the cathedral.

Erected in the 1750s by the Oratorian order and dedicated to St. Philip Neri, their patron and founder, this imposing baroque church was designed by the noted *tapatío* architect Pedro Ciprés. As with so many other 18th century churches in Guadalajara, the design features stylistic traits from earlier periods.

Corinthian columns divide the lower tiers of the retablo facade and enclose the ornamental shell niches. The statuary constitutes a catalog of the founders of Catholic religious orders, includ-

ing St. Francis of Assisi, St. Peter of Alcántara, St. Francis de Sales and, of course, St. Philip Neri.

The upper facade is sculpturally more venturesome. Capped by an undulating, mixtlinear gable with surmounting statues, the *rocaille* decoration and dripping lambrequin reliefs firmly date the decoration to the late 1700s.

Archangels, perched atop Plateresque columns, flank the central relief of the Virgin of the Assumption, who rises from a projecting corbel amid a swirl of clouds and cherubs. Flanking oval cartouches enclose full length reliefs of St. Philip Neri and St. Joseph—the patron of missionaries in the New World. Assorted urns and shells, with religious monograms and inscriptions including

the Oratorian insignia, add to the textural richness.

The exuberant facade is brilliantly set off by the plain tower base, a classic example of the "concentrate and contrast" style that marks much Mexican architecture. Traces of red on the relief of the Virgin suggest that the facade was once brightly painted—a spectacular sight that can only be imagined today.

The two-tiered belltower is often considered the most beautiful in the city. Certainly it is the most ornate, and an outstanding example of the elaborate Guadalajaran style. The square lower stage, engorged by fleshy, layered pilasters and a multiplicity of cornices, supports an octagonal second tier that rises, pagoda-like, above the church front.

The somber neoclassical interior, albeit roofed with the ubiquitous rib vaulting, comes almost as a disappointment after the flamboyant facade. Somehow we expect a surfeit of ornament. The nave exterior is also plain, its austere buttressed walls adorned only by the occasional seahorse-like gargoyle.

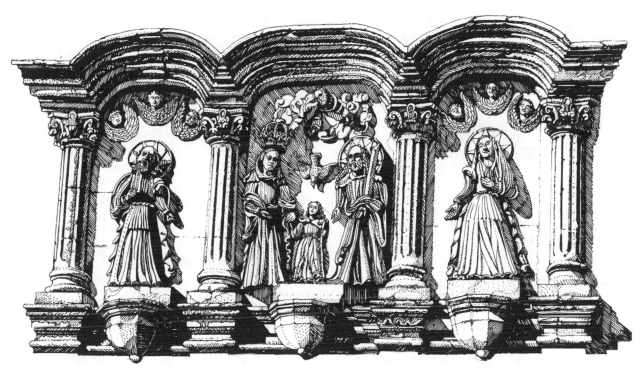

Guadalajara, Temple of Jesus and Mary: relief of the Holy Family

Temple of Jesus and Mary

The intriguing colonial church known as Jesús María is to be found five blocks south of San Felipe Neri. Like Santa Mónica, it is located on a narrow cross street, with a busy bus stop outside its gates. Opposite stands an unsightly spiralling concrete parking garage that looks like a caricature of the Guggenheim Museum.

Fortunately, the long church facade of ocher stone is somewhat protected by its narrow forecourt, enclosed like that of La Merced by ornamental wrought-iron gates and railings strung between *tezontle* posts.

The convent church was built for the Dominican Tertiary nuns, between 1760 and 1772. Its classic twin portals project from the nave wall, divided by a slender prow buttress that is inset with a tiny, primitive statue of the Virgin of Sorrows (La Soledad). Sculpture galleries span both portals, and scalloped "roofs" above each arcade protect the enclosed reliefs.

On the right, a charming folk baroque grouping of the Holy Family is still in remarkably good condition, while on the left, a rather more battered relief of the Virgin of Light is flanked by

diminutive figures of St. Francis and St. Dominic—archaic sculptures no doubt brought here from an earlier church.

A statue of St. Christopher is mounted in a niche on the southeast corner of the building. Unlike the primitive figure at Santa Mónica, the strained pose, powerful musculature and realistic rendering of the costume of the "Bringer of Christ" are reminiscent of the magnificent figure of St. Christopher in Cuernavaca cathedral, clearly radiating the feeling of the early Baroque.

An ornamental carved stone canopy adorns the blank exterior wall of the church. Beneath a bishop's miter, mischievous angels draw aside a tasselled curtain from a niche—now empty, but probably once containing a monstrance or representation of the Host.

The Cross of Jerusalem

San Francisco

Only a fraction remains today of the vast Franciscan monastic complex that once dominated the area south of the cathedral. Sited in the former Indian barrio of Santiago, its spacious precincts were virtually a city within the city.

The early history of the Franciscan Order in Guadalajara was a checkered one. The area was first evangelized by Fray Antonio de Segovia, who erected a number of primitive missions, the most important at Tetlán, the remnants of whose sculpted cloister is now embedded in the eastern suburbs of the modern city near Tlaquepaque.

This outlying location proved precarious and in 1543, the Franciscans were invited to establish a permanent convento in Guadalajara, primarily to serve the city's Indian population. In the 1550s, after several more changes of location, the friars settled on the present site.

As early as the 1580s, the roving Franciscan commissioner Father Alonso Ponce described the adobe convento as *muy antiguo*, roomy enough to accommodate several dozen friars. By the mid-1700s, the monastery had become the mother house of the Franciscan province of Santiago and the hub of its evangelical empire in western Mexico. The conventual complex was rebuilt and greatly expanded. Its atrium was enlarged and bounded by high walls with ornate gateways, enclosing no less than seven church buildings, including four large corner chapels.

This grand enclave was not to last. During the religious reforms and political upheavals of the 19th century, the monastery was mutilated and much reduced in size. Two of the chapels were demolished, leaving only the Aranzazú Chapel, which is now separated from the main church by a busy street.

The former *posa* of St. Anthony is now a side chapel, and the small Jardín de San Francisco in front of the church is all that remains of the huge atrium. A simple modern arcade, enclosing a fountain and market stalls on the south side of the church, marks the former location of the great cloister that housed as many as one hundred friars at its peak.

The north facing church, dedicated in 1611 to St. Francis of Assisi, the Franciscan founder, is still an imposing landmark. Construction continued throughout the 17th century, and the imposing retablo facade was completed in 1692 by the master mason Pedro Nuñez. With its clean lines and tiers of foliated spiral columns, it is the purest example of the Solomonic baroque style in the city.

A rounded pediment, surmounted by "flaming" pinnacles and the Franciscan Cross of Jerusalem, caps the facade, forming a giant archway that echoes the doorway below. Spiral columns frame the side niches, which retain their hieratic 17th century sculptures of Franciscan saints. St. Francis and St. Anthony of Padua step boldly from their pedestals on the lower tier, while the figures on the upper tier are recessed. The graceful figure of La Purísima, draped in swirling baroque robes, occupies the pediment niche overhead. Note the relief of the Mexican eagle carved below the choir window, a clumsily reworked Hapsburg eagle from the colonial years.

The majestic tower of pitted red *tezontle*, crowned by an octagonal upper tier, still holds its own against the rows of bank buildings now encircling the church. Tragically, the rich 18th century interior, famous for its carved *artesonado* ceilings and gilded baroque altarpieces, was burned out during the Cristero rebellion in 1936, to be replaced by the somber gray stone vaults and wall arcades that form the present nave.

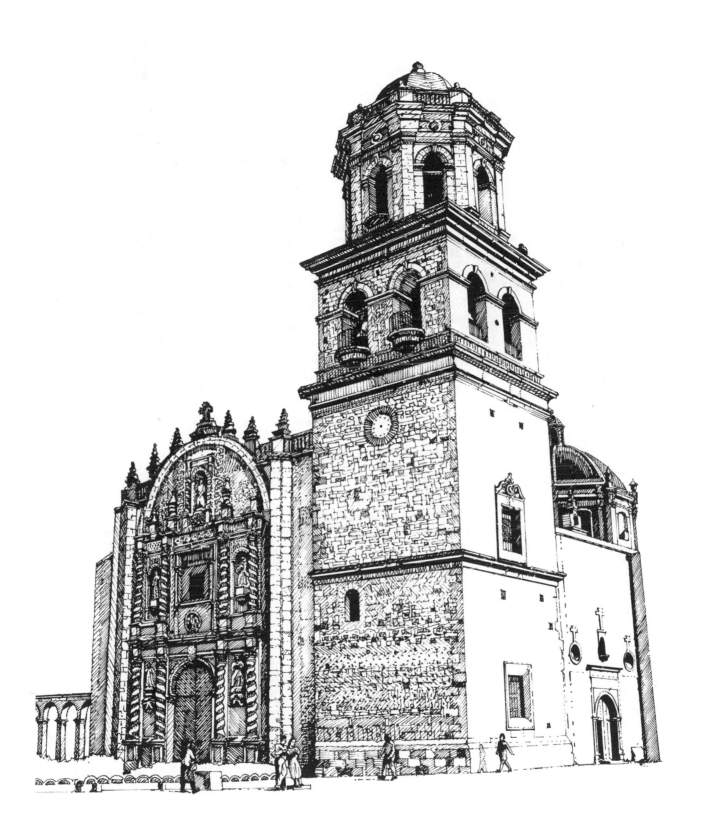

Guadalajara, San Francisco

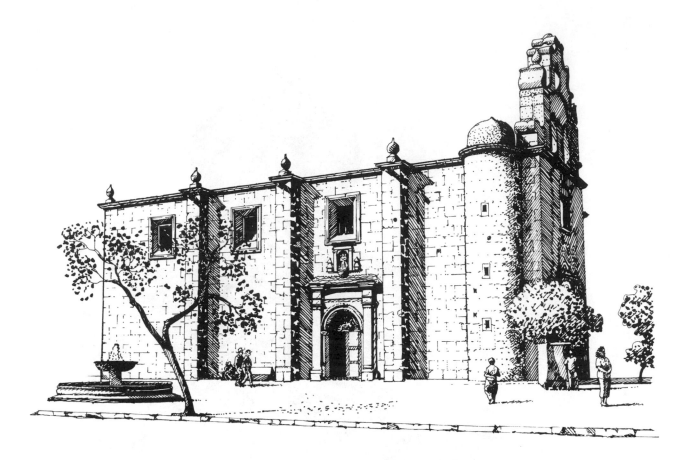

The Aranzazú Chapel

Our Lady of Aranzazú was the patroness of the Basque nation and also of the Oñate brothers—the founders of the city of Guadalajara—who established a religious brotherhood in her honor.

In the mid-1700s this wealthy *cofradía* erected a temple in her name on the site of an earlier *posa* chapel of San Francisco. Built of honey-colored stone in a spare provincial style, the buttressed chapel has been handsomely restored and now overlooks the pretty little plaza of Santiago.

Flanked by a domed, cylindrical *caracol* staircase, the slender facade rises into a curvacious *espadaña*, with arched bell openings, scrolls and bulbous, urn-like finials. A stylized stone statue of the Virgin of Aranzazú rests in a sculpted niche above the doorway, while oval reliefs in the gable display the crossed arms of the Franciscan Third Order, to which many members of the *cofradía* doubtless belonged.

In contrast to the severe exterior, the chapel interior is astonishingly ornate. The narrow nave is almost overwhelmed by the painted ceilings, canvas covered walls and, above all, three enormous Churrigueresque altarpieces—the only examples in this extravagant, late colonial style to survive in Guadalajara.

The richly gilded main retablo is the least exuberant of the three. Subtly detailed in the highly refined Queretaran manner (see p.218), its decorative motifs—a melange of niche-pilasters, shells, scrolls and strapwork—are all intricately layered in low relief against the shimmering, tapestry-like background. The carved wooden saints with their painted robes, which include the figures of St. Clare and St. John the Evangelist as well as Our Lady of Aranzazú herself, seem to be almost an afterthought.

Of the two side altarpieces, the one on the north is the bolder and more sculptural, marked by layers of broken cornices and aggressively projecting *estípites* and niche-pilasters. Here, the freestanding santos seem ready to take wing from their pedestals. St. Francis and St. Clare reappear, but this time as statues of superior quality—expressive figures with sympathetic faces and delicate gestures, clad in beautiful *estofado* robes.

Decorative rib vaults, painted in red, blue and yellow, add to the opulence of the interior, as does a huge canvas opposite the entry that traces the Spiritual Lineage of St. Francis.

ACROSS THE RIVER

In colonial times, the swift Río San Juan separated the sedate Spanish city from its teeming native barrios to the east. Today the river still flows, but through a giant conduit buried beneath the asphalt of the Calzada Independencia, known locally as La Barranca, the busy north-south traffic artery that still divides Guadalajara's administrative center from its poorer commercial and residential sections.

Several of the colonial churches and chapels of the east bank still stand, ministering to the working people of this unglamorous quarter of the city. Although less sophisticated than the monuments of the historic center, these buildings have their own integrity, displaying a popular character in tune with their more humble origins.

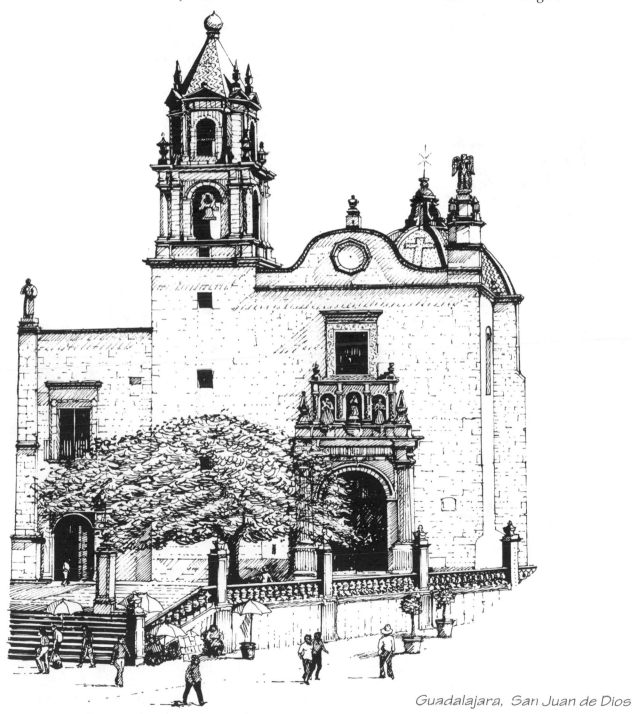

Guadalajara, San Juan de Dios

127

San Juan de Dios

Perched on an elevated terrace above La Barranca, amid the bustle of the teeming city market, the historic 18th century church of San Juan de Dios occupies the site of one of the earliest city missions.

The 16th century chapel of Santa Veracruz and its hospice served the dwellers of this humble *barrio*. The hospice was subsequently enlarged by the Hospitallers of St. John—popularly known as *los juaninos*—who also built the present church in the 1720s.

Fronted by a prow-shaped atrium, San Juan de Dios features a tall west front in the restrained Guadalajara style. The generous Doric porch is surmounted by a sculpture arcade of skirted saints, and discreet bands of floral relief frame the choir window and entry archway. Only in its irregular masonry, cut from pocked *cantera amarilla*, does the facade evince a rustic flavor that distinguishes it from the smoother church fronts of the city center.

Colorful tiles in a zigzag pattern decorate the dome as well as the spire of the two-stage tower. A statue of the Archangel Raphael, messenger of divine healing, stands like a beacon atop the facade, still proclaiming the importance of San Juan de Dios and its humanitarian mission in the life of this ancient *barrio* of Guadalajara.

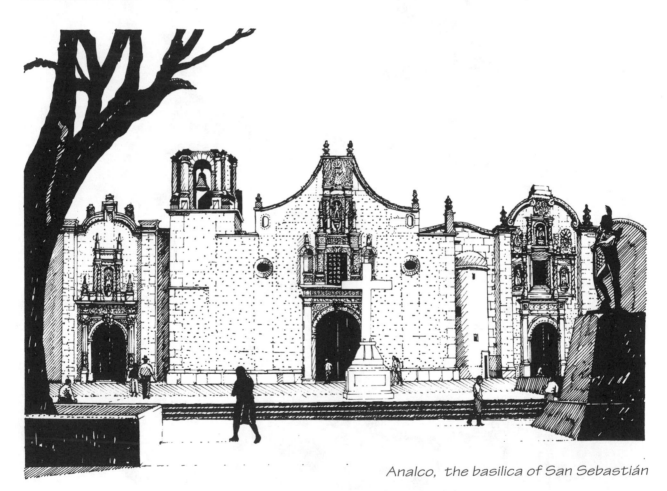

Analco, the basilica of San Sebastián

ANALCO

The old native quarter of Analco, located a few blocks south of San Juan de Dios, was originally settled in early 1500s by Mexican native troops who came with the *conquistador* Nuño de Guzmán.

Now bordered by gritty auto workshops, Analco retains an indigenous flavor in its humble side streets, especially in the vicinity of its two surviving churches, San Sebastián and San José.

San Sebastián Analco

Set on a broad paved terrace at the heart of Analco, this rambling pilgrimage church faces a huge tree-shaded square with sculptures and fountains.

San Sebastián was one of the first Franciscan missions in Guadalajara. It was founded by Fray Antonio de Segovia, a great favorite of the Indians who affectionately called him *tatita blanco*, or Little White Father.

Fray Antonio brought with him an image of the martyr St. Sebastian which he placed in a small hermitage here. The *santo* rapidly attracted a devoted following among the Indians, and has been the object of a religious cult ever since. To encourage and accommodate the pious, the chapel was enlarged in the mid-1700s to encompass a basilican church with elongated transepts that serve as side chapels.

Exposed masonry of rough-hewn red *tezontle* give the wide west front a rustic appearance. The multi-tiered main porch rises into a curved, stepped gable sculpted in Jaliscan folk baroque style with shell niches and bands of foliated relief. A naive, half-naked figure of the arrow-riddled St. Sebastian gestures from an upper niche, while at the apex of the gable, a fussy relief of the Virgin—probably a 19th century addition—is almost lost in a flurry of carved tendrils.

The entrances to the side chapels are also handsomely carved, framed by urn-topped buttresses and rounded baroque pediments. The chapel front on the right is the more ornate of the two, its statuary and reliefs elaborately bordered by spiral columns and shell arches that recall the facade of San Francisco just across the Calzada.

Each side chapel contains its own Marian image, and the basilica interior is decorated throughout in a somber brown-and-gold rococo fashion.

Sections of the original convento survive, including its tiny cloister whose intricately carved arcades rest on stubby folk Corinthian columns. Although known to locals as the Patio of the Angels, no figures of angels are now in evidence.

San José Analco

San José Analco, a block to the east, is a later building. Its handsome retablo facade is carved with shell niches containing several creditable pieces of 18th century statuary, including robust "barococo" figures of St. Joseph and the Virgin.

ZAPOPAN

On October 5th every year, after ceremonially visiting the churches of the city, the Virgin of Zapopan returns in triumph by limousine to her sanctuary in this basilica on the northern outskirts of Guadalajara. Since colonial times, she has enjoyed exalted status as the patron saint of the *tapatíos* —their protectress against epidemics and the heavy flooding brought on by fierce summer storms.

The story goes that the diminutive cornpith statuette of the Virgin was brought to Guadalajara by Fray Antonio de Segovia, the tireless apostle of Jalisco whose luggage seems to have been full of miraculous images.

The tiny Virgin, also known as "María de la Expectación," is a stylized, triangular figure, fashioned after the biblical image of the Woman of the Apocalypse, although her kindly, pale countenance and black curly hair are difficult to discern amid her sumptuous costuming and the gilded splendor of the high altar.

Zapopan (Place of the Sapodilla Trees) had been a center of Franciscan missionary activity since the 16th century. During the 1600s the friars zealously promoted the cult of the Virgin, which soon acquired an immense following.

Early in the next century, the archbishop decided to build an imposing new pilgrimage church with a convento attached. Although the basilica was dedicated in 1734, when the Virgin was officially declared the patron saint of Guadalajara, work on the grandiose building was not completed for another twenty years.

Fronted by a gray, stone-flagged atrium with imposing gateways, the basilica is one of the most striking architectural sights in the region. Although termed a basilica, the church actually consists of a single nave, vaulted with Gothic ribbed compart-

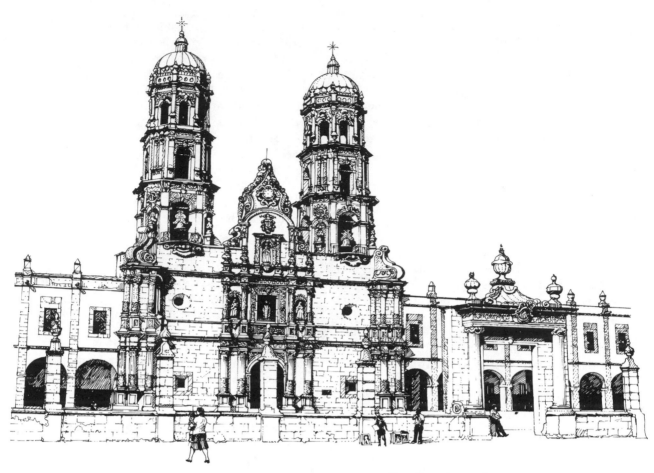

The Basilica of the Virgin of Zapopan

ments in traditional Guadalajara style. Neverthe-less, the imposing church front is extraordinarily wide—a design reputedly modeled on the old Basilica of Guadalupe in Mexico City. Veneered entirely with marbled *piedra amarilla* from the local Atemajac quarries, it extends on both sides to encompass the powerful tower bases.

Great projecting piers faced with decorative pilasters and capped with giant angled scrolls anchor the facade at either end. The austere arcades of the former Franciscan seminary and convento on either side present a satisfying counterpoint to the grandiose church front.

Although radically remodeled late in the 19th century, the sculpted center facade retains its traditional retablo form. The carved ornament of the lower facade is a fine example of the Jaliscan baroque style of the region, marked by passages of dense arabesque carving above the doorway and around the choir window. As on the outer piers, pairs of fluted neo-Plateresque columns

flank the doorway, while wavy spirals adorn the columns on the second level.

Squeezed between the upper columns are baroque niches containing figure sculptures of the popular saints, Joseph (left) and Francis of Assisi. A magisterial statue of St. Peter, wearing the papal tiara and a sumptuous robe with stylized folds, gazes out from an ornamental niche in the top tier of the facade. The gable is surmounted by the Franciscan crossed arms, and overhead, a showy "barococo" clock of much later vintage.

The sweep of the west front is matched by the soaring twin towers, similar in style to those surmounting the pilgrimage temples of the Bajío and the Los Altos region of Jalisco, to the east. Both towers rise to a height of 120 feet through three octagonal tiers—each heavily ornamented with carved half-columns, sculpture niches, foliated friezes and baluster merlons—and are crowned by prominent melon-shaped cupolas. Great bells can be seen protruding from the lower openings.

POINTS SOUTH: THE LAKE MISSIONS OF JALISCO

South of Guadalajara stretches a region of dry hills and long, shallow lakes. The largest and best known of these is Lake Chapala, an idyllic body of water bordered by picturesque villages and resort towns.

At the time of the Spanish conquest, when the lakes were larger and more numerous than today and the hills thickly wooded, this benign region was densely populated. This attracted Franciscan missionaries, who evangelized the natives and founded mission towns along the lake shores.

Although few colonial buildings have survived along Lake Chapala, the towns bordering the lesser known lakes of Cajititlan and Sayula still harbor remnants of colonial churches and missions, some dating back to the "spiritual conquest" of New Galicia.

We look first at the colonial buildings around Lake Cajititlan. After briefly describing the mission towns bordering the north shore of Lake Chapala, we then go south to explore the lakeside churches and chapels of the Sayula Valley.

LAKE CAJITITLAN

Between the southern fringes of expanding Guadalajara and the shores of Lake Cajititlan—an isolated and beautiful lake set among purple hills—lie numerous fascinating colonial churches and chapels.

Almost all of these were built, or rather rebuilt, during the 18th century, in many cases to replace earlier missions or hospital chapels. Several of these buildings have been tastefully restored in recent years, often through the dedicated efforts of the local citizenry.

Although each structure is unique, they are united by common architectural and ornamental features that together constitute what has been called the Jaliscan popular Baroque. Influenced by the densely sculpted facades of Santa Monica in Guadalajara and the Basilica of Zapopan, they use to advantage the same local limestone, *la cantera amarilla*, and display a varied repertory of folk carvings endowed with great charm and imagination.

Our first major stop going south is at the imposing parish church of **Santa Anita**, noted for its soaring, sculpted facade. En route we visit some smaller village churches and chapels at **San Juan de Ocotán** and **San Sebastianito**. Continuing down the highway, we arrive at **Santa Cruz de las Flores**, whose ornamental hospital chapel is the one of the jewels of the Jaliscan folk baroque. From there we head towards Lake Cajititlan itself, stopping on the way to look at the old hospital chapel at **Tlajomulco**. After exploring the principal lakeside town of **Los Reyes Cajititlan**, notable for its grand Basilica of the Three Kings and the little Guadalupe Chapel, we follow the south shore of the lake to the missions of **San Juan Evangelista** and **San Lucas Cajititlan**, both of great visual appeal for their lively stonecarving.

San Juan de Ocotán

A pleasant paved plaza lies at the heart of this working class *barrio*, close to the *periférico*—the bustling beltway around Guadalajara. An imposing carved stone cross is mounted in the *alameda* of eucalyptus and jacaranda trees leading to the church. Dated 1684, the cross is incised in a distinctive local style, similar to the larger atrial cross at Los Reyes Cajititlan.

The 18th century facade of honey-colored limestone, cut from the fabled Atemajac quarry nearby, has been restored to showcase its classical baroque doorway and choir window, both adorned with foliated arabesque panels in low relief.

A heraldic escutcheon in the overhead niche is carved with Marian symbols and the lions and castles of Spain, and is inscribed with the date 1779, which probably marks the completion of the church. The two-tier *espadaña* and curving baroque gable give the church a simple but elegant profile.

Inside the church, the main item of interest is a folk baroque statue of the Virgin of the Immaculate Conception, with silver crown and windblown draperies. This image was a fixture of the old hospital chapel, formerly attached to the mission but now demolished.

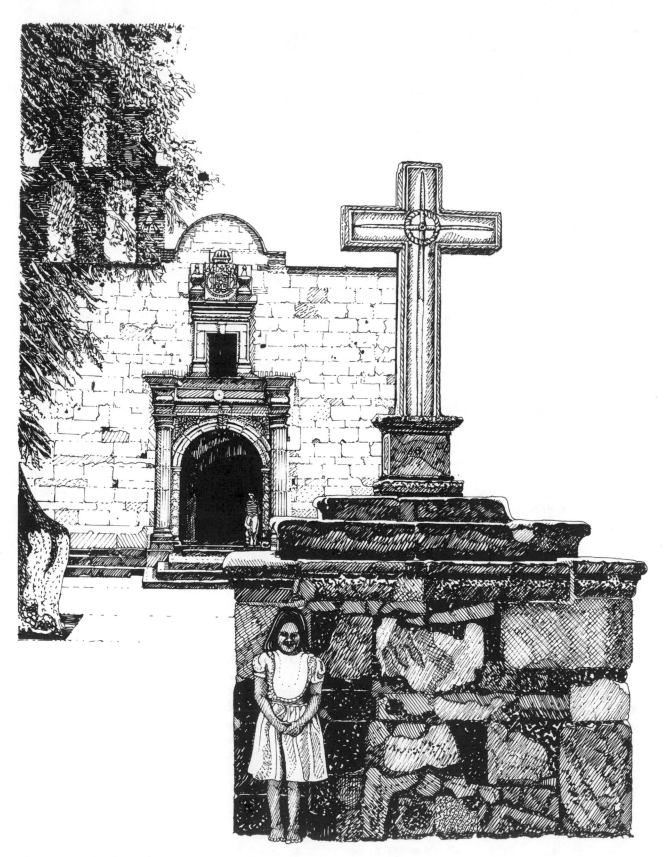

San Juan de Ocotán, west front and atrium cross

San Sebastianito

Not to be confused with nearby San Sebastian el Grande, whose old hospital chapel now lies in ruins, San Sebastianito is a quiet village of cobbled streets, where two colonial churches face each other across a broad plaza.

As at Ocotán, a rounded baroque gable and *espadaña* top the main church, which is raised above the plaza at the head of a wide flight of steps. Fragments of primitive reliefs stud the reconstructed 18th century front, including the sun, moon, and a winged figure above the doorway that may represent St. Sebastian.

Even though it claims the earlier date of 1692, the renovated former hospital chapel of La Concepción opposite seems more sophisticated, within the folk baroque idiom. Its striking retablo facade of smooth white limestone is neatly sand-wiched between textured walls of dark red *tezontle* bordered by giant limestone pilasters.

The well-proportioned classical porch is similar to that of Santa Cruz de las Flores. A stone crown with the monograms of Jesus and Mary adorns the keystone of the arched doorway. The upper facade and crowning pediment—probably added in the mid-1700s—are profusely carved with leaves, flowers, vines and other motifs including a two-headed eagle and religious monograms. Diminutive statues of saints in the upper niches include the figure of La Purísima.

Like Santa Cruz de las Flores and other regional chapels, including the carved Refugio Chapel of nearby **San Agustín** (now called Nicolás Casillas), the interior features a transverse nave with a double arcade set on sturdy pillars.

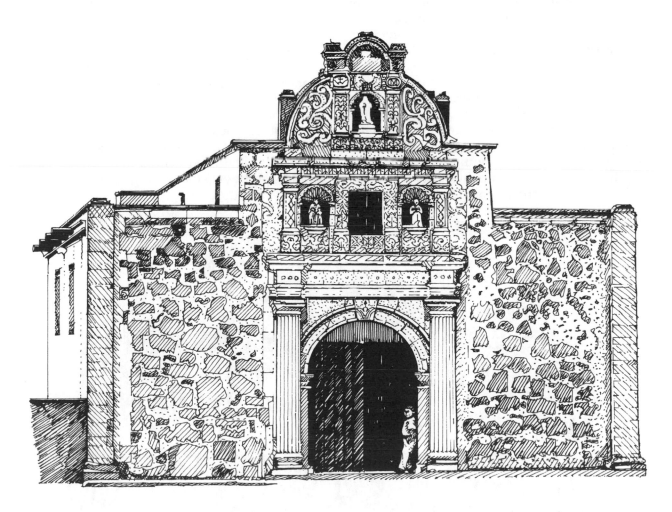

San Sebastianito, hospital chapel of La Concepción

SANTA ANITA

Located just south of Guadalajara, off busy Route 54, is the attractive town of Santa Anita Atliztac, dominated by the grand church of Santa Anita.

The settlement of Atliztac (White Water) is an ancient one. Long before the arrival of the Spaniards, it flourished under the lords of Tlajomulco, its rich soils producing prodigious harvests. In the 1530s, the Franciscans succeeded in converting the local nobility and founded a modest mission here. Although this humble adobe church was replaced by the present edifice in the 1700s, sections of the 16th century convento still stand.

Facing an open plaza, the twin-towered church is the most imposing in the area. The retablo facade dates from 1732, and in its forms and wealth of architectural sculpture is closely related to its regional contemporaries, the sumptuous convent of Santa Monica in Guadalajara and the nearby chapel of Santa Cruz de las Flores.

Sharply projecting cornices separate its three tiers, each layered with densely carved ornamental friezes, some of twisting foliage, others of byzantine scrollwork. Solomonic columns encircled with twisted vines border the numerous openings, also framed by interwoven spiral bands.

Cherubs clamber around the doorway, some holding books and others playing archaic instruments—one of the many instances of musical angels decorating local churches. Pelicans—symbols of blood sacrifice and Christ's Passion—straddle the elaborately scrolled side niches and upper capitals. Statues of Franciscan saints occupy the upper niches.

But the facade reaches its sculptural climax in the crowning pediment, where a large relief depicts the Holy Family amid a riot of ornamental foliage. In this charming folk tableau, Joseph and Mary clasp the upstretched hands of the child Jesus, flanked by St. Joachim and St. Anne, who is the patron saint of the church. Awkward in their flowing robes, the figures incline their ecstatic faces towards the youthful Christ. The dove of the Holy Spirit hovers overhead, while above them all, almost lost in the mass of exuberant carved vegetation, God the Father beams down benevolently. Similar sculptures decorate the crossing inside the church. Beneath an octagonal dome, bold reliefs of the Four Evangelists project from the pendentives amid a welter of foliated decoration around the supporting arches.

A plain rectangular doorway beside the church gives access to the convento, now occupied by the Franciscan order once more after a lapse of many years. The spacious cloister, enclosed by plain gray stone arcades, has again become a place of peaceful religious retreat.

Across the plaza, the former hospital chapel has been modernized, with a new stained glass window portraying its traditional patron, the Virgin of Guadalupe.

Santa Anita, facade relief of the Holy Family

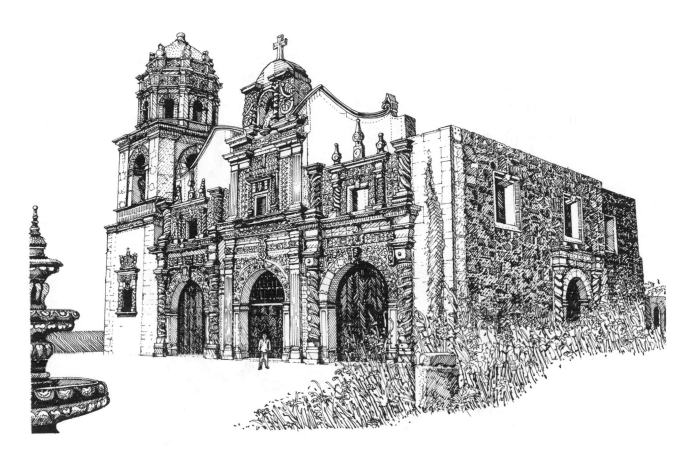

SANTA CRUZ DE LAS FLORES

The restored former hospital chapel of this "Place of the Flowers" is another gem of the Jaliscan baroque. As at San Sebastianito, parts of the 16th century sanctuary and apse are still preserved behind its ornamental 18th century facade.

With the takeover of the Franciscan mission by secular clergy in the late 1600s, a large transverse nave was added to the sanctuary. This wide but shallow nave was divided by arcades into three aisles covered by a beamed roof, creating on a small scale the effect of a colonnaded basilica. According to a dated plaque over the central doorway, the facade was added in 1692, and the tower and staircase shortly afterwards A frieze in the belfry mentions the year 1712. If these dates reflect actual construction, then Santa Cruz may be the earliest building to reflect the mature Jaliscan style.

Restoration of the roofless chapel was begun in the early 1900s, and during the final phase—not completed until the 1970s—the chapel was re-roofed and the facade rejoined to the apse, with new columns supporting the masonry vaults.

To emphasize the basilican form, three door-ways of equal size open to the aisles, with square windows above. The larger central window is crowned by a pediment with a sculpture niche, flanked by unusual, wing-like roof parapets. As was customary with colonial hospital chapels, Santa Cruz was dedicated to the Virgin Mary, and the niche contains a primitive statue of the Virgin of the Rosary.

A web of carved stone ornament links the triple entries, liberally sprinkled with classic baroque motifs interpreted in a vigorous popular manner. Solomonic columns flank the outer porches, some with shafts bedecked with flowers, vines and bunches of grapes, and others banded with simple spirals, while fluted pilasters frame both the door and window of the center porch.

Bands of foliated relief border the windows and doorways, inset with decorative corbels and keystones. Friezes densely carved with urns, rosettes, rustic birds, angels and religious mono-grams, complement the foliated panels, unifying the facade into a folk baroque tapestry that in-

spired imitations throughout the area. A decorative window frame also embellishes the tower base, which supports an octagonal *mudéjar* belfry with carved bell openings. The walled atrium is landscaped with carefully tended gardens and fountain, and incorporates the arch of an old stone gateway framing the charming chapel front.

Although the colonial parish church, which faces the chapel across a shaded plaza, has also been substantially rebuilt, we can still admire the carved spiral columns and shell niches of its mellow retablo facade.

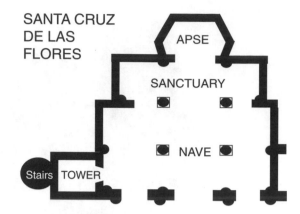

SANTA CRUZ DE LAS FLORES

Tlajomulco, inscribed cross on the fountain

Tlajomulco

Ringed by low hills to the west of Lake Cajititlan, Tlajomulco (Hidden Place) was a ceremonial center and favorite retreat of the Indian nobility before the Spaniards arrived on the scene. Dedicated in 1551, San Antonio Tlajomulco was among the earliest Franciscan foundations in Jalisco—a busy mission, in which friars were trained to man not only its many outlying *visitas*, but also to serve a chain of missions extending to the north and southwest.

Although the original mission has been replaced by a grandiose modern church, and the convento altered almost beyond recognition, the simple 18th century hospital chapel of the Virgin, at the far end of the main plaza, has survived.

The narrow, block-like chapel preserves its geometric portal, embellished with cord-like colonnettes and beaded jambs. Relief sculpture is confined to the upper facade, notably in the ornate gable, where we see a statue of the Virgin,

with Franciscan insignia and religious monograms, framed by undulating sections of a carved, tasseled cord.

In one corner of the churchyard, a vine bedecked cross, dated 1734, adorns the archway of a wellhouse, also carved with the figures of musical angels. Its waters are regarded by the locals as a universal curative, and on the alcove stands a statue of the Archangel Raphael—divine patron of the healing arts.

An ancient statue of the La Purísima, the patron of the chapel, is honored during the major fiesta, in early December. When Father Ponce sojourned here at Christmastide, 1586, he witnessed the fiesta of the Three Kings, even then famous for its lavishly staged Nativity play.

Undoubtedly the successor to an ancient pagan celebration, this early colonial festival has taken on new life in the neighboring community of Los Reyes.

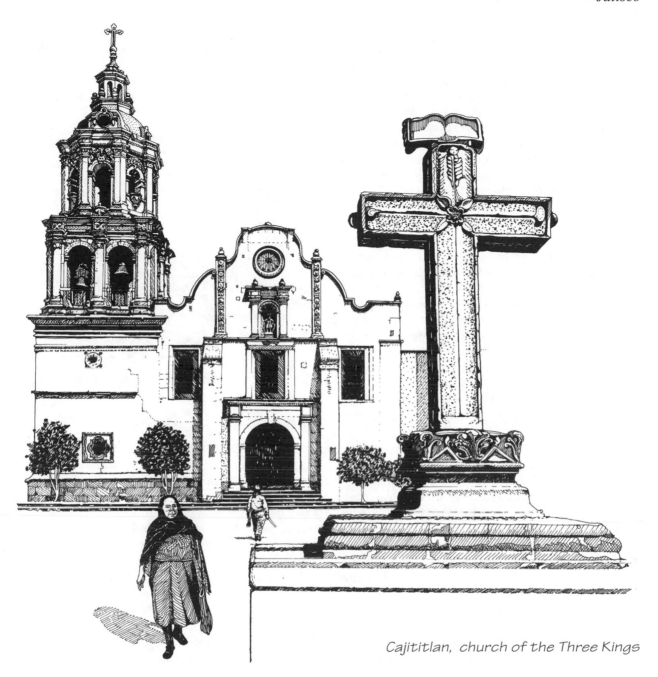

Cajititlan, church of the Three Kings

LOS REYES CAJITITLAN

Cajititlan is in its most folkloric mood during the boisterous festival of Los Reyes Magos, every January, when the church is colorfully decorated for Epiphany.

In accordance with ancient tradition, both church and atrium are crowded with the faithful from all over the region, paying homage to the Three Kings, whose statues are lowered into the nave for the occasion—a thriving example of cultural continuity in this area of rapid change.

Between participating in religious processions, music and folk dancing, *fiesteros* sample the out-size buns, almond tequila and other traditional local foods on the busy market stalls. On January 6th, when the fiesta comes to a climax, spectacular firework displays, featuring *toros*, *castillos* and skyrockets, light up the night sky.

The largest of the lakeside towns, Los Reyes boasts Cajititlan's most imposing church. The parish church of the Three Kings, begun in the

late 1600s and completed in the 1770s, was restored to its former glory in the 1960s by Father Luís Méndez, the energetic local priest.

Its wide basilican facade, extended by a massive tower base on one side and the chapel of the Virgin on the other, faces west towards the lake across a huge terraced atrium. The striking church front, recently cleaned and repointed, and the paved atrium are both fashioned from same reflective brownstone, hewn from local quarries. Arched niches—possibly the modified remnants of former *posa* chapels—are built into the sides and corners of the atrium walls. A monumental stone cross stands on the center pedestal, its arms and shaft scored and pitted in imitation of the body of Christ.

A single Doric doorway pierces the facade, although three rectangular upper windows mark the interior aisles. Surmounting this austere geometry, the curvilinear gable strikes a note of baroque exuberance. A youthful statue of Gaspar, one of the Three Kings, stands jauntily in the sculpture niche, flanked by ornamental pilasters carved with alternating rosettes and winged cherubs.

The plain tower base supports an ornate two-tier belfry encrusted with layered pilasters, carved friezes and arabesque reliefs. Nice touches include the bull's eye windows of the crowning cupola and the lion's head gargoyles projecting from the nave walls.

The church interior is also impressive. Climbing the flight of steps and passing through the doorway, we are drawn in by rows of white columns and a succession of painted vaults leading towards the sanctuary. The raised apse is a richly ornamented space, obliquely lit by Moorish side windows and divided horizontally by large, complex entablatures. Figures of winged angels, bearing musical instruments and the symbols of the Passion, seem poised in flight along the ribs of the vault.

The main retablo is carved and gilded in simple neo-Plateresque style. Naive, frontal statues of the Three Kings occupy the lower niches. These sumptuously costumed 17th century figures, carved from heavy mesquite wood, were badly burned in a fire earlier this century.

Scarred by the flames, the mutilated images were hidden by the priest, who attempted to substitute modern *santos*. To the joy of the townspeople, however, the hidden Magi were rediscovered during church repairs in the 1930s, and restored to their rightful positions.

Although disfigured by a newly added belfry, the side chapel also features several charming passages of exterior stonecarving, including animals, flowers and a *mariachi* of musical angels.

Cajititlan, Guadalupe Chapel: facade angel

El Santuario de Guadalupe

Tucked away in the far corner of the plaza, on the edge of the lake, stands the partly restored Guadalupe Chapel, formerly the centerpiece of the Indian hospital here. Its intimate scale, delicate detailing and unmistakeable indigenous flavor provide a contrast to the more imposing, but sparely ornamented facade of the basilica opposite.

Below a delicate frieze of sunflowers and fleurs-de-lis, a chubby angel emerges from a flower in the carved relief over the doorway. Overhead, ornate shell niches project from the facade. In two lower niches, surmounted by eagles, stand statues of the Virgin of Sorrows and St. John the Evangelist, traditional mourners of Christ at Calvary, whose stocky figure hangs from the cross in the upper niche.

The diminutive facade terminates in a mixtilinear gable crowned by a foliated stone cross. The gable encloses a stone tapestry of entwined coronets, scrollwork, and rampant foliage, from which peek the heads of smiling cherubs. Almost lost in the whirl is small cartouche bearing the name of the sculptor, Juan Sebastián, one of a talented family of native stonecarvers who worked around Lake Cajititlan.

A decorative belltower, dating from the 1760s, complements the facade, its two tiers fringed with floral friezes. Atop the cupola stands a statue of

the Archangel Michael, dressed in 18th century garb. Beneath a pair of feline gargoyles, lateral bull's eye windows dimly illuminate the nave. A few primitive reliefs of angels and eagles in the vaulting lend character to the simple interior, whose main relic is a 17th century wooden figure of Christ mounted on the altar.

We complete our survey of Lake Cajititlan by following the cobbled road along its south shore, where we come to a charming pair of 17th century chapels dedicated to two of the Four Evangelists: St. Luke at **San Lucás Cajititlan** and St. John the Evangelist at **San Juan Evangelista**.

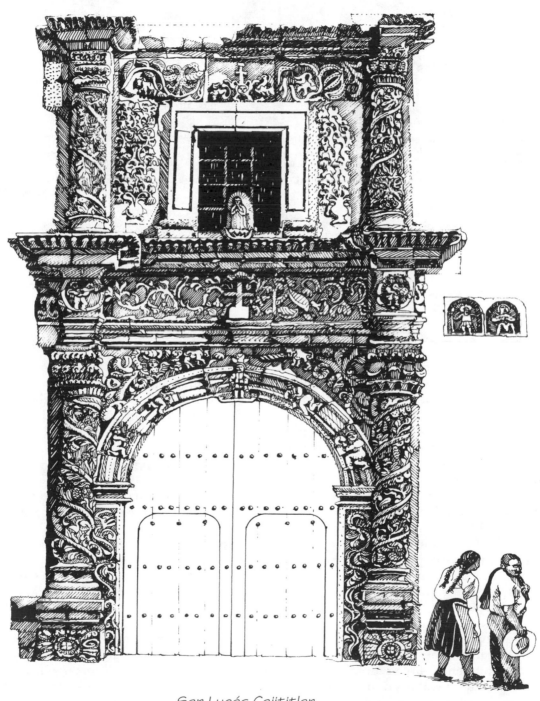

San Lucás Cajititlan

San Juan Evangelista

San Lucás Cajititlan

The little basilican chapel of St. Luke is nestled in a churchyard of old crosses, gravestones and acacia trees. Much of the intricately carved portal has survived, its surfaces enlivened with naive reliefs of angels and assorted animals, including a two-headed eagle and several bulls—the emblem of St. Luke—that peer out from the whorls and tendrils of sculpted foliage.

Spiral columns with grapevines frame the entry and the choir window overhead. In a sequence clearly related to the church doorway at nearby Santa Anita, cherubs around the arch carry the Gospels and play antique musical instruments. An effigy of St. Luke is carved on the keystone and angels also appear in medallions at each end of the frieze playing the violin and guitar. A tiny statuette of the Virgin of Guadalupe is propped in the window opening.

Several figural reliefs and niches—most likely funerary monuments—are randomly set into the fabric of the church wall. A double archway adjoining the chapel leads to the remains of a patio.

Various dated inscriptions from the later 1700s—on the atrium cross, the facade and the sacristy doorway—mention the names of Martín and Juan Sebastián, local stonecarvers and master masons thought to be responsible for the construction and decoration of this delightful chapel.

San Juan Evangelista

The restored 18th century mission of St. John the Evangelist is somewhat grander than San Lucás. Occupying its own atrium and cemetery a few kilometers to the east, it offers even more colonial treasures to intrigue the visitor.

The broad church front boasts a sculpted retablo facade in classic Jaliscan baroque style, although the quality and consistency of the carving seem less assured than at San Lucás. Mixed fluted and spiral columns frame its various openings—doorway, choir window and sculpture niches—while naive saints and angels emerge from festoons of serpentine foliage. The most interesting of these is a primitive archangel carved on the keystone of

the doorway, whose eye sockets are inset with obsidian.

An impressive baroque gable with delicate projecting volutes caps the facade, enclosing a niche with a carved stone crucifix. The figure of Christ is surmounted by a dove symbolizing the Holy Spirit and at the apex of the gable, cherubs hold a crown over the Marian monogram.

Gargoyles with gaping mouths punctuate the exterior nave wall, otherwise blank except for a fine, decorative side porch with an ogee arch and a foliated frieze. Narrow double arcades divide the basilican interior, propelling the eye towards the polygonal apse. Numerous folk reliefs enliven the interior. The keystones along the arcades are carved with the Instruments of the Passion and a primitive relief of St. Christopher projects from the wall above the side entrance.

The apse frames a handsome baroque altarpiece, designed and painted in provincial Churrigueresque style. Paired *estípite* pilasters entwined with foliage frame two tiers of boldly outlined shell niches. The fanciful pediment is adorned, like the facade, with baroque scrolls and flourishes.

LAKE CHAPALA

Although the Franciscans founded several early missions along the pleasant shores of Lake Chapala, very few colonial buildings have survived to the present.

Even when Father Alonso Ponce passed through in 1586, on his way to Guadalajara, there was little to detain him in the lakefront communities. Following the north bank of the lake, he stopped briefly in Jocótepec, then a humble *visita* of Ajijíc to the east.

After resting a while in the small convento at Ajijíc, Ponce proceeded to the Chapala mission, then no more than "a small house still unfinished," pausing to admire its orange walls and tropical gardens before hastening on to Poncitlán and Guadalajara.

San Andrés Ajijíc

Virtually nothing remains of the early mission seen by Alonso Ponce, which was founded in 1531. By 1539, the friars had moved in, thanks to the help provided by the local Tarascan chieftain. Even though the small adobe and thatch mission had been partly rebuilt after a fire in 1567, it seemed old to Father Ponce only twenty years later.

Today, the reconstructed west front of the parish church—located within its atrium a block from the central plaza—is baroque in style. Fragments of carved colonial reliefs have been embedded in the facade and an old stone baptismal font can still be found inside the entrance.

The small neocolonial chapel of Santiago stands on the north side of the plaza, probably occupying the site of an earlier hospital chapel.

Chapala

Fire also proved to be a major hazard at Chapala. The primitive mission, laid out by Fray Miguel de Boloñia in the 1540s, was destroyed by fire in 1557, and again in 1581. It was still incomplete when Father Ponce passed through a few years later.

It rose again from the ashes in the next century, and by 1650 was reported to have a spacious church with several good altarpieces. A modernistic church now stands on the site of the colonial mission and the altarpieces are gone.

Poncitlán

St. Peter and St. Paul was another early mission, founded here in 1533. The crumbling wood and adobe church and convento described by Father Ponce was a great source of controversy at the time of construction, when the builder, one Fray Miguel de Diosdado, was accused not only of forcibly rounding up Indian labor from local villages, but pillaging other nearby missions to complete his project.

The present substantial church has been totally remodeled. Only the apse seems to be of colonial vintage, and mere fragments survive of the original convento. But the venerable 16th century wooden image of the Virgin of the Rosary has survived and still reigns over the main altar.

THE SAYULA VALLEY

Soon after the Spanish conquest, the Franciscan missionaries Fray Martín de Jesús and Fray Juan de Padilla journeyed south from Lake Chapala to evangelize the lakes and valleys bordering the scenic Sierra Tapalpa.

Early attempts at conversion by the Franciscans met with resistance from the native chieftains, who were reluctant to give up their ancestral religion and cultural practices, such as polygamy, which were abhorrent to the friars.

But starting in the 1530s, and through the 1550s, mission towns were established in every valley community, including Zacoalco, Amacueca, Sayula, Zapotlán (now Ciudad Guzmán) and Tuxpan.

Today hardly anything remains of these primitive adobe missions, although in several cases later colonial churches and chapels stand atop the earlier foundations. At **San Juan Tuxpan**, only the atrium cross, much altered, still stands, while at **Zapotlán**, only an old baptismal font, lying forgotten in a hospital garden, is all that survives from the Franciscan era.

We focus on the northern mission towns of **Zacoalco** and **Amacueca**, where significant colonial monuments have survived.

Zacoalco, La Concepción Chapel: minstrels on the facade

Zacoalco

San Francisco Zacoalco has a long history of destruction and rebirth. The primitive lakeside mission was destroyed by an earthquake soon after its completion in the 1550s. Although its successor was built on sturdier stone foundations, the adobe superstructure failed to withstand earthquakes and was replaced by a masonry structure in the 1650s, under the supervision of Fray Antonio Tello—the Franciscan chronicler of the spiritual conquest of New Galicia. This ill-fated third building also succumbed to the elements, replaced by the post-colonial parish church.

What has survived at Zacoalco, however, is the little hospital chapel of La Concepción, recently restored by INAH with partial funding from a private donor.

Against the rustic facade of rough *tezontle* blocks, the sculpted entry stands out for its rich variety of folk carvings. Reliefs of angels, crosses and foliated monograms are embedded throughout the facade, including a pair of guitar- and violin-playing minstrels to the right of the doorway.

Lively grotesque panels and foliated carving decorate the pilasters and door jambs as well as the choir window. Cherubs hold up the Virgin's crown above the entry and a little statue of La Purísima, the patroness of the chapel, rests in the gable niche.

The intimate interior also has great charm, its vaults and running cornices adorned with reliefs and figure sculptures.

Amacueca

Cut into the mountainside at the summit of this attractive hill town located at the north end of Lake Sayula, the stone-flagged atrium affords an intimate view of the baroque front of this colonial mission—the most complete in the Sayula valley.

Boldly framed by two tiers of Solomonic columns separated by friezes of carved foliage, and surmounted by an ornamental pediment, the retablo facade nevertheless seems spare and geometrical.

Archaic statues of Franciscan saints occupy the shallow niches, including a timeworn figure of St. Anthony of Padua holding the infant Christ. The stone cross affixed to the gable signifies the dedication of the church to the Holy Name of Jesus.

A fine Churrigueresque altarpiece occupies the east end of the church—a surprisingly sumptuous work of art for such a rural setting. Designed in the sophisticated Queretaran style, this remarkable red and gold retablo reveals a high order of craftsmanship, especially in its sophisticated *estípite* columns and intervening niche-pilasters. By contrast, the homely image of El Niño Atocha in a side chapel has inspired a gallery of popular devotional art in the form of handmade *recuerdos* and ex-votos.

The adjacent convento provokes another change of mood. Walking beneath its unadorned gray stone arcades, we can still experience the timeless simplicity of a 16th century Franciscan cloister.

Amacueca, the church of the Holy Name

THE PILGRIMAGE CHURCHES OF LOS ALTOS

The high plain of northeastern Jalisco, which forms the western end of the Bajío, is paradoxically known as Los Altos.

Although fertile—amply watered by the San Juan river and its tributaries—because of frequent incursions of warlike Chichimecs, this frontier region was sparsely settled in early colonial times.

But with the prosecution in 1542 of the Mixton War, which broke the power of the Chichimecs, and the subsequent development of the lucrative silver mines of Zacatecas to the north, colonists arrived in large numbers to settle the new trading towns along the treasure routes.

In Lagos de Moreno and San Juan de Los Lagos—two of the principal towns of Los Altos, whose names commemorate the many small lakes that dotted the region in early colonial times—religious cults flourished around sacred images. In the 18th century these attracted large numbers of the faithful, prompting the construction of large baroque churches that still draw pilgrims from all over Mexico.

LAGOS DE MORENO

Lagos de Moreno is an unspoiled provincial town of shaded plazas and river walks, set beside the Rio Los Lagos—now more a stream than a river.

Founded in 1563 as La Villa de Santa María de Los Lagos—a strategic way station on the silver route from Zacatecas to Mexico City—the fledgling town was often prey to bandits and smugglers as well as Chichimec raiders.

Sections of early defensive walls still border the river bank.

The surviving colonial buildings stand side by side with genteel 19th century mansions, reflecting the general prosperity and cultural pretensions of the 19th century when the town became known as "The Athens of the Bajío," an honorific still cherished by *laquenses*—the city residents.

Lagos de Moreno, the Cathedral: facade medallions

The Cathedral

This magnificent structure is one of the most imposing colonial buildings in Mexico. Officially the parish church of the Assumption, but popularly known as the "Cathedral," it towers dramatically above the town plaza from its raised terrace—previously the location of a 16th century chapel and possibly a sacred prehispanic site before that.

Sculpted in its entirety from pink limestone, the great church was built between 1765 and 1800 to house the shrine of St. Hermion, an early Christian martyr. The saint's relics were brought from

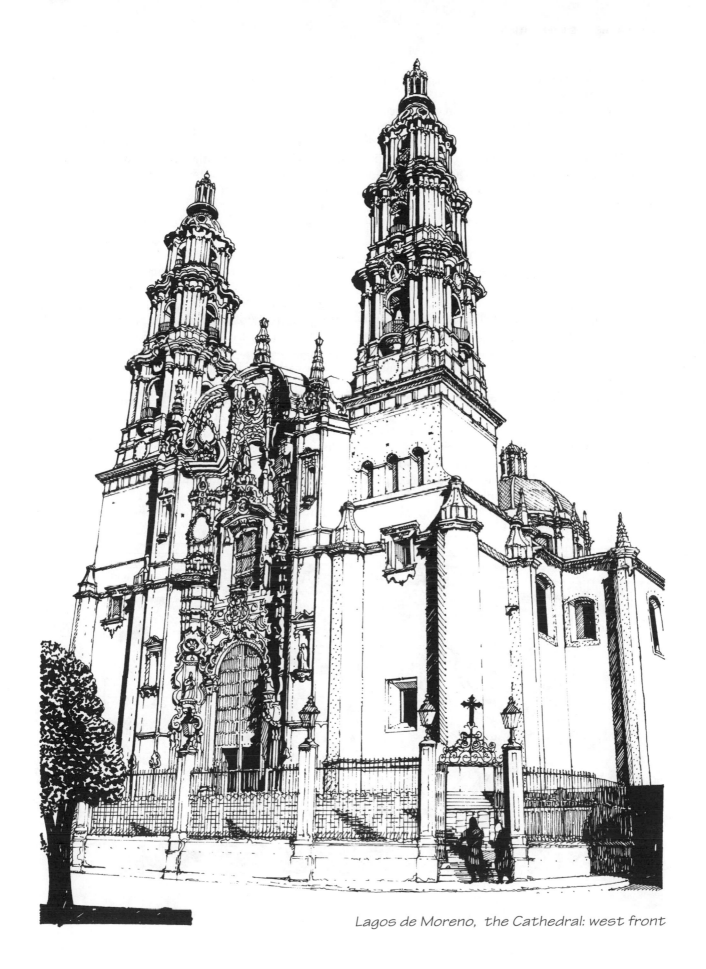

Lagos de Moreno, the Cathedral: west front

Rome in 1790, and the cathedral was dedicated amid great pomp.

Planted firmly above the terraced forecourt and framed by elegant twin towers, the graceful facade is a fine example of terminal baroque or neostyle architecture. Derived in part from the Guanajuatan Baroque, it reflects a period of transition, in which the dense ornament and multiple forms of the Churrigueresque are lightened by rococo flourishes and, under the influence of neo-classicism, given a new clarity of outline.

Encased in a slightly projecting center pavilion, beneath a curving, lobed gable, the facade is actually concave, setting up a dynamic interplay of planes and angles.

While architectural structure still takes second place to surface ornament, elongated niche pilasters, replete with scrollwork and *rocaille* decoration, rise almost uninterrupted to the gable. Much of the original statuary remains, carved in an attenuated Mannerist style with a discernible popular accent.

Multi-staged twin towers—the glory of the church—crown the west front, which wasn't completed until 1795. Massed columns and pillowed pilasters shape the belfries, separated by complex projecting cornices and diminishing in scale as they rise. The lateral entrances of the cathedral complement the facade. Sparely framed with fluted double pilasters, they focus primarily on sculptural detail. Statues in ornate, full-length niches above the doorways are linked to swagged medallions with figural reliefs The featured saints are a virile St. Sebastian on the west doorway, while on the east, a battered St. Catherine leans on her wheel, flanked by busts of St. Barbara and John the Baptist.

Also on the east side of the church, towards the rear, is the remarkable sacristy doorway—a neostyle fantasy flanked by spiral columns and Moorish ocular windows. A complex folk-baroque relief surmounts the doorway, in which naive angels and assorted animals gambol in sea of fringed scrollwork and writhing vines, surrounding an archaic inscription in praise of the Holy Trinity.

The cathedral interior is a kaleidoscope of white, gold and pink. The crossing and the dome above are extraordinarily ornate, layered with ribbed and geometrical vaulting, incised with chevron designs and painted with angels and arabesques. Rococo statues of the Four Evangelists point towards an octagonal cupola encircled by elaborately framed baroque windows.

The surprisingly modest altar of St. Hermion is still found on the right side of the tall nave.

Lagos de Moreno, the Cathedral: carved relief above the sacristy doorway

Las Capuchinas

Abutting the old city wall beside the river are the remnants of the rambling former Franciscan convent of Las Capuchinas, the only other colonial church in Lagos de Moreno, which now serves as an arts and cultural center. A few old stone doorways have been incorporated into the new brick walls of the present complex, and the nuns' washhouse still stands in the rear patio. But the best preserved part of the convent is its former nave front, which displays the traditional double portal of a nun's church—in this case a pair of austere classical doorways framed by hexagonal buttress pilasters—and an apron cornice topped by simple belfries and a few headless statues.

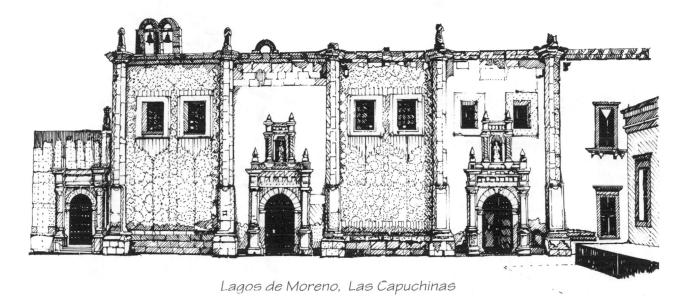

Lagos de Moreno, Las Capuchinas

SAN JUAN DE LOS LAGOS

As we neared San Juan de los Lagos, the highway was crowded with festive pilgrims from distant towns on their way to town. Some rode bicycles, wearing the traditional yellow and black shirts of the Virgin of San Juan.

Families thronged the narrow streets leading down to the main square, accosted on all sides by eager vendors of religious souvenirs, colorful candies and the embroidered blouses that seem to have replaced the traditional woven serapes for which the town was once famous.

The cult of the Virgin of San Juan is one of the oldest and most popular in Mexico. Despite the commercialism, when down in the plaza with the crowd of pilgrims gathered in front of the great basilica, we may experience at first hand the authentic dreams, fears and aspirations of the Mexican people.

The Basilica of Our Lady of San Juan

The image of the Virgin is an antique—a *caña de maíz* figure reputedly brought here from Michoacán in 1542 by Fray Miguel de Boloñia, the Franciscan founder of the original settlement of San Juan Mezquititlan. But it was not until the Virgin's prodigious miracle-working powers emerged in the early 1600s, that her cult took firm hold.

One block west of the plaza stands the little **Temple of the First Miracle**, site of the first mission. It was here, in 1623, that the youngest daughter of a family of traveling acrobats fell to her death from the high wire. The image of the Virgin was rushed to her side, at which point she miraculously revived. A painting of this event hangs in the adjacent cloister.

Starting in the mid-1600s, a series of chapels and shrines was erected in her honor, all of which proved inadequate to accommodate the growing

numbers of devotees. Construction of the basilica began in the mid-18th century, and this grandiose Catholic shrine was dedicated in 1797.

From its elevated trapezoidal forecourt, the Basilica of Our Lady of San Juan soars above the busy central plaza, surrounded by the stone-framed windows and carved cornices of several older colonial buildings.

Designed and built by the Mexico City architect, Juan Rodríguez de Estrada, the form of the basilica is clearly influenced by the nearby cathedral of Lagos de Moreno, although its neostyle west front bears even fewer traces of Churrigueresque ornament.

Harking back to the highly structured retablo facades of the previous century, plain orders of paired columns frame the larger than lifesize statuary. Only the scalloped gable overarching the classical sobriety of the facade hints at baroque exuberance.

The lofty twin towers are almost identical to those at Lagos de Moreno. Yellow tiled cupolas cap each tower, and clustered columns on each stage erupt into projecting interwoven cornices overlain with rocaille decoration, producing a pagoda-like profile. Enormous bells are hung in each tier, vigorously swung at intervals by teams of acrobatic youths, to create an ear-splitting cacophony summoning the faithful to the frequent masses.

The showy neoclassical interior is reminiscent of Guadalajara Cathedral, glittering with white and gold. Mounted on the main altar is the miracle-working image of Our Lady of San Juan, a simple, armatured figure with modeled hands and a sweetly naive face almost buried beneath the array of costly silks, stiff brocades and her weighty silver crown.

The *santo* is constantly surrounded by attendant priests, crowds of pilgrims and legions of the infirm seeking help. Within the precincts of the basilica, a few colonial paintings of quality are hung incongruously beside tawdry trinkets and homely *recuerdos* testifying to the favorable intervention of the Virgin.

In the cool of the early evening, the plaza is a feast for the senses. Weary pilgrims settle around the huge circular fountain to the sound of accordion music and the savory fragrance of barbequed chicken from street stalls, watching the setting sun transform the rosy limestone front of the basilica to gold.

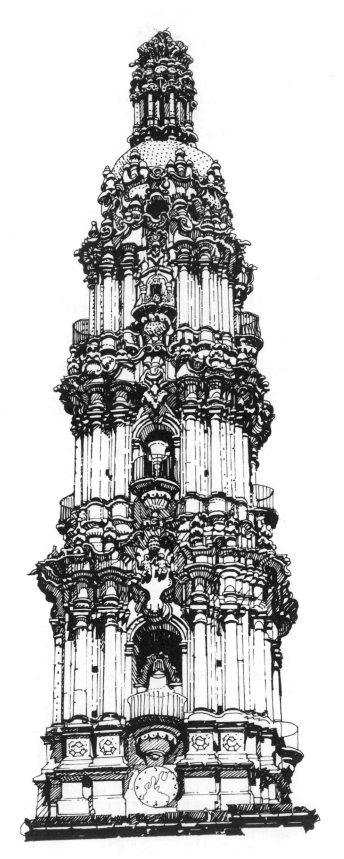

The Basilica of Our Lady of San Juan: north tower

P A R T T H R E E **GUANAJUATO**

The state of Guanajuato is at the heart of the Bajío, a region of fertile plains and rugged hills, veined with rich mineral deposits, that was one of the most prosperous provinces of New Spain.

In early colonial times, this was a frontier region of Spanish settlement and missionization. The lakeland area along the southern fringe of the state originally belonged to the colonial province of Michoacán and was the first part to be developed.

Settlement followed in the agricultural belt along the middle tier of the state, which became the breadbasket of colonial Mexico.

Meanwhile, in the mountainous mining country of northern Guanajuato, rich silver lodes yielded unprecedented wealth, sparking a prodigious 18th century building boom in that area.

Outstanding monuments of colonial art and architecture are found all across the state, dating from the period following the conquest to the final years of the viceregal era.

In the lakeland region are two notable 16th century buildings: the Franciscan mission and hospital at **Acámbaro**, and the Augustinian fortress-priory of **Yuriria**, one of the most impressive Plateresque buildings in Mexico.

Although the colonial towns of the central plain have grown into modern industrial cities, **Salamanca**, **Celaya** and **Irapuato** have managed to retain their historic colonial cores containing a rich mix of architectural monuments, from rambling monasteries to baroque churches and picturesque *barrio* chapels.

The **City of Guanajuato** is internationally known for its wealth of late baroque art and architecture, an artistic heritage that has also left its mark in 18th century hill towns such as **Dolores Hidalgo** and **San Miguel de Allende**.

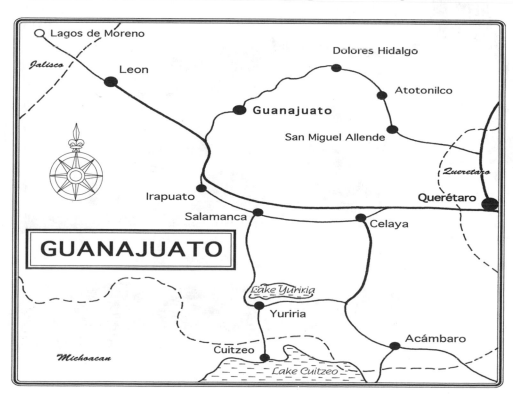

THE TRIUMPH OF THE PLATERESQUE: ACAMBARO AND YURIRIA

Located in the southern lakelands of Guanajuato, these two exceptional 16th century monuments—the Franciscan monastery and hospital at Acámbaro and the magnificent Augustinian priory of Yuriria—have much in common architecturally with colonial Michoacán, of which they were once a part. Both buildings draw on the hybrid Plateresque traditions of Spanish architecture and ornament, but interpret them in contrasting ways that not only reflect their different periods of construction, but also illuminate the diverse approaches of the two religious orders who built them. For while Acámbaro looks back to earlier medieval and *mudéjar* traditions long associated with the Franciscan order in Michoacán, Yuriria embraces the new architecture and decoration of the Renaissance favored by the more forward looking Augustinians.

ACAMBARO

Before the Spanish conquest, when it bordered the banks of an ancient lake, Acámbaro was a key link in the chain of garrison towns protecting the eastern flank of the Tarascan empire. Later, under Spanish domination, it became one of the first missionary towns in the area, settled with Otomís, Tarascans and even a sprinkling of Chichimec tribesmen.

Early chronicles tell us that the friars erected a wooden cross and a rude chapel with a belfry. To inaugurate the mission, a formal mass was celebrated here on September 1526, with processions and great ceremony to impress the Indians.

At the heart of town, surrounded by spacious plazas and parks—once part of a vast atrium—the Franciscan monastery is the most ambitious and architecturally original religious complex in the region. A wonderful 16th century fountain, known locally as La Fuente Taurina, sparkles under the trees. It was reputedly installed to celebrate the

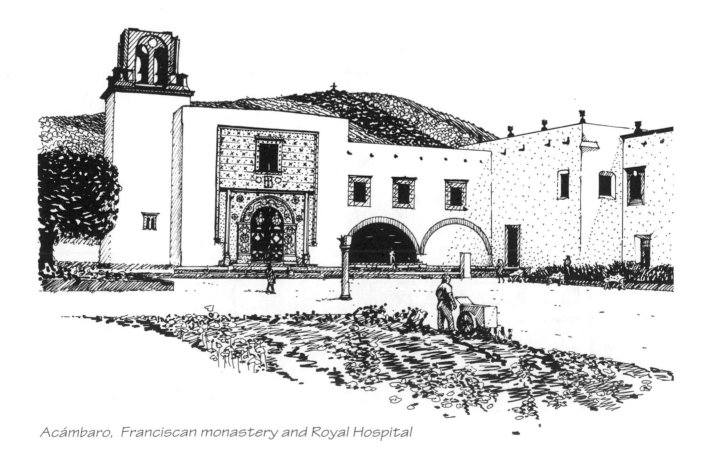

Acámbaro, Franciscan monastery and Royal Hospital

first bullfight held in Acámbaro, and is carved in *tequitqui* style with scenes of the *corrida*, playful reliefs of fish, seashells, grotesque masks and even an Aztec speech scroll.

The Royal Hospital

The hospital dates from 1532, the year in which the convento was founded, and its chapel remains the oldest surviving structure in the group. The newly restored facade, expertly carved from the warm local graystone, is its most picturesque feature. A triumph of the *mudéjar*-influenced Pidgin Plateresque style, it recalls the Michoacán church fronts of Santiago Angahuan and La Guatapera Chapel in Uruapan.

The porch contains the most accomplished stone carving. Stylized busts of Saints Peter and Paul, encased in wreathed medallions, are emblazoned on its wide door jambs, alongside winged cherubs and ornamental cords with stylized tassels and birdshead knots. Similar medallions, enclosing the Five Wounds of Christ, are linked by a grape-

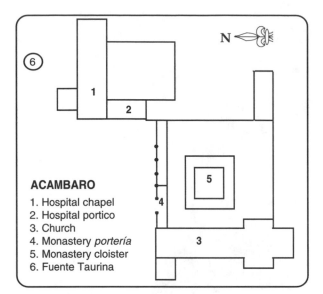

ACAMBARO

1. Hospital chapel
2. Hospital portico
3. Church
4. Monastery *portería*
5. Monastery cloister
6. Fuente Taurina

vine with sharply undercut leaves and fruit that undulates around the arch of the doorway. The archway is outlined by the Franciscan knotted cord and a thorn-and-ribbon molding in high relief.

Another cord, flanked by rosettes, frames the stone cross above the doorway. Wooden doors, carved with reliefs of saints and angels, complement the sculpted porch. A great *alfiz* fringed with Isabelline pearls frames the entire upper facade, including the star-spangled attic and choir window.

The carved stone facade is nicely set off by the whitewashed chapel front, whose only other features are a north tower, notable for its sheared off belfry and archaic *ajímez*, or divided window. The simple chapel interior houses a full complement of local santos, including at least one gruesome *cristo de caña* with gaping wounds and a fearful crown of thorns.

Two low archways beside the chapel are all that remain of the former "pilgrims' portico," or hospital entrance. Unfortunately, too, the interior patio has been altered beyond recognition.

Although the adjacent monastery of Santa María de Gracia was founded in the 1520s, it was wholly rebuilt in the 1700s. The understated classical facade, neatly displayed—like the chapel—against a rectangular whitewashed churchfront, displays a refined Mannerist geometry. The "eared" niche over the entry, containing a large, frontal statue of St. Francis of Assisi, is more frankly baroque.

The unassuming adjacent *portería*, plain in keeping with the Franciscan disdain for ostentation, scarcely prepares the visitor for the grandiose

cloister within. A handsome, moorish fountain rises in the center of the patio, surrounded by unconventional arcades that can only be compared to the eccentric cloister of San Agustín in Querétaro. The lower arcade is faced by unadorned pilasters and archways, but the upper walks are spectacularly flamboyant.

Above elaborately scrolled, carved capitals, richly molded arches spring from the statues of Franciscan and Dominican saints clothed in flowing robes. Their heads are crowned by ornate foliated niches and flanked by winged angels with scalloped headdresses.

Acámbaro, Royal Hospital: medallion of St. Peter

Colonial Acámbaro

In addition to the Franciscan monastery and its hospital, the visitor can also explore several other Spanish colonial monuments in Acámbaro. These include the 18th century **Temple of Guadalupe**, which in addition to its modern frescoes, is noted for a handsome colonial mural illustrating the Genealogy of the Virgin in precise detail.

The **Puente de Piedra**, a late colonial bridge built in 1786 to a design by the neoclassical architect Eduardo Tresguerras, crosses the Lerma River on the eastern side of town. On the west side, sections of a 16th century aqueduct are still in place along the busy main street, Calle Hidalgo, leading to a baroque fountain, **La Fuente Morisca**, now located within the Hidalgo Market.

Also along Hidalgo, three of the fourteen original *ermita* chapels that marked the stations of the cross have survived from the 18th century.

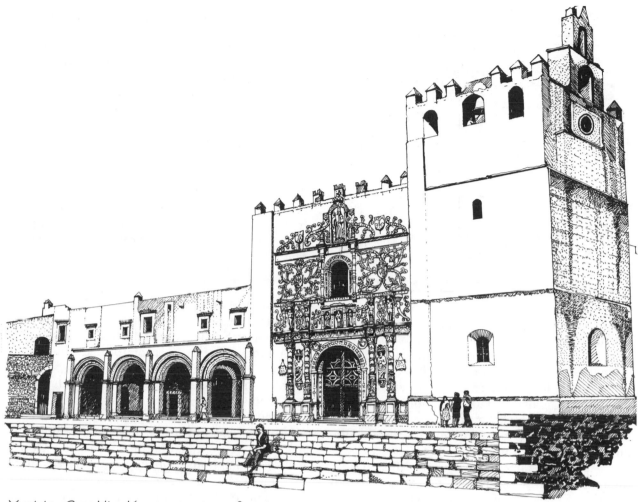

Yuriria, San Nicolás: monastery front

YURIRIA

Some 35 km north of Cuitzeo, across the shimmering plain that divides Michoacán from Guanajuato, lies diminutive Lake Yuriria—a modest 15 kms in length and less than 5 kms across. Looming above its shallow waters from high on the south bank is the majestic 16th century priory of San Nicolás Yuriria, the grandest of the Augustinian monasteries in western Mexico.

The native settlement of Yuririapúndaro, "Bloody Lake" in the Tarascan language—a reference to algal blooms rather than human blood—was initially evangelized by order of Bishop Quiroga. Because of its strategic importance as a frontier town, in 1548 Quiroga ceded the opportunity to establish a mission here to the Augustinians, who were looking to establish a strong presence in the vicinity.

Intended as the flagship priory for the new Augustinian province of San Nicolás de Tolentino, building of the great fortress monastery began without delay. The massive size of the project and its hasty construction were partly a response to repeated incursions of nomadic Chichimecs from the north. Even before it was finished, the monastery served as a refuge against their attacks. The Augustinian chronicler Diego de Basalenque reported that the statue of St. Nicholas above the south doorway bore the marks of Chichimec arrows.

Although work continued through the 1560s, Viceroy Velasco ordered construction halted in reaction to complaints about its lavish scale. But building resumed and the priory was completed in 1570 by Fray Gerónimo de la Magdalena, the

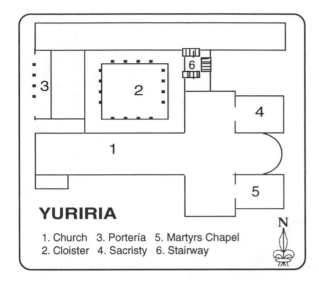

YURIRIA

1. Church 3. Portería 5. Martyrs Chapel
2. Cloister 4. Sacristy 6. Stairway

N

talented friar-architect also responsible for building the monasteries of Cuitzeo and Copándaro.

The viceroy's objections may have had some justification, for the enormous scale and sumptuous appointments of Yuriria cannot be denied. Indeed, another historian of the order, Juan de Grijalva, described the completed priory as "the most superb building imaginable."

The buildings are stepped up the hillside from the lake, which was formerly much more extensive than today. A broad flight of steps climbs to the paved forecourt—part of the terraced atrium, which included the gardens below. The sculpted church facade is flanked on the left by the arcaded portico of the convento, and on the right by a massive tower, whose brutal strength and castellated parapets contribute much to the formidable appearance of this classic fortress monastery.

The Church

The church was conceived on a grand scale, laid out in the form of a Latin cross—rare for a mendicant church in the 1500s. The nave ends in a rounded apse, braced by stout buttresses and flanked by the sacristy and the Chapel of the Martyrs.

A great Renaissance barrel vault covers the nave, compared by the Augustinian writer Matías Escobar to the Temple of Diana at Ephesus. By contrast, the rest of the church—the crossing, apse, transepts and sacristy—is roofed by magnificent star vaults with intricate Gothic tracery. The classical coffered doorways of the sacristy

and Martyrs' Chapel, carved with medallions of the Augustinian pierced heart, are especially handsome. Tragically, during the 19th century the gilded baroque retablos that lined the nave were torched, in an attempt to remove their gold leaf, and subsequently replaced by the uninspired neoclassical altars we see today.

The main glory of the church is its crenellated facade, fulsomely described by Escobar as "the Entrance to Paradise." Although the facade is derived from the famous Augustinian priory of Acolman, just north of Mexico City—generally considered to be the finest Plateresque church front in Mexico—the design underwent significant change in its move to provincial Michoacán. The riot of foliated reliefs erupting across the Yuriria facade has transformed the Castilian reserve of Acolman into a lush pattern of floral decoration that has been dubbed "Tropical Plateresque."

Although the framing of the doorway is similar to Acolman, it has been simplified and is less skilfully executed. Swagged candelabra columns, with lion's head capitals and siren reliefs carved on the lower shafts, flank the doorframe, whose coffered jambs and archway are studded with miniature reliefs of fruits, breads and shells. Ornamental cusped baldaquins head the Gothic niches, which house the elegantly robed statues of Saints Peter and Paul, who are clearly identified on the outlying plaques. Winged cherubs are scattered throughout the porch—upholding the sculpture niches, emerging bird-like from the medallions over the doorway, and fluttering across the surmounting frieze.

As at Acolman, the youthful Christ stands in an ornamental triple niche above the porch, chaperoned by musical angels playing the flute and guitar, except that here, El Niño Jesús still retains his head. The trio is flanked by atlantean figures bearing baskets of fruit on their heads.

Restraint is thrown to the winds in the upper facade. In contrast to the plain ashlar wall behind the sculptural ornament at Acolman, here the intervening spaces are luxuriant with cornucopias and tendrils in the form of slotted scrolls—an agreeable popular touch, reflecting Mexican pictorial preferences that go back to the *horror vacui* of pre-hispanic design.

Giant, ribbon-like floral reliefs flank the choir window, which also features the coffered archway and Plateresque columns of the doorway. Entwined in the foliage, cupid-like figures with

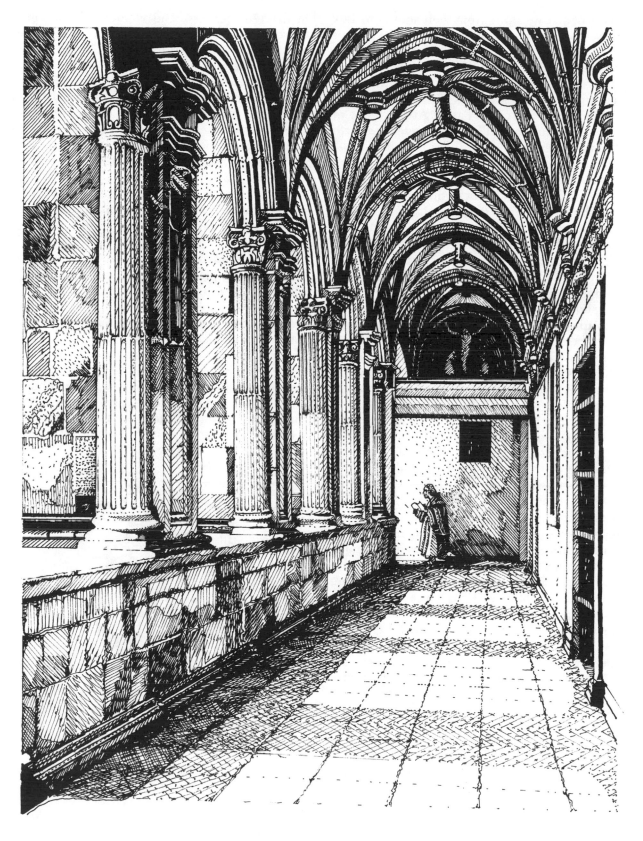

Yuriria, cloister walk

quivers of arrows slung from their shoulders flex their bows—figures thought by some to represent the Chichimec warriors who constantly threatened Yuriria throughout the 16th century.

Above the window, a classic Augustinian lettered frieze unfolds across the entire facade, quoting the words of St. Paul, "At the name of Jesus every knee should bow, in heaven, on earth and under the earth."

Outsize scrollwork extends to the gable, directing our attention to the imposing figure of St. Augustine in the center niche, here portrayed as the Bishop of Hippo, in full episcopal regalia. Escutcheons displaying the pierced heart flank the niche, whose outlying shields are emblazoned with what appear to be Hapsburg imperial eagles.

Many of the facade motifs—swagged baluster columns, coffered and paneled doorframe, and decorative slotted scrollwork—are restated on the south doorway of the church. Still in place in its overhead niche is the arrow-pitted statue of Nicholas of Tolentino, the saint in whose honor both the priory and the Augustinian Province of Michoacán were named, wearing his signature star-spangled robe and holding up a plate of quails.

The Convento

Beside the church, an imposing classical portico fronts the monastery, its four large bays framed by Doric arches and faced with sharp prow pilasters. A handsome Plateresque doorway behind the portico admits us to the enormous two-story cloister, enthusiastically praised by Basalenque as "unparalleled in the Indies."

In general, the stonework of the cloister is more refined than that of the church front, and is expertly finished throughout. Five bays on each side divide the arcades, faced by squared buttresses below, narrowing into "prow" pilasters on the upper level. Prominent "apron" cornices cap both tiers, and lively gargoyles punctuate the upper parapet.

The spare Renaissance forms of the *portería* are continued in the cloister arcades, where molded arches spring from fluted Corinthian half-columns. In a motif that recalls the Dominican priories of Oaxaca, the walks are covered by Gothic vaults set on curved corbels embedded in running cornices.

Gothic rib vaults also span the broad open staircase on the eastern corridor that conveys us to the upper cloister. This second level was added in the 17th century, and is roofed by a simple barrel vault. Friars' cells open on three sides, although the larger prior's chamber faces its own loggia at the rear.

Among the conventual rooms, the most elegant interior doorway—a carved and painted triumphal arch—is reserved for the former refectory. This room now serves as a gallery of colonial art, displaying a group of small sculptures and several, mostly anonymous, religious paintings of saints and martyrs.

Sadly, most of the splendid frescoes that once embellished the walls of this great priory have succumbed to the depredations of time and changing fashions.

These included a huge stairwell mural of St. Christopher, a powerful portrayal that impressed Matías Escobar as "like the Augustinian friars, a giant of the Faith."

The few surviving mural fragments around the lower cloister include some poor quality 17th century scenes of the Crucifixion in the corner niches, complemented by a sequence of earlier monochromatic Passion scenes in the lunettes above. These are linked by lively but intermittent black and orange grotesque friezes along the walks.

Yuriria, "Chichimec" warrior on the facade

THE BAJIO

North of Lake Yuriria, the fertile crescent of the Bajío stretches from east to west in a broad swath across Guanajuato, extending into the neighboring state of Querétaro.

The wheat of this high plain, generously watered by the twisting Rio Lerma, fed the burgeoning population of 17th and 18th century Mexico and created an economic powerhouse. Hundreds of haciendas were also devoted to raising livestock, primarily sheep, whose wool helped foster a substantial local textile industry. Finally, the fabulous wealth generated by the silver mines to the north made fortunes and fed a vigorous trade and commerce.

Such prosperity promoted rapid urban growth, culminating in a prolonged building boom. Churches, mansions, schools and nunneries arose in many cities, often sponsored by the silver barons of the region, creating the rich architectural heritage that we admire today.

The principal colonial settlements of the Guanajuatan Bajío were Salamanca, Irapuato and Celaya. Fueled by an industrial boom, these colonial towns have in recent years mushroomed into large cities, ringed by dusty suburbs and urban sprawl. However, their historic centers still contain colonial buildings of note, several of which have been carefully restored in recent years.

Salamanca and, to a lesser extent, **Irapuato** boast fine 17th and 18th century buildings that exemplify the best of the baroque and Churrigueresque styles in art and architecture, while **Celaya** is home to a group of late colonial monuments designed by its native son, the architect and designer Eduardo Tresguerras, a leading exponent of the neoclassical style in Mexico.

Lambrequin with volutes

THE CHURRIGUERESQUE STYLE

Originating in Spain, this highly ornate style of church altarpiece and facade design reached its apogee in 18th century Mexico. The style took its suitably tortuous name from the Churrigueras, a prominent family of baroque architects and artists who dominated the production of elaborate altarpieces and church fronts in central Spain during the early 1700s.

As brought to Mexico by such Andalusian designers as Lorenzo Rodríguez and Gerónimo Balbás, this eclectic artistic movement drew on motifs from northern European Mannerism and French Rococo to create an intricate and convoluted style that perfectly expressed the complex temper of late colonial Mexico.

The Solomonic column, lavishly encrusted with spirals of carved and painted vines, which had adorned the gilded retablos of the Churrigueras, gave way in the work of Balbás and Rodríguez to the ornamental *estípite*, a complex Mannerist-derived support of inverted obelisks, blocks, moldings and lambrequin pendants, piled one on another. This distinctive motif defined the Churrigueresque style in 18th century Mexico, where it blossomed into a truly native form with the addition of *mudéjar* and even indigenous motifs.

In its final stage, known as the *anástilo*, formal structure was all but abandoned in favor of ever more exuberant ornament.

The Churrigueresque reached its apogee in the sumptuous facades and altarpieces of a select group of late 18th century churches and mansions located in the capital and prosperous silver cities of New Spain. Especially in the Bajío, this opulent style embodied the concept of *grandeza mexicana*, the swelling of patriotic nationalism espoused by the restive Mexican aristocracy during the last years of Spanish domination.

SALAMANCA

At the time of the Spanish conquest, several Indian villages existed in the vicinity of present day Salamanca—notably the Otomí town of Xidoó.

As spiritual subjects of the bishop of Michoacán, the Otomís and Chichimecs of the area were evangelized in the 1550s by the Franciscans, with the encouragement of Vasco de Quiroga, who was instrumental in founding an Indian hospital here.

Although a modern church now stands on its site, the 16th century crucifix sent here by the bishop from Pátzcuaro has survived—still the object of special pilgrimage during Holy Week.

This classic black Christ, known as El Señor del Hospitál, remains mounted on the high altar, his bulging veins and knotted torso standing out starkly against his richly embroidered skirt.

However, it was not until 1603 that the frontier town of Salamanca was officially founded. Settled by colonists from nearby Irapuato, the new town was laid out beside the banks of the Río Lerma,

and named after the stately university city in northern Spain.

The principal colonial monuments to be seen in Salamanca today are, first and foremost, the great priory of San Agustín with its double cloister, and second, the old parish church of San Bartolo, renowned for its intricate carved baroque facade. Around the city there are also several *barrio* chapels of historic and artistic interest, in particular the little church of La Nativitas.

	Revolución					
5	4		1			
	Juarez					
					3	
	Hidalgo					2

SALAMANCA

1. Priory of San Agustín 4. La Nativitas
2. San Bartolo 5. San Juan
3. Templo del Hospital

Zaragoza *5 de Mayo*

SAN AGUSTIN

Although the Augustinians founded a mission here soon after the incorporation of the new town, it not until 1615 that the order decided to establish a permanent priory here. The project was delayed even further, and only in the 1640s did construction of the church and adjacent convento begin, under the enterprising prior Miguel de Guevara.

In the mid-1700s, a second, larger cloister was added, and a series of opulent retablos commissioned for the church by the Augustinian Provincial, José Luis de Ortega, nicknamed "The Craftsman." At its zenith, the great priory of San Agustín housed some 60 friars. Located only a few minutes walk from the river, the church and convento fill almost an entire city block and face north across a spacious plaza.

The Church

Surmounted by massive twin towers, the broad church front is uncompromisingly plain. Its modest openings and sculpture niches seem almost lost in the unarticulated expanse of stone. The severe lines of the elongated Renaissance doorway are leavened by a few traces of baroque ornament—some spirals on the columns and in-

conspicuous fleurs-de-lis on the supporting pedestals. The only remarkable feature is the sculpted figure of Christ Crucified affixed to the upper facade beneath a sheltering shell archway. The towers are more ornamental, ringed by slender statues of Augustinian saints and the Twelve Apostles, and capped with octagonal tile-covered spires.

Remodeled in the 18th century, the splendor of the church interior compensates for its plain exterior. The long, single nave and shallow transepts are illuminated by a majestic, paneled *mudéjar* dome. Ornate baroque doorways open from the transepts into the sacristy and the richly appointed *camarín* at the rear of the apse. The Churrigueresque side entrances are framed in high style, with swags and crowns above the doorways.

Sumptuous church furnishings include an ornamental carved wooden confessional and the lavish pulpit, whose swagged box and canopy are exquisitely inlaid with Philippine ivory and ebony, and its curving stair rail painted with panels of souls ascending to Heaven. An expansive canvas of the Holy Trinity, by baroque artist Juan Báltasar Gómez, hangs beneath the choir.

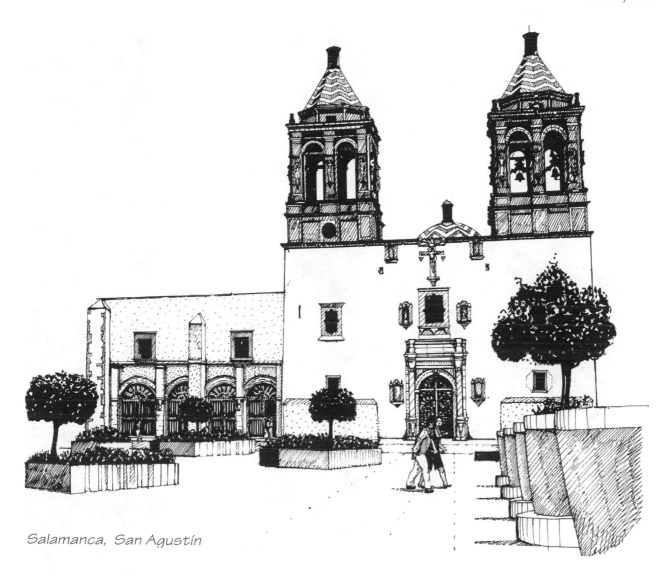

Salamanca, San Agustín

The Retablos

The gilded retablos lining the nave and transepts establish this as one of the most spectacular late baroque interiors in Mexico. Attributed to the master sculptor Pedro de Rojas and the regional architect and designer Mariano de Las Casas, these extraordinary altarpieces push the envelope of Churrigueresque art to its extreme. Their intricate forms, based on highly ornate *estípite* pilasters and sculpture niches, are virtually overwhelmed by the profusion of opulent rococo and *mudéjar*-inspired detail.

The transept retablos of St Joseph and St Anne, both by Pedro de Rojas, face each other across the church. These are remarkable for their lifelike tableaux, illustrating episodes in the lives of the two saints, which are among the finest examples of 18th century figure sculpture in Mexico (see diagrams p.162).

The St. Anne altarpiece depicts "the Five Mysteries of Saint Anne with the Seven Princes (Archangels)." The masterfully executed figures, opulently arrayed in *estofado* garments, play out their roles in a theatrical setting of swagged canopies framed with openwork crowns against an intricate gilded basketweave backdrop, aswirl with angels, foliage, scrolls and strapwork. Although the figure of St. Anne is conventionally posed and stony-faced, other figures—especially the archangels—are expressive and animated, revealing the gifted hand of Rojas himself.

The elongated lower niches show St. Anne in the presence of God the Father (left) and in the Annunciation scene (right). Beneath a grandiose crown, St. Anne holds the infant Mary in the swagged center niche. The Archangel Michael poses above the crown, silhouetted against the window behind. A charming scene of the saint

with the young Virgin Mary appears in the rather confined upper right niche, balanced by a Presentation at the Temple on the left, dominated by the imposing figure of a rabbi. The original centerpiece, a tableau illustrating the Nativity of the Virgin, is unfortunately missing.

The altarpiece of San José is virtually identical in form, although the sculptural quality of the figure sculpture seems superior in this later retablo, thought to be Rojas' last major work. A moving, and rarely depicted, study of Christ at the deathbed of a gaunt St. Joseph occupies the center niche, flanked by Christ among the Doctors on the right, and a solemn Dream of Joseph, on the left, in which the Archangel Gabriel gestures gracefully to the sleeping saint.

The Marriage of Joseph and Mary on the upper right is matched on the left side by a delightfully anecdotal Flight into Egypt, complete with donkey—a masterly relief that is, however, difficult to see clearly due to its elevation and backlighting from the nave window.

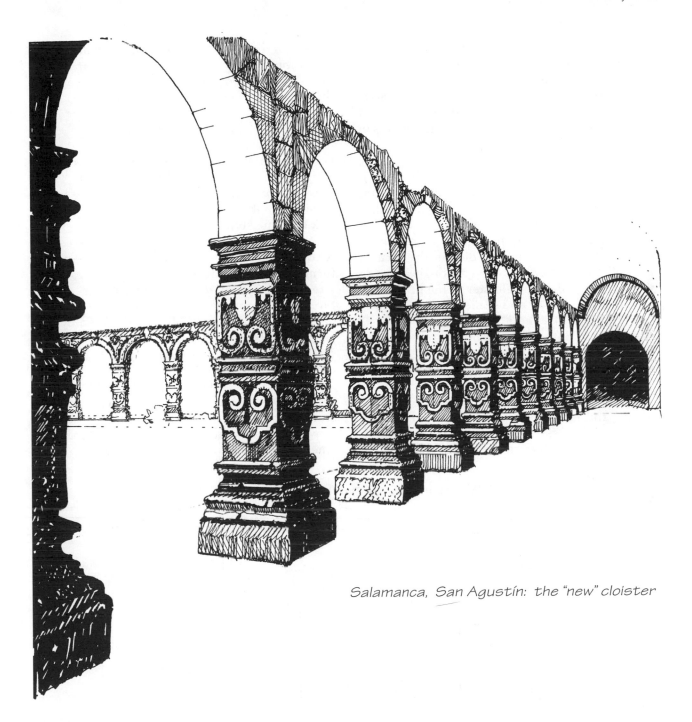

Salamanca, San Agustín: the "new" cloister

The three other major retablos along the nave are dedicated to various Augustinian saints. Executed in a less exuberant style than the transept altarpieces, they are believed to be the work of the famous Queretaran sculptor Mariano de Las Casas. On the left side, beside the transept, stands the altarpiece of San Nicolás de Tolentino. Crowded scenes from the saint's life are rendered in high relief, accompanied by voluptuous shell arches and sweeping rocaille spirals projecting from the gilded tapestry behind. Among these colorful and expressive reliefs, the tableau of St. Nicholas ministering to a group of ragged beggars is especially lively—a virtuoso work from Las Casas' own chisel.

The altarpiece opposite, which is dedicated to St. Thomas of Villanova, the Spanish Augustinian missionary, is more purely decorative—its giant *estípite* pilasters are a sculptural achievement in themselves. The ornamental screen, or *celosia*, at its center hides a balcony and an inner doorway that communicates with the cloister behind.

The adjacent retablo of Santa Rita de Cascia, the 15th century Italian visionary, also has great visual appeal. The flat, gilded checkerboard surface shows off the reliefs to perfection—a series of medallions, alive with black-robed nuns and friars, depicting the miracles and tribulations in the eventful life of this Augustinian saint.

The Convento

The four bays of the *portería* beside the church are outlined in Renaissance style by molded arches and pilasters hung with lacy lambrequins—a harmonious effect only marred by an obtrusive exterior buttress that now bisects the arcade. Beyond the portico, we pass through an wide vestibule into the first cloister of the priory.

This is the smaller and earlier of the two cloisters, framed, like the *portería*, in spare *purista* style with smooth round archways separated by flat Tuscan pilasters. The upper arcades are noted for their decorative forged iron railings, which are original.

The larger cloister is very different. Created during the late 18th century makeover of the convento, the vast patio is enclosed by striking lower arcades boldly decorated in a provincial Churrigueresque style. Their bulky piers are carved on all four faces with volutes and *pinjantes*, ingeniously combined in two almost mirror images on the upper and lower sections.

San Bartolo

Formerly Salamanca's parish church (*la parroquia antigua*), this simple building boasts one of the most exotic church fronts in the region—a rose-colored "fantasy facade," carved in an ebullient folk baroque style.

Sandwiched between plain tower bases, the retablo facade is a riot of exuberant ornamental forms and sculptural detail. Hybrid *estípites*, wreathed in spirals, vie for attention with complex Moorish cartouches. Shell niches, adorned with oakleaf and acanthus scrolls, are outlined by exuberant floral cords. The *mudéjar* choir window also catches the eye with its starfish profile and intricate foliated casement.

Beside the doorway, gesticulating figures of Spanish conquistadors and Indian warriors with scalloped bonnets are matched with a rogues' gallery of grotesque masks and grimacing gremlins, emerging from clumps of curling foliage.

Transept Altarpieces of San Agustín, Salamanca

RETABLO OF ST. ANNE
1. St. Anne & the infant Mary
2. St. Anne & God the Father
3. The Annunciation
4. Presentation at the Temple
5. St. Anne & the young Mary

RETABLO OF ST. JOSEPH
1. Christ & Death of Joseph
2. The Dream of Joseph
3. Christ among the Doctors
4. The Flight into Egypt
5. Marriage of Mary & Joseph

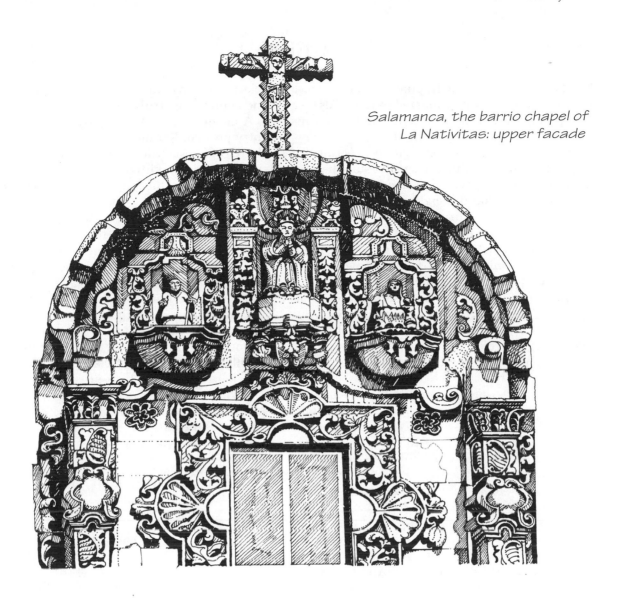

*Salamanca, the barrio chapel of
La Nativitas: upper facade*

THE BARRIO CHAPELS OF SALAMANCA

Scattered on the fringes of the old city are several modest churches and chapels dating back to colonial times.

Just around the corner from San Agustín, facing the attractive Jardín de la Constitución, is the towering neoclassic **Templo del Hospital**, thought to stand on the site of the 16th century hospital chapel of La Asunción. The church is the shrine of El Señor del Hospital, a *santo* believed to be the crucifix sent here by Vasco de Quiroga.

The little **Chapel of San Juan**, in the *barrio* of the same name, is located on a bend of the Río Lerma in the eastern part of the city. Also reputed to date from the 16th century, the primitive church faces its former atrium, now a park, where a carved atrial cross still stands.

But the most interesting of the Salamancan chapels is **La Nativitas**, a folk baroque gem located in a workaday quarter on the east side of town.

This tiny 18th century chapel boasts an extraordinary sculpted facade, bounded by *estípite* pilasters and crowned by a scalloped, rounded gable. Boldly carved shells and spiralling foliage decorate the openings and niches.

The upper niches house archaic statues of the Virgin of the Assumption and her aged parents, Joachim and Anna—all carved in primitive frontal stances.

An unusual serrated cross, carved with the Instruments of the Passion and mounted atop the gable, creates a striking silhouette.

CELAYA

Unlike Salamanca and Irapuato, Celaya was a wholly Spanish town, colonized in the 1570s by a group of Basque settlers. Its name, in fact, means "flat land" in the Basque tongue.

The city flourished in colonial times because of its productive agriculture, large livestock haciendas and brisk trade with the silver mining region to the north. But like its neighbors, Celaya entered a period of troubles during the waning decades of the viceregal era. The city was a hotbed of *criollo* unrest, and played an important role in the Independence movement. It also later became a bloody battleground during the Mexican Revolution.

Once past Celaya's unprepossessing industrial outskirts, the visitor finds a spaciously laid out historic center of parks and plazas, fronted by many elegant colonial buildings. Although the monastic churches of San Francisco and San Agustín date back to the 1600s, Celaya's main architectural heritage belongs to the neoclassical tradition of the late colonial years, in particular the work of its favorite native son, Francisco Eduardo Tresguerras (1759-1833).

Tresguerras was among the best known exponents of the neoclassical style in Mexico. A poet and musician as well as an architect and sculptor, he was also a polemicist, whose vilification of the Mexican Baroque, and especially the practitioners of the Churrigueresque, precipitated the mutilation of many colonial buildings and the destruction of their magnificent baroque altarpieces. Ironically, his architecture is now viewed as a hybrid style, in which neoclassical forms blend with many of the very baroque elements he so vigorously attacked.

In addition to his masterpiece, the church of El Carmen, Tresguerras work can be seen in many other Celaya churches. He also designed the Independence monument in the main Plaza de Armas, and a bridge over the nearby Río Laja.

Nuestra Señora del Carmen

This imposing structure, designed and built by Tresguerras, is his best known building and a major landmark in Celaya.

Completed in 1807, this Carmelite church is considered to be his finest work. But far from being a model of the neoclassical style, it is wildly eclectic, which lends it considerable native charm and confirms its truly Mexican character.

A single central tower surmounts the Greek entry portico. Reputedly based on James Gibbs' church of St. Mary le Strand in London, this idiosyncratic tower, with its giant scrolls and broken pediments, remains more baroque than correctly classical.

Similarly, despite its zigzag decoration in yellow tile, the high dome recalls Michelangelo's design for St. Peter's in Rome. The south porch too, arrayed with stepped columns, an interrupted pediment and curving balustrade, pays greater homage to the Italian high baroque than to the classical canons of antiquity.

The vast white and gold interior, lined with colonnaded marble altars, appears at first glance to follow neoclassical edicts more faithfully, but even here scrolls and broken pediments intrude, testifying to the irrepressible influence of the baroque. Tresguerras also painted the striking frescoes of the Last Judgement and the Raising of Lazarus in the adjacent Capilla del Juicio.

OTHER CELAYA CHURCHES

San Agustín

San Agustín was the earliest of Celaya's monasteries, founded in 1609. The convento dates from the mid-17th century, the stately arches and paneled piers of its *portería* and cloister arcades showing a pleasing if severe Renaissance character.

The Plateresque church was given a facelift a century later, when the majestic baroque porch with its relief of St. Augustine was added.

San Francisco

This 17th century monastic church was altered early in the 19th century under Tresguerras' supervision, when towers and a new portico were added in pure neoclassical style. He also designed the main altar. The 17th century convento, with its spare Plateresque cloister, remains largely unchanged.

Two other churches of colonial origin, near the arcaded Plaza de Armas, are the neoclassical **Temple of the Third Order**, also with altars by Tresguerras, and the **Chapel of the Cross**.

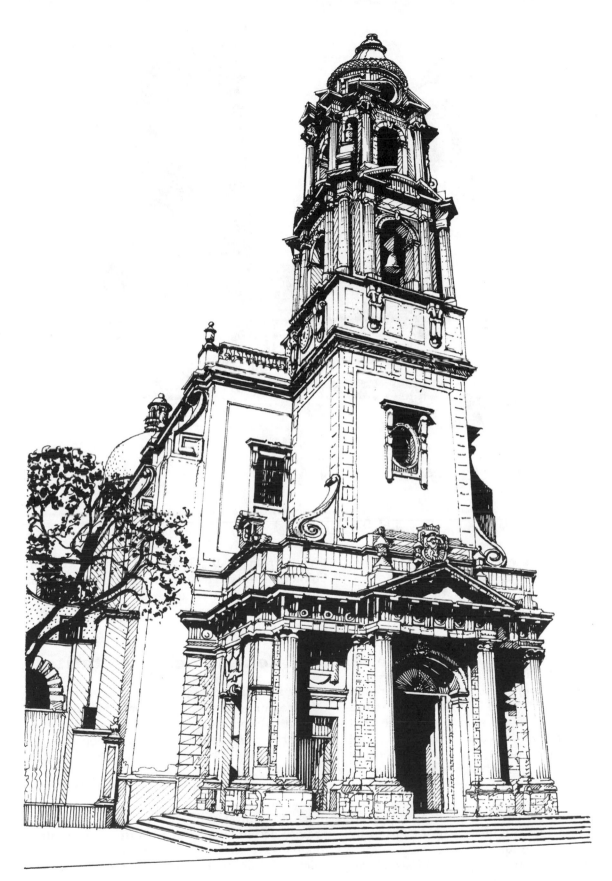

Celaya, Nuestra Señora del Carmen

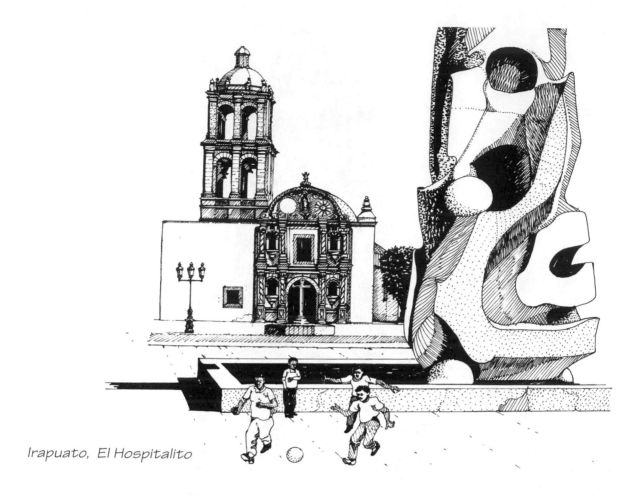

Irapuato, El Hospitalito

IRAPUATO

Located only a few minutes from greater Salamanca by superhighway across the dusty plain, busy Irapuato is ringed by nondescript industrial suburbs. But a visit to the historic center with its numerous colonial monasteries, churches and chapels, can be rewarding, especially during the Strawberry Festival in early April.

Originally a fortified Tarascan outpost—the most northerly of their defences against marauding Chichimecs—Irapuato had become a settled Spanish town by 1550, with sizeable indigenous communities of Tarascans and Otomís.

Few 16th century buildings now stand, although the chapel of the hospital, founded by Vasco de Quiroga, is commemorated by the later Templo del Hospitalito. Most of the surviving religious monuments date from the 18th century and can be found within a few minutes' walk of El Jardín Hidalgo, the central plaza.

Although conservative in plan and structure, and subjected to much remodeling, Irapuato's churches illustrate a range of popular baroque styles: from rustic folk architecture, through Solomonic retablo facades, to ornate fronts influenced by the Churrigueresque buildings of the silver cities to the north.

El Templo del Hospitalito

Facing its own little garden plaza apart from the other colonial buildings of Irapuato, El Hospitalito is reputedly built on the site of a hospital established by order of Bishop Quiroga, soon after the city's founding, to minister to the Otomí Indians of the fledgling settlement.

Its rustic retablo facade, dated 1733, is similar to that of the parish church in its emphatic outlines—the spiral columns and shell niches are heavily accentuated. But because of its prolific folk baroque sculpture, it seems more approachable. A statue of the Virgin of the Immaculate Conception, carved by the native sculptor Crispín Lorenzo, occupies the center of the gable, flanked

by outsize reliefs of the sun and moon—common symbols of La Purísima. The bold scalloped pediment rising above the church front is reminiscent of the Nativitas Chapel in Salamanca.

A stone cross, carved with Passion symbols, stands before the chapel door, and gargoyles in the form of elephants and alligators jut out from the parapet along the nave wall. The oversized tower is a later addition.

La Soledad

Unfortunately, the ornate baroque church front of La Soledad has been mostly eclipsed by the arcaded patio of the adjacent convent school of **La Enseñanza**, now the Palacio Municipal, a spartan work by Eduardo Tresguerras added in 1810. Nevertheless, the partly obscured facade—a frothy delight of filigree carving and stylish rococo statuary—can still be glimpsed from the courtyard.

A worn Churrigueresque portal on the south side of the church, around the corner from the Jardín Hidalgo, gives access to the dowdy interior.

San Francisco

On the opposite side of the Jardín Hidalgo lie the remaining constituents of the rambling Franciscan mission—the large church of San Francisco and its smaller cousin, the Chapel of the Third Order. Finished in 1799, the San Francisco facade reflects an unhappy transition from the late baroque to neoclassicism—a work of little character, with few engaging features. The Churrigueresque portal of the adjacent Third Order Chapel seems more successful, if somewhat provincial.

A few blocks north of the Jardín Hidalgo we enter a bleak market plaza, somewhat enlivened by the presence of two contrasting colonial church fronts: the parish church of **La Merced** and its neighbor, the **Temple of San José**—a chapel that enjoys the devotion of the indigenous inhabitants of the area.

La Merced

This south-facing parish church, dedicated to the Virgin of Mercy, is the oldest of Irapuato's standing colonial churches, dating from the early 1700s. Plateresque and Solomonic columns frame the retablo facade, strongly accentuating the doorway, choir window and sculpture niches.

This geometric severity is partly mitigated by the intricate surface ornament. Arabesque panels of tightly knit, almost abstract relief foliage fill every surface—bordering the openings, enveloping the niches, and spreading to the pedestals and even the shafts of the columns. The scalloped niches still contain colonial statuary, which includes several jaunty archangels.

San José

Painted dark red and decorated in popular Churrigueresque style, San José is the most ornate and striking of the Irapuato facades. Blocky *estípite* pilasters frame a series of sumptuously canopied and tasseled niches, inhabited by folk baroque statues of assorted saints.

The high lobed gable is fringed by an exaggerated, wavelike border and profusely adorned with eclectic reliefs and architectural sculpture, recalling the churches of Morelia.

A Calvary scene with a spreading, draped crucifix is the main focus; the foreshortened statue of Christ hangs from the cross above the mourning figures of Mary and St. John. The tableau is surmounted by an elaborate niche containing the figure of John the Baptist. Diminutive archangels prance on atlantean pedestals, flanked by *fleur-de-lis* medallions.

The temple interior, cluttered with dusty *santos*, is normally crowded with Indians, especially on market days.

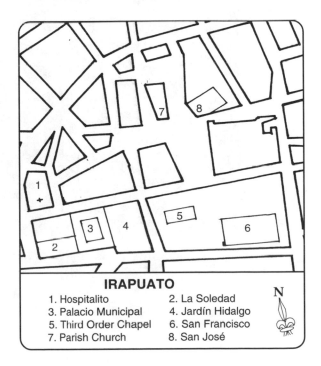

IRAPUATO

1. Hospitalito
2. La Soledad
3. Palacio Municipal
4. Jardín Hidalgo
5. Third Order Chapel
6. San Francisco
7. Parish Church
8. San José

N

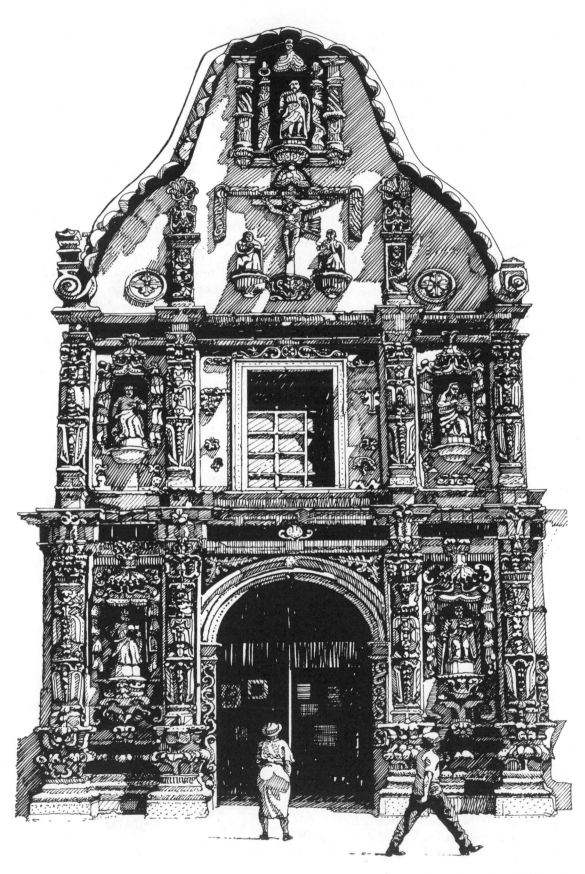

Irapuato, San José facade

THE CITY OF GUANAJUATO

Striking north from the plain of the Bajío, we find ourselves in rugged mining country. The city of Guanajuato was one of the richest and most famous of the colonial silver cities.

Built along the sides of a steep ravine between ore-bearing hills, it consists of a series of plazas linked by narrow, twisting surface streets and a labyrinth of tunnels along an ancient, subterranean river bed.

The mountainous terrain of this arid region, inhabited at the time of the conquest by warlike Chichimec tribesmen, discouraged early Spanish colonization. It was only after major silver strikes here in the 1550s, and the subsequent construction of a hilltop fort, that the area was settled in earnest. Within twenty years, the population of Santa Fé de Real de Minas, as early colonial Guanajuato was known, burgeoned to more four thousand Spaniards, Tarascan Indians and blacks.

During the 1600s, rich new silver veins were discovered in the surrounding hills, bringing fabulous wealth to their owners and prosperity to the colonial city. Famous mines, among them La Valenciana, Rayas and Cata, were located above the north side of the city, where the lower slopes were densely settled with *barrios* that housed miners and other artisans. Advances in mining technology, with the easing of trade and other restrictions in the 1700s, resulted in even greater affluence, stimulating an unprecedented building boom in the second half of the 18th century.

The Architecture

The Churrigueresque is king in Guanajuato. This complex and highly ornate style reached its apogee in a remarkable group of 18th century church facades and altarpieces in and around the city.

Some earlier churches, notably the Basilica of Our Lady of Guanajuato and San Roque, continue the sober baroque tradition of the 1600s. But after the mid-1700s, the city saw the triumphal unfolding of the Churrigueresque style, from its tentative beginnings among Guanajuato's numerous churches to its full flowering in the opulent silver chapels situated on the surrounding bluffs.

There are many ways to explore Guanajuato's colonial buildings. By simply wandering haphazardly through its maze of squares and alleys, the visitor is often delighted by the sudden view of a tall tower or ornamental facade. In this chapter we start from the center and work towards the periphery, a route that parallels the chronological development of the city's architecture.

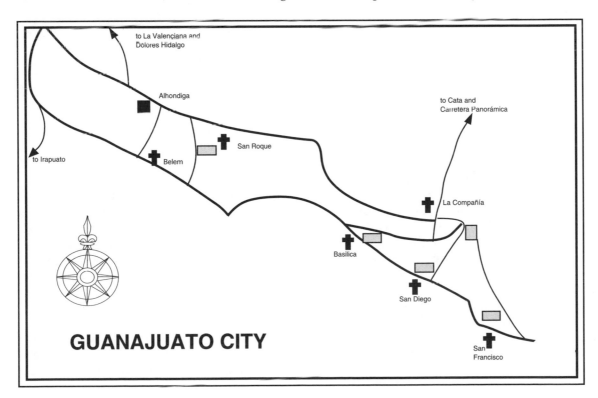

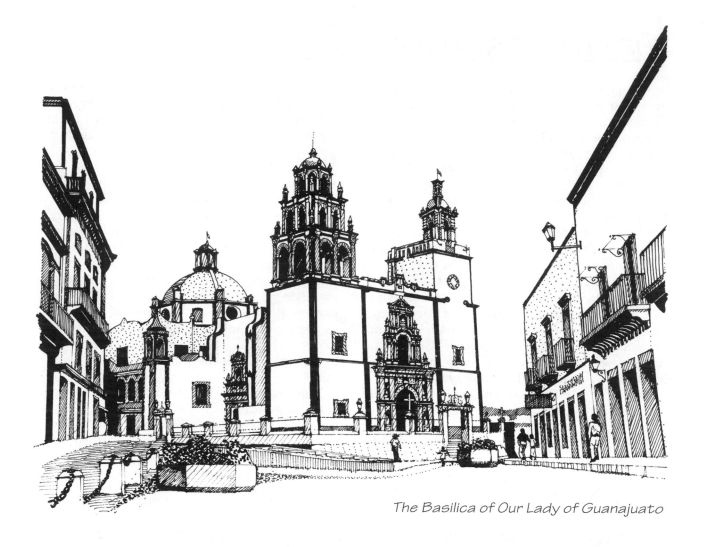

The Basilica of Our Lady of Guanajuato

The Basilica of Our Lady of Guanajuato

According to local tradition, Perafán de Rivera, Guanajuato's first royal superintendent of mines, brought with him from Spain a wooden statue of the Virgin Mary, as a gift from the reigning monarch, Philip II. This revered 16th century image of the patron saint of the city now rests on the high altar of the Basilica of Our Lady of Guanajuato.

From its elevated terrace, the basilica overlooks the wedge-shaped Plaza de la Paz, an urban space at the heart of the city, lined with elegant colonial palaces and public buildings. The basilica presents a rectangular, cathedral-like west front of apricot-colored stucco, striped with reddish-brown accents. The towers are mismatched, with only the north one completed as originally designed.

Framed by this geometrical front, the triple-tiered limestone facade dates from the late 1600s—the earliest in the city. Although retaining the orderly classical lines of the 17th century baroque, this *portada* reveals an inventive use of ornament in its detailing that anticipates the Churrigueresque exuberance of the coming century.

A triumphal arch of fluted pilasters and discreet shell niches frames the lofty doorway, which is crowned by arabesque reliefs. The upper tiers are more decorative. Fluted pilasters and decorative colonnettes, headed by acanthus leaf capitals, flank the *mudéjar* choir window. The praying figure of the Virgin looks out from the ornate top tier, which is densely carved with trailing vines. A chubby pair of winged cherubs hold up the cross and orb in the crowning pediment.

A great lanterned dome rises above the crossing—part of a neoclassical makeover of the basilica in the late 1700s. At that time, the original baroque

retablos inside were dismantled and all have since been lost, except for a few decorative fragments now banished to the sacristy.

The jewel-encrusted image of the Virgin of Guanajuato, however, remains prominently displayed on a solid silver pedestal before the main altar.

San Roque

Every June, the plaza of San Roque—an enclosed square with a Spanish medieval ambience—comes to life with poetry, drama, song and dance during the city's famous Cervantes Festival.

Elevated above the plaza at its north end, the church was designed in 1726 by a local architect,

José Sopeña y Cervera. According to local lore, because of the terrible plagues that were sweeping Mexico in the 1730s, it was dedicated to San Roque, the patron saint of pilgrims and protector against pestilence.

Currently, the fabric of the church is crumbling and in urgent need of repair. At the head of a two-sided stairway rises the plain facade—much more severe than that of the nearby Basilica, upon which it is based.

A classical geometry of fluted and paneled pilasters frames the simple openings and scalloped niches, which still house stone statues of saints, including the headless San Roque above the choir window, identified by his pilgrim's garb and faithful dog.

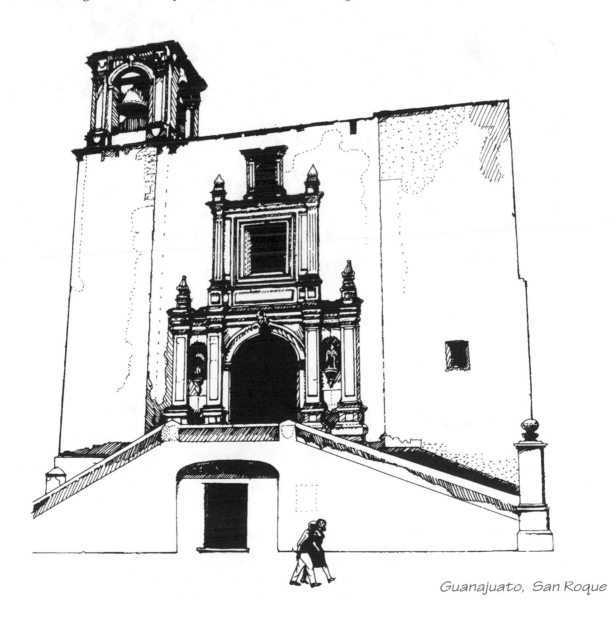

Guanajuato, San Roque

171

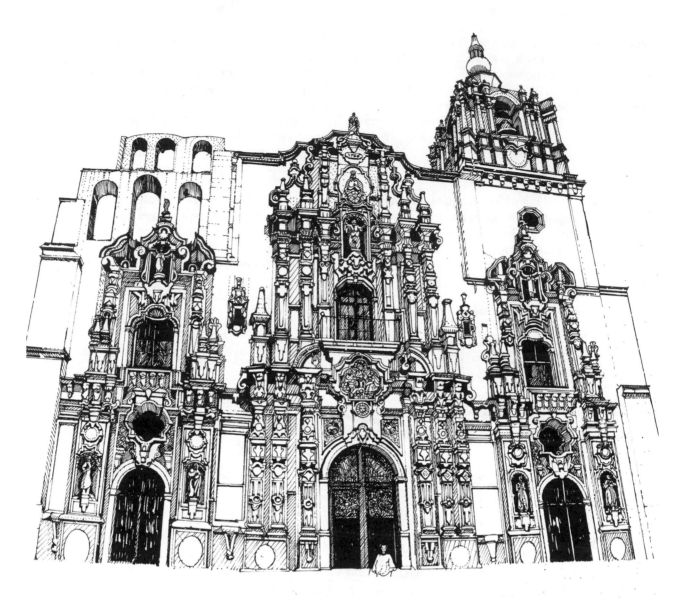

Guanajuato, La Compañía

La Compañía

Located on a narrow street beside the University, just a few steps from the Plaza Juárez, the majestic hillside basilica of La Compañía is the grandest church in the city and one of the noblest Jesuit monuments in Mexico. The church is an architectural as well as an historical landmark, marking the ascendancy of the Churrigueresque style in Guanajuato.

Although the Jesuits had long played a role in colonial Guanajuato—Ignatius Loyola was one of the early patron saints of the city—it was not until the 1730s that leading citizens, including several wealthy mine owners, agreed to support the es-

tablishment of an independent Jesuit college and church.

A sloping site on the northeastern side of the city was chosen and elaborate plans were drawn up. In 1747 the foundation stone was laid for the opulent new church, which rose on a massive terrace that had been carved out of the hillside. The architect Felipe de Ureña, a member of a distinguished family of Mexico City sculptors and a leading Mexican exponent of the emerging Churrigueresque style, designed the sumptuous facade and supervised construction. This ambitious and costly project, estimated at 200,000

pesos—a huge sum for the time—became a major focus of civic pride.

The basilica was consecrated in 1765 and dedicated to the Holy Trinity, as symbolized by its triple naves. To commemorate its dedication, a celebratory poem, entitled *Rasgo breve de la grandeza Guanajuateña*, was commissioned. This literary work, which described in tortuous baroque verse the design, construction and appointments of the temple, is nevertheless an invaluable source for historians. Ironically, the publication of this document in 1767 coincided with the expulsion of the Jesuit order from Mexico, a traumatic event for the citizens of Guanajuato who vigorously protested the expulsion in street demonstrations.

La Compañía was never finished as planned. The grand plaza in front did not materialize and its tall towers were not built. The undistinguished south tower is a later addition, while the crude *espadaña* on the north side disfigures the entire west front. Subsequent modifications have also changed its appearance, both inside and out. The scaling back of the exterior forecourt and staircases has weakened the imposing sweep of the basilica's west front.

A thoroughgoing neoclassical remodel in the last century entailed removal of the superb Churrigueresque altarpieces, irrevocably debasing the interior, whose white and gold scheme contrasts unfavorably with the dramatic original vaulting of exposed black *tezontle*. Only the lofty, triple-tiered cupola, which replaced the fallen colonial dome in the 19th century, comes close to the expressing the majesty of the original church.

After the expulsion of the Jesuits, the Oratorian order assumed responsibility for the basilica, which was renamed San Felipe Neri for the Oratorian founder. But the church is still popularly called La Compañía, honoring the Company of Jesus.

The Facade
Sculpted in high relief from roseate limestone, the triple portals of the basilica mark the starting point—many would claim the high point—of Churrigueresque architecture in the city. Formerly thought to be derived from the Sagrario facade of the cathedral in Mexico City, a seminal work by Lorenzo Rodríguez, Felipe de Ureña's Guanajuato front is now known to predate the metropolitan facade, thus making La Compañía one of the earliest masterpieces of the mature Churrigueresque style in Mexico.

Traces of color in its recesses tell us that the facade was once painted in brilliant polychrome, a finishing touch that might be expected from Ureña, a master of retablo design.

The ornate central portal dominates the composition, establishing the twin themes of the facade: the Exaltation of the Trinity and the glorification of the Jesuit order.

Massed *estípite* columns carved with geometric motifs soar on either side of the doorway. Framed by an elaborate scrolled cartouche, the magnificent central relief of the Holy Trinity rises from the keystone through the surmounting *alfiz* and cornice. The robed figures of the Trinity, represented here as identical bearded sages, are accompanied by their divine symbols—the sun (God), the lamb (Christ) and the dove (Holy Spirit)—nested in the *alfiz* amid luxuriant acanthus foliage.

Estípite columns and pilasters, inset with disks, lozenges and layered lambrequins, flank the choir window, below an animated statue of Ignatius Loyola embracing the constitutions of his order. A mixtilinear gable, fringed by a scrolled cornice, caps the facade. Beneath the dedicatory plaque, dated 1765, is a relief medallion of St. Philip Neri, which replaced the original Sacred Heart emblem of the Jesuits.

The two flanking portals echo the center in their elaborately framed openings, but instead of *estípite* columns, scalloped niche-pilasters display the statues of prominent 16th century Jesuits: St. Francis Borgia, St. Louis Gonzaga, St. Stanislaus Kostka and St. Francis Xavier. Ocular windows with deep Moorish frames open above the doorways.

The Temple Interior
Rows of white and gold piers lining the cavernous interior draw the eye towards the raised sanctuary and the lofty crossing beneath the great dome. Although the 18th century retablos have gone, several impressive baroque canvases—some of which, no doubt, formed the centerpieces of the lost retablos—still survive inside the church.

Unfortunately, the most ambitious and accomplished works are hung at the rear of the choir, where the visitor cannot easily inspect them.

Beneath a large allegorical painting of the Triumph of St. Ignatius are two fine panels by Miguel Cabrera, the pre-eminent Mexican artist of the mid-1700s. Both paintings use a striking pyramidal composition to glorify the Jesuit order. On the left St. Francis Borgia and the French Jesuit, John

Francis Regis gaze up in adoration at the Virgin of the Immaculate Conception amid clusters of cherubs, while in the right hand panel, Ignatius Loyola and St. Francis Xavier worship the youthful Christ.

The canvases convey the artist's keen sense of drama, inspired by the work of Rubens, as well as Cabrera's reliance on chiaroscuro effects, derived from the Andalusian school of Murillo and Zurbarán.

Numerous other colonial paintings are hung around the church and in the sacristy, including some attributed to other major artists of the period such as José de Ibarra, a close friend and colleague of Cabrera, and the early baroque master Luís Juárez.

The sacristy itself is an imposing structure, spanning the entire temple behind the high altar; its Churrigueresque doorways, emblazoned with Jesuit saints and symbols, successfully resisted the neoclassical tide. The pulpit, decorated with paintings of the Four Evangelists, is another exceptional colonial work.

The College

The adjacent college, begun a few years before the Jesuit expulsion, was also never completed. Some of its austere arcades still stand, and the entry beside the church, with its geometric baroque decoration, is said to have been brought here from the hospital chapel at nearby Marfil.

Three other Churrigueresque churches are located in the city center: **San Diego de Alcalá**, the **Temple of Bethlehem** (Belén), and **San Francisco**. Although each is highly individual, as a group they illustrate the different facets of the ornate Guanajuatan baroque.

San Diego de Alcalá

This is the most sophisticated city facade in Guanajuato. Rebuilt in the 1780s following a disastrous flood, this handsome church faces the Jardín Unión, a wedge-shaped plaza of restaurants and outdoor cafes that is the social focus of the city.

The building makes the most of its restricted site, rivaling the ambitious neoclassical front of the adjacent Teatro Juárez. Its ornate facade seems taller than it is, sandwiched between plain tower bases that extend beyond the narrow nave, adding needed breadth to the church front. The small interior, too, is skillfully illuminated, made to appear larger by a broad octagonal cupola.

Its dynamic composition, sophisticated detailing and superb sculptural quality invest the late Churrigueresque facade with an opulence that transcends its modest scale. Although its formal structure seems to melt away under the profusion of sensuous stonecarving, the contrast and balance of architecture and ornament is quite masterly.

Curved and rounded forms predominate, instead of the geometric motifs at Belén and San Francisco. A scalloped arch spans the doorway, which is flanked by narrow *estípites* and canted, bulbous niche-pilasters, whose scrolled fringes overlap the outer colonettes. Candelabra-like *estípites*, faced with atlantean figures, flank the crowning niche, which is encased by an elaborately scrolled, garlanded frame.

Statues of Franciscan saints occupy the main niches. The austere figure of San Diego, arms outstretched, is framed by the choir window. Numerous smaller sculptures and reliefs appear in medallions and cartouches, further enriching this complex and imaginative facade.

San Francisco: fountain with lambrequin

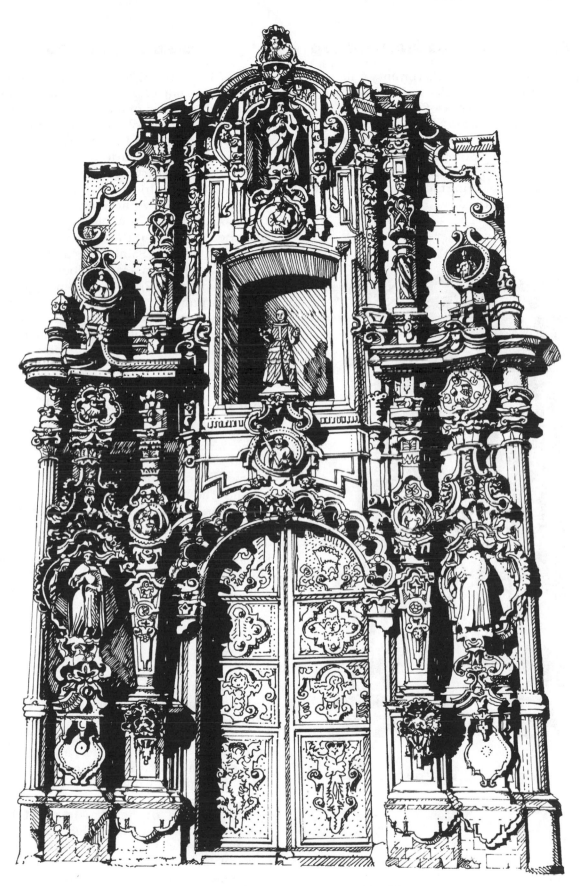

Guanajuato, San Diego de Alcalá

The Temple of Bethlehem

Sited opposite the city market on busy Calle Juárez, the former Templo de Belén is now designated the parish church of the city of Guanajuato.

Although prominently faced with *estípite* pilasters and decorated with Churrigueresque motifs borrowed from La Compañía, its static 1775 front harks back to the geometric retablo facades of an earlier era, underscoring the conservatism of Mexican popular architecture.

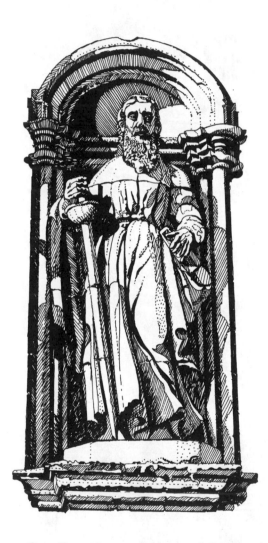

San Francisco, statue of St. Paul

San Francisco

Built in the early 1780s, this charming church faces the intimate plaza of San Francisco, located at the southeast end of the city. In contrast to the rather mechanical look of the Templo de Belén, the San Francisco facade is more fluid, showing a greater sophistication in design as well as a higher standard of stonecarving skills.

Prominent, multi-layered *estípite* columns, clearly inspired by the main doorway at La Compañía, flank narrow niche-pilasters that retain their elegant 18th century statuary. The imposing figures of Saints Peter and Paul in their flowing garments guard the doorway on either side, although the Franciscan saints grouped on pedestals around the choir window have less authority. The workmanship of the cornucopia reliefs in the spandrels above the doorway displays a more popular touch.

COLONIAL CIVIL BUILDINGS

Colonial Guanajuato owed much of its splendor to the mines surrounding the city. Gold, copper and above all, abundant deposits of silver brought prosperity and enhanced status to many of its citizens. The mineowners' wealth permitted them to purchase noble titles and erect sumptuous urban mansions.

As proud citizens of Guanajuato, the silver barons were also devoted subjects of the Spanish crown. But as time went on, these leaders of colonial society came to resent the interference and injustices they suffered at the hands of greedy and privileged Spanish officials. These sentiments gave rise to the Independence movement of the early 19th century, which erupted with special fury in the Bajío.

Although they do not match the grandeur of its churches, Guanajuato's surviving colonial civil structures dignify and enhance the historic center. Colonial buildings of character fringe the Plaza de la Paz on Calle Juárez, among them the **Casa del Conde de Rul y Valenciana**, now serving as the Superior Court building (**El Tribunal**). This rose-colored mansion was built around 1800 by the apostle of neoclassicism, Eduardo Tresguerras, for the ennobled owner of the Valenciana mine. From the rusticated geometry at street level, through its pedimented second floor windows, up to a fretted frieze and the huge triangular gable, enclosing the noble escutcheon

of the Rul family, the mansion's clean lines proclaim the gospel of the neoclassical revival.

La Casa Real de Ensayo, opposite, was at one time the Royal Assay Office. Originally built for the Marqués de San Clemente, a silver baron whose coat of arms is prominently emblazoned on the facade, this 18th century palace is distinguished by ocular windows and elaborate wrought-iron balconies.

Further along the block, at Juárez 62, we come to the former residence of another member of the local nobility, **La Casa del Conde de Pérez Gálvez**. This mansion is set apart from its neighbors by its handsome colonial wooden doors with distinctive lion's head knockers.

The rambling colonial house of the **Marqués de San Juan de Rayas**, also a wealthy mineowner, is located just up the hill beside the University, and has been converted into a regional art museum, **El Museo del Pueblo**. Behind its Churrigueresque facade, the visitor can explore exhibits of colonial art displayed in intimate *salas* and courtyards.

But the most impressive secular building in Guanajuato is the **Alhóndiga de Granaditas**, a forbidding structure whose name reflects its former roles as a colonial granary and arsenal.

Completed in 1809, the structure came under siege within a year by Mexican insurgents. Following the 1810 proclamation of Independence by Father Miguel Hidalgo in nearby Dolores, the rebels, under General Ignacio de Allende, dynamited the entrance and stormed the stronghold, with the heroic aid of a local miner, "El Pípila", and ousted the occupying Spanish garrison in a bloody massacre.

This triumph was shortlived, however. By the next year, after the royalists' defeat of the rebel army, the severed heads of both Hidalgo and Allende were hung in baskets from the corners of the building.

The fortress-like exterior with its imposing classical doorway and giant entablature is attributed to the Pueblan architect, José Manzo. The interior has been lavishly restored as the Museum of Mexican Independence; the former storerooms surrounding the austere courtyard are now devoted to exhibits that document the painful progress of the Mexican Independence movement.

Guanajuato, Alhóndiga de Granaditas

THE SILVER CHAPELS OF GUANAJUATO

Concerned as much with their immortal souls as with the future of Mexico, the colonial aristocracy fervently believed in pious works, principally the endowment of churches and charitable hospitals. Among the most conspicuous of these founda- tions were the "silver chapels" erected in the hills above Guanajuato, often located beside the rich- est mineshafts—at Cata, at Rayas, and above all, at La Valenciana.

La Valenciana, facade relief of the Holy Trinity

LA VALENCIANA

In 1760, after many lean years, Don Antonio Obregón finally hit the mother lode at the bottom of his deep mineshaft, La Valenciana. In sudden possession of fabulous wealth, Don Antonio cel- ebrated his new status with the purchase of an impressive title from the Spanish crown and was henceforth addressed as El Conde de Valenciana.

As a more tangible tribute to the source of his wealth and with an eye to his place in heaven as well as to the esteem of his fellow citizens, Don Antonio decided to proclaim his civic spirit by erecting an imposing church beside the mine en- trance. The sumptuous temple, dedicated to San Cayetano, a pious 16th century Italian Catholic reformer, was begun in 1765.

It was completed twenty years later for the then princely sum of 360,000 pesos—part of which came from the miners, who were compelled to donate cash, in addition to their labor, for the project.

The Church

The church is conspicuously perched on a knoll, commanding a panoramic view of the city and its surrounding hills. Its elevated forecourt, enclosed by battlemented walls and an ornamental wrought-iron gateway, is approached by a steep double staircase.

Recessed between twin towers, the soaring facade is expertly carved from mellow, rose-colored stone, exhibiting a quality of workmanship unequalled in Guanajuato. Designed by an unknown architect, in the late Churrigueresque fashion, the facade is derived from La Compañía, but exhibits a fluid style quite distinct from the static geometry of the Jesuit church. At La Valenciana, slender *estípite* columns take second place to expansive niche-pilasters, lavishly encased with volutes and cartouches. Carved rocaille decoration and curling foliage snake sensuously around the layered cornices and numerous sculpted reliefs.

Although the statuary that once filled the main niches has gone, many of the delicate miniature reliefs are still in place, notably a medallion of the Holy Trinity set over the doorway. As at La Compañía, the Trinity is portrayed as three elderly men in rich attire, solemnly resting their feet upon the globe. Tiny reliefs of the sun, the lamb and the dove, their symbolic counterparts, are also woven into the dense stone tapestry above the arch. The sole remaining statue is that of San Cayetano, posed atop the crowning parapet.

Grandiose windows with *mudéjar* frames accent the flanking towers. Because of complaints by local clergy about the scale and splendor of what was, after all, merely a hacienda chapel, only one of the weighty belfries was completed, leaving an unfinished stump on the east corner. The handsome lanterned dome, sheathed with colored tiles, is seen to best advantage from the east side of the church.

The grand north porch exemplifies the eclipse of architectural structure in favor of pure decoration that characterizes the final, *anastilo* phase of the Churrigueresque. Giant niche-pilasters, extravagantly scrolled and capped with multiple cornice fragments rise on either side of the doorway. Ornament has become structure.

The interior of La Valenciana outshines the exterior in its opulence. Beneath lush rococo vaults, arabesque shell niches alternate along the nave with foliated archways and coffered pilasters, in a controlled decorative procession. The ornate sacristy doorways are children of the north porch,

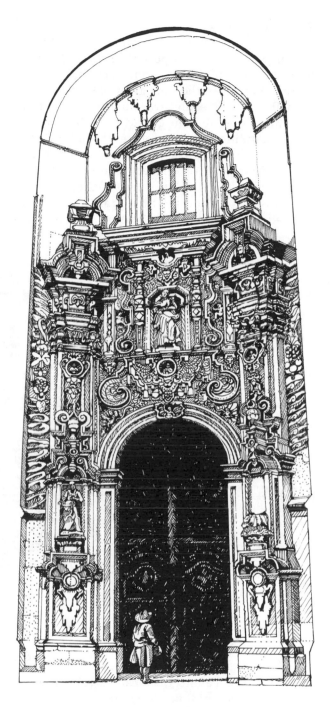

La Valenciana, the north doorway

their Moorish archways springing from cushioned pilasters headed with giant volutes.

Among the exceptional pieces of church furniture, the exquisite wooden pulpit is outstanding. Beautifully carved, painted and inlaid with ivory and marquetry, the rippling curves of pulpit, canopy and stair rail combine to create a dazzling display of artistic virtuosity.

179

The Altarpieces

Eighteenth century artistry achieves its climax in La Valenciana's three superb altarpieces. Believed to be the work of the Queretaran master sculptor Manuel Cárdenas, the chief glory of these retablos is their dynamic sculptural quality, evident not only in their exuberant gilded structures, but in the outstanding figure sculptures that adorn them.

Inspired by the intricacies of the stone facade, the carved wooden retablos are framed with elaborate *estípites* and niche pilasters, festooned with garlands and dripping with spirals, volutes and layered lambrequins. In addition to numerous wriggling cherubs and heroic archangels, there are several superlative statues of saints in the rococo-inspired Queretaran style, marked by their elegant carriage, fluent gestures and sumptuous *estofado* robes of gold and polychrome.

Especially noteworthy are the Virgin of Charity, surrounded by angels and children high on the main altar, the expressive statue of St. Joseph with windblown draperies in the retablo of the left transept, and a sympathetic, almost childlike figure of the usually severe Ignatius Loyola, at the foot of the Guadalupe retablo in the right transept.

Cata, facade relief of the Taking of Jesus

CATA

The elegant La Valenciana facade is reinterpreted in a more popular idiom at the smaller, but no less ornate pilgrimage chapel of Cata, located on a hilltop to the east, within sight of La Valenciana.

Cata stands at the head of a flight of steps overlooking the quaint Plaza del Quijote, not far from the mine entrance. Popularly known as El Santuario, it is a shrine to El Señor de Villaseca, a miracle-working crucifix brought from Spain by one of the early mine owners.

Although the mine had been profitable since the 16th century, in 1725 a major new silver vein, *la veta madre*, was struck. With the new wealth it yielded, the humble chapel was radically enlarged and redecorated.

The Facade

Work proceeded slowly, however, and the folk Churrigueresque facade was only added in the 1760s, or even later—possibly executed by some of the stonecarvers who worked at La Valenciana. The upper tier was never completed, and the tower belfry and gable are modern additions.

The complex design is reminiscent of finely crafted silverwork in its profuse detail. The center facade is dominated by bulky, multi-tiered

estípites, draped with lambrequins. Miniature figure sculptures and reliefs are mounted above the doorway and adorn the niche-pilasters.

Although the principal sculpture over the doorway again depicts the Holy Trinity—echoed by a keystone relief of the Three Virtues—most of the other carvings are little tableaux illustrating episodes from the Passion of Christ, carved in an attractive neo-Romanesque style. Tiny reliefs of Christ suffering on the Cross are embedded in the surrounding arabesques, while related Passion scenes are carved on the medallions and capitals of the niche-pilasters. These include, on the left, the Taking of Jesus and Christ at the Column, and on the right, Christ before Pilate.

The chapel interior is almost as lively as the facade. More lilliputian sculptures embellish the underchoir, notably a delightful, folk baroque relief of the Last Supper. An octagonal dome spans the crossing, whose lobed arches, studded with angels and rosaries, spring from flamboyant capitals carved with eagles.

The Retablos

In the transepts, a pair of fine retablos in provincial style pursue the themes of sacrifice and suffering. The left hand altarpiece is dedicated to the Man of Sorrows, while the retablo of Our Lady of Sorrows, opposite, is distinguished by its affecting *estofado* reliefs of the grieving St. Joseph and Virgin Mary.

El Señor de Villaseca, a handsome image in early baroque style, still graces the sanctuary, framed by hundreds of ex-votos—eloquent testimony to the enduring appeal of this 17th century miners' *santo*.

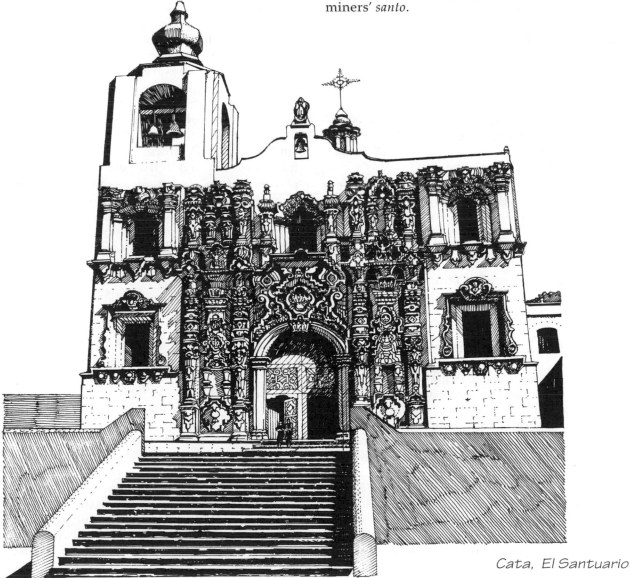

Cata, El Santuario

181

*Dolores Hidalgo,
La Casa de Visitas:
ornamental gable*

DOLORES HIDALGO

Northeast of La Valenciana, the main road winds through parched hills to the charming tile and pottery town of Dolores Hidalgo.

Dolores is enshrined in Mexican history as the place where Miguel Hidalgo struck the first blow in the War of Independence. In September 16, 1810, from the steps of the imposing parish church, he issued his famous *Grito de Dolores*—a call to action that is publicly re-enacted each year by the Mexican president, from the balcony of the National Palace in Mexico City.

A 19th century bronze statue of *El Padre de la Patria* stands in the Plaza del Gran Hidalgo, the tree-shaded main square. Two superb late colonial monuments face the square: on the north side, the parish church of Our Lady of Sorrows, and along its east side, La Casa de Visitas, a magnificent residence built for visiting royal officials.

Our Lady of Sorrows

The church dominates the plaza and the town. And it is easy to understand why Father Hidalgo, then the parish priest, chose its high porch steps for his momentous proclamation.

Founded in 1712 by Alvaro de Ocio y Ocampo, one of Hidalgo's predecessors, the church was not completed until 1780. In its dizzying verticality, this handsome structure perfectly exemplifies the 18th century Mexican parish church, and represents one of the high points of the Churrigueresque style in the Bajío.

The imposing facade rises at the head of a broad flight of steps, flanked by blank towers with or-

nate triple-tiered belfries—the tallest and most complete in this region of unfinished towers. Although its designer is unknown, the exuberantly carved facade is fashioned from *cantera rosa*, a locally quarried, fine-grained brownstone.

Narrow *estípites*, outflanked by larger ones, frame the scalloped porch. And in a reversal of the usual pattern, niche-pilasters trim the edges. All the decorative architectural elements—scrollwork, lambrequins, cut cornices and capitals—are carefully modeled and intricately layered. Curves predominate over geometrical lines in a proliferation of sinuous relief sculptures, cherubs and curling foliage.

Projecting from their twisting shell canopies, the figure sculptures are disappointingly lackluster. Exceptions are the statue of the Virgin of Sorrows, splendid in her triangular gown with puffed sleeves and elaborate flared skirt, and the truncated figure of Christ Crucified set in a cross-shaped frame at the apex of the facade—a regional motif also seen at San Agustín in Salamanca, San José in Irapuato and San Agustín in Querétaro.

The Retablos

The interior follows the classic cruciform plan, with its crossing and transepts illuminated by a lofty dome. Although the main altarpiece was replaced by a neoclassical altar, the two magnificent retablos in the transepts have fortunately survived.

The altarpiece of Guadalupe in the left transept is especially opulent. *Estípites* of exaggerated proportions enclose niche-pilasters richly hung with lambrequins and divided scrolls. But the most complex ornament is reserved for the center pa-

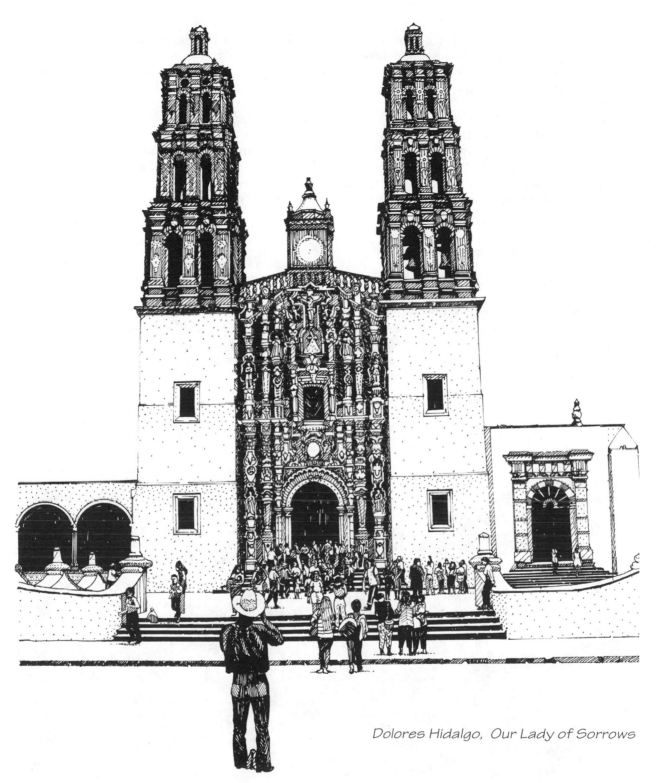

Dolores Hidalgo, Our Lady of Sorrows

vilion that carries through both tiers of the retablo with multi-layered swags, volutes and spirals. Despite its rococo extravagance, the apparent decorative excess of the retablo is nevertheless carefully controlled, the power of the whole successfully withstanding the seductive profusion of luxuriant detail.

The unfinished retablo of San José, opposite, is more restrained. Complex niche-pilasters again dominate the design, emerging from decorative *estípites* on either side. But the overall effect, although still dazzling, seems less voluptuous, partly because of the absence of paint and gilding—perhaps omitted for lack of funds. However,

this lapse allows us the unique opportunity to appreciate the high quality of the original wood-carving. The seasoned cedarwood retains its own special texture and lingering fragrance after more than two centuries.

Other colonial artifacts of interest in the church include a vast allegorical canvas of the Assumption of the Virgin, mounted beside the Guadalupe retablo, and a scattering of baroque statues of saints on the neoclassical stone altars. The rococo figure of the Archangel Michael is especially lively in his dashing *estofado* cape.

La Casa de Visitas

This arcaded former mansion for visiting royal officials, also known as La Casa del Subdelegado, is one of the most elegant civil buildings in the region. Constructed from the same roseate stone as the church, the palace was completed in 1786 according to a plaque above the center archway. Stylistically, its long front favors the geometrical mode of the Churrigueresque—less exuberant than the church. Six lobed arches spring from square piers to form the street level arcade. On the second level, five large French windows, each capped by an ornate scrolled pediment, are placed over the piers, opening onto corbelled balconies with lambrequin pendants.

A prominent beaded cornice, punctuated by hooded cartouches, runs the length of the building, sweeping upwards into a highly ornate mixtilinear gable over the center window. A balustrade of omega-shaped banisters supports the surmounting parapet.

Two other colonial buildings of interest in Dolores are the diminutive **Basilica of the Third Order**, located one block south of the plaza—an 18th century Franciscan church with a provincial baroque facade also fashioned from mellow *cantera rosa*. Another block to the west stands **Father Hidalgo's former residence**, now a modest house museum with a charming interior patio.

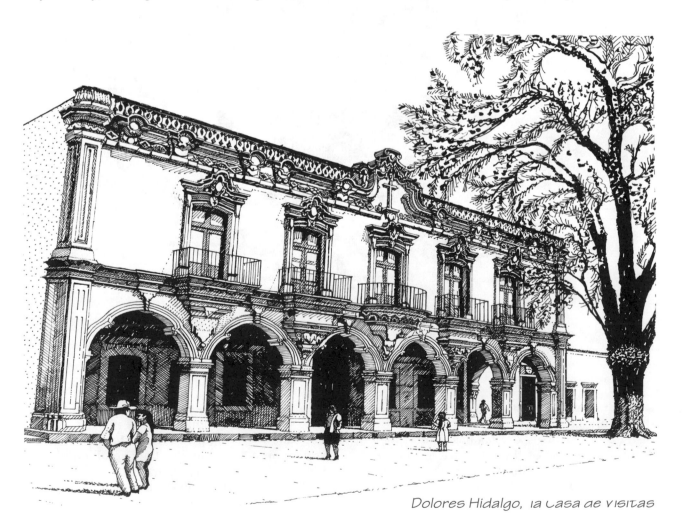

Dolores Hidalgo, la Casa de Visitas

Dolores Hidalgo marks the northernmost point of our journey through Guanajuato. From there we follow the former course of the Río Dolores southeast through arid, treeless highlands towards San Miguel de Allende. En route, we pass hot springs and crumbling haciendas and stop at the historic Santuario de Atotonilco.

El Santuario de Atotonilco

This rambling pilgrimage church and monastery, located off Highway 51 some 25 kms from Dolores Hidalgo, also enjoys a unique place in Mexican history. For it was here in 1810 that Father Miguel Hidalgo, heading south at the head of his insurgent army, paused to take from the church a painting of the Virgin of Guadalupe, which he adopted as the banner of the Independence movement. This momentous action enshrined the image forever as a unifying symbol of the Mexican nation.

The ancient spa and shrine of Atotonilco, or "Place of Thermal Waters," was appropriated in 1740 by Fray Felipe Neri de Alfaro as the site for a religious sanctuary and hospice for the Oratorian Fathers. This activist, somewhat eccentric priest was a leading figure in the religious and civic life of San Miguel de Allende, with strong connections to its ruling elite.

The religious complex was under construction from the 1740s until the end of the century, although "assembled" might be a better term, because of the constant addition of chapels and conventual rooms. However, the main church or Sanctuary, which is dedicated to Jesus the Nazarene, was built and decorated in a sustained burst of creative energy under the personal direction of Fray Felipe in just two years, between 1746 and 1748.

The exterior is surprisingly modest, even plain, compared to the opulent pilgrimage churches erected elsewhere in Mexico at this time. Above a narrow, terraced atrium, the otherwise nondescript facade terminates in an undulating gable, capped by unusual, mushroom-like merlons.

Merlons also punctuate the roofline of the adjacent Calvary Chapel, a building almost as large as the Sanctuary itself. The crown-shaped chapel dome—the largest of the distinctive cupolas that rise above the church and its chapels—effectively anchors the west front. A single south tower, its stark neoclassical lines relieved by a column of round, bull's eye windows, stands between the church and its adjacent convent.

The Murals

Behind the carved entry doors lies the fantastical painted interior, aptly described as a "polychrome grotto" by the Mexican art critic Francisco de la Maza. Many of the murals, hidden beneath coats of whitewash, were uncovered in this century by the parish priest, José Mercadillo Miranda, who has described them in his detailed study, *La pintura mural del Santuario de Atotonilco*.

The floor-to-ceiling murals are rendered in a colorful, popular style, exerting considerable psychological power. Using the conventions of late baroque painting as a point of departure, the dramatic narrative scenes and reliefs are linked by text banners and floral flourishes.

Many of the images are taken from a 16th century pictorial book by Géronimo Nadal that enjoyed wide circulation throughout New Spain, and whose illustrations were based on European Mannerist engravings.

The nave murals, illustrating the Passion of Christ and scenes from the lives of the saints, are well preserved on the vaults and upper walls, but are faded and worn within reach of visiting pilgrims. The decoration inside the porch, attributed to the folk artist Miguel Antonio Martinez Pocasangre, vividly portrays the agonies of souls in torment.

Although the great wooden main retablo erected in colonial times was later replaced by a stone altar, some of its statuary and paintings are stored in the dimly lit *camarín* behind the apse. These include relief images of the Twelve Apostles, carved in popular style, and the cult statue of Jesus the Nazarene, which stands beside the tomb of Fray Felipe, flanked by wall displays of ex-votos left by generations of pilgrims.

The long, narrow Calvary Chapel is the most elaborate of the side chapels. Its walls, vaults and dome are painted with polychrome figures in 18th century dress. A lifesize, openwork tableau of the Crucifixion is displayed beneath the cupola, surrounded by large canvases depicting the Way of the Cross, some bearing dated inscriptions.

In the smaller Rosary Chapel, at the far end of the nave, a mural of the naval battle of Lepanto, in which Spanish forces routed the Turks, unfolds across the vault. This famous 1572 victory—a decisive blow for Christendom against Islam—was widely attributed to the intercession of the Virgin of the Rosary, lending strong impetus to her cult in Spain and Spanish America.

El Santuario de Atotonilco, west front

Another much venerated religious image at Atotonilco is the crucifix known as El Señor de la Columna, mounted just inside the entrance. Every year, two weeks before Easter Sunday, the *santo* is carried in a torchlit procession to the old church of San Juan de Dios in San Miguel de Allende.

Despite its great historic and artistic importance, the effects of neglect and wear and tear, have placed the Santuario and its unique murals at risk. The World Monuments Fund has declared it to be an endangered monument, and funds are currently being sought to meet the urgent need for its preservation.

SAN MIGUEL DE ALLENDE

San Miguel and region, from a 1580 map

San Miguel's benevolent climate, picturesque hilly streets and colonial ambience have long made it a favorite destination for tourists.

The town's charms have also attracted many cosmopolitan residents, including Mexicans prominent in the arts as well as expatriates, who have contributed to its considerable cultural amenities.

San Miguel has been designated a national monument. For a community of modest size, with a population of only 65,000, it boasts a wealth of colonial art and architecture—the heritage of its former prosperity as a leading textile center and a strategic location on the colonial silver route.

Some of its architectural monuments have sustained post-colonial changes, most notably the parish church (the Cathedral), which suffered a neo-Gothic facelift in the last century.

However, several other colonial buildings of distinction remain, ranging in date from the early 17th to the 18th century—the golden age of colonial architecture in San Miguel.

In addition to the remodeled cathedral, the principal religious monuments are the monastic church of San Francisco, north of the main plaza, the huge nunnery of La Concepción to its west, and the rambling Oratorio complex on San Miguel's north side.

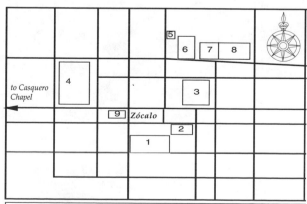

SAN MIGUEL DE ALLENDE Historic Cente
1. Cathedral 4. Las Monjas 7. La Salud
2. San Rafael 5. Loreto Chapel 8. Colegio
3. San Francisco 6. Oratorio church 9. Casa De Canal

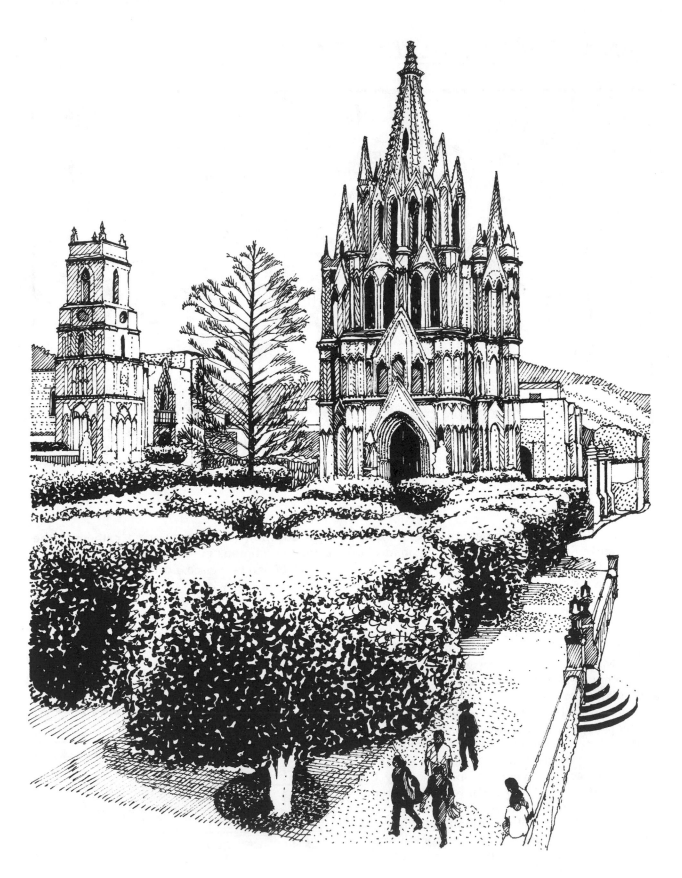

San Miguel de Allende, the Cathedral from the zócalo

The Cathedral

The whimsical Gothic front of the parish church of San Miguel, facing the Plaza Allende, or *zócalo*, is probably the town's best known landmark, for residents and visitors alike. But the current appearance of the Cathedral, as the locals call it, is relatively modern. Photographs taken in the 19th century show its baroque church front still intact.

In fact, the origins of the church go back to the 1560s when the aging Vasco de Quiroga, Bishop of Michoacán, first established the parish and ordered the founding of a church and hospital here. Much of the present fabric, excluding the facade, dates from the 17th and early 18th centuries when the deteriorating 16th century building was replaced by a larger church. This second church was designed in a severe baroque style, with twin towers and a fine hexagonal dome.

Sadly, Quiroga's ancient hospital and Indian chapel, situated behind the original church, also fell victim to this reconstruction and have since disappeared. The 17th century interior suffered devastating changes in turn, when the rich, gilded retablos were removed and replaced by undistinguished neoclassical altars in the late 1700s—the fate of so many Mexican baroque churches.

Although few of the original furnishings survive, the side chapel by the entrance houses the oldest and most precious relic of the church—a 16th century crucifix known as El Señor de la Conquista. Bloodied and contorted in traditional Michoacán style and sporting a distinctive forked beard, this dark-skinned and sinewy *cristo de caña* was brought here from Pátzcuaro, probably at the behest of Bishop Quiroga himself.

Several large colonial paintings adorn the chapel walls including a striking Assumption of the Virgin, attributed to the talented 18th century painter Juan Rodríguez Juárez. Other canvases by the same artist, which may have belonged to the lost main altarpiece, are hung in the sacristy and the baptistry, and include a particularly harmonious Annunciation.

The apsidal chapel of the Virgin, or *camarín*, was added in 1786 by Eduardo Tresguerras, the neoclassical architect from Celaya, who was also active in San Miguel. This imposing chamber is noted for its vaulted crypt, which contains several ornate tombs.

Shortly after 1880, the city fathers decided to replace the unfashionable baroque facade. They commissioned a native stonemason, one Zeferino Gutiérrez, to create the pseudo-Gothic front that now encases the cathedral. In designing the new facade, this imaginative but unlettered artisan was apparently inspired by a postcard of a French cathedral.

For good measure, he also designed a new tower for the adjacent chapel of San Rafael. Popularly called La Santa Escuela because of its former use as a school by a religious *cofradía*, the chapel retains most of its earlier facade, including the original porch and a tiny, primitive relief of the Crucifixion carved above the choir window.

On the opposite side of the church forecourt, stands a modern statue of Fray Juan de San Miguel, in tribute to the pioneering Franciscan missionary for whom the town is named.

*Fray Juan de San Miguel,
the "Apostle of Michoacán"*

San Francisco, facade relief

San Francisco

In 1542, Fray Juan de San Miguel, the "Apostle of Michoacán," arrived to evangelize this former outpost of the Tarascan empire. Fray Juan gathered Tarascan and Otomí Indians into a settlement here, which he named San Miguel de Los Chichimecas, and erected a primitive mission.

Although this first tiny mission was abandoned because of Chichimec raids, Spanish colonists and native settlers from Tlaxcala arrived soon after, swelling the size of the fledgling community.

In 1555 the town was relocated and renamed San Miguel el Grande. By the close of the 16th century, San Miguel was securely established as a center for the growing woollen industry, as well as an important way station on the silver route to Zacatecas in the north.

In the mid-1600s the rude, pole-and-thatch chapel had been replaced by a sturdy stone church and the friars took up residence in their newly completed convento. This simple mission, for-merly known as San Antonio and now associated with the lay Franciscan Third Order, still stands beside the later, even grander church of San Francisco. A timeworn relief of St. Joseph is mounted below the picturesque *espadaña* or wall belfry.

The Church

In 1779, work began on the monumental church of San Francisco—the last major colonial building to be erected in San Miguel. Neatly framed by a well-maintained *alameda* with a stone fountain, the dazzling Churrigueresque facade is far and away the most accomplished example of 18th century architecture in San Miguel.

Although its designer is unknown, the facade bears a strong family resemblance to the parish church at Dolores Hidalgo, as well as to Felipe de Ureña's basilica of La Compañía in Guanajuato.

Beautifully carved from fine-grained roseate stone, the facade shows great clarity and har-mony of design. The main focus is on pairs of

giant *estípites*, which enclose ornamental niche-pilasters of similar weight and emphasis.

In keeping with the Guanajuatan Churrigueresque style, special attention was devoted to architectural and decorative reliefs, especially the finely detailed figure sculptures. Atop the *estípites*, for example, expressive busts of kings, saints and prelates emerge on each side of bulging cartouches, while simple, elegantly posed statues of Franciscan saints fill the niches. The elongated figure of St. Francis of Assisi, in particular, seems to radiate a sorrowful spirituality.

A classic sculpture of the Archangel Michael, patron saint of San Miguel, takes pride of place in the ornate center niche, and a magnificent statue of Christ Crucified, encased in a cruciform frame at the apex, is flanked by the mourning figures of the Virgin Mary and St. John the Evangelist. A second statue of St. Francis surmounts the facade.

The soaring tower—a project funded, according to local lore, by receipts from bullfights—was the final addition to the church. This is another work by Eduardo Tresguerras, and is considered one of his noblest designs. Boldly projecting double columns at the corners of each tier compel the eye skywards to the crowning, octagonal cupola.

The bright interior was also remodeled by Tresguerras, and is an agreeable, if rather cool, exercise in neoclassical taste. It is dominated by a huge colonnaded tabernacle, complemented by nine stone altars around the nave—each flawlessly fashioned from rose-colored limestone.

The sole surviving baroque artifacts, now hung in the spacious sacristy, are the large, allegorical paintings attributed to various members of the prolific Juárez family.

Begun in 1606 and completed in 1638, the intervening convento is older than either of the churches. Its two patios are linked by an old corridor that still bears vestiges of early murals that include fragments of a primitive Calvary scene. Unusual serrated arcades surround the principal cloister, whose distinctive pilaster buttresses are embellished with religious escutcheons and baluster finials.

*San Francisco, facade statue of
St. Francis of Assisi*

Las Monjas

This grand nunnery, traditionally called La Concepción, fills an entire block just west of the Plaza Allende. It comprises the imposing church of the Immaculate Conception and a spacious arcaded convent. A smaller cloister at the rear houses a community of Franciscan Concepcionist nuns, who can often be seen tending to the church.

In 1749, Don Manuel de la Canal, a wealthy landowner and San Miguel's most prominent citizen, died leaving a fortune to his young daughter. Advised by her confessor, Felipe Neri de Alfaro, the pious 15 year old vowed to dedicate her inheritance to the building of a nunnery, which she resolved to enter as a novice.

Plans for the proposed complex were commissioned from the Queretaran architect Francisco Martínez Gudiño. Originally estimated to cost a princely 50,000 pesos, the elaborate project had consumed twice that sum by the time the nuns took up residence in 1756. Even so, another century was to elapse before the tower and dome were added, and much of the planned sculptural decoration was never completed.

The church is built on a grand scale, with a huge crossing vaulted by a lofty dome, shallow transepts and the deep, two-tier choir typical of a nun's church. The double doorways—customary for convent churches—provide the main relief in the cliff-like nave exterior. Cut from the local brownstone, they are discreetly ornamented with scrolled cornices, lambrequins and medallions in the geometrical neostyle manner of the later Mexican baroque.

The vast interior is generally unadorned. Although grandiose stone altars help fill the apse and broad transepts, many bare walls and arches still await the sumptuous decoration that was planned by Gudiño before the funds ran out. But the few remaining works of colonial art are of the highest quality. In particular, a beautiful statue of the youthful St. Joseph stands on a side altar, distinguished by its noble head and delicate hands. The saint's elegant *estofado* robe of black, red, blue and gold is patterned with an almost oriental design of large, intricately entwined flowers.

Opposite San José is hung a monumental painting of the Assumption of the Virgin, probably one of a series illustrating her life, and again attributed to the baroque master, Juan Rodríguez Juárez. An ancient, bearded black Christ is almost lost among the parade of saints on the main altar.

The nun's choir is still separated from the nave by a great iron screen, upon which is mounted a primitive crucifix in the Pátzcuaro style.

Although structurally austere, in keeping with the strict rule of the *conceptionistas*, the lower choir retains its patterned, painted ceilings and is further graced by a semicircular wall retablo, gilded and decorated in a sophisticated *fin-de-siecle* rococo style. At its center rests a sumptuously costumed image of the Virgin of Loreto, the patron saint of the Canal family.

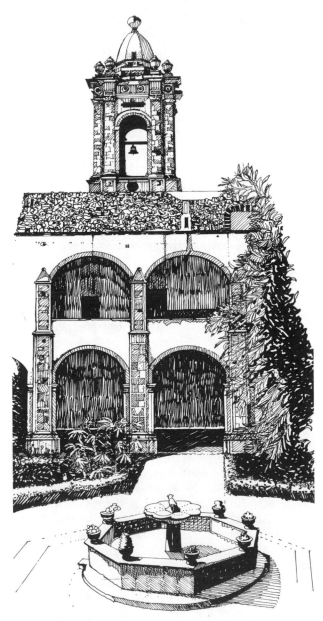

Las Monjas, the church tower viewed from the cloister

THE ORATORIO COMPLEX

This unique "city within a city" of 18th century churches, chapel and cloisters is located to the northeast of the *zócalo*. Its picturesque parade of domes, towers and sculpted facades climbs the hillside across from the old market plaza.

Sheltered behind a walled forecourt at the base of the hill stands the **Oratory of San Felipe Neri**, famed for its ornate **Loreto Chapel**. The **Temple of La Salud** and the **Seminary of St. Frances de Sales** face the terraced plaza with its bronze equestrian statue of Ignacio de Allende, the Independence hero and native son of San Miguel.

The Oratory

The Oratory of San Felipe Neri is the principal structure in this complex. In the early 1700s this part of town was a mulatto *barrio* called Los Trasteros (the warehouses), with its own chapel dedicated to La Soledad (Our Lady of Solitude). In 1712, a charismatic Oratorian priest from Pátzcuaro, Juan Antonio Pérez de Espinosa, preached such an effective Easter sermon in San Miguel that the city fathers promptly invited him to found a church here.

The Oratorians, followers of the 16th century Italian mystic St. Philip Neri, the "Apostle of Rome," were then new to Mexico, and eagerly took up the offer. Despite protests from the *barrio* residents, the *felipenses*, as they were known, quickly appropriated the site of the Soledad Chapel for their new church and convento.

The Oratory is distinguished by its simple, folk-baroque retablo facade of striking reddish-mauve stone, which dates from 1714. Beneath the broad, scalloped pediment, two tiers of decorative paired columns frame the openings and the sculpture niches. Every element of the facade—columns, pedestals, door and window frames—is incised with sharply undercut filigree reliefs in spiral, floral and geometric designs, while foliage and scrollwork cover the intervening surfaces

The statuary, cut from eroded white limestone, contrasts handsomely with the rosy facade. Squat figures of Saints Peter and Paul take up their customary places on either side of the doorway, while John the Baptist and St. Philip Neri occupy the upper niches. St. Joseph gazes out across the city from the ornate top niche. In common with other San Miguel churches, the awesome gilded retablos that formerly lined the walls of the Ora-

Las Monjas, statue of San José

The magnificent dome and more modest tower are works by the eclectic Zeferino Gutiérrez, who designed the Gothic facade of the parish church. Supposedly inspired by the church of Les Invalides in Paris, the polygonal dome is the finest of its kind in San Miguel.

A vast, tree-shaded cloister occupies the heart of the former convent. Its agreeably proportioned arcades now house the galleries and studios of Las Bellas Artes, San Miguel's busy arts and culture center.

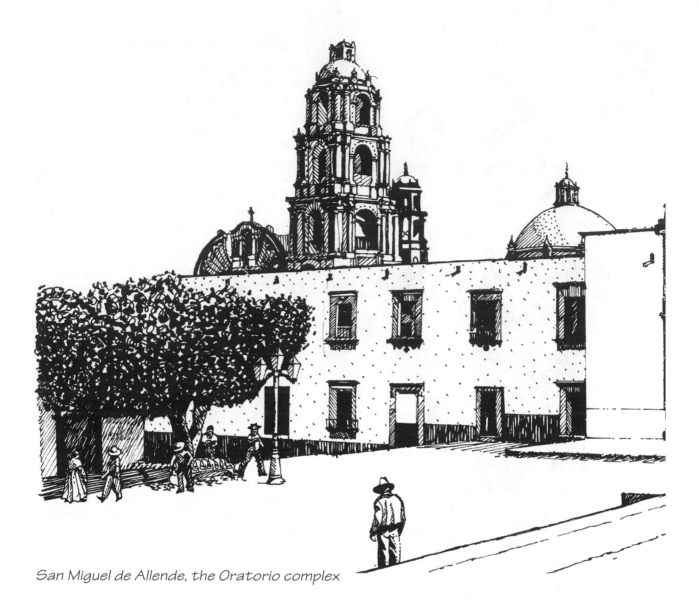

San Miguel de Allende, the Oratorio complex

torio were replaced in the last century with dull neoclassical structures. Luckily, some of the polychrome saints from these retablos still stand on altars along the nave, identifiable by their faded *estofado* garments.

A florid baroque organ case rests in the choir, surmounted by a lifelike panoply of musical instruments. A few paintings of note have also survived, now kept in the sacristy. These include an 18th century Virgin of Guadalupe, attributed to Miguel Cabrera, and another large Immaculate Conception by Juan Rodríguez Juárez.

The east porch of the church, which now faces an inner courtyard, is believed to have formed the entry to the old Soledad Chapel. Placed in a niche above the modest carved doorway, the diminu-

tive, but finely featured statue of the Virgin of the Rosary may also be a remnant from the chapel.

The Loreto Chapel

This jewel-like chapel, attached to the Oratorio, also known as La Casa de Loreto, was designed in 1736 as a replica of the Santa Casa de Loreto in Italy. The chapel was a project dear to the heart and costly to the purse of Don Manuel Tomás de Canal, the fabulously wealthy head of the Canal family who had adopted the Virgin of Loreto as their patron and protectress.

From the northwest transept of the Oratory, a palatial swagged entry flanked by gilded Solomonic columns admits us to the narrow, rect-

194

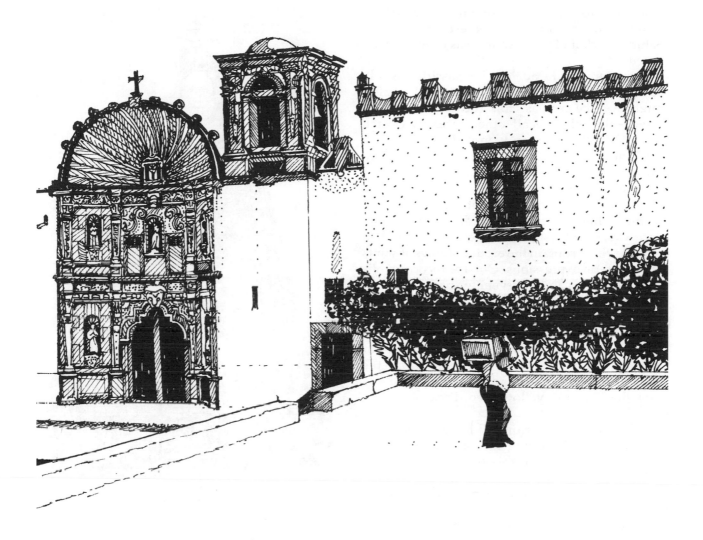

angular chapel. Reflective gold rosettes wink at us from the ceiling and dome, but our attention is drawn to the sumptuous high altar, which houses the regally costumed figure of the Virgin of Loreto—an image brought by Canal from Italy at great expense. The kneeling figures of Don Manuel and his wife Doña María gaze at her with devotion from the side niches.

Azure tiles from Puebla, Spain and China pave the floor and walls of the narrow aisles that lead to the octagonal *camarín* behind the chapel. Beneath its tiled *mudéjar* lantern, a sequence of ornate gilded wall retablos lines the surrounding walls, each one lavishly adorned with *rocaille* swirls. They also gleam with superb polychrome statues of saints and archangels, some of which may be

the work of the great 18th century sculptor, Pedro de Rojas.

La Salud

Up the hill, recessed between the Oratorian convento and the seminary of St. Francis de Sales, stands the unusual brownstone facade of the chapel of La Salud. In contrast to the rather patrician atmosphere of the Oratory, La Salud has a more workaday atmosphere. Its popular saints are gaudily festooned with testimonials to their efficacy on behalf of the common people.

The chapel was founded and built in the late 1700s by Felipe Neri de Alfaro, the influential founder of el Santuario de Atotonilco. Intended

as a chapel for the adjacent seminary, it was dedicated to Our Lady of Health (Nuestra Señora de la Salud) to whom Padre Alfaro was especially devoted.

If the Oratory facade can be classified as folk baroque, then the recessed facade of La Salud might well be seen as "folk rococo" in style. Its screen-like folds recall other recessed church fronts, like those of San Juan de Dios in Mexico City and the Third Order Church in Cuernavaca (Morelos).

Beneath a giant scalloped gable, fringed with whorls, the faceted front is quite sparingly ornamented. Beside the swagged, Moorish-style doorway, simple *estípite* pilasters frame the shell niches, which contain the eroded statues of saints with ecstatic expressions. Outsize rococo scrolls trim the friezes and intervening spaces.

The figure of the Virgin of La Salud occupies the center, flanked by her parents, Joachim and Anna. A pair of doorways on either side of the Virgin hints at the former presence of an exterior balcony. The modest belfry is in keeping with the facade, although a curious, turban-shaped cupola caps the blue and yellow tiled dome above the crossing.

The reworked interior still holds a few older colonial relics, including once again, the figures of Joachim and Anna, this time in the form of painted and gilded wooden images on the high altar. A simple but monumental painting of the Crucifixion, thought to be another work by Juan Rodríguez Juárez, is the star of La Salud's sparse collection of religious paintings.

The College of St. Francis de Sales

The long, unadorned facade of this former seminary, also called El Colegio, climbs the hill from La Salud. A handsome stone fountain fills the center of the small arcaded patio at the upper end, where distinguished scholars and teachers once disputed and proponents of Mexican independence first advocated their ideas of freedom. These included Juan Benito Díaz de Gamarra, the leading philosopher of the 18th century Mexican enlightenment, and Ignacio Ramírez, "El Nigromante," a noted liberal writer of the Reform era.

In these historic precincts, local craftsmen and woodcarvers now ply their trades and display their wares.

The Virgin of Loreto

THE CHAPELS OF SAN MIGUEL

The churches of the historic center are not the only religious survivors from the colonial era. A number of other old churches can be explored around San Miguel, including several neighborhood or *barrio* chapels.

San Antonio de la Casa Colorada

This little church, sitting on a rise just west of the Instituto Allende, is believed to stand on the site chosen for the San Miguel mission after its relocation in 1555. The image of St. Anthony of Padua kept in the modest 17th century church is one of the most beloved in the city, and the saint's festival in June enjoys a huge popular following.

San Juan de Dios

Located on the western edge of town, San Juan de Dios was the chapel of the adjacent hospital of San

Rafael, which was the city infirmary in late colonial times. Flanked by the old municipal cemetery, the former hospital retains its pleasant arcaded patio and several airy interior rooms.

Once inside the chapel's walled forecourt, which still contains a primitive atrium cross carved with the Instruments of the Passion, we face the picturesque folk Churrigueresque facade, dating from the 1770s.

Barrio Chapels

These former Indian chapels, found in outlying *barrios*, are collectively called *calvarios*, because of their rustic wood or stone Calvary crosses. Frequently decorated with mirrors and Passion symbols, these quaint crosses are carried in procession through the city neighborhoods on feast days.

Typical chapels include the folk baroque shrines of **La Capilla del Señor de la Piedad** (Our Lord of Piety) on the north side, and the tiny **Oratorio de los Siete Dolores** (Oratory of the Seven Sorrows of Our Lady), one of a cluster of one-room shrines perched on the *mesas*, or steep ridges east of town.

The Casquero Chapel

Worth a special detour is the historic Casquero Chapel, situated in the outlying *barrio* of San Miguel Viejo, some five kms west of the Plaza Allende. This was the site of the original settlement and mission of San Miguel, abandoned because of Chichimec raids and inadequate water supplies.

The chapel was subsequently rebuilt in its present form, together with three of the original *posa* chapels, known locally as *calvaritos*. The naive Plateresque porch is a charming example of 17th century folk stonecarving. Angels disport around the doorway, amid reliefs of the sun, stars and rosette-like medallions.

Although the bearded face of Christ at the center of the arch seems to show Indian features, according to a local tradition it portrays Fray Bernardo Cossín, the first Guardian of the rebuilt mission.

Inside, a pair of rabbits—an echo of pre-hispanic imagery—is carved on the choir arch. Here, too, are the figures of the Archangel Michael and of Christ Crucified, the latter called El Señor de la Conquista, no doubt after the image in the cathedral. Like El Santuario de Atotonilco, the Casquero Chapel is in a precarious state of repair and in urgent need of restoration.

The Casquero Chapel, keystone relief

SAN MIGUEL'S MANSIONS

At the height of San Miguel's prosperity in the 18th century, its leading citizens—notably the Canal and Hervas families—vied with each other in building stately palaces and elegant townhouses.

After Mexican independence, several celebrated Mexican patriots lived in these imposing residences, whose baroque portals give considerable character to the narrow streets of the historic center. Here we mention just a few of the most prominent mansions.

La Casa de Canal

Not only did members of the Canal family endow religious institutions, but they also built several palatial houses of note.

La Casa de Canal was their principal residence, and was among the first great palaces to be erected in San Miguel. Built in the late 1700s, the main front is designed in the neostyle fashion and is distinguished by its stylish, pedimented portal.

An aristocratic eagle adorns the keystone of the doorway, while the Canal and Hervas escutcheons, capped with noble plumed helmets, are prominently displayed overhead.

A commanding niche above the portal frames a statue of the Virgin of Loreto, the family's patron saint. The dagger-like Cross of Calatrava is carved into the pediment, signifying that its owner was a member of this exclusive Spanish military order.

The exposed reddish black stonework of the portal, the elaborate window frames and the

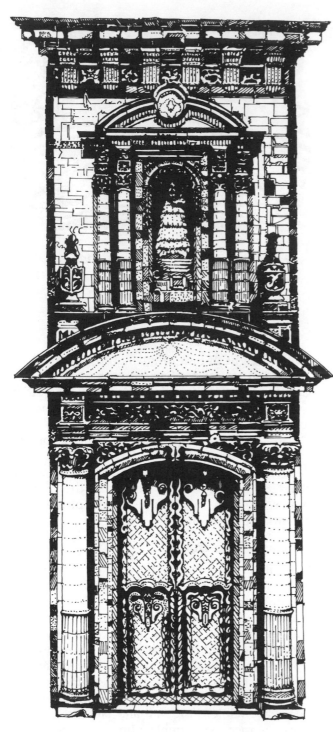

La Casa de Canal, the "neostyle" entry

crowning classical cornice integrate handsomely with the white stucco walls and wrought iron balconies.

Stylish filigreed doors, carved with scrolled lambrequins, open onto the Calle Canal, while the long arcaded east front of giant pilasters and carved archways faces the Plaza Allende. High arcades with foliated spandrels frame the inner courtyard, which now houses bank offices.

La Casa de Allende

This splendid colonial mansion was the birthplace of General Ignacio de Allende, the Independence leader, whose alabaster statue stands in a corner niche, facing the Plaza Allende.

Now home to the San Miguel Historical Museum, its brownstone front boasts a voluted baroque entry and large upper windows embellished with overhanging cornices and ornamental ironwork.

La Casa del Conde de Canal

Another prominent member of the Canal family established this suburban estate in the 1730s. Before building began, however, the property was sold for a Carmelite convent, whose spacious courtyards, large salas and extensive grounds today form the campus of the **Instituto Allende**—an internationally known arts and language school.

Although plans for an imposing church and nunnery were drawn up by the renowned neoclassical Spanish architect, Manuel Tolsá, because of the War of Independence they were never fully realized.

The only break in the austere front of the building is the sober classical doorway, whose single ornament is a projecting baroque niche with an image of the Virgin of Loreto, thus identifying the property as another Canal family residence.

A small interior chapel contains religious frescoes and other mementoes from the Carmelite years.

P A R T F O U R **QUERÉTARO**

The sparsely populated state of Querétaro enjoys a varied climate and scenery. From its historic capital of Querétaro, located on the edge of the Bajío, the state extends northeastwards across arid uplands and over rugged mountain ranges into the lush subtropical valleys of the Sierra Gorda. For the visitor, the colonial arts and architecture of Querétaro, too, cover a broad spectrum,

in quality of imagination as well as execution. In this section we explore first the elegant colonial city of Querétaro, where the Mexican baroque reached its apogee in the sumptuous church altarpieces. We conclude our journey in the Sierra Gorda, whose 18th century mission churches display an extraordinary late flowering of folk baroque architecture and decoration.

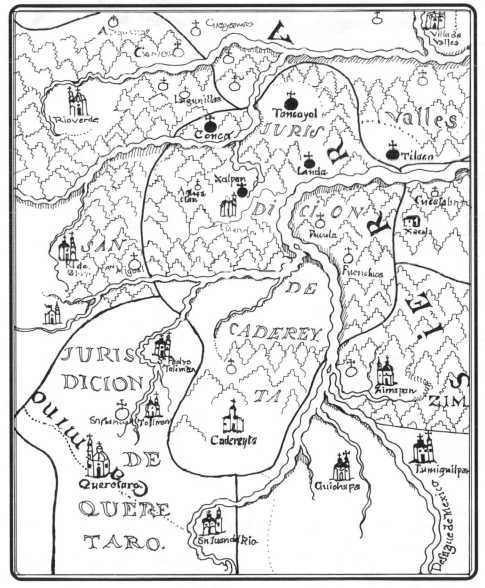

The Querétaro region in 1747 (from a map of colonial silver routes)

THE CITY OF QUERETARO

San Francisco, portería: the city insignia of Querétaro, with Santiago Matamoros, the flaming cross and the thorn tree.

"The most noble and loyal city of Santiago de Querétaro has always been counted among the most beautiful, most grand, most opulent and most agreeable of cities gracing these northern Americas. It was conquered by that eminent lord Don Fernando de Tapia of the Otomí nation on the twenty fifth of July 1531, with the intercession of St. James the Apostle, who, according to an ancient tradition, was seen by the combatants flying in the air at the height of the battle, a fiery red cross by his side—a vision that revived the faltering spirits of the Spaniards. And from this decisive event, the city draws its great and honored title of Santiago de Querétaro."

Glorias de Querétaro

In July 1680, Carlos de Sigüenza y Góngora, the scholar, poet, antiquarian and journalist, traveled to the burgeoning city of Querétaro to observe the solemn dedication of a grand new church to the Virgin of Guadalupe.

In his *Glorias de Querétaro* he described the city, the church and the elaborate celebrations attendant on the dedication.

Don Carlos was one of the leading savants of the Mexican baroque era, second only in stature to his friend and confidante, the celebrated poet and intellectual Sor Juana Inez de la Cruz. Fascinated by the lore of ancient Mexico and influenced by the enlightened ideas of the Age of Reason, he became an articulate spokesman for the emerging Mexican national consciousness. Like many intellectuals of the period he was also a devotee of the Virgin of Guadalupe, and his writings helped to establish her as the patriotic symbol of Mexican nationalism.

Querétaro in History

The Spanish conquest of Querétaro was largely a negotiated affair, rather than a violent confrontation. In the 1520s the fertile valley was sparsely populated by Chichimec tribesmen, attracting the attention of Otomí Indians emigrating from the Mesquital region, to the southeast. Through the skilled diplomacy of their leader Conín, the Otomís established a settlement here, trading with the Chichimecs on the one hand and the encroaching Spaniards on the other.

When Spanish forces arrived on the scene, tensions mounted. The Otomís sided with the Spaniards, and in 1531 a battle took place on the Sangremal hill overlooking the valley. Inspired, as Sigüenza y Góngora relates, by the miraculous appearance in the heavens of Santiago Matamoros, the patron saint of Spain, on his white charger, the Spanish and their Otomí allies carried the day against the Chichimecs.

Following the battle, the Otomí initially settled in the valley while the Spanish occupied the heights. But with the eventual pacification of the Chichimecs, the Spanish also moved down later in the century. Querétaro flourished as an important way station on the silver route to Zacatecas, as well as an agricultural and commercial center. In the 1600s, the city became the site of a prosperous textile industry and the preferred place of residence for wealthy silver barons.

The 1680 dedication of the church of La Congregación to the Virgin of Guadalupe signified that Querétaro was finally taking its place among the leading cities of New Spain. Thereafter, its prestige waxed, reaching a peak in the opulent 18th century.

By the early 1800s however, the swelling patriotism of the city's elite spawned a movement promoting Mexican independence from Spain. Protests and armed conspiracies turned the region into a battleground, eventually bringing down destruction and great suffering on Querétaro and its proud citizens.

Glorias de Querétaro: title page

Colonial Arts and Architecture

Artistically, Querétaro was a late bloomer. Although the city grid had been laid out in the 1550s by Juan Sanchez de Alanís, a Spanish cleric, very little survives from that time. The only 16th century buildings of note were the parish church of Santiago (now San Francisco) and the hilltop convent of Santa Cruz, which marked the place of the city's colonial beginnings—both since altered beyond recognition.

Several other city churches were founded during the first half of the 17th century, but they were generally primitive in design and construction— simple adobe structures with wooden or thatched roofs—and all were rebuilt in later centuries.

In 1656, by royal assent, Querétaro was granted the coveted designation of city. Driven by prosperity and civic pride, the citizens embarked on a series of ambitious building projects—primarily churches and convents to accommodate the burgeoning religious orders.

These new monuments stimulated a belated architectural flowering in Querétaro that evolved through several phases, from the 1650s until the last years of the 18th century. Although increasingly ornamental and sophisticated as time went on, taken together, these buildings and their decoration form a distinctive regional style known as the Queretaran Baroque.

During the first wave of new building, between 1650 and 1700, many existing religious foundations were rehoused in permanent masonry churches and cloisters.

The consecration of La Congregación marked Querétaro's artistic as well as civic coming of age. One of the first churches in Mexico to be dedicated to the Virgin of Guadalupe, its measured classical appearance also announced the arrival of the imposing, Mannerist-inspired architecture of the great Mexican cathedrals to this provincial city. Sober classical facades came into fashion, together with handsome stone vaults and lofty domes and towers.

Many of these new church fronts were designed by José de Bayas Delgado, a Pueblan sculptor and architect who had settled in Querétaro. He pioneered the severely elegant geometry that became a hallmark of these early Queretaran facades—of which La Congregación and the rebuilt monastic church of San Francisco are outstanding examples.

The principal catalyst for this building boom was the wealthy and pious Queretaran philanthropist, Juan de Caballero y Ocio. An inquisitor

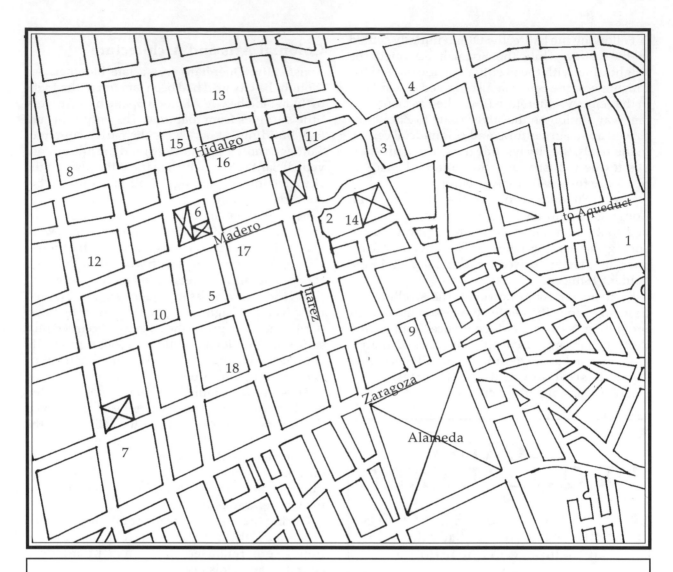

QUERETARO THE HISTORIC CENTER

1. Santa Cruz
2. San Francisco
3. La Congregación
4. Santiago
5. San Agustín
6. Santa Clara

7. Santa Rosa de Viterbo
8. Las Capuchinas
9. Las Teresitas
10. Santo Domingo
11. San Antonio
12. San Felipe Neri (Cathedral)

13. El Carmen
14. Casa de Ecala
15. Casa del Conde
16. Casa del Marqués
17. Casa de la Marquesa
18. Casa de los Perros

and member of a lay religious order, he donated the bulk of his own fortune and encouraged others to fund civil and religious projects throughout the city.

After 1700, waves of new construction and reconstruction changed the face of the city's churches. Bayas Delgado's "incipient baroque" style was refashioned by his successors into the full-blown Queretaran Baroque, characterized by greater dynamism and bold sculptural ornament within a prevailing classical framework. In its culminating phase, late in the 1700s, this style blossomed into a subtle architecture whose intricate geometry was animated by a highly original sculptural program, most notably in the brilliant, idiosyncratic monastery of San Agustín.

But it is in the church interiors that late baroque taste reached its zenith in Querétaro. The convent churches of Santa Clara and Santa Rosa de Viterbo are famous for their collection of exuberantly

carved and gilded Churrigueresque altarpieces, enriched with paintings, reliefs and polychrome statuary.

Unhappily, numerous church interiors were despoiled in the 19th century, because of sweeping neoclassical makeovers, sheer neglect, or the vandalism that accompanied the Independence struggle and post-colonial reforms. As a result, many of the magnificent altarpieces and sculptures adorning the city's churches were either dismantled and relegated to sacristies and obscure storerooms, or simply consigned to the flames as *leña dorada*—gilded firewood.

As with the architecture and sculpture, most colonial painting in Querétaro was religious in nature. Spanning the period from the late 1600s through the last years of the viceregal era, all of these works were broadly baroque in style. Despite the vicissitudes of history, a body of fine late colonial painting has survived in Querétaro, including several unique and unusual works by the leading artists of the day such as Miguel Cabrera and members of the Juárez family.

Although not always easy to appreciate, because of their poor condition, inaccessibility or bad illumination, the high quality of these colonial canvases is undeniable, and would greatly benefit from restoration and re-installation.

Our Itinerary

Fortunately, almost all of the great colonial buildings of Querétaro lie within a few blocks of each other in the historic center, and can be easily visited in one day.

Starting with the historic hillside church of Santa Cruz, we explore the city's numerous religious buildings—its most distinguished churches, monasteries and nunneries. Finally we look at several of the city's civil structures, focusing on its 18th century mansions and palaces.

Querétaro, Santa Cruz (1796 map)

Santa Cruz (La Cruz)

Sangremal Hill, a place of legend and special historical significance for Querétaro and Mexico, rises above the city to the east.

It was here on July 25, 1531—the feast day of Santiago Matamoros, the militant patron saint of Spain—that the Spanish conquistadors and their Otomí allies vanquished a force of Chichimec warriors.

At the height of the battle, with the outcome in the balance, the sky suddenly darkened, and a flaming cross appeared in the heavens accompanied by Santiago on his shining white horse, who urged the beleagered Spaniards onward to their eventual triumph.

To celebrate this miraculous victory, a cross was erected on the hilltop, which became the object of intense veneration among the Otomí. Conín, the Otomí chieftain, converted to Christianity, taking the name Don Fernando de Tapia. In concert with the Franciscans, he founded a hermitage (*ermita*) and chapel—the nucleus of the colonial *barrio* of La Cruz. This little *ermita* was then expanded into a small convento, named La Santísima Cruz de Los Milagros, which served as a Franciscan house of retreat through the mid-1600s.

In 1683 the convento was rededicated as the first Apostolic College for the Propagation of the

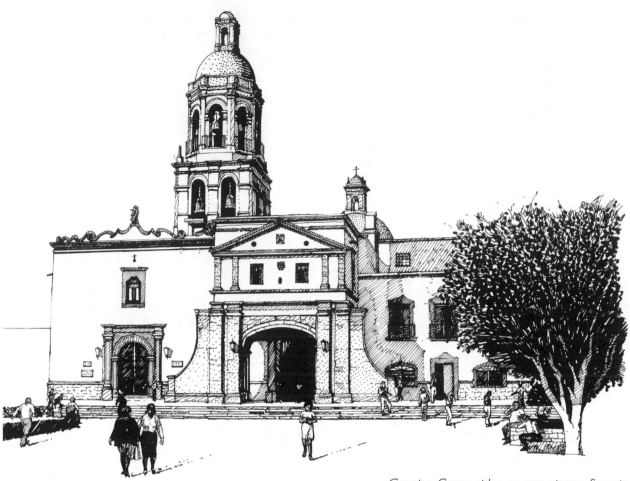

Santa Cruz, the monastery front

Faith in Mexico. The college rigorously trained Franciscan missionaries for work throughout the Americas, including such luminaries as Fray Antonio Margil de Jesús and Fray Junípero Serra, who evangelized the neighboring Sierra Gorda and later, Texas and the Californias.

Although wrested from the Franciscans during the 19th century, under the anti-clerical laws of the Reform, the monastery continued to play its part in history. American troops occupied the convento during the signing of the Treaty of Guadalupe Hidalgo in 1848, and it was here that the Emperor Maximilian was arrested and subsequently imprisoned in 1867. Thereafter, the monastery and college fell into ruins and it is only in recent years that the Franciscans have returned to the renovated church and convento.

As the visitor ascends the hill from the city center, along tree-lined streets of colonial buildings, the Santa Cruz church comes into view, glowing brightly in the afternoon sun above its shaded terraces. The 17th century facade still reflects the classical sobriety of the period, despite some later touches. Plain Tuscan doorways punctuate the broad west front, although the main entry is obscured by a baroque portico. Colorful tiled domes crown the single tower and the cupolas above the church.

A rude stone cross, believed to be the original cross installed on Sangremal Hill by the first Franciscans, rests in a niche above the main altar. Later colonial works of art inside the church include an ethereal Virgin of Light, by the prolific painter Miguel Cabrera, and a painting of Souls in Purgatory similar to one in the church of San Antonio downtown.

Beside the church, the rambling convento of rough stone encompasses several courtyards with rude arcades, as well as a maze of conventual rooms including kitchens, storerooms and the remnants of a complex system of water cisterns and channels. The baroque cloister fountain sup-

ports a statue of La Purísima, to whom the Franciscans were especially devoted, and in an enclosure nearby, a thorn tree with cross-shaped spines said to have miraculously sprung up from a staff thrust into the ground by Father Margil de Jesús.

The great tree-shaded atrium in front of the church and the adjacent Plaza of the Founders are lined with bronze statues of prominent figures in Queretaran history, including Fernando de Tapia and the Franciscans Junípero Serra, Jacobo Daciano and Antonio Margil de Jesús.

Among the more interesting colonial monuments at Santa Cruz is the fountain, located at the southwest corner of the atrium. Known as the Caja de Agua, it remains the oldest functioning fountain in the city. It was constructed in 1725 as

the principal outlet for the water flowing into the city through the imposing aqueduct built by the Marqués del Villar del Aguila.

Emblazoned above the basin and lion-shaped faucet were the quartered arms of Spain and the family escutcheon of the Marqués, both now virtually obliterated. In the shell niche, the figure of a Franciscan saint has replaced the colonial statue of the Spanish Virgin of Pilar.

In commemoration of the apparitions at Santa Cruz, Santiago Matamoros appears on the City Arms of Querétaro, mounted on his rearing charger, with the flaming cross and miraculous thorn tree. A handsome, wrought-iron version of this escutcheon can be seen in a fanlight above the *portería* of the former convento of San Francisco, now the Regional Museum of Querétaro.

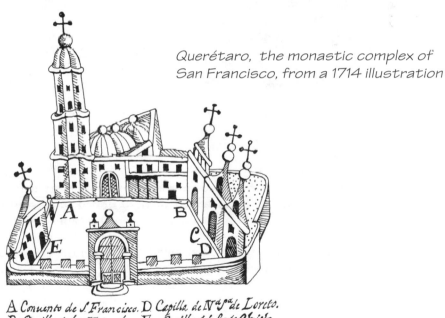

Querétaro, the monastic complex of San Francisco, from a 1714 illustration

A *Convento de S. Francisco.* D *Capilla de Nª Sª de Loreto.*
B *Capilla de los Naturales.* E. *Capilla del Santo Christo.*
C *Capilla de la 3 Horden.*

SAN FRANCISCO

Facing the busy Plaza de la Constitución—its former atrium—the grand monastery of San Francisco still occupies Querétaro's historic and spiritual center. In colonial times, the Franciscan monastic complex was a great deal larger than today, and was the social and religious heart of the early city—a role that it fulfills to this day as the shrine of the Virgén del Pueblito, the most beloved of Querétaro's patron saints.

In the decades following the conquest, the present city center was a predominantly indigenous settlement, ruled by the Otomí chieftain Conín, who provided Indian labor and expended his own funds for the construction of the first mission.

As Spanish settlers moved into the valley after the 1550s, the monastery church served as the first parish church of the new city of Santiago de

San Francisco de Querétaro, facade relief of Santiago Matamoros

Querétaro. In 1568, San Francisco was designated as the principal monastery of the new Franciscan province of St. Peter and St. Paul, which then encompassed most of western Mexico including Michoacán.

A century later, the monastery was radically expanded. A spacious new church with side chapels was built and the convento enlarged. As the 1714 plan shows, other elements of the extensive compound—tragically destroyed during the Reform movement of the 19th century—included the original hospital and Indian chapel, a Third Order church and the Loreto Chapel, all grouped around a gated, battlemented atrium. Other Franciscan foundations were built close by, notably the friary of San Antonio and the convent of Santa Clara.

The Church

The rebuilt monastery church is the most important work of the mid-1600s in Querétaro, and its oldest surviving monument from this period. In 1658 the architect José de Bayas Delgado arrived to design the new church of San Francisco—the first of his many commissioned projects in the city.

With this building, he introduced the sober baroque style to Querétaro, an architecture of ribbed stone vaults, high cupolas, and geometrical facades derived from the classical designs of the 16th century Italian architect Sebastian Serlio. The entire church, with its lofty vaulting, imposing tower and ,dome, and meticulously detailed facade and doorways, has been documented as the architect's original work.

The cathedral-like retablo facade is fashioned in gray stone—a cool Renaissance pavilion framed by the mellow orange stucco of the enveloping west front. Fluted Corinthian pilasters with unorthodox feathered capitals and rosette-banded friezes frame the narrow shell niches and rusticated choir window.

Sculpture and statuary were all-important features of the baroque church front. The oustanding example here is the brownstone relief of Santiago Matamoros dominating the upper facade. Probably salvaged from the earlier church and possibly dating from the 16th century, this vigorous carving is the oldest sculpture in the city, and a conspicuous local landmark. The equestrian saint is shown in his time-honored medieval pose,

seated on a rearing horse, with sword raised and cloak flying, vanquishing the turbanned infidel.

The four statues in the lower niches date from the late 1600s. St. Peter and St. Paul stand like sentinals on either side of the entry porch, while St. Anthony of Padua and St. Bonaventure flank the choir window. The figure of St. Anthony was moved here from the north doorway, replacing a statue of St. Francis, now stored in the convento museum.

The massive north tower (dated 1676 by an inscription) is the other outstanding feature of the building, consisting of two polygonal upper tiers set on a squared first stage, all fringed by conical pinnacles.

The church interior was made over in opulent neoclassical style during the last century, furnished with huge stone altars and elaborate ironwork. Occupying pride of place on the main altar is the popular Virgén del Pueblito, a curious image of the Virgin with the young Christ, both robed in stiff, flared dresses. She stands over the bowed figure of St. Francis of Assisi, who holds aloft the triple globes of the three Franciscan Orders.

None of the baroque retablos and only a handful of the original furnishings have survived. Chief among the survivors is the ornamental organ, adorned with angels playing trumpets and viols. This rare baroque instrument is credited to the noted 18th century Queretaran designer, Mariano de las Casas, who worked in several other city churches and designed the newly restored organ at Santa Rosa de Viterbo. The wooden choir stalls are also thought to date from the late 1600s or early 1700s.

A vivid miniature tableau of Las Animas (Souls in Purgatory) rests on a pedestal beneath the choir. Expressively detailed figures of agonized sinners from all walks of life, including bishops and other clerics, caught in the leaping flames, appeal to St. Francis in his blue habit.

Hung opposite this relief is a huge painting of the Virgin of the Apocalypse, attributed to Gregorio Romero, another 18th century Queretaran artist. The ethereal, gracefully draped Virgin floats above the Archangel Michael, who vigorously dispatches the writhing demon beneath her feet. A second canvas by Romero, also depicting Souls in Purgatory, this time with the Holy Family, hangs in the sacristy.

The Convento

The former convento now houses the **Regional Museum of Querétaro**, which contains a number of interesting, but indifferently mounted exhibits of historical and artistic interest.

Architecturally, the most pleasing aspect of the convento is its spacious cloister, especially the upper arcades whose bulbous Corinthian columns are carved with chevrons.

The surrounding galleries display a variety of paintings, sculptures, furnishings and artifacts. Several canvases depict episodes from the early history of Querétaro, including grim portraits of martyred friars from nearby Santa Cruz. There is a striking deathbed depiction of José de Escandón, the conqueror of the Sierra Gorda, and a portrait of Juan de Caballero y Ocio, Querétaro's great colonial benefactor.

Other exhibits of note include two cycles of baroque paintings in the upper corridors, attributed to Miguel Cabrera and taken from the Jesuit church in Querétaro. These comprise scenes from the life of St. Ignatius and a colorful sequence of angels displaying the Instruments of the Passion.

*San Francisco,
the cloister fountain*

Querétaro, La Congregación: *statue of the Virgin of Guadalupe*

The Temple of Guadalupe (La Congregación)

This is the most complete 17th century church in Querétaro, built for a group of secular clergy known as La Congregación. As eloquently described by Sigüenza y Góngora, the temple was dedicated to the Virgin of Guadalupe on May 12, 1680—the first church in Mexico to be so consecrated.

Its wealthy patron was Juan de Caballero y Ocio, whose silver fortune made possible its construction and decoration. As a tribute to the colonial philanthropist, his bronze statue was recently erected above the fountain in front of the church. To realize the project, Caballero y Ocio commissioned José de Bayas Delgado, by then recognized for his elegant Queretaran buildings, including the monastery church of San Francisco, to draw up the plans and design the facade.

The church front—the architect's last recorded work in Querétaro—is a classic study in the architect's sober geometrical manner. Imposing whitewashed twin towers, each capped with pyramidal cupolas, frame the narrow brownstone facade, which is subtly articulated by a variety of discreet pilasters and moldings. Rectangular panels neatly contain accents of filigree foliage, triangular spandrels crown the polygonal arch of the doorway and a baroque "eared" frame outlines the choir window.

Following the adoption of the Virgin of Guadalupe as the official patron of New Spain in 1737, minor changes were made to the church. The dome was enlarged and a gable added to the facade to house a statue of the Virgin—the only figure sculpture in this sober facade. An elaborate Churrigueresque niche, framed by caryatid-*estípites* and a mixtilinear arch, contains the simple polychrome statue, colored red, blue and gilt.

As befell so many other city churches, the interior was robbed of its original character during the 19th century. Although the graceful rib vaulting is still in place, mausoleum-like altars replaced the gilded retablos—baroque masterworks that Sigüenza y Góngora described in detail in his *Glorias de Querétaro*, some of which were designed by Bayas Delgado himself.

Luckily, some colonial paintings, as well as a few fragments of the retablos and their sculptures, have survived within the church precincts. The main altar, for instance, retains an authentic 18th century canvas of the Virgin of Guadalupe—one of several copied directly by Miguel Cabrera from the original icon. Beneath the choir is a diptych documenting one of the Miracles of St. Anthony of Padua, by Tomás Xavier de Peralta—the last known work of this talented regional genre painter.

In the north transept hangs a canvas, in the style of Zurbarán, illustrating the Lamentation of the Virgin. Dated 1784, it is rendered in muted colors with dramatic chiaroscuro effects, and is attributed to Juan Rodríguez Juárez, one of the most illustrious members of the Juárez artistic dynasty.

The sole remaining colonial retablo, small but superbly crafted with sinuous rocaille gilding, is stored in the sacristy. Its unique feature is a miniature of Christ painting an image of the Virgin of Guadalupe—an unusual subject found only rarely in Mexican art.

Before leaving the temple, glance up at the splendid baroque organ (1753) placed inconspicuously at the rear of the choir, another colonial treasure by the Queretaran sculptor and specialist in organ cases, Mariano de las Casas.

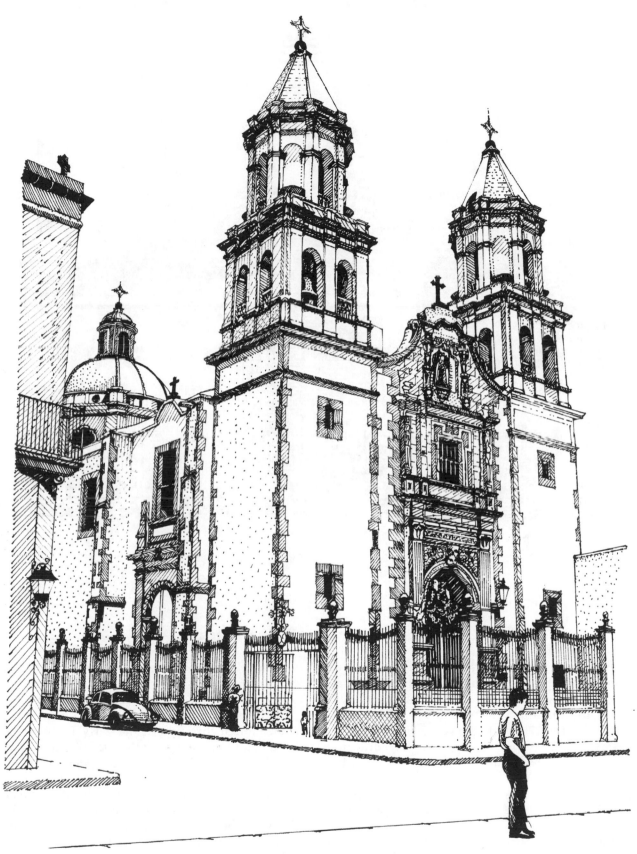

Querétaro, the Temple of Guadalupe (La Congregación)

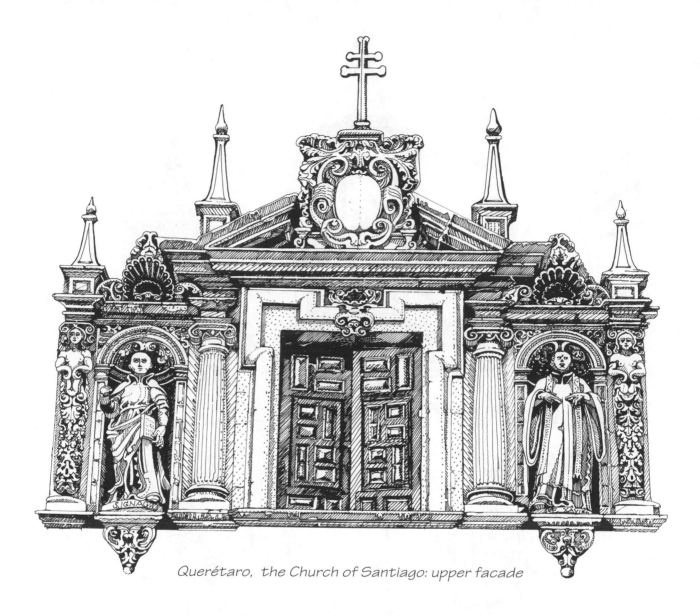

Querétaro, the Church of Santiago: upper facade

The Church of Santiago

Now the official parish church of Santiago de Querétaro, this late colonial church, with its attached schools and convento, was originally a Jesuit foundation.

During the 17th and 18th centuries, the Jesuits bore the major responsibility for higher education throughout New Spain. By the early 1600s, because of the growing wealth and influence of Querétaro, the mayor and colonial governor invited the Society of Jesus to establish a college here.

Enjoying royal patronage and endowed with more than 30,000 pesos—a considerable fortune for the period—the church of La Compañía and a modest college, dedicated to St. Ignatius Loyola, were erected on a site located just to the east of La Congregación (Temple of Guadalupe.)

Many new additions and alterations were made to the church throughout the early 1700s, some through the beneficence of the ever generous Juan de Caballero y Ocio. The college, too, was greatly expanded, with the addition of the prestigious seminary of St. Francis Xavier, whose precincts eventually included three interior courtyards. Although the complex was essentially complete by 1755, finishing touches were still being applied in 1767, when the Jesuits were summarily banished from Mexico by royal order.

After this devastating blow, La Compañía was designated the parish church of Querétaro, and renamed in honor of Santiago, the city's original patron saint—a role it still fulfills. Following a brief hiatus, during which it was occupied by Spanish troops, the college resumed its educational role, which it continues to play as part of the University of Querétaro.

The Church

Opinions are divided as to which parts of the church belong to the 17th century and which ones date from later renovations. Although it was reportedly "rebuilt from the foundations up" during the 18th century, much of the present fabric probably dates from the mid-1600s.

The single tower—rare for a Jesuit church—as well as the porch are constructed of dark stone. The severe lines of the doorway, flanked by classical Corinthian pilasters, follow the school of Bayas Delgado. But the upper façade, added in the 18th century, is freer and more sculptural, in common with the ornamental facade of San Agustín, across town.

Caryatids, festooned with foliage, flank the two main sculpture niches, which hold rococo statues of Saints Francis Xavier (right) and Ignatius Loyola (left), draped in extravagantly folded garments. Obelisks and shell reliefs are mounted above the broken pediment, and an elaborate scrolled medallion at its apex supports a two-armed episcopal cross. A similar cross marks the corner of the church forecourt.

The west-facing belfries on either side of the church are also 18th century additions, as is the scrolled flying buttress beside the tower—a form undoubtedly derived from the convent church of Santa Rosa de Viterbo (see p.223).

Geometrical relief decoration in the understated Queretaran style adorns the underchoir. Moorish windows around the broad dome light the crossing as well as the rather spartan interior, while in the sacristy, ornate octagonal windows illuminate several 18th century canvases, notably a large allegorical painting of the Mystery of the Trinity—a favorite Jesuit theme.

Other colonial paintings crammed into the sacristy and its anterooms include an unusual Allegory of the Immaculate Conception (dated 1756) by Tomás Xavier de Peralta, in which the Virgin literally "blooms" from the family tree, represented by her parents, Saints Joachim and Anna.

A naturalistic double portrait of the college benefactors, Diego Barrientos Rivera and his wife María de Lomelín, posed in dignified 17th century dress, is of special interest as a historical and social document.

The College of St. Ignatius

The original school of San Ignacio lies beside the rear of the church. Its patio, together with a plain second courtyard, have suffered many modifications and are now of little architectural interest.

However, the principal cloister, immediately adjacent to the church at the front, is intact. Highly distinctive in design and decoration, it was added around 1755 as the centerpiece of the new seminary of St. Francis Xavier.

An imposing neo-*mudéjar* entry with rusticated jambs admits us to this exceptional cloister—recently renovated, and now in excellent condition. Its assertive ornamental geometry is very much in the Queretaran tradition, with high, open arcades surrounding an octagonal fountain in the center of the patio.

Handsome paneled piers and pilasters with delicately molded arches outline the five bays on each side. Tightly composed triangles of relief foliage fit into the spandrels, and animated cherubs—sculpted in various attitudes—project from the apex of each archway.

A sequence of ornamental doorways—boldly framed like the entry in Moorish style—lead off the cloister walks. A grand balustered staircase conveys the visitor in elegant style to the upper cloister, whose corridors are enclosed, in the manner of many Jesuit colleges, with large square windows, heavily framed with projecting jambs, cornices and consoles.

The tower, with its *mirador*, rising above the southeast corner, was the last addition to the building, completed in the summer of 1767—only weeks before the expulsion of the Jesuits from the New World.

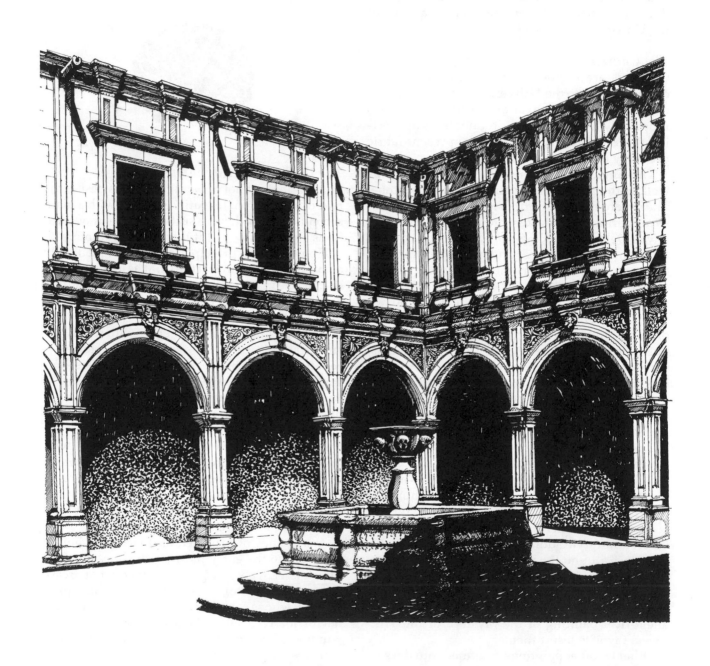

Querétaro, the College of St. Ignatius: the seminary cloister

*Querétaro, San Agustín:
horn-playing angel on the dome*

SAN AGUSTIN

The magnificent priory of San Agustín is the crown jewel of late colonial architecture in Querétaro—impressive in its sweeping scale, innovative in its design and unique in its assemblage of architectural sculpture.

Its great blue and white dome seems to hover above the church, ringed by a band of angels playing instruments whose strains rise heavenward like the cupola itself.

As early as 1602, Querétaro had been chosen as the site for the flagship priory of the new Augustinian Province of San Nicolás de Tolentino de Michoacán, but because of disputes within the Order, the actual founding of San Agustín was long delayed. The monastery was finally sanctioned in 1727, and construction of church and convento began four years later. The church was reportedly complete as early as 1736, and was formally dedicated in 1745, two years after friars had moved into the finished convento. The tower was never completed, but was unceremoniously abandoned above the first tier.

The 19th century was not kind to San Agustín. In 1833, a disastrous fire destroyed the main altar and, following the closing of the priory in 1859, its few remaining baroque altarpieces were vandalized by occupying troops. After initial attempts at restoration and modernization, around 1900, the monastery was eventually declared a historic monument in 1935.

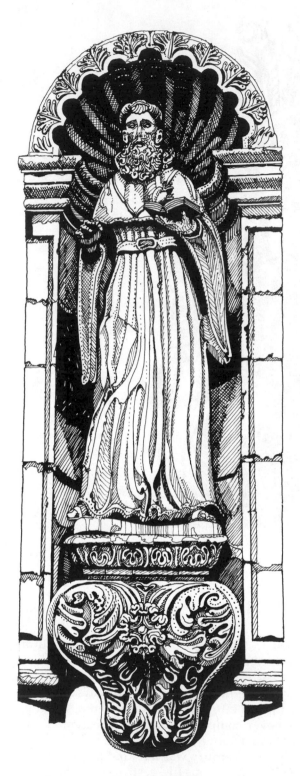

*San Agustín, facade:
statue of St. Augustine*

Painstaking renovation of the sculpted cloister in the late 1980s, in preparation for its new role as the Querétaro Art Museum, has restored this baroque gem to its former glory. And thorough refurbishment of the church is proceeding at this time.

The Church

The design of San Agustín represented a startling break with the austere classicism of the 17th century, dominated by José de Bayas Delgado and his followers.

Traditionally attributed to the great Queretaran designer Ignacio Mariano de las Casas, the monastery was in all probability a collaborative effort, involving other regional architects and sculptors that included Francisco Martínez Gudiño and Juan Manuel Villagómez, the architect of Tlalpujahua (Michoacán).

Although Mariano de las Casas most likely drew up the plans, Villagómez is usually credited with the facade design and Gudiño may have supervised the sculptural program.

The broad facade retains the retablo form, but on a grander and more theatrical scale. Within its playfully geometric framework, the San Agustín facade is unabashedly sculptural. Its principal features—the unusual octagonal columns with slashed spirals, the polygonal main doorway, the coffered choir window, the faceted projecting cornices and sausage-like friezes encrusted with foliage—all reveal a disciplined but highly mannered architecture that deliberately attracts attention to itself, clearly rejecting the self-effacing restraint of the traditional Querétaro style

The eye-catching sculpture seems especially idiosyncratic. Narrow scalloped niches squeezed between the spiral half columns house the statuary—a gallery of elongated figures that includes St. Augustine and St. Francis below, and the Augustinian saints Santa Monica and Santa Rita de Cascia on the middle level.

The elaborate carved keystone of the entry—a minor hallmark of 18th century Queretaran architecture—features a tiny relief of St. Augustine, nestled in a scalloped cartouche entwined with cherubs.

Giant candelabra pinnacles bracket the exuberant top tier of the facade, where layered shell niches are underpinned by intricately carved corbels, on which cherubs play around children dressed in the Augustinian habit.

Pilasters bearing atlantean figures with smiling, childlike visages and leafy skirts flank the large central niche, where an ornamental, cruciform frame encloses the foreshortened figure of Christ on the cross—a motif seen in other regional Augustinian churches, notably at Salamanca, Guanajuato. The niche is a sculptural tour-de-force, profusely decorated with vines and swirling foliage in high relief. Fantastic, siren-like caryatids cling below, and naked cherubs gaze down from above.

From the lateral niches, the Virgin of Sorrows (La Dolorosa) and St. John the Evangelist incline in sympathy towards the suffering Christ.

The north porch is plainer, with paneled pilasters instead of columns. The tiny figure of La Dolorosa—the original patron of the church—is carved into the keystone, pierced by the arrows of her Seven Sorrows. A statue of St. Nicholas of Tolentino fills the overhead niche, and an ornate eared upper opening frames a second image of Santa Mónica.

The facade is anchored on the north by a polygonal buttress, and on the south side by a heavy, blank tower base supporting a single tiered tower. Work was stopped so abruptly on the unfinished tower, or *torre mocha*, that the sculpted angels on each corner remain severed at the waist.

The handsome octagonal dome soars above the church, prominently tiled in blue and white—colors emblematic of La Dolorosa. Eight lifesize angels stand erect on the corners in plumed helmets and windblown skirts, playing horns, violins and guitars.

The Interior
The intensely sculptural character of its facade continues inside the church, where the gray stonework contrasts with expanses of whitewashed wall. Because of the shortened nave and shallow

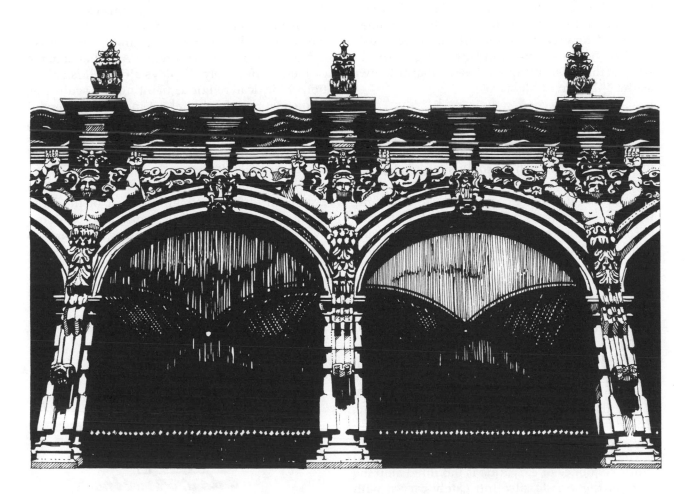

San Agustín, the upper cloister (detail)

transepts, the interior is dominated by the grand crossing with its octagonal cupola and dome.

Eight of the Apostles look down from the corner niches of the drum, between neo-Moorish windows, while the apostolic martyrs St. Peter, St. Paul, St. Andrew and St. James the Greater (Santiago), occupy shell niches in the supporting pendentives. The capitals of the arches below the crossing are carved with angels, sacred monograms and pelicans—symbols of Christ that underscore the sacrificial theme of the church.

Sadly, the majestic late baroque retablos that formerly lined the nave and transepts of San Agustín, including a celebrated altarpiece of St. Anne created by the Queretaran sculptor Pedro de Rojas, have been destroyed. But, as in other vandalized churches, a few of the original furnishings have survived.

In the sacristy are two shaped canvases that formed the corner panels of one of the lost retablos. They depict the grim-visaged Augustinian martyrs of Africa, with men on one side and women on the other. Although unsigned, they combine a powerful, tonal composition with the looser brushwork of the late baroque, and are thought to be the work of the Jaliscan painter, José de Ibarra, known as the "Murillo of Mexico."

The Cloister

The sculptural complexity of the priory reaches its climax in the cloister (1731-45)—one of the most exciting and exotic baroque spaces in Mexico. The two stories of the arcaded cloister form an enveloping display of dynamic stonecarving, whose esoteric imagery, drawn from Italian Mannerist sources, unites voluptuous figures and boldly modeled foliage into a new and original sculptural synthesis.

Along the lower bays, slender herms with bulging breasts and tapering bodies divide the paneled piers, their heads and feet inclining towards the center of the patio. The faces of the corner figures are lined and bearded, while the others are more youthful. Fantastic birds and beasts, carved in exuberant high relief, peer out from lush foliage in the intervening spandrels. Of particular interest are the scalloped keystones of each archway, where cameos of Augustinian saints alternate with emblems of the order.

The upper arcades are even more fantastic. An exotic sequence of caryatids is mounted atop the piers of the arcade, also intricately carved with volutes and geometrical strapwork. Part human and part plant, these massive, broad-breasted fig-

ures have virile faces and wear foliated skirts. Tiny, playful cupids peek out from behind their elaborate feathered headdresses. But the most curious features of the caryatids are their giant upraised arms, whose obscure hand gestures have been interpreted as symbolic of the liturgy of the Eucharist.

Portraits of Augustinian saints, martyrs and hermits are carved on the keystone cartouches, each with his individual gestures and attributes. Pomegranates frame the medallions, while a melange of vines, foliage and grotesque animals trail across the spandrels, echoed by the rhythmic, undulating cornice that crowns the cloister. The impact of all these extraordinary sculptures must have been even greater in times past when they were painted in black, red and other hues.

Although many interpretations of this iconographic puzzle have been put forward—variously linking the imagery to the Catholic liturgy, the Passion of Christ and the aspirations of the Augustinian order—what finally impresses is the joyful virtuosity and imagination of the artists who created this unique sculptural environment.

Now reborn as the **Querétaro Art Museum**, the convento effectively displays a first class collection of Mexican religious painting and sculpture. Choice works of colonial art include a splendid series of Rembrandt-like portraits of the Apostles by the baroque master Cristóbal de Villalpando, as well as a stunning group of gory, early colonial crucifixes in the Pátzcuaro tradition.

My particular favorites include the Flight into Egypt, an idyllic, intimate portrait of the Holy Family from the early 1700s, luminously rendered by the baroque master Juan Rodríguez Juárez, a sensuous Ecce Homo by José de Ibarra, and an icon-like image of The Divine Shepherdess by the Mexican "folk rococo" painter Luis Berrueco.

Querétaro, San Agustín (1796 map)

QUERÉTARO'S NUNNERIES

Like other Mexican baroque cities, Querétaro is especially rich in nuns' churches and convents. But in no other city do they match the opulence seen in these interiors, where some of the nation's most treasured works of late colonial art are preserved.

Santa Clara and Santa Rosa, in particular, house an unequalled collection of Churrigueresque altarpieces, crafted by the most talented and skillful 18th century designers and sculptors: Pedro de Rojas, Francisco Martínez Gudiño and Ignacio Mariano de las Casas.

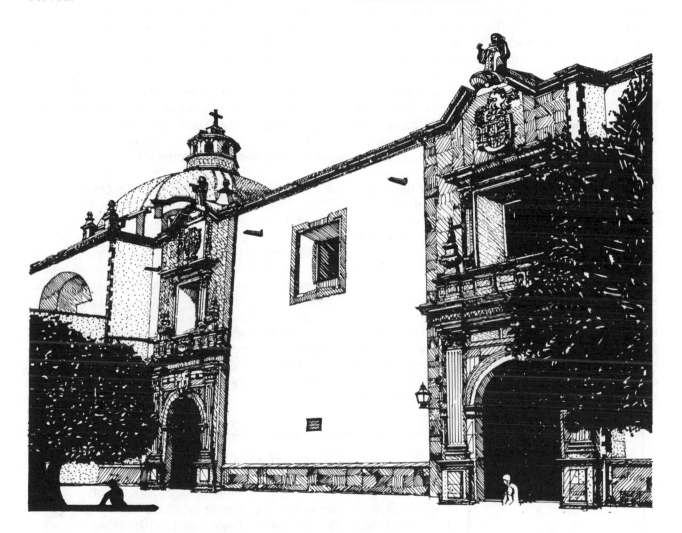

SANTA CLARA

It is only a few minutes walk west along traffic-free Madero Street from San Francisco to its sister convent of Santa Clara, nestled behind the corner fountain of Neptune—a city landmark designed by the Celayan architect Francisco Tresguerras.

Santa Clara is the oldest of Querétaro's nunneries, founded in the year 1600 by Don Diego de Tapia, the son of the Otomí chieftain and conquistador Fernando de Tapia, for his daughter María

Luisa. The primitive adobe convent was soon replaced by a stone building, and in 1633 the *clarisas* moved into their new quarters. However, it was not long before they found these accommodations inadequate, and within 30 years, both church and convento were enlarged yet again.

Apparently pleased by his work on San Francisco, the Franciscans commissioned José de Bayas Delgado to make the necessary additions.

Although the spacious convento—"a city within the city," as it was described in the 18th century—has since been demolished, the church and its treasures remain largely intact.

Recessed behind its newly repaved forecourt, the unassuming exterior features the classic twin porches that mark it as a nuns' church.

Fashioned from the local brownstone, these slender, vertical facades hew to the austere Mannerist forms favored by Bayas Delgado and his followers, with geometrically framed openings that are subtly refined in their detailing and ornament.

Outsized heraldic reliefs, including the Querétaro city arms on the right, are emblazoned below pediments that pierce the roof parapet to support monumental statues of St. Francis and St. Clare—possibly survivors from the earlier church.

The long, narrow church interior was entirely remodeled in the 18th century, under the direction of Mariano de las Casas. Its lavish interior, including the retablos, is attributed to same team of artists and craftsmen who worked at nearby Santa Rosa de Viterbo.

The Santa Clara Retablos

Although the baroque main altarpiece has gone—replaced by a grandiose stone altar—the six magnificent Churrigueresque side retablos have survived. Together with those of Santa Rosa de Viterbo, they represent the culminating moment of the ornate Queretaran style of late baroque and rococo decoration, or "Barococo," as it has been dubbed by Joseph Baird, a leading authority on the Mexican baroque.

The altarpieces are conceived on a grand scale. Closely integrated into the architecture, each retablo fills a bay along the nave, reaching to the vault and often incorporating the window into the composition, reflecting the baroque love of dramatic lighting effects.

Completed between 1740 and 1770, with the assistance of the finest designers and artisans of the era, all the retablos are related stylistically. Nevertheless, each is a distinctive work of art, embellished with woodcarving, gilding and polychromy of the highest order, to achieve a creative synthesis of design, ornament and craftsmanship without equal in Mexican colonial art.

The retablos are described in counter-clockwise order, according to the plan below.

Retablo 1. *Virgin of Sorrows (La Dolorosa)*
This sumptuous retablo adjacent to the choir, dated 1766, is attributed to Francisco Gudiño. Ornate niche-pilasters are mounted on a gilded basketwork background. Lush gold rocaille work and polychrome enhance a full decorative repertoire of shells, scrolls, lambrequins, hearts, angels, clouds and the symbols of Christ's Passion.

Above an elaborate tabernacle or *sagrario*, fashioned in the shape of the Sacred Heart, stands the richly appareled image of La Dolorosa, contained in a vitrine or glassed-in niche. On either side, pilasters bear the statues of eminent *clarisas* holding infants.

SANTA CLARA RETABLOS

1. La Dolorosa
2. St. John Nepomuc
3. Virgin of Guadalupe
4. Archangels (tribune)
5. Immaculate Conception
6. Santa Rosa de Lima
7. Choir retablo (Purísima)

Sacristy

Choir

The figures of Mercy and Piety appear in the projecting upper part of the retablo, flanking a draped tree cross that is theatrically silhouetted against the nave window. Both statues are clothed in Franciscan habits with fine *estofado* patterning.

Retablo 2. *St. John Nepomuc*
The earliest of the Santa Clara altarpieces, this was initially worked on by a local woodcarver, Luis Ramos, but was completed in the 1740s by Pedro de Rojas, the master sculptor of the Bajío, who probably carved the statuary—generally considered to be the finest in the church.

An early date is indicated by the clarity of the retablo structure. Complex *estípite* columns enclose statues of the Doctors of the Church, with St. Bonaventure and St. Thomas Aquinas. Another imposing *estofado* figure is that of St. Louis, Bishop of Toulouse, standing above the vitrine.

The figure of St. John Nepomuc—the 14th century Bohemian aristocrat and Franciscan saint to whom the retablo is dedicated—rests in the center showcase, ringed by oval panels illustrating his life and his martyrdom by drowning in the Moldau River. These scenes are rendered in uneven chiaroscuro, and signed by the little known Queretaran painter Agustín Ledesma.

The usual vocabulary of baroque ornament—predominantly scrolls and angels, here accented with mirrors—enriches the surface texture of the retablo.

Note the bulbous gilded pulpit projecting from the nave wall between retablos 2 and 3, luxuriously encrusted with Churrigueresque ornament in keeping with the adjacent altarpieces.

Retablo 3. *Virgin of Guadalupe*
Similar to the first retablo in its lavish polychrome ornament, this complex altarpiece is also attributed to Francisco Gudiño.

Large paired niche-pilasters set against a woven gold background flank the swagged center painting of the Virgin of Guadalupe, signed by Miguel Cabrera and dated 1752.

Since Cabrera was one of a select group of artists permitted to view the original icon—imprinted on the cloak, or *tilma*, of the Indian Juan Diego—his interpretation is authentic, although rather outshone by the dazzling altarpiece surrounding it. A bust of God the Father, accompanied by biblical figures, looks down from the elaborate upper niche, while a group of blue-robed nuns flanks the Virgin.

Garlands, massed cloudlets and flaming hearts stand out in high relief from the surrounding profusion of sensuous decoration.

Retablo 4. *Retablo-Tribune of the Archangels*
Dated 1766, this magnificent gilded structure is thought to be another work by Gudiño.

More a grandiose portal than an altarpiece, it presents an ornate front that surpasses the adjacent retablos in its opulence. A cherub-encrusted overhang frames the entry to the sacristy that lies beyond, while a wrought-iron filigree screen encloses the Mother Superior's tribune, or balcony, above.

Wide, pillowed niche-pilasters enframe two archangels—graceful statues, trailing windblown *estofado* robes. Shells, scrolls and lush *rocaille* again dominate the surface ornament, together with sculpted garlands and burgeoning foliage.

Retablo 5. *Virgin of Immaculate Conception*
Facing the tribune across the nave, this related retablo is also by Gudiño and, like his other works in the church, was created during the 1760s.

Although the retablo is now dedicated to San Juan Bautista María Vianney, an obscure 18th century cleric whose statue in the central case has replaced the original image of La Purísima, the female Franciscan saints that were the Virgin's companions remain in place. The figures of Rose of Viterbo and Margarite of Cortona are later copies, but the *estofado* statues of the martyrs Santa Inés and Santa Otilia above are of higher quality, and probably original.

Barely contained by a bold, scalloped outline, the retablo's giant niche-pilasters seem to spread organically across the surface, entwining the statuary with foliage and scrollwork.

Retablo 6. *St. Rose of Lima*
Dedicated to Santa Rosa, the first American saint, this small retablo links the double doorways on the south side.

Earlier than the Gudiño altarpieces, it is thought to be another work by Pedro de Rojas. This attribution is supported by its less exuberant ornament, and graceful lifesize sculptures of angels—a signature of Rojas' altarpieces, and probably from his own chisel.

Above a pair of intricately carved and painted doors surmounted by reclining angels and cornucopia, ornate pilasters with curtained niches house polychromed figures of Saints Dominic and An-

Querétaro, Santa Clara: the sacristy doors

thony of Padua, who flank St. Rose of Lima inside her vitrine.

Overhead, a decorative cartouche of the Virgin of Guadalupe is encircled by Marian symbols, each accompanied by one of the Archangels of the Apocalypse, popularly called the "Seven Princes."

The Choir

The miraculously preserved nun's choir of Santa Clara is one of the great works of the Mexican baroque, and one of the artistic high points of the Queretaran style in its full florescence.

The enclosed choir occupies three entire bays at the east end of the church, and is built on three levels, if we include the spacious crypt designed by Mariano de las Casas.

The choir retains its ornate, two-tiered screen—a masterpiece of the metalworker's art. Newly restored, the screen achieves a perfect marriage of delicate filigree ironwork with gilded reliefs and decorative painted sculptures.

Intricate shells and fans frame the rectangular lower grid, which is flanked by Old Testament figures beautifully finished in red, blue and gold. On the right is Jesse, the father of David and biblical progenitor of the Virgin Mary. Above the grid, three elaborate rocaille medallions frame reliefs of St. Clare and the monastic virtues, Poverty and Chastity.

The upper part is lighter and freer in feeling than the lower tier. Above a long, open grill that stretches across the nave, an intricate decorative semicircular screen rises to the vault. Festoons in imitation of cloth are drawn aside to unveil a spreading tracery of acanthus leaves, to which is pinned a large crucifix.

The naive figure of Christ is an expressive copy of an 18th century statue by the popular sculptor Mariano Perusquía.

Retablo 7. *La Purísima*

Fragments of gilded retablos and reliefs line the choir, together with paintings of obscure saints so beloved in the baroque age.

Fitted into the curve of the vault at the end wall of the upper choir rests one of the church's great treasures—a pedimented wall retablo designed by Francisco Gudiño and executed by Maestro Ximénez, a skilled indigenous woodcarver

Sculpted in painstaking bas-relief, this late baroque retablo sets splayed, scrolled niche-pilasters against a gilded tapestry of *rocaille* and foliated arabesques.

Currently under restoration, it is dedicated to La Purísima, whose image is flanked by the figures of Saints Joachim and Anna.

The Sacristy

The sacristy and baptistry are reached through the doorway beneath the tribune-retablo.

On the left, we notice first a pair of exquisitely carved and painted doors. Embellished with angels and alive with red and gold rocaille relief, they are emblazoned with the Franciscan insignia.

The doors open to the sacristy, containing several colonial paintings of note. Here are an expressive Communion of St. Bonaventure by the early baroque master Juan Correa, a kneeling St. Martin of Tours by Miguel Cabrera, a sinuous Virgin of the Immaculate Conception in high baroque style, and finally, a winsome portrait of the Virgin, known as Our Lady of the Sacristy, accompanied by St. Peter and St. Paul.

Another local 18th century artist of note, Pedro José Noriega, painted the rounded triptych of the Betrothal of Joseph and Mary in the baptistry opposite—a colorful work rendered in the anecdotal style of much Mexican popular art.

The Hospital

Across the street from the Neptune Fountain stands the modest charity hospital once attached to Santa Clara. A worn escutcheon surmounts the plain portal, which leads into a little cloister, currently displaying old telegraph equipment, simply arranged around the patio fountain.

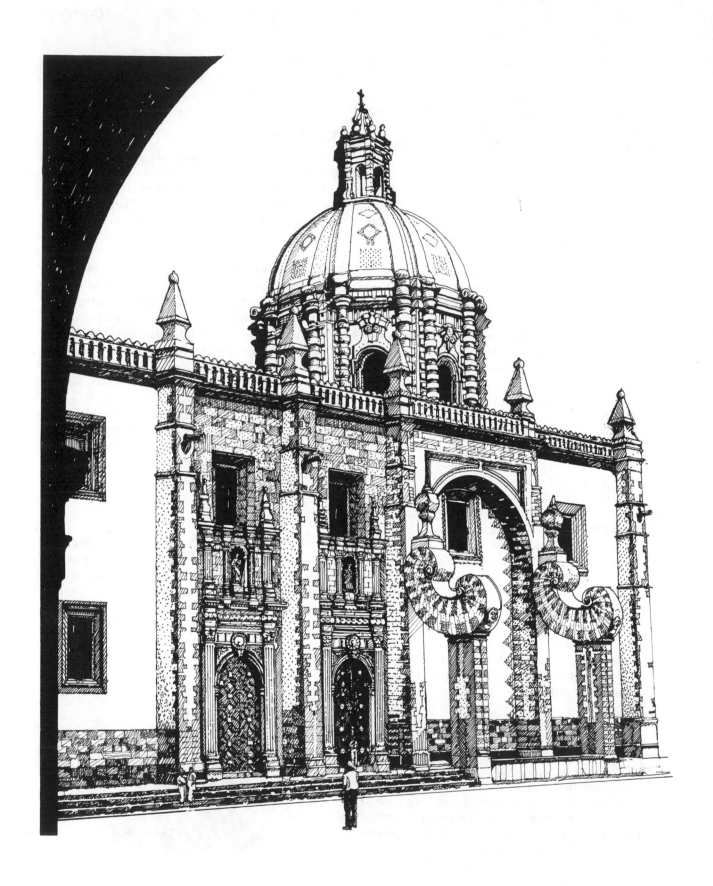

Querétaro, church of Santa Rosa de Viterbo

222

*Santa Rosa de Viterbo
from a 1796 map*

SANTA ROSA DE VITERBO

The richest collection of colonial art in Queretaro is to be found in the sumptuous convent of Santa Rosa de Viterbo, located a few blocks southwest of Santa Clara.

Facing a handsome plaza named for Ignacio Mariano de las Casas, who worked here as an architect and designer, the church of Santa Rosa is a late baroque banquet, remarkable for the variety, high quality and imagination of virtually all the works of art within its walls. Even more remarkable is that such a rich decorative ensemble should have survived virtually intact during the turbulent history of post-colonial Mexico.

Established in 1670 as a charitable nunnery for a teaching order of Franciscan Tertiary nuns—the last in the line of distinguished Franciscan foundations in the city—the convent was located in an area on the fringe of the colonial center, notoriously infested by bandits. Once they were cleaned out by General José Velazquez de Larea, he donated the site to the Franciscans. Sometime after 1700, Juan Caballero y Ocio agreed to fund construction of a new convent, to include a college and grand church, which was dedicated in 1752.

The Church

Although the original architect of the church is uncertain, we know that Mariano de las Casas and Francisco Gudiño were responsible for several aspects of its design, architectural detailing and decorative additions.

Santa Rosa is a typical nuns' church, whose plain elevations and double porches are framed in a severe geometrical style that reveals the continuing influence of Bayas Delgado and his school. Narrow and elongated, the porches display statues of St. Francis and Santa Rosa de Viterbo, and are fitted with carved, *mudéjar* wooden doors.

The huge octagonal cupola is girded by rusticated columns and capped by a majestic tiled dome and lantern. Attributed to Mariano de las Casas, its outline still reflects the Serlian classicism favored by Bayas Delgado. This vast dome was deemed too weighty, however, and Gudiño was called in to strengthen the nave, which he did with flying buttresses in the form of giant scrolls or volutes—an eye-catching architectural innovation that has become a city landmark.

According to local lore, these playful buttresses, emblazoned with grimacing masks, were intended to mock the miscalculations of the original architect, or perhaps the timorous patrons of the building.

The slender tower, decorated with lambrequins and capped by an unusual dome of oriental appearance, is also the work of Mariano de las Casas who is additionally credited with the clock design.

The Interior

The narrow interior is luxuriously outfitted in a late baroque manner, influenced by mid-18th century rococo fashions. Standouts among the church furnishings include the neo-*mudéjar* pulpit, richly inlaid with rare woods, precious metals, ivory and tortoiseshell. An oriental flavor is conveyed by its fringed canopy and sinuous painted stairway resembling a Chinese screen—possibly reflecting influences from the Philippines.

Portraits of prominent Old Testament women—Rebecca, Judith, Esther and Deborah—adorn the pendentives below the crossing, and intimate Mannerist paintings of the Nativity and the Flight into Egypt are mounted above the doorways.

Although the original baroque main altarpiece was replaced, several lifesize wooden statues from the *apostolado* that stood before it are now on display before the high altar. These include all Twelve Apostles, as well as assorted kings and turbanned Prophets. Originally set up as a tableau of the Last Supper, these rough-hewn bearded figures personify the character of the artisans

who became Christ's apostles. The focal statue of Christ has an opening in the chest, suggesting that it may originally have been used to display the host.

But like Santa Clara, the special distinction of Santa Rosa lies in its richly decorated choir and extraordinary ensemble of side retablos.

The Santa Rosa Retablos

The Santa Rosa altarpieces exemplify the high achievement of the Queretaran baroque style. In this final stage of the Churrigueresque, often referred to as *anastilo*, virtually all structure seems to evaporate in favor of richly ornate surface decoration, paintings and sculpture.

Retablo 1. *Calvary (La Dolorosa)*

This stunning red, green and gold altarpiece adjacent to the choir is the most architectural of the Santa Rosa retablos, and is recorded as being the work of Gudiño, the innovative designer of the scrolled exterior buttresses.

Like several other retablos on this side of the nave, ornamental doors in the predella, or base level, communicated with the convento behind. Bulbous baluster *estípites* emerge, wreathed by vines, from a gilded woven background to frame the projecting centerpiece of the retablo. This basketweave motif, common among the retablos at Santa Clara, is only employed this once at Santa Rosa.

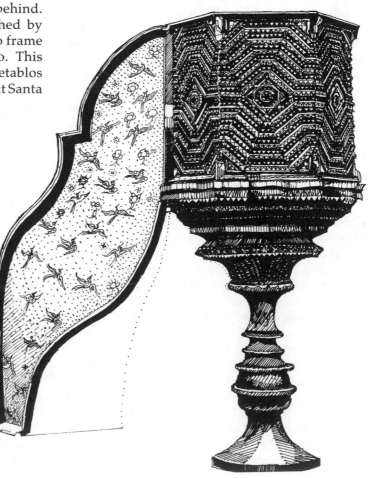

Querétaro, Santa Rosa: the pulpit

Although officially dedicated to the Virgin of Sorrows, whose diminutive figure rests in the lower vitrine, the retablo is dominated by a dramatic statue of Christ Crucified above. This larger-than-lifesize crucifix, popularly referred to as the Martyr of Golgotha, is affixed to a gilded screen worked with feather-like arabesques.

The figures of Mary Magdalene and St. John the Apostle gaze up sorrowfully from the outer niche-pilasters, while a pair of angels, carrying the Passion symbols of the lance and sponge, perch on the curvilinear crowning cornice.

Retablo 2. *St. Francis of Paola, with tribune*
Encrusted with ornate foliage, this florid structure from the 1760s is the least architectural of the nave retablos. It serves mainly as a frame for the raised tribune—an enclosed balcony whose filigreed screen is fashioned from wrought-iron petals painted red and emblazoned with sacred monograms. An elaborately festooned console underlies the balcony, supported by willowy caryatids and youths emerging from a dense field of *rocaille*.

Several large oval panels cluster around the glassed-in statue of St. Francis of Paola, the 15th century Italian hermit and Franciscan reformer, who occupies the center panel. Vivid painted scenes illustrating the life and miracles of the saint fill the smaller ovals.

Retablo 3. *The Virgin of Guadalupe*
Expertly restored in 1993, this colorful altarpiece is the best known of the Santa Rosa retablos. Recent research attributes its design to the great regional sculptor Pedro de Rojas. The fine carving

of the retablo is especially evident in its ornamental tabernacle, flanked by scalloped doorways that gleam with green and gold foliage. The central panel of the Virgin of Guadalupe is theatrically displayed beneath an enormous swagged canopy, and ringed by oval paintings—thought to be from the hand of the Mexican master Miguel Cabrera—illustrating the famous Apparitions of the Virgin. In the pediment, a graceful statue of the Archangel Raphael, robes aflutter, is silhouetted against the nave window.

Retablo 4. *St. Joseph (San José)*
Almost identical in its structure and luxuriant detail to the Guadalupe altarpiece opposite, this retablo is perhaps the finest in the church, also considered to be a masterwork by Pedro de Rojas. Angels draw aside drapes and look down fondly at St. Joseph, venerated in the Americas from early colonial times, who stands with the Christ Child in the center vitrine. The saint is flanked by garlanded ovals relating episodes from his life—again reputedly painted by Cabrera. The tender scene depicting Christ at the deathbed of St. Joseph is, as far as we know, the only portrayal of this event in Mexican religious art.

Retablo 5. *Santa Rosa de Viterbo*
This narrow altar, fitted between the double doorways on the south side, is dedicated to Rose of Viterbo, the patron saint of the nunnery. This medieval Franciscan nun was a noted healer and miracle worker.

Above her image, which is crammed into a small, glassed-in niche, stands a large statue of

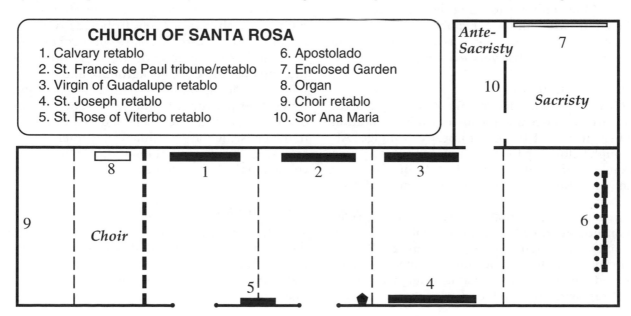

CHURCH OF SANTA ROSA

1. Calvary retablo
2. St. Francis de Paul tribune/retablo
3. Virgin of Guadalupe retablo
4. St. Joseph retablo
5. St. Rose of Viterbo retablo
6. Apostolado
7. Enclosed Garden
8. Organ
9. Choir retablo
10. Sor Ana Maria

San Rafael with wings spread, and knees bared below his flamboyant swirling skirts.

The Choir

The east end of the church is taken up with a double choir, screened by an ornamental wrought iron screen, or *reja*. This two-tiered screen is a complex tapestry of gilded grillwork and sumptuous *rocaille* carving.

On the lower level, angels draw aside simulated draperies to reveal a gallery of portraits depicting Christ, the Virgin Mary, John the Baptist and the Twelve Apostles, displayed around the opening in a checkerboard of interlocking rococo frames. Suspended on the grating is an expressive crucifix known as the Christ of Tears. Above a row of waving palm fronds stretches a second grid, and above that, a delicate fan of gilded tracery that spans the choir and ascends to the vault. A statue of the young Christ is suspended in a shell cartouche at center.

Mariano de las Casas' resplendent gilt and polychrome organ, dated 1759, was recently restored to pristine condition. With its colorful rococo angels, it is his finest work in this genre—one in which he specialized—and among most magnificent examples in Mexico of this universally popular baroque instrument.

Beside the organ hang several paintings of artistic and historical note. The most intriguing of these is an anecdotal work by Tomás Xavier de Peralta, which records a penitential procession of an image of the Virgin through Querétaro in 1742—staged in an attempt to halt a plague then raging in the city. A paralysed nun of Santa Rosa convinced the penitants to bring the image to her in the choir, whereupon her mobility was miraculously restored, and she was able to play the organ at vespers that very evening.

The Choir Retablo

This rare semicircular retablo, recently restored, is placed at the rear of the lower choir—a location where it cannot be seen to best advantage. Although belonging to the19th century, it is a prime example of the transitional style of altarpiece known as *barroco republicano*—a characteristically Mexican hybrid that combined neoclassical forms with late baroque ornament. The statuary is colonial, however, dating from the late 1700s. The plainly robed figures of St. Clare and St. Rose of Viterbo and the serene, more elaborately costumed image of La Purísima offer a dramatic contrast with the two bloodied statues of Christ,

especially the seated, scourged figure of Jesús Nazareno.

The Sacristy

The sacristy is an unusually large and well lit space. It is lavishly furnished, with an extravagant wall basin and a superb 18th century table inlaid, like the pulpit, with fine woods, shell and ivory. There is also a group of three booth-like confessionals, with scalloped, wreathed canopies and semicircular doors inlayed and painted red and blue. In use continuously since the late 1700s, these attractive pieces have recently undergone much needed restoration.

A vast allegorical painting of the *Hortus Conclusus* or Enclosed Garden on the end wall portrays the Virgin Mary as the Divine Shepherdess (*La Divina Pastora*)—a popular depiction in Mexico. She is shown within convent walls, surrounded by nuns at their tasks. Above, set in in a bucolic landscape, the Christ of Redemption hangs upon a tree-like cross with sheep at its foot. To one side stands the emblematic Fountain of Salvation, which closely resembles the fountain in the cloister. This unsigned picture has been attributed to Miguel Cabrera, who painted other canvases in the church, although it is more likely a work by his equally prolific contemporary, José de Páez. One undisputed Cabrera painting in the sacristy, however, is his noble portrait of Don José Velázquez de Larea, the convent's first benefactor.On our last visit, the famous picture of the novice Sor Ana María de San Francisco y Neve—one of the most striking works in Mexican colonial portraiture—was hanging neglected in the adjacent ante-sacristy. This stunning formal portrait, which has also been attributed to Cabrera, is a study in contrasts. The stark white robes of the nun, rendered in precise detail, stand out forcefully against the dark background, and contrast with her glowing but wistful face. A double portrait in the same room, honoring other benefactors of the convent and dated 1748, shows the nunnery under construction—a valuable document for the history of this important institution as well as of colonial building methods.

The Cloister

The adjacent convent now functions as a school of the arts. Its large, ornamental cloister is enlivened by undulating arcades and a goblet-shaped central fountain. Faded traces of colored friezes still line some of the arcade walks.

Las Capuchinas, from an 1874 photograph, showing the convent at the time of the Emperor Maximilian.

Templo de Las Capuchinas

On the 19th of June 1867, the Emperor Maximilian and his generals were marched from the cells in the Capuchinas convent to their execution by firing squad on the top of the Cerro de Campanas.

Aside from this brief moment in the spotlight of history, Las Capuchinas has generally languished in obscurity.

Founded in 1718 for this humblest order of Franciscan nuns, a modest convent was built un-der the patronage of Juan Antonio de Urrutia y Arana, el Marqués del Villar del Aguila, whose chief claim to fame was the planning and construction of the great Querétaro aqueduct.

Although dedicated in 1721, the church stood incomplete until 1771 for lack of funds.

Simple twin portals of dark stone, pierced by Moorish upper windows, are flanked by prominent wall buttresses with decorative quoining.

Las Teresitas

Endowed by a pious local widow, this nunnery was founded in the mid-1700s for las Beatas Carmelitas, a teaching order of nuns living under the strict rule of the Spanish mystic and Carmelite reformer, St. Teresa of Avila, to whom the convent is consecrated.

Constructed in the early 1800s, the church is designed in the austere neoclassic style of the era, with a theatrical pedimented front much like a Greek temple.

The building is attributed to the neoclassical architect and idealogue, Francisco Eduardo Tresguerras, who also decorated the interior.

His allegorical and devotional frescoes, although artistically uninspiring, surely helped to alleviate the icy severity of the church and its bleak nuns' choir, still barred by prison-like iron grids.

OTHER QUERETARO CHURCHES

Querétaro, Santo Domingo in 1796 (map)

Santo Domingo

Because of tenacious opposition by their Franciscan rivals, the Dominicans were the last of the religious orders to establish themselves in Querétaro.

The church and convent of Santo Domingo were founded in 1692, with building funds once again coming from the seemingly bottomless purse of Juan de Caballero y Ocio.

The church presents the visitor with one of the most unusual fronts in Querétaro. Facing a narrow forecourt, with its large atrium cross boldly carved with Instruments of the Passion, two highly

contrasting facades are set side by side: one from the late 1600s, and the other from the 18th century.

Cut from local brownstone, the sober facade on the left was completed in 1697 in the geometric style popularized by Bayas Delgado. Faced with shallow pilasters and discreet herms, the facade is capped by a prominent Cross of Lorraine. The Rosary Chapel facade on the right, added in 1760 and attributed to Mariano de las Casas, exhibits a florid Churrigueresque design, a study in curves and scrolled reliefs notable for its flamboyant plumed and mustachioed atlantes—figures that seem to echo, or mock, the sedate herms of its austere neighbor.

The handsome octagonal dome and cupola of the chapel rise behind the centrally placed tower. Interestingly, an earlier Rosary Chapel is still in place behind this late 18th century addition, its interior recently refurbished in a garish, rococo-Moorish style.

El Carmen

The primitive Carmelite church was among the earliest foundations in Querétaro, erected in 1618 by Fray Juan de San Miguel, the celebrated Carmelite builder and architect.

Although upgraded in the 1600s, again through the generosity of Juan de Caballero y Ocio, the monastery was virtually reconstructed, beginning in 1736, under the supervision of Juan Manuel Villagómez, the innovative architect who also worked on San Agustín.

Church and convento occupy two sides of the narrow plaza, recently renovated and adorned with a striking, wrought-iron cross. The deceptively simple classical facade is distinguished by a handsome octagonal window and intricately layered pilasters.

Inside, a large dome rises above the crossing, where painted figures of Carmelite saints, including St. Teresa of Avila and St. John of the Cross, replace the traditional Four Evangelists.

A number of elegant paintings in the church, portraying Santa Teresa's Vision of the Assumption and St. John of the Cross Adoring the Virgin, have been attributed to the prolific Miguel Cabrera. Displaying his usual skill as a draftsman and sensitive portrayer of women, he also painted the powerful image of the Virgin of Carmen that rests in one of the side chapels.

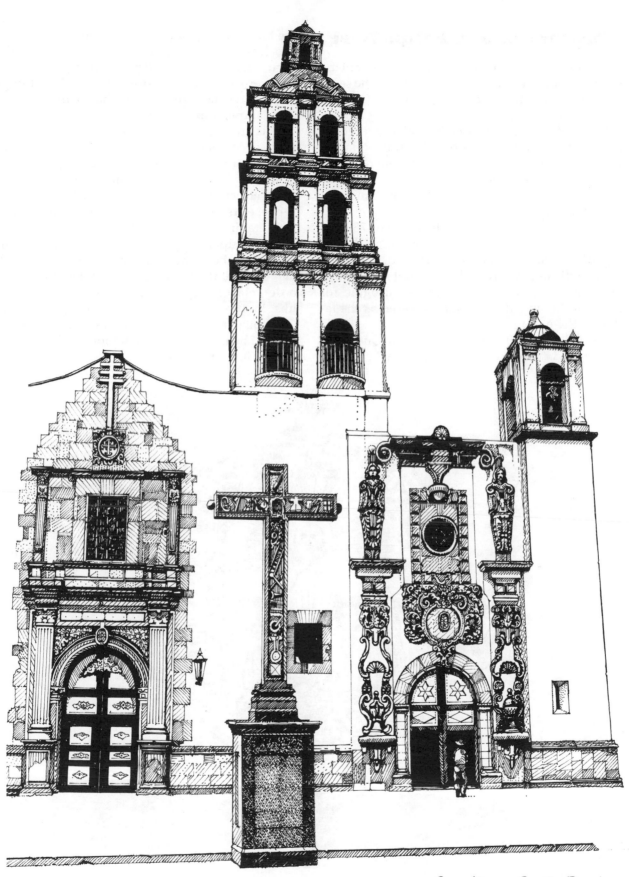

Querétaro, Santo Domingo

Oratory of San Felipe Neri

This church is named for the Italian founder of the Oratorians, a pious but worldly order of the secular clergy devoted to the tenets of the Counter Reformation.

Today it is officially the cathedral of Querétaro, and an image of the city's patron saint, St. James the Apostle rests on the main altar—here represented as a peaceful pilgrim rather than the belligerent Santiago Matamoros of the San Francisco facade.

This distinctive church, built between 1786 and 1804, was the last major colonial religious building to be constructed in Querétaro, and, ironically, was dedicated in 1800 by Miguel Hidalgo y Costilla, the leading figure in the struggle for Mexican Independence, today revered as the father of the nation.

San Felipe Neri is the only example in Querétaro of "neostyle" architecture, the terminal phase of the Mexican baroque that heralded the advent of neoclassicism. It was built to a design by the innovative Mexico City architect, Francisco Guerrero y Torres, whose influential buildings include the famous Pocito Chapel in the Villa Guadalupe, Mexico City.

This transitional facade already incorporates many neoclassical ideas, including the reassertion of the traditional column. Its striking elevated front of white marble columns and relief sculpture, set against a background of dark red *tezontle*, represents a sharp break from traditional Queretaran architecture.

Its principal sculptural feature is the large stylized relief above the hexagonal doorframe, which depicts St. Philip Neri as Protector of the Oratorian order, elaborately framed with clouds and cherubs in the nervous, layered manner of the Guanajuatan baroque. This central relief is complemented by large lateral medallions of St. John the Baptist and St. Joseph.

Querétaro, the Cathedral: facade relief of San Felipe Neri

Note the slender decorative pilasters, intricately carved with foliage and the Instruments of the Passion, behind the freestanding columns flanking the doorway. Bulbous Corinthian columns support the classical pediment—a later addition to the facade.

An unusual rayed medallion, showing the young Virgin with the Trinity, projects above the shallow pediment, which encloses swagged medallions that portray her parents, Saints Joachim and Anna.

While the facade still revels in the sinuous movement and rich surface decoration of the late baroque, its prominent neo-Plateresque columns and crowning classical pediment point to a new direction in late colonial architecture.

The adjacent convento, known as the Palacio Conín, now houses government offices. Its main cloister is extremely plain, although bearing traces of the geometrical decoration that characterized Querétaro's earlier classical tradition.

San Antonio

Despite its central location just north of San Francisco, the friary of San Antonio is inconspicuous behind its narrow, shaded forecourt.

San Antonio has endured wrenching changes since its founding in the early 17th century. Established in 1613 as a sanctuary for the Barefoot Franciscans—a strict, reformed order of mendicant friars, commonly called *los dieguiños*—the first church was provided through the generosity of an unknown silver magnate, and to judge by a facade date of 1628, was probably rapidly erected during the preceding decade.

The monastery was rebuilt around 1700, this time funded by Juan de Caballero y Ocio, the perennial patron of Querétaro's churches. Although the classical facade and circular dome are the work of Bayas Delgado or one of his students, the upper facade was altered during the 1730s, with the addition of a flamboyant curved pediment and oval relief medallions. A statue of the patron, St. Anthony of Padua, occupies the center niche.

As part of the early 18th century renovations, the church's Renaissance altarpieces were replaced by a suite of lavish Churrigueresque retablos, some designed and fabricated by Pedro de Rojas.

These, in their turn, were replaced by neoclassical altars at the end of the same century, although a pair of baroque statues from one of the original altarpieces remains in the church—a figure of St. Francis, and an expressive San Pedro de Alcántara, the founder of the *dieguiños*, believed to be from the hand of Rojas himself.

Passion scenes above the choir, painted by Tomás Xavier de Peralta, provide an appropriate backdrop for the 18th century organ case that still stands mute and neglected in the loft.

A vast composition of Souls in Purgatory, painted in 1728 by the artist Gregorio Romero, occupies one side of the underchoir. The Holy Trinity, accompanied by the Virgin Mary and ranks of the Blessed, sits in the heavens, while a gathering of mostly Franciscan saints, led by the Archangel Michael, occupies the center, some waving banners of salvation and others reaching down to the stricken souls below. Adorning the spandrels above the doorway to the side chapel is the Stigmatization of St. Francis, one of the few surviving colonial murals in Querétaro.

Perhaps the most exotic feature of the church is its eight-sided sacristy, a lavish late 18th century chamber that is remarkable for its octagonal cupola supported on cone-like vaulting with a complex interplay of curved, lobed and polygonal lines and forms.

The sacristy houses a handful of colonial paintings, principally a lustrous Immaculate Conception in the high baroque style of Juan Correa, and a picture of St. Francis holding a chalice in the local landscape, signed by Miguel Ballejo—a minor Queretaran painter. But the most attractive works are eight anonymous panels, painted in a fresh popular style, that portray lively angels holding symbols of the liturgy.

The small convento, noted for its attractively tiled corridors and anterooms, currently houses a private school.

CIVIL BUILDINGS

In addition to its numerous religious structures, Querétaro's historic center also boasts a wide range of distinguished civil buildings. These include various colonial government edifices and several luxurious mansions and town houses, as well as its famous aqueduct—a triumph of 18th century engineering.

The Aqueduct

On October 17, 1738, the city of Querétaro exploded in a frenzy. Enthusiastic crowds from every class of society filled the streets with colorful processions, overjoyed to see water bubbling from fountains all across the colonial city.

A jubilant group of Indians gathered outside the mansion of the Marqués del Villar del Aguila—the guiding force behind the spectacular aqueduct that had, at long last, brought fresh water to the parched city. To the sound of the *teponaxtle*, or native drum, they regaled residents with songs of praise for the recently deceased marquis, including verses extolling the role of indigenous peoples in the project and in the life of colonial Querétaro.

As chief benefactors of Las Capuchinas convent, the marquis and the marquesa had heeded the requests of the concerned sisters for a supply of clean water for the growing city. Twelve years earlier, he had provided funds for a long aque-

duct to bring in spring water from the ancient settlement of La Cañada, some nine kilometers distant, personally supervising the construction and even laying stones with his own hands.

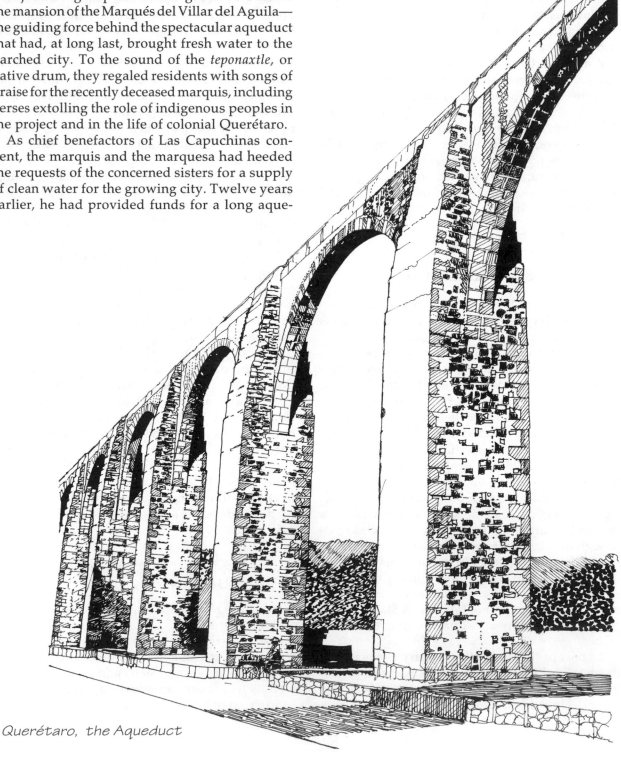

Querétaro, the Aqueduct

Although the initial section lay underground, the final stretch of the channel ran atop a long arcade that stretched almost five kilometers down into the valley. The aqueduct terminated at the Caja de Agua, near the Santa Cruz monastery, releasing water to Querétaro's numerous fountains, many located in the cloisters and atriums of the city's churches.

Now restored to pristine condition, the elevated structure comprises 74 arches—some as high as 90 feet—entirely built of the honey-colored local stone. Although it no longer carries municipal water, the colonial aqueduct is still an imposing sight as it sweeps into the city from the hills.

Querétaro, La Plaza Mayor (1796 map)

La Plaza Mayor

Many of city's most distinguished viceregal buildings face **La Plaza Mayor,** located at the heart of the colonial city and traditionally known as La Plaza de Armas. This oldest and most attractive square in Querétaro is now traffic free. Fringed by manicured trees and enhanced by a vigorous fountain, it retains much of its colonial ambience.

La Casa de la Corregidora

This imposing building was erected in 1770 as Las Casas Reales—an official residence for visiting dignitaries and viceregal officials. Named for a heroine of the Independence movement, Doña Josefa Ortiz de Domínguez, known as La Corregidora (her official Spanish title), it now contains the offices of the state government.

Attractive balconied upper windows, with superimposed coats-of-arms in traditional Spanish style, break up the broad, plain front. While simple arcades enclose the interior courtyard.

In 18th century Querétaro, Spanish officials, affluent *criollos* and wealthy silver barons vied to build imposing townhouses. Known as *casas señoriales,* many of these were virtual palaces, boasting lavishly carved facades and ornate arcaded courtyards that rivaled the churches and nunneries in their splendor.

The Queretaran mansions are especially noted for their rich and inventive decoration in stone, stucco and tile. Religious and armorial medallions adorn the facades, while a host of multi-shaped arches—of Moorish, Gothic and oriental inspiration—crown the entrances, stairways and window frames.

Several of these handsome viceregal buildings have been restored in recent years, some repainted in their original glowing colors, and now serve as hotels, restaurants and elegant stores.

La Casa de Ecala *(Pasteur 6)*

Without any doubt, La Casa de Ecala is the most ornate and best known of Querétaro's urban mansions. Built in late 1700s for a royal offical, the palace faces La Plaza Mayor and boasts the only full-blown Churrigueresque front in the city, closely related to La Casa de Visitas in Dolores Hidalgo.

Beautifully carved in fine-grained golden limestone, the facade is enriched by a profusion of intricate architectural detailing, with an intensive layering of arches, pilasters, moldings and cornices.

The lower level is recessed behind an elegant arcade that formed part of the *portales* around the colonial plaza. The entryway behind the arcade leads to an intimate interior courtyard and surrounding salons that, although less ornate than the facade, feature several *mudéjar* ceilings and archways.

The principal rooms are on the upper level, facing the plaza through decorative windows. Three of these are full length French windows, with layered Moorish arches and serpentine cornices, that open onto jutting balconies with extravagant wrought iron railings adorned with eagles enmeshed in ornamental scrollwork.

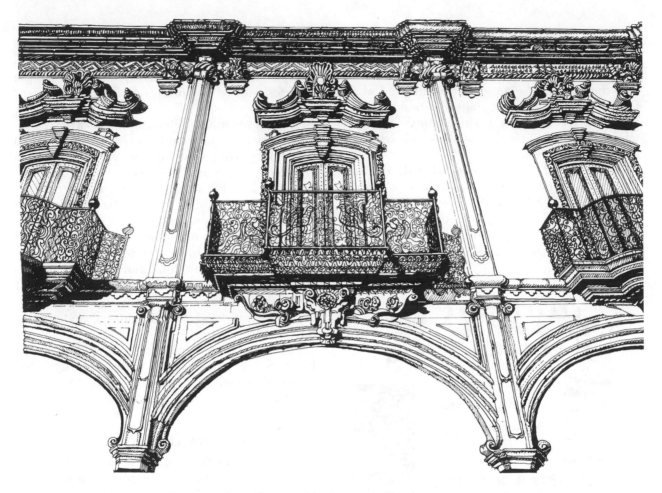

Querétaro, La Casa de Ecala

Stone gargoyles and scalloped reliefs also enliven the upper facade, and a corbelled cornice sweeps along the roofline, above tiled and twisted cord friezes. A smaller window stands over the fourth bay of the arcade, swagged with stone curtains and surmounted by the noble coat-of-arms of a former owner.

On the opposite side of the square stands a less conspicuous but intriguing group of colonial mansions. The former **Portal de Samaniego** now houses craft shops, and the **Mesón de Santa Rosa** is an attractive inn with intimate, fountain-filled patios. Just below the Mesón we find the **La Casa del Marqués de Rayas** *(Pasteur 21)*, identified by its conspicuous corner window with a wrought iron balcony. The carved stone entry boasts fine wooden doors. Its arcaded courtyard has an old wall fountain, and some of the original tiled floors can be found in the adjoining rooms.

La Casa del Conde de la Sierra Gorda
(Hidalgo 18)

This impressive mansion was built in the mid-1700s for the descendants of Captain-General José de Escandón, an energetic military officer ennobled in recognition of his pacification of the rugged Sierra Gorda region, from which he took his title.

Seven balconied windows pierce the long front, each decorated with relief foliage and supported on curved stone consoles. The corner corbel is carved in the form of a lion.

The charming patio is framed with Moorish arches displaying small reliefs of birds and cherubs. Now a bank building, it retains its stout wooden doors, embossed with a decorative knocker and iron studs. The general's escutcheon is still emblazoned on the facade.

La Casa de los Perros *(Allende Sur 16)*

Ignacio Mariano de las Casas, the Queretaran sculptor and architect, designed this surprisingly modest colonial house for himself—now home to a bustling nursery school.

As might be expected, the single-story residence is distinguished by its fine stonework. The long front is capped by a protruding cornice, punctuated at intervals by canine gargoyles—hence the house's name. An escutcheon with a delicately scalloped relief of a draped cross with angels is mounted above the doorway (see p.270), its devotional theme representing a departure from the self-important heraldry displayed on Querétaro's other noble mansions.

Carved grotesques, gargoyles and animal masks look down from the arcades on the intimate but well-proportioned patio. At its center stands a striking sculpted fountain whose basin is supported on fantastic, sphinx-like figures, perhaps reflecting Mariano de Las Casas' sly, self-mocking humor.

La Casa del Marqués *(Hidalgo 19)*

This handsome structure was the home of the Marqués del Villar de Aguila, the builder of the aqueduct. Built before 1750, this is one of the earlier Queretaran mansions, and also one of the least pretentious.

The sober baroque front reaches around the corner, encompassing five windows. Each has a balcony of ornamental ironwork supported on stone corbels—some of which are carved with cats' faces, and others with foliage. Giant canopies arch over the windows and facade niches.

Although the Marquis' aristocratic *escudo* on the keystone is today all but erased, the old carved wooden doors are still in place, displaying the original bronze masks and ornamental iron spikes.

The arcaded courtyard, whose wave-like *mudéjar* arches spring from delicate octagonal columns, is one of the most decorative in Querétaro, and remains accessible to the public as a cafe.

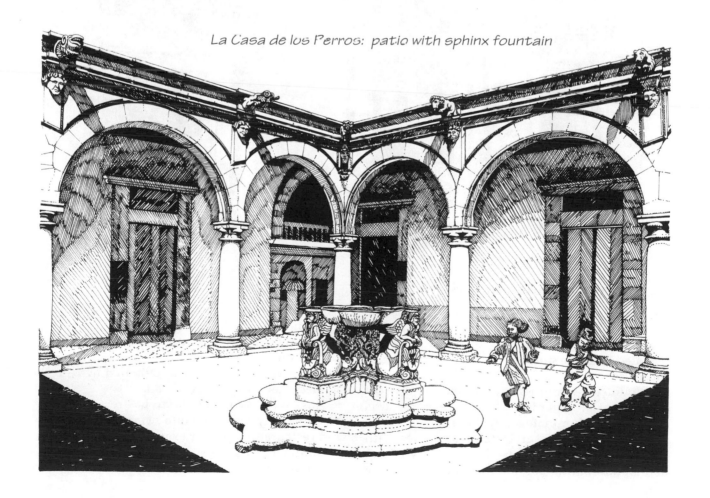

La Casa de los Perros: patio with sphinx fountain

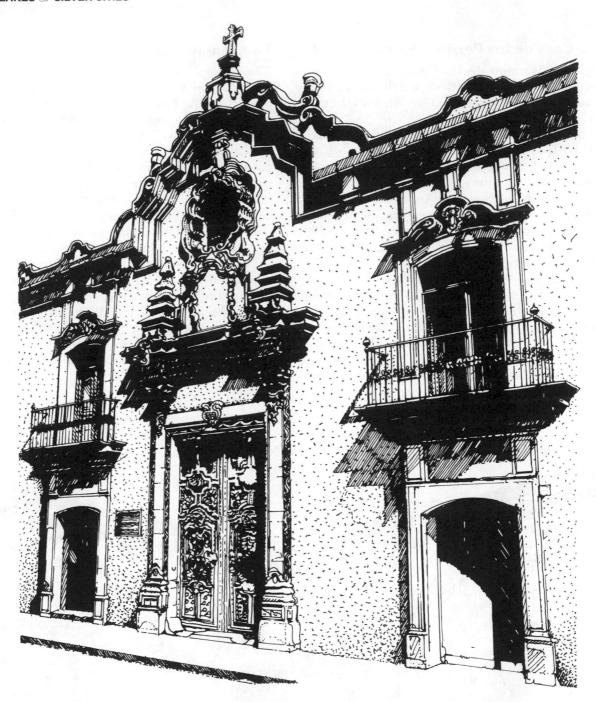

La Casa de la Marquesa *(Madero 41)*

By tradition, this mansion was built for the Marquesa del Villar del Aguila, who wished to live apart from her husband, the third marquis.

Dated 1756, the sumptuous two-story residence impresses us first with its grandiose doorway, surmounted by multi-staged pinnacles. The ornate Moorish opening above the entry was designed to illuminate an upstairs chapel.

Scrolled cornices and stone balconies with carved lambrequins frame the upper windows and an undulating parapet runs along the entire front of the building, rising into a showy mixtilinear gable above the entry.

The fantastic painted interior exceeds the Casa del Marqués. Its bescrolled, neo-*mudéjar* arcades and stairways are artfully illuminated by a great stained glass skylight overhead.

This lavish colonial palazzo has recently been imaginatively converted into a small luxury hotel and restaurant—another example of Querétaro's commitment to preserving its remarkable colonial heritage.

THE SIERRA GORDA

This scenic but until recently inaccessible region of sub-tropical valleys, folded into the Sierra Madre Oriental, is home to an exceptional group of 18th century Franciscan missions, best known for their link to Fray Junípero Serra, the Franciscan apostle of California.

The 200 km journey to the Sierra Gorda from the city of Querétaro is varied and picturesque. As we cross the eastern edge of the Bajío, irrigated plains gradually give way to an upland region of cactus-covered hills and spectacular rock formations lying in the rain shadow of the Sierra Madre. By a series of switchbacks we climb to the pineclad summit at Puerto de Cielo (Heaven's Gate), then descend rapidly more than 7000 feet to **Jalpan**, the principal town of the Sierra Gorda and site of the flagship mission of Santiago.

Surrounding Jalpan are several green valleys, separated by wooded hills and narrow gorges, each with its own settlement. At the heart of every village—at **Landa**, **Tilaco**, **Tancoyol** and **Concá**—rises a mission church with a majestic sculpted and painted facade.

Although primitive missions had been founded in these distant valleys in the early 1700s, it was not until the arrival of Father Junípero Serra and his companions in 1751 that this beautiful but untamed region was truly missionized.

Fray Junípero Serra

Father Serra was born in 1715, in the town of Petra, Majorca. A pious and precocious youth, he joined the Franciscan Order and entered the Palma monastery, choosing the name Junípero, after the simple companion of St. Francis.

A brilliant student, he soon became an inspired teacher of theology and philosophy. Among his students were Juan Crespí and Francisco Palou (Serra's biographer) both of whom accompanied him to Mexico and California.

Father Serra also had a reputation as a charismatic preacher in the rural villages of Majorca. This powerful missionary urge eventually took precedence over his academic career, and in 1749 Serra sailed for Mexico with a select group of friars, to attend the Franciscan Apostolic College of San Fernando in Mexico City.

A missionary revival in the late 1600s had prompted the Franciscan Order to expand the network of its apostolic colleges both in Spain and

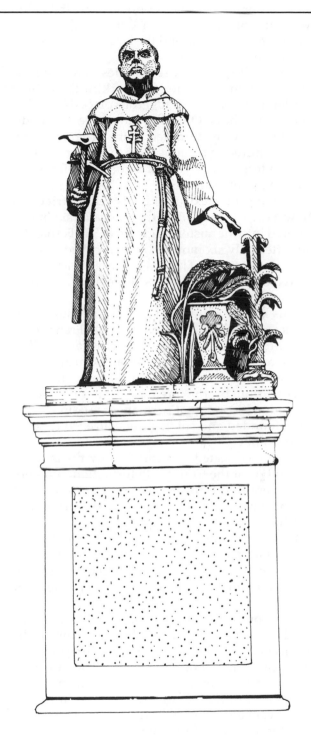

Junípero Serra stands outside the church of La Santa Cruz de Querétaro. He holds a hoe and points to a native corn plant to symbolize his sowing the seeds of Catholicism among the indigenous peoples of the Sierra Gorda.

the frontier areas of the Americas. The first of the Mexican colleges, at Santa Cruz de Querétaro, was founded in 1683, and the larger college of San Fernando, a little later.

These self-governing seminaries were designed to prepare missionaries for work in the remote borderlands—lonely, dangerous places beset with many hardships. Only the most able and dedicated friars were admitted to the program. They were required to commit themselves for 10 years and undergo a full year of rigorous training before going into service.

Arriving in Mexico with his fellow friars on New Year's Day 1750, Father Serra immediately entered into the austere regimen of San Fernando. But after only six months, he was called into the field, with several of his Majorcan companions, to revive the flagging Franciscan missionary effort in the Sierra Gorda.

This remote region had a troubled history. Dominicans and Augustinians as well as Franciscans had attempted to evangelize the different tribes of the region—Pames, Jonaces and Chichimecs—but with little success. It was only after the pacification of the area by General José de Escandón in 1744, that permanent mission towns were founded and colonists encouraged to settle in the valleys.

Highly educated and fortified by the militant certainties of the Counter Reformation, Junípero Serra ventured forth in the same apostolic spirit that had inspired the first missionaries in the New World over 200 years earlier.

With his fellow Franciscans, he labored in the Sierra Gorda to establish permanent mission towns and build the stone churches we see today—a monumental task that continued for almost 20 years.

The florescence of these missions was short-lived, however. Following the expulsion of the Jesuits in 1767, the Franciscans, including Junípero Serra and many of his Majorcan colleagues, were called upon to man the former Jesuit missions along the northern frontiers of New Spain, as well as to evangelize the Californias.

After so much effort, the Sierra Gorda missions were abandoned less ten years after the departure of Father Serra. The Indians deserted the settlements and the churches fell into ruin. It was only in the 1940s that they were rediscovered by researchers and preservationists, among them Maynard Geiger, Father Serra's biographer.

Landa, cherub on nave pilaster

Art & Architecture

Nowadays, the presence of good paved roads and comfortable inns makes a visit to this once remote region a pleasurable experience. All five of the churches have recently been restored and their facades repainted in their original colors, appearing much as they did when new in the 18th century.

The missions follow a similar plan. Girded by a walled atrium with a centrally placed cross, each church is flanked by a single, two-stage tower and a small convento with an arched entrance and interior courtyard.

The stunning carved and painted stucco facades of the Sierra Gorda missions represent the high point of the folk Churrigueresque style in Querétaro. They combine Solomonic columns, *estípite* pilasters and other late baroque ornament to create a vivid popular architecture replete with painted statuary and polychrome reliefs of indigenous foliage and motifs.

These effects are neither accidental nor merely decorative, for the church fronts were meticulously designed by the Franciscans, not only to impress the Indians, but also to instruct them. For these well-schooled friars, the Sierra Gorda facades were "sermons in stone," whose colorful ornament and complex iconography were intended to illuminate the fundamental tenets of the Catholic faith, while glorifying the history and achievements of the Franciscan Order.

In addition to the numerous figures of Franciscan saints, familiar and obscure, the Franciscan insignia—the knotted cord, the Stigmata and the Crossed Arms of Christ and St.

Francis—are also recurrent motifs, as well as the two-headed Hapsburg eagle and other emblems long associated with the order.

Aside from their religious iconography and radiant color, the most striking aspect of these facades is the extraordinary profusion of relief ornament, much of it based on various native plants and vines of sacred significance that we can only partially understand today.

The plants are presented on a large scale, in every stage of growth from buds to flowers to fruits. Rendered in precise although often stylized detail, they are painted in a broad palette of greens and earth colors.

In addition to their colorful facades, the Sierra Gorda missions have also preserved a few of their interior murals. Significant fragments remain at Jalpan and Concá.

Finally, a word about the beautiful wrought iron crosses that stand in every atrium and atop every church. Although of recent manufacture, they remind us of the regional traditions of fine artesanry that made possible the building and ornamentation of the Sierra Gorda missions in these remote mountain valleys.

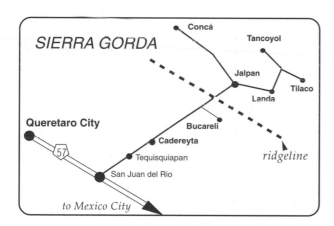

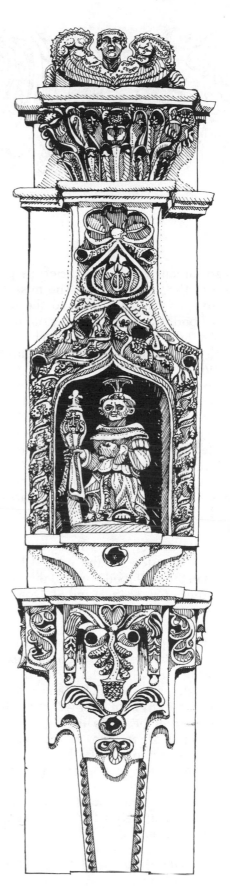

Landa, estípite column on the facade

Jalpan, the Hapsburg imperial eagle

Jalpan

Santiago Jalpan was Junípero Serra's principal mission in the Sierra Gorda. The mission faces east across its walled atrium to the mountain ridges beyond. A decorative tower rises above the facade on the left, and a double archway admits us to the mission courtyard and its peaceful garden patio.

The soaring red and gold church front is the largest in the Sierra Gorda, fashioned in the ornate Queretaran fashion of the mid-1700s, but with a vigorous popular flavor. The facade is articulated by *estípite* columns, ornamented with cherubs on the lower tier and caryatids, or herms, above. Swagged stucco curtains, another late baroque motif, frame the diamond-shaped choir window as well as the niche at the apex of the facade.

Stucco figures of Saints Peter and Paul, the traditional founders of the early Church, are mounted in the scalloped porch, flanked by mutilated statues of St. Francis and St. Dominic—the founders of the mendicant orders who carried forward the apostolic mission in the New World. Above them appear diminutive statues of the Virgin of Guadalupe, the symbol of Mexican national pride, and a rare image of the Spanish Virgin of Pilar. Along with St. James the Apostle (Santiago), the Virgin of Pilar was the patron and protectress of medieval Spain.

The selection of Santiago, the warrior saint and militant defender of the Catholic faith, as the standard bearer for his flagship mission reveals Father Serra's determination to renew the long delayed spiritual conquest of all Mexico. The figure of Santiago himself, which once occupied the upper niche, was unfortunately replaced by a clock in the last century.

The Stigmata, the Crossed Arms of Christ and St. Francis, and the traditional knotted cord worn by the Franciscans are emblazoned across the facade, which is entwined with garlands of vines, fruit and flowers in multicolored stone and stucco. Even the shell-shaped arch of the entry porch is formed by the petals of an exotic flower.

Another unusual device is the double-headed eagle of the Hapsburgs found on either side at the base of the facade. Like the Aztec eagle on the Mexican flag, the birds grasp serpents in their beaks, although this may be a later alteration.

Since this ruling dynasty of early imperial Spain was long gone by the 1750s, the presence of the Hapsburg insignia on the Sierra Gorda facades has long puzzled observers. It has been suggested that the friars retained the image because of its similarity to the Christian sacrificial symbol of the pelican, with its head bowed. However, its use here may also reflect the traditional loyalty of the Majorcan people to the Hapsburg kings and an ingrained dislike of their Bourbon successors, who mistreated the proud islanders.

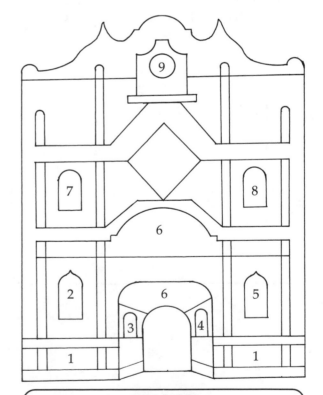

JALPAN

1. Eagle
2. St. Dominic
3. St. Peter
4. St. Paul
5. St. Francis
6. Franciscan Arms
7. Virgin of Guadalupe
8. Virgin of the Pillar
9. clock (formerly Santiago)

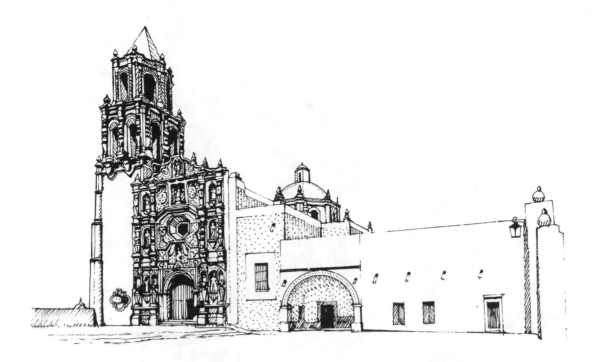

LANDA

From busy Jalpan, the road winds southeastwards to the village of Landa, home to the hillside church of Santa María de las Aguas— the last of the Serra missions to be completed.

At Landa, the red and ocher church front proclaims the Franciscan message of devotion to the Virgin of the Immaculate Conception (La Purísima). In a design even more complex than at Jalpan, spiral columns intermingle with *estípites* across the facade, which is crowded with numerous saints and martyrs, many of which are obscure and rarely portrayed in Mexican religious art.

Above the doorway, fluttering angels draw aside curtains of stone to showcase the crowned image of La Purísima, accompanied by kneeling angels who swing smoking censers.

Portrayed sitting at their desks, quills poised, are reliefs of the historic defenders of the doctrine of the Immaculate Conception, the Franciscan theologian Duns Scotus and the Spanish mystic María de Agreda—the "Blue Nun"—whose visionary work, *The Mystical City of God*, enjoyed great influence in New Spain.

Junípero Serra was especially devoted to this 17th century nun, a traditional protectress of missionaries. She claimed to have been transported by angels to what is now New Mexico, where she preached to the Indians.

Peter and Paul flank these theologians on the middle tier of the facade. As at Jalpan, triumphant

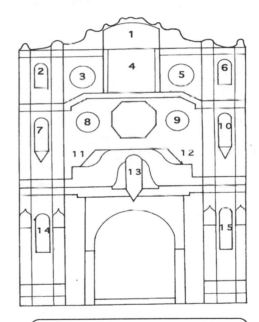

LANDA

1. St. Michael and the dragon
2. St. Stephen
3. The Entrance into Jerusalem?
4. St. Lawrence
5. The Flagellation
6. St. Vincent
7. St. Peter
8. Franciscan Arms
9. The Stigmata
10. St. Paul
11. Duns Scotus
12. Maria de Agueda
13. Virgin of Immaculate Conception
14. St. Dominic
15. St. Francis

Landa, Santa María de Agreda, "The Blue Nun"

states of St. Francis and St. Dominic occupy canopied niches on the lower tier. Haloed Franciscan saints holding furled crusaders' banners look down from the *estípites*.

Tableaux in high relief, illustrating the interrogation and flagellation of Christ, are interposed on the upper tier between statues of Christian martyrs, notably a headless St. Lawrence leaning on his martyr's grill in the center. The Archangel Michael, in his role as Protector of the Virgin, vigorously dispatches a cringing dragon at the apex of the facade.

The facade is also rich in other emblematic devices. Serpentine borders, dotted with drops of blood and terminating in Hapsburgian birds' heads, outline the sculpture niches of the lower *estípites*. Smiling sun-like faces top the mid-tier columns, and caryatids in the form of sirens or mermaids stretch forward from the upper pilasters. Angels hold up the knotted cord around the octagonal choir window, which is flanked by the Franciscan emblems of the Five Wounds and the Crossed Arms.

Luxuriant carved vegetation invades the facade at every point. Clusters of ripe fruit emerge from sheaves of spiky foliage, melons hang from twisting vines and floral bouquets stand in each corner. Atop the gable, pinnacles point skyward like corncobs from their segmented calabash bases.

Relief sculptures in the style of the facade also adorn the church interior. Rotund cherubs support the choir arch. Duns Scotus makes a second appearance, pen held aloft, on a ceiling medallion, this time in the symbolic guise of an avenging angel wrestling with the giant dragon of heresy. St. Michael is shown again on another medallion.

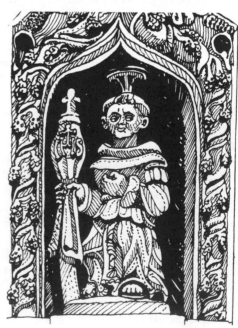

Landa, St. John Capistrano

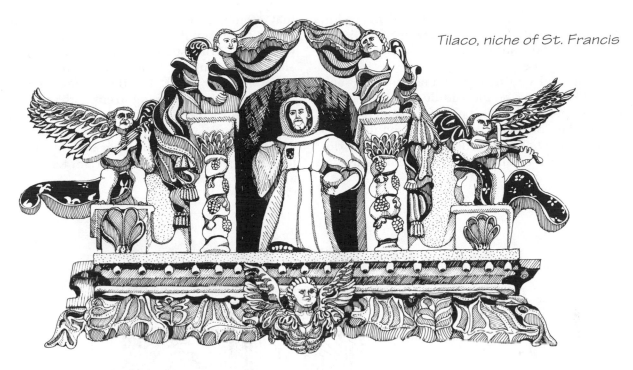

Tilaco, niche of St. Francis

TILACO

South of Landa, a side road snakes off through a green valley to the tiny hamlet of Tilaco, where crenelated walls, gateways and corner chapels frame the charming hillside mission of San Francisco.

Founded by Father Serra's constant companion Fray Juan Crespí, Tilaco is the happiest of the five missions, tinted in hues of blue, white and ocher, and possessing an elegant and slender three stage tower. Its festive facade is the most intimate of all the churches, busy with figures of cherubs, sirens and angels—some playing instruments, others grasping grapevines or holding tasseled stone draperies, and a few just smiling joyfully.

The iconography honors the founder of the Franciscan order and patron of Tilaco, St. Francis of Assisi. From his elaborately festooned niche, set like a projecting stage in the upper facade, the cowled and barefoot saint leans forward, smiling ecstatically as he listens to the celestial music of angels playing violin and guitar.

A mass of vines reaches around the niche towards the "horned" gable, which is supported by caped caryatids at the sides and surmounted by a gigantic urn. Berry plants with fleshy leaves climb up the sides of the urn, which is capped by stylized conch shells. Another unusual pinnacle, on the right side of the gable, sports exotic tropical

TILACO

1. St. Francis with Angels
2. Virgin of Immaculate Conception
3. St. Joseph
4. Franciscan Arms
5. St. Peter
6. St. Paul

vegetation as well as a dog and lion engaged in play or combat. Two eagles are perched in an archaic frontal stance with spreading wings, just below the gable.

A youthful Virgin Mary and mature St. Joseph attend St. Francis on the middle tier. The rapturous Joseph, clothed in beautiful painted robes, carries the Christ child, who tugs playfully at his beard. Naked angels, veiled in spotted blue ribbons, disport around a curtained choir window that resembles a waterlily blossom whose curling petals reach out from the recesses below. The Franciscan Arms spread out below the window, almost engulfing the small relief of a dove—symbol of the Holy Spirit. And the entire middle tier is held up by four grinning sirens with scaly tails.

On the lower level, comfortably lodged in decorative niches flanked by spiral columns, Saints Peter and Paul stand on either side of the scalloped doorway fringed by luxuriant tendrils.

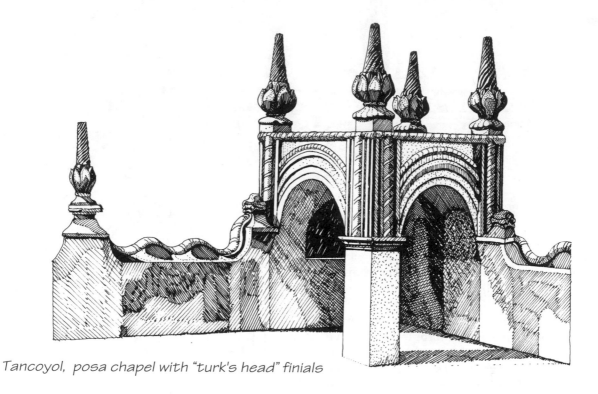

Tancoyol, posa chapel with "turk's head" finials

TANCOYOL

Today, a good paved road cuts through a rocky, moss-draped ravine to the village of Tancoyol, isolated in a valley some 30 kms to the north of Landa. Conical "turk's head" finials sprout along the walls and two remaining corner chapels of the atrium in front of the mission, which is dedicated to the Virgin of Light.

The elevated facade resembles the one at Landa, employing a similar layout, color scheme (predominantly ocher and white) and a strong emphasis on statuary. Four tiers of carved and painted stucco *estípites* frame a series of polychrome figure sculptures. Above the deep bottom tier, which is prettily decorated with reliefs of flower vases, Peter and Paul take their traditional place beside the entry, framed by ornamental Gothic niches. The Franciscan insignia are prominently emblazoned over the archway.

Although the image of the Virgin is now absent from her niche above the entry, her parents, Joachim and Anna, appear on either side of an elaborate Moorish choir window that extends through two tiers of the facade. Above the window, a rakish folk relief of the Stigmatization of St. Francis graphically depicts the rays of divine force. Note the tiny figure of Fray León, St. Francis' companion and an eyewitness to the event, crouching on the left of the window cornice.

As if also witnessing this event, two other popular Franciscan saints survey the scene: a now

TANCOYOL

1. Dominican Cross of Calatrava
2. Cross of Jerusalem
3. St. Anthony of Padua
4. St. Francis receiving the Stigmata
5. San Roque
6. St. Joachim
7. St. Anne
8. St. Pater
9. St. Paul
10. Franciscan Arms
11. Five Wounds
12. Angels with Passion symbols

the intervening arabesque reliefs represent cornucopias of native fruits and foliage.

The single archway beside the church, in addition to serving as the cloister entrance, may also have functioned in the early years as an open chapel. Together with the two *posa* chapels in the corners of the atrium, this is a remnant of the "open-air" churches of the spiritual conquest, when the friars conducted outdoor services to accommodate the large native congregations.

Concá, the Archangel Michael

headless figure of Anthony of Padua, wrapped in a voluminous habit, and San Roque, another saint traditionally invoked during times of pestilence. According to legend, as the saint lay ill with a wounded leg on a pilgrimage to Rome, a dog brought him bread to sustain him until he recovered.

The top tier of the facade is devoted to the theme of the cross. A simple cross, recessed in a curtained, cruciform niche, takes center stage, attended by a pair of angels waving censers and flanked by the intricate crosses of Jerusalem and Calatrava—traditionally associated with the Franciscan and Dominican orders respectively. Turk's head pinnacles like those on the atrium wall also cap the undulating overhead gable.

An interesting iconographic variation at Tancoyol is the presence along both sides of the facade of angels displaying the instruments of Christ's Passion—objects related to the crucifixes of the pediment. As elsewhere in the Sierra Gorda,

CONCA

Traveling northwards from Jalpan, the highway follows the tumbling Río Verde as it snakes through lush low hills, rich sugar fields, and mossy bluffs that become waterfalls in the rainy season. Some 40 kms along, we arrive at Concá, the northernmost of the Sierra Gorda missions.

Nestled behind its own walled churchyard opposite a rather desolate village plaza, San Miguel Concá is the smallest, most colorful and folkloric of the five area missions. Flanked by a yellow

CONCA
1. Holy Trinity
2. Archangel Michael
3. Hapsburg eagle
4. San Fernando Rey
5. Franciscan insignia
6. San Roque
7. St. Francis
8. St. Anthony of Padua

gel Michael, trailing a mass of flowering grapevines, poses in a plumed headdress, with his sword raised to slay the dragon of heresy sprawled at his feet. Silhouetted atop the curving gable is a freestanding sculpture of the Holy Trinity, portrayed in the traditional Mexican manner as an identical trio of bearded young men with their feet resting on a globe.

The upper surfaces of the facade buttresses are carved with several curious motifs. Naive monkeys and grimacing masks face outwards, while on the sides we see double-headed imperial eagles paired with floral devices, and even a rabbit—a rare, pre-Christian survival.

Inside, the patron of the church St. Michael appears again, above the main altar. This time he is represented, scales in hand, as the peaceable weigher of souls. Above his head, the half dome of the apse is veined by shell-like ornament in the form of an opening flower with petals and stamens—a final reminder of the pervasive presence of nature's fecundity in the decoration of these magnificent Sierra Gorda churches.

tower and arcaded patio entrance, the restored church facade is colored in warm tones of rust, ocher and china blue. Headless statues of St. Francis and St. Anthony of Padua flank the Moorish doorway, sandwiched between divided columns of fluted leaves.

A huge escutcheon of the Crossed Arms dominates the center facade, framed by stucco curtains, spreading foliage and a tumble of vines. The sword, scepter and coronet beside the cross draw attention to noble patronage of the Franciscan order, a theme emphasized by the figures of San Fernando Rey and San Roque—both saints of royal birth—occupying the flanking niches.

The jaunty figure of San Roque is shown as a pilgrim, with his staff, water gourd and shell-emblazoned cloak, accompanied by his faithful dog. In addition to his popularity as a healer and miracle worker, St. Ferdinand was the first patron of the Apostolic College of San Fernando, among whose alumni we count Father Serra and his companions.

Outsize finials atop the twisted columns of the niches thrust powerfully into the upper facade, where the militant winged figure of the Archan-

Concá, San Roque and his dog

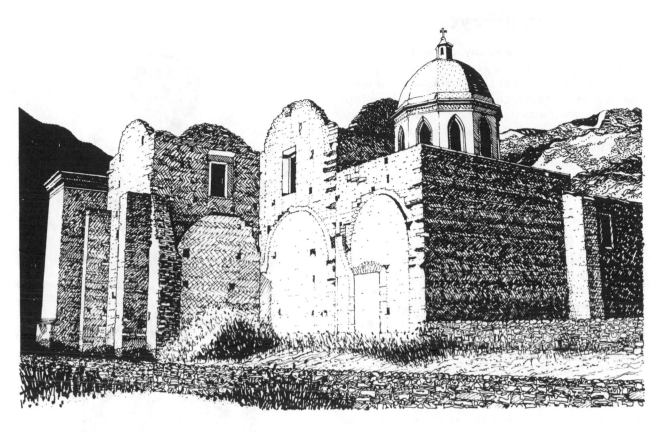

Bucareli, the ruined monastery of La Purísima

off the beaten track . . .

Returning from the Sierra Gorda towards the city of Querétaro, a rewarding detour can be made on the arid western side of the mountain range to two little known colonial monuments of interest: the picturesque ruined mission of **Bucareli**, isolated in the rugged foothills, and down in the plain, the parish church of **Cadereyta**, noted for its carved atrial cross and superb late baroque altarpiece.

Bucareli

Isolated on a knoll, the bright ocher walls of the ruined fortress monastery of La Purísima Concepción de Bucareli present a striking image outlined against the purple ridges of the Sierra Gorda.

After the secularization and subsequent abandonment of the Sierra Gorda missions, the Franciscan order felt the need to renew their missionary effort in the region. To this end, in 1779,

the eccentric friar Fray Guadalupe de Soriano tirelessly lobbied for a monastery to be built on the western flank of the sierra.

With the support of the reformist Bourbon viceroy Antonio de Bucareli, for whom the mission settlement was named, the monastery was intended as a refuge and religious center for the dispersed Indians—Pames and Jonaces—of the area. It was also planned as a seminary, to prepare the friars for future missionary work in the sierra region.

Although the grand church was never completed, the rambling convento was extensive, with two arcaded courtyards and a warren of conventual rooms including kitchens, a separate novitiate and dormitory, a library and chapel. Although much of the convento is now roofless, the library remains in use, containing a treasury of early devotional and instructional volumes.

The rustic vaulted chapel is also still used, housing several folk *santos* that include a black Christ and the figure of St. Francis of Assisi, on whose feast day a special mass is celebrated every October fourth.

Cadereyta

Two churches face the sunny, paved plaza in this dusty crossroads town. The late colonial parish church of Peter and Paul has been greatly altered over the years although it retains an archaic 16th century stone cross densely carved with the face of Christ and other Passion symbols (now kept in the baptistry).

But the chief attraction at Cadereyta is its sensational gilded altarpiece. This was recently documented as a major work by the celebrated 18th century sculptor and designer Pedro de Rojas, whose retablos grace other monastic churches in Querétaro and Guanajuato.

Designed in an elegant Churrigueresque style, the retablo entirely fills the apse at the east end of the church. Narrow *estípites*, emphatically ornamented with masks and bands of foliage, flank the three tiers of paintings and statuary. The columns on the middle tier are prominently headed by ornamental herms.

Of the five statues of saints commissioned in the original contract for the altarpiece (dated 1752), those of Saints Peter and Paul, housed on the middle tier, are believed to have been carved by Rojas himself. The sculpture of St. Paul is especially powerful—a commanding figure in the Mannerist mold, with a strong, expressive face, assertive stance and boldly chiseled robes. The staid figures of St. Francis and Nicholas of Tolentino—the patron saint of Cadereyta—on the lower stage, may be from Rojas' workshop, but lack the vitality of the master's touch.

The paintings, in their bold Moorish frames, illustrate conventional scenes from the lives of Christ and the Virgin Mary in a naive baroque style.

Cadereyta, retablo statue of St. Paul

C O D A: **MALINALCO**

Finally, we consider the Augustinian priory of San Salvador Malinalco.

Although located in the state of Mexico—an area outside the general purview of this guidebook—this important monastery played a key role in the Augustinian campaign of evangelization and missionizing of colonial west Mexico. It became the principal link between the main priory of San Agustín in Mexico City and the scattered missions and monasteries of the Augustinian province of San Nicolás de Tolentino de Michoacán.

Within its ample precincts, a special seminary prepared the friars for the arduous work of missionizing the vast Tarascan empire to the west.

Malinalco, portería medallion showing "malinalli" grass

MALINALCO

Occupying the southern end of a strategic corridor and buffer zone between the Valley of Mexico and the Tarascan empire, Malinalco was ever vulnerable to invasion by its more powerful neighbors.

In pre-conquest times the lush, fertile valley was associated with various earth deities, notably the goddess Malinalxochitl (Malinalli Blossom) a sorceress and the sister of the Aztec patron deity Huitzilipochtli.

According to Aztec myth, Malinalxochitl came into conflict with her powerful brother. Threatening him with witchcraft, she was banished to the Malinalco Valley, whose association with black magic and the underworld persists even today in the popular imagination.

Malinalco's place name is literally derived from *malinalli*, a wiry grass native to the region whose outline is emblazoned on the front of the convento and is integral to the spectacular murals that grace its cloister.

Not long before the Spanish conquest, the independent Matlatzincas of the area saw their fertile lands annexed to the burgeoning Aztec empire. Because of the warlike character of the people and their reputation for witchcraft, the Aztecs took care to establish a strong garrison there, erecting hillside temples to glorify the imperial warrior

cults of the eagle and the jaguar—a building complex that was still unfinished when the Spaniards arrived in 1519.

Following the conquest of Malinalco in 1521 by Andrés de Tapia, one of Cortés' lieutenants, the Spaniards moved quickly to exploit the rich agricultural potential of the valley, and initiated the process of converting the natives to Catholicism.

As elsewhere, Franciscan friars were the first to evangelize the area, but it was left to the Augustinians to establish the first missions there.

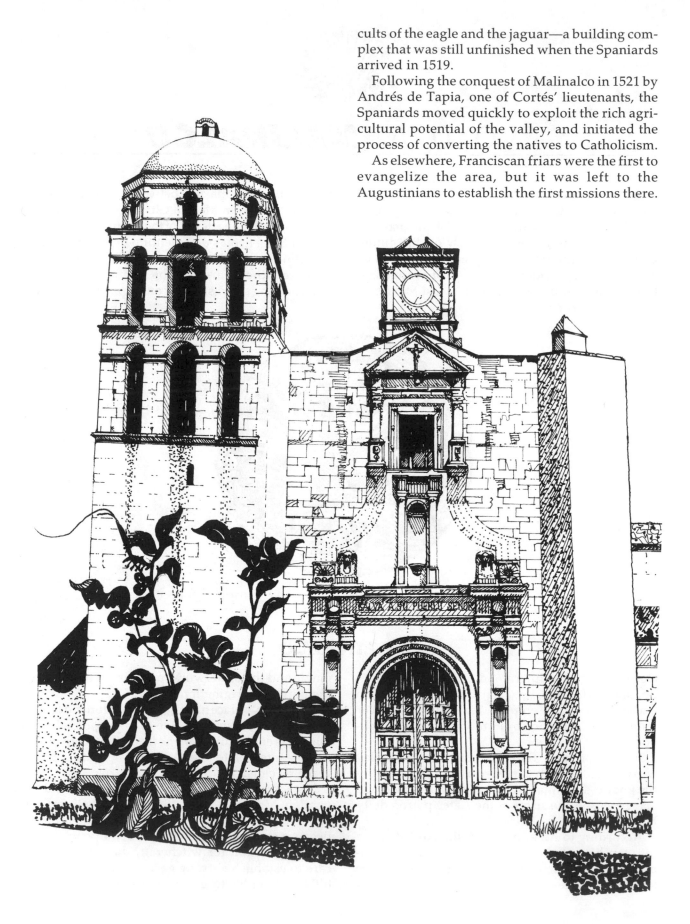

Beginning in 1537, the native population was congregated into the principal towns of Malinalco and nearby Ocuilán, where primitive missions were founded by the friars Diego de Chávez and Juan de San Román.

Substantial monasteries were soon under construction in these two centers, together forging a critical link in the chain of Augustinian missions that stretched from the Valley of Mexico to the chief western houses of Tacámbaro, Tiripetío, Cuitzeo and Yuriria.

The first mission at Malinalco, erected in the 1540s, was a humble, pole-and-thatch structure. But in 1550, by direction of the Augustinian Provincial Fray Jorge de Avila, work began on a large stone monastery with a fortress church and a spacious convento, salvaging the abundant stone from a demolished Aztec temple.

Progress was slow, however. Vaulting of both church and cloister was not completed until the late 1560s, at the same time as the church facade. And finishing touches to the monastery were be-

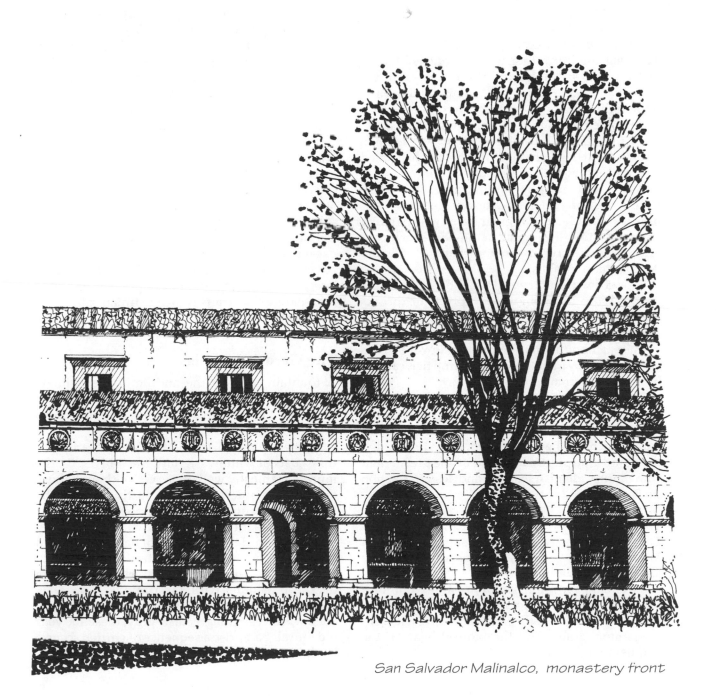

San Salvador Malinalco, monastery front

ing made well into the 1570s. Both Diego de Chávez and Juan Cruzate, who was the prior during the main building phase, were known as architects and builders.

Today the grand priory of San Salvador still dominates the crowded town center, its handsome double gateway enticing the visitor into the grassy openness of the atrium. Beyond the trees, the far side of the atrium opens out to reveal the broad monastery front. The fortress church stands at center, flanked by a squat tower on the left and the arcade of the monastery portico stretching away to the right.

The Church

The pleasing but rather undistinguished facade at Malinalco lacks the sculptural interest of the great Plateresque facades of Acolman and Yuriria. Although influenced by the severe Renaissance style of the mid-16th century, it nevertheless follows the classic outlines of most Augustinian church fronts. Its closest, but more sophisticated relative, is that of San Agustín in Morelia.

A broad triumphal arch frames the plain rounded doorway. High above, the choir window rests inside a rectangular frame with flanking columns and a triangular pediment, which contains a small crucifix in the manner of many Augustinian facades.

Separating the entry and the choir window is a narrow sculpture niche, now empty, which breaks the stepped symmetry of the facade, in contrast to the soaring facade at Cuitzeo. The tower, too, seems earthbound, its compressed lower belfries surmounted by a squat, octagonal top tier, capped by a shallow dome.

The vast interior was entirely redone in the prevailing neoclassical mode during the 19th century. Virtually all traces of the original decoration and furnishings have vanished, including, sadly, the grand altarpieces designed by the preeminent 16th century Flemish sculptor and designer, Simón de Pereyns.

The Convento

The frescoed convento is the star attraction at Malinalco. An arcaded *portería* of impressive length shades the entry. Simple arches atop stolid square piers form the arcade, plain except for a row of ornamental relief medallions overhead, in which stylized *malinalli* plants alternate with religious monograms and the pierced heart of the Augustinian order.

Originally, the portico interior was painted throughout, preparing the visitor for the feast of frescoes inside the cloister. The seven bays of the portico may stand for the first seven apostolic Augustinians, who arrived in Mexico in 1533—a number with special significance for the order, symbolizing the seven angels of the Apocalypse, the seven pyramids of Egypt and, eventually, the seven monasteries of Michoacán.

In fact, the seven first friars were portrayed, with their names, on the inner faces of the arcade piers. Only two of these portraits now remain, adorning the corner supports. One of them is the bust of Francisco de la Cruz, "El Venerable," the leader of the first Augustinian contingent to reach the shores of the New World.

The *portería* barrel vault retains its geometrical Serlian design, painted in unexpectedly bright hues—protected until recent times by the blocking up of the arcade. Fragmentary murals also decorate the enclosed interior of the old *portería* chapel, whose outline can still be traced beside the monastery entrance.

From the *portería* it is only a few steps to the two story cloister, whose warm gray stone arcades are carved in a restrained Plateresque style. As with the entrance portico, the walks are barrel-vaulted except for the corner compartments which are covered by intricate Gothic ribbing. Like the portico too, the inner faces of the piers at one time bore painted portraits of Augustinian saints and martyrs.

The Garden Murals

A fountain plays in the middle of the intimate patio, from where the spectacular cloister murals are viewed to best advantage—as may have been intended.

Painted in the 1570s and hidden beneath multiple coats of whitewash until the mid-1970s, the murals are mostly well preserved, although those on the west side have been partly erased. The frescoes surround the lower cloister on all four sides like a giant frieze and are contained within horizontal borders consisting of bands of foliated and grotesque decoration. In traditional Augustinian style, the ornamental running frieze overhead includes Latin inscriptions.

Boldly sketched in broad monochrome leavened with accents of greenish-gray, these 400 year old murals comprise a sequence of garden scenes, in which native American and Old World fauna,

Malinalco, cloister "garden" mural with monogram of Christ

birds, animals and insects, disport in a tapestry of twisting vines, grasses and flowers—a mixed flora of New World and traditional European origins.

Although the design elements are drawn from Islamic and European graphic sources, the execution of the frescoes is undisputedly the work of native artists or *tlacuilos*, who were skillful observers of the natural world and who, almost fifty years after the conquest, still retained detailed knowledge of pre-hispanic customs and beliefs. In fact, the telltale Aztec signature of the *tlacuilo*—a slotted "song scroll"—appears at intervals in the murals on the vault.

Unlike most other Mexican cloister murals, however, no human figures appear in the garden sequences, nor is there any narrative theme. Only large armorial medallions of Augustinian insignia and intricate Christic and Marian monograms

stand out from the interwoven floral background, hanging in the air like mystical talismans reminiscent of Islamic decoration.

Like the walls, the cloister vaults are painted in black and gray monochrome, although with blue accents. But here we see different hands at work. Although entwined foliage remains the dominant theme, the European inspired intricacy of design and the subtleties of line and shading in the wall frescoes give way to a more indigenous approach using codex-style outlining of objects and a dense, almost abstract patterning of the foliage.

Interpretations of this unique mural program vary. The favorite Augustinian theme of the Paradise Garden is clearly implied in the frescoed cloister. This subject was rooted in their eremitic origins and elaborated upon during their later expansion as an apostolic order. It extols the

Christian message, conveyed by the friars to bring order and enlightenment to what they viewed as the vast pagan wilderness of the New World.

This utopian theme is reinforced by the inclusion within the murals of plants and animals that traditionally symbolized sin (serpents and monkeys) and redemption (butterflies and doves), reiterating the medieval view of a civilized and Christian world in constant conflict with untrameled nature and the dark, disordered domain of the Devil.

Opinions vary as to whether the murals themselves represent Paradise before or after the Fall of Man—a well tended Christian garden, or a sin-tainted nature run riot. While there is support for either view, the sequence of carefully arranged murals suggests order rather than disorder, presenting a didactic visual panorama which might aid the friars in instructing their native acolytes.

The Marian emblems embedded in the murals draw attention to another aspect of 16th century mendicant thought, in which the enclosed garden of the cloister also serves to symbolize the inviolate sacred nature of the Virgin Mary.

Other Murals

The painted archway of one of the wall confessionals that communicate between the church and cloister forms a Calvary, framing a somber mural in which an Augustinian friar confronts the Grim Reaper.

A circular mural above the stairwell portrays a pelican succoring its young with the blood from its own pierced breast, another traditional motif that symbolizes the sacrifice of Christ—no doubt intended to remind the friars of their own self

sacrifice in the fulfillment of Christ's work. A pre-hispanic note is also sounded in this key mural, where the pelican resembles an eagle—the war-like Aztec symbol of pride and valor. The mural is also framed by a wreath of *malinalli* grass.

Recessed niches at the ends of both upper and lower cloister walks were originally painted with narrative scenes, in contrast to the figureless frescoes along the corridors. Those of the lower cloister have disappeared, but eight murals depicting episodes from Christ's Passion in the upper cloister are still recognizable, some in fair condition, especially the Crucifixion with the Three Marys in the southeast corner. These murals were devotional images intended to inspire the friars as they walked and meditated. Like the entrance portico, the barrel vaults of the upper cloister are bright with painted geometric coffering.

In the former prior's room, we find a partial 16th century mural of St. Augustine sheltering the friars of his order, whose tonsured heads recede into the distance beneath his spreading cape. Sections of ornamental friezes, including decorative grotesques, can be found throughout the convento.

Fragments of garden murals have also been uncovered in the upper cloister and beneath the choir in the church, suggesting that this was a pervasive theme throughout the monastery, reminding the friars at every turn of the daunting apostolic task to which they were committed.

Throughout the 16th century, spiritually fortified by the message of these encompassing frescoes, Augustinian friars went forth in zeal from this cloister at Malinalco to spread the Catholic message and bring hispanic civilization to the furthest corners of the territories to the west.

Malinalco, "song scroll"

SELECT BIBLIOGRAPHY

Aguilar Moreno, Manuel, et al. *En busca del Atlquiahuitl: Cajititlán.* Guadalajara: 1995.

Anaya Larios, José Rodolfo. *Los retablos dorados de Santa Clara y Santa Rosa de Querétaro.* Querétaro: Univ. Autónoma de Querétaro, 1984.

Arvizu García, Carlos. *Urbanismo novohispano en el siglo XVI.* Querétaro: Gobierno del Estado, 1993.

————. *Querétaro: sitios y recorridos.* Mexico, DF: Grupo Editorial, 1994.

Bargellini, Clara, et al. *La catedral de Morelia.* Zamora: Colegio de Michoacan, 1991.

Bargellini, Clara; Rogelio Ruiz Gomar, Mina Ramírez Montes, et al. *Querétaro, ciudad barroca.* Querétaro: Gobierno de Querétaro, 1988.

Berchez, Joaquín. *Arquitectura Mexicana de los siglos 17 y 18.* Arte Novohispano, Vol. 3. Mexico DF: Grupo Azbache, 1992.

Bleyleben, Karl Anton. *The Treasures of the Sierra Gorda.* Unpublished ms., 1986.

Boils Morales, Guillermo. *Arquitectura y sociedad en Querétaro: Siglo XVIII.* Querétaro: I.I.S., 1994.

Bravo Ugarte, José, ed. *Inspección ocular de Michoacán.* Mexico DF: Editorial Jus, 1960.

Burke, Marcus. *Pintura y escultura barroca en Nueva España.* Arte Novohispano Vol. 5. Mexico DF: Grupo Azbache, 1992.

Burton, Tony. *Western Mexico: A Travellers Treasury.* Guadalajara: Editorial Agata, 1993.

Calderón, Victor Manuel. *Monografía histórica de Querétaro.* Querétaro: Archivo Histórico del Gobierno del Estado,1993.

Ciudad Real, Antonio de. *Viajes de Fray Alonso Ponce al occidente de México.* Guadalajara, 1968.

Cornejo Franco, José. *Guadalajara colonial.* Guadalajara: Cámara de Comercio, 1938.

Díaz Berrio, Salvador, & V. Manuel Villegas. *Templo de la Compañía en Guanajuato,* Guanajuato: Universidad de Gto, 1969.

Díaz Miramontes, Ana Cristina, et al. *Templo de Santa Rosa de Viterbo.* Querétaro: Gobierno del Estado, 1994.

Díaz, Marco. *La arquitectura de los Jesuitas en nueva España.* Mexico DF: UNAM-IIE, 1982.

Early, James. *The Colonial Architecture of Mexico.* Albuquerque: University of New Mexico Press, 1994.

García Acosta, María. *Imagenes y vida de Irapuato.* Guanajuato: Ayuntamiento de Irapuato, 1993.

García Oropesa, Guillermo. *Guia informal de Guadalajara.* Mexico DF: Editorial Cosmos, 1978.

Gómez Cañedo, Lino. *Sierra Gorda; un típico enclave misional en el centro de México,* Querétaro: Gobierno de Querétaro. serie: Documentos de Querétaro, 1988.

González Galván, Manuel. *Arte Virreinal en Michoacán*. Mexico DF: Frente de Afirmacion Hispanista, 1978.

————. *La arquitectura de Morelia*. Morelia., n.d.

————. *Catedral de Morelia*. Monografias de Arte Sacro 10-11. Mexico DF: Comisión nacional de arte sacro, 1982.

Gouy-Gilbert, Cecile. *Ocumicho y Patamban: maneras de ser artesano*. Mexico DF: CEMCA#2. 1987.

Guanajuato. Artes de Mexico #73/4, Mexico DF: 1968.

Gustín, Monique. *El barroco en la Sierra Gorda*. Mexico DF: INAH. series: Monumentos Coloniales, 1969.

Keleman, Pal. *Baroque and Rococo in Latin America*. New York: Macmillan Co. 1951.

Kubler, George. *Mexican Architecture of 16th century Mexico*. (2 vols) Yale University Press, 1948.

Lázaro Jiménez, Simón. *Paricutín: Fifty Years after its Birth*. Trans: Tony Burton. Guadalajara: Editorial Agata, 1993

Loarca Castillo, Eduardo. *Guia histórica de la ciudad de Querétaro*. Querétaro: Ayuntamiento de Qro, 1991.

Loarca Castillo, Eduardo, et al. *Querétaro*. Artes de Mexico #15 (nuevo serie) Mexico DF. 1992

Maza, Francisco de la. *Arquitectura de los coros de monjas en México*. Mexico DF: UNAM—IIE, 1983.

————. *San Miguel de Allende: su historia, sus monumentos*. Mexico DF: Frente de Afirmación Hispanista. 1972.

McAndrew, John. *The Open-Air Churches of 16th Century Mexico*. Cambridge: Harvard University Press, 1965.

Mata Torres, Ramon (ed). *Iglesias y edificios antiguos de Guadalajara*. Guadalajara: Ayuntamiento, 1984.

Morelia. Artes de Mexico #100-101. 1967.

Moreno Negret, Sarbelio. *Casas y casonas de Querétaro: el barroco queretano*. Mexico DF: the author, 1984.

Muriel, Josefina. *Hospitales de la Nueva España* (2 vols). Mexico DF: UNAM-IIH, 1990.

Murillo Delgado, Ruben. *El centro historico de Morelia*. Morelia: FIMAX, 1990.

Paseo por San Miguel. Artes de Mexico #139. Mexico DF. 1969.

Perry, Richard D. *Mexico's Fortress Monasteries*. Santa Barbara: Espadaña Press, 1992

Peterson, Jeanette F. *The Paradise Garden Murals of Malinalco*. Austin: University of Texas Press, 1993.

Ramírez Montes, Mina. *Catedral de Vasco de Quiroga*. Morelia. 1986.

————. *Pedro de Rojas y su taller de escultura en Querétaro*. Querétaro: Gobierno del Estado de Querétaro, 1988.

Ramírez Romero, Esperanza. *Arquitectura religiosa en Morelia*. Morelia: Instituto Michoacano de
 Cultura, 1994.

———— . *Catálogo de construcciones artisticas, civiles y religiosas de Morelia*. Morelia: Universidad de San
 Nicolás, 1981.

———— . *Catálogo de monumentos y sitios de la región lacustre: Pátzcuaro*. Morelia: Gobierno de
 Michoacán, 1986.

———— . *Catálogo de monumentos y sitios de Tlalpujahua*. Mexico DF: Universidad de San Nicolás, 1985.

———— . *Morelia en el espacio y en el tiempo*. Morelia: Gobierno de Michoacán, 1985.

Ricard, Robert. *The Spiritual Conquest of Mexico*. Trans: Lesley Byrd Simpson. Berkeley: University of
 California Press, 1966.

Rojas, Pedro. *Acámbaro Colonial*. Mexico DF: UNAM—IIE, 1967.

Septien y Septien, Manuel. *Acueducto y fuentes de Querétaro*. Querétaro: Gobierno del Estado de
 Querétaro, 1988.

Septien y Septien, Manuel et al. *Querétaro*. Artes de Mexico #84/85. Mexico DF. 1966.

Silva Mandujano, Gabriel. *La catedral de Morelia: arte y sociedad en la Nueva España*. Morelia: Gobierno de
 Michoacán, 1984.

Sixtos Lopez, Gerardo. *Morelia y su centro histórico*. Morelia: Inst. Michoacano de Cultura, 1991.

Storm, Marian. *Enjoying Uruapan: A Book for Travelers in Michoacán*. Mexico DF: 1945.

Super, John. *La vida en Querétaro durante la colonia*. Mexico DF. 1986.

Tavera Alfaro, Xavier. *Morelia*. Mexico.DF: FONAPAS, 1978.

Toussaint, Manuel. *Colonial Art in Mexico*. Trans & ed: Elizabeth Wilder Weismann. Austin: University
 of Texas Press, 1967.

———— . *Paseos Coloniales*. Mexico DF: Editorial Porrua, 1983.

Vargas Lugo, Elisa & José Guadalupe Victoria. *Un edificio que canta: San Agustín de Querétaro*. Querétaro:
 Documentos de Querétaro #14, 1989.

Vargas Lugo, Elisa. *Las portadas religiosas de México*. Mexico DF. 1969.

Warren, Fintan B, OFM. *The Conquest of Michoacán*. Norman, OK: University of Oklahoma Press, 1985.

———— . *Vasco de Quiroga and his Pueblo-Hospitals of Santa Fe*. Washington, DC: Academy of
 American Franciscan History, 1963.

Weissmann, Elizabeth Wilder. *Mexico in Sculpture*. Cambridge: Harvard University Press, 1950.

Zaldivar G., Sergio. *"Arquitectura religiosa del siglo XVIII en el valle de Atemajac."* Artes de Mexico
 94-5, Mexico DF, 1967.

———— . *Arquitectura y carpinteria en Nueva España*. Arte Novohispano Vol 7. Mexico DF: Grupo
 Azbache, 1992.

Zaldivar G., Sergio, et al. *Catedrales de Mexico*. Mexico DF: CVC Publicaciones, 1993.

Zavala Paz, José. *El Bajío*. Mexico DF. 1955.

GLOSSARY

agave *(S)* Succulent plant with large spiky fleshy leaves, native to Mexico. *(also Maguey)*

ajímez *(S)* Moorish two-light window with ornamental mullion

alameda *(S)* Tree-lined avenue, from *alamo*, cottonwood

alfarje *(S)* Wooden *mudéjar* (hispano-moorish) ceiling, syn: *artesonado*

alfiz *(S)* Rectangular *mudéjar* frame above an arched opening

anastilo *(S)* Ornate late baroque style of altarpiece. lit: "without style"

apostolado *(S)* Sequence of paintings or statues depicting the Twelve Apostles

artesonado *(S)* 1. Decorative *mudéjar* ceiling of intricately joined, inlaid and painted wood.
2. Coffered wood or masonry vault in Roman Renaissance style

ashlar. Cut or dressed building stone of even shape

atlante. Architectural support in the form of a male figure

atrium. Walled forecourt or churchyard

baluster. Bulbous decorative column or support

Barococo. Transitional late baroque architectural style, heavily influenced by the rococo

barrio *(S)* Neighborhood or ward of a Mexican town

barroco republicano *(S)* Postcolonial architectural style with baroque and neoclassical elements

calabash. Mexican squash with a hard rind, often used as a water vessel

calvarito. *(S)* 1. hilltop chapel or shrine. 2. processional chapel or *posa*

camarín. *(S)* Apsidal chapel used for storing or dressing religious images

cantera. *(S)* Fine-grained marble or limestone

caña de maíz. *(S)* Pulverized corn stalks or pith used as sculptural material (also *pasta de caña*)

caracol. *(S)* Spiral or circular stairway, usually enclosed. Lit: snail

cartouche. Ornamental medallion or sculptural frame

caryatid. Architectural column or support in the form of a female figure

casa señorial *(S)* Urban mansion or townhouse built for the Spanish or Mexican upper classes

castillo *(S)* 1. Castle 2. Firework frame in the form of a castellated tower

celosía *(S)* Decorative screen or grille

Churrigueresque. Ornate late baroque style of architecture and design

clarisas *(S)* Sisters of the Franciscan Order of Poor Clares

cofradía. *(S)* Religious fraternity

colonette. Narrow column of Gothic origin

convento *(S)* Monastic residence and its precincts

coro bajo *(S)* Church underchoir

corrida *(S)* Bullfight or horserace

criollo *(S)* Creole, someone of Spanish ancestry born in Mexico

cristo de caña *(S)* Lightweight crucifix fabricated from corn pith

cuauxicalli *(N)* Aztec ceremonial vessel for holding the hearts of sacrificial victims

ermita *(S)* 1. Hermitage 2. Barrio chapel 3. Hilltop shrine

escudo *(S)* Heraldic medallion or escutcheon in the form of a shield

espadaña *(S)* Wall belfry or gable arcade placed atop the church facade

estípite *(S)* Ornamental composite column or pilaster based on the herm or inverted obelisk

estofado *(S)* Decorative technique for imitating brocade or the texture of clothing on painted, gilded statuary

fleur-de-lis. Ornamental motif in the form of a lily flower

grotesque. Style of decoration based on designs from classical antiquity, combining fantastic birds, masks and foliage

herm. Column or pilaster in the form of a stylized bust

INAH. Instituto Nacional de Antropología e Historia

interestípite *(S)* Ornate niche-pilaster set between estípites

lambrequin. Ornamental pendant or scalloped relief in the form of an inverted glove.
(Spanish: *pinjante*)

leña dorada (S) "Golden firewood," dismantled gilded altarpieces consigned to the flames

lunette. Fanlike or half-moon shaped window or vault compartment

Mannerism. Expressive, post Renaissance style of art and architecture characterized by distorted forms and harsh colors

mariachi (S) Group of traditional Mexican musicians, originating in the state of Jalisco

mestizo (S) Person of mixed race, part-Indian and part-Spanish

mirador (S) Balcony with a view, or scenic viewpoint

mixtlinear. Gable of mixed curved and angular profile

mudéjar (S) Hispano-Moorish art and architecture, created by muslims under Spanish rule

neoclassicism. 18th century revival of classical canons in design and architecture

neostyle. Late baroque Mexican architecture incorporating neoclassical elements

obsidian. Volcanic glass

periférico (S) Ring road or beltway around a town or city

pila (S) Basin or font

pirindas (T) Refugees, or resettled people of different ethnic backgrounds

Plateresque. Decorative style of 16th century Spanish architecture and design. From *platero*, silversmith

poma (S) Isabelline decorative motif in the shape of an apple or pearl

portales (S) Arcades surrounding a square or plaza

portería (S) Arcaded monastery entrance

posa (S) Corner chapel in a monastery atrium

predella. Base of an altarpiece

purépecha (T) Tarascan language and people

recuerdo (S) Religious memento. Also called an "ex-voto"

retablo (S) Large compartmented altarpiece with paintings and statuary

reja (S) Metal screen, usually separating the nave from the sanctuary or choir

rocaille. Scrolled motif characteristic of rococo ornament

rococo. Delicate, highly ornate 18th century style of art and architecture

rustication. Architectural use of large or rough stone blocks for decorative effect

sagrario (S) 1. Annex to a cathedral 2. Tabernacle

santo (S) Saint or religious image

Solomonic. Spiral column, often carved with grapevine reliefs. Signature of the early Mexican baroque style based on biblical descriptions of the Temple of Solomon in Jerusalem

strapwork. Interwoven, geometrical style of decoration derived from European Mannerism

tabernacle. Receptacle for the Host, often a part of the altarpiece

tapatío (S) Popular term for a citizen of Guadalajara (Jalisco)

tenebrista (S) early baroque style of painting distinguished by chiaroscuro effects

teponaxtle (N) Aztec drum

tequitqui (N) 16th century Christian art in Mexico, influenced by pre-hispanic techniques and forms

tezontle (N) Coarse-textured, reddish-black volcanic building stone

tilma (S) Aztec smock

torre mocha (S) Unfinished tower, cut off at a lower stage

toro (S) 1. Bull 2. Portable headdress in the shape of a bull's head, fitted with fireworks

tribuna (S) Screened gallery or balcony in a church

visita (S) Non-residential church or mission, visited by an outside priest

vitrine. Glassed in compartment or showcase

yácata (T) Tarascan temple platform or pyramid

yurishio (T) Traditional Tarascan sacred compound or chapel

zapata (S) Decorative beam end, or corbel

zócalo (S) Main square or plaza of a Mexican town

KEY: (S) = Spanish; **(N)** = Nahuatl; **(T)** = Tarascan (*purépecha*)

INDEX

Querétaro, La Casa de los Perros: draped cross relief above the entry

Blue Lakes & Silver Cities is the fourth in our series of illustrated regional guidebooks to the colonial arts and architecture of Mexico.

Our previous guides include **Mexico's Fortress Monasteries**, which describes the 16th century monasteries of Central Mexico and Oaxaca, and two books on the colonial buildings of the Maya region of Mexico: **Maya Missions**, which explores the Yucatan peninsula, and **More Maya Missions**, on the state of Chiapas.

We welcome your comments and inquiries. Additional copies of our guidebooks are available direct from Espadaña Press. PO Box 31067 Santa Barbara California 93130

Maya Missions (ISBN 9620811-0-8)	$12.95
More Maya Missions (ISBN 9620811-2-4)	$12.95
Mexico's Fortress Monasteries (ISBN 9620811-1-6)	$19.95
Blue Lakes & Silver Cities (ISBN 9620811-3-2)	$25.00

(please add $2.00 shipping per copy)

Artist and writer Richard Perry has a
longstanding interest in hispanic art and
architecture. A native of England, he be-
came fascinated with the Spanish colonial
monuments of Mexico during his travels
there. Dismayed by the lack of material on
the subject for English speaking readers,
with his wife Rosalind he undertook to
produce a series of regional guidebooks for
the art traveler.

Together they own a small publishing com-
pany and continue to pursue the less traveled
roads of Mexico in search of undiscovered
colonial treasures.